AGNES MARTIN

First Paperback Edition
Printed in the United States

Cover Photo: Granted by Permission of Susan Sharpe
Cover and Interior Design: Jordan Wannemacher

The Publisher gratefully acknowledges the following for permission to reprint from these published works: Li Po, "Questions Answered" from Crossing the Yellow River: Three Hundred Poems from the Chinese, translated by Sam Hamill. Copyright © 2000 by Sam Hamill. Reprinted with thepermission of The Permissions Company, Inc., on behalf of Tiger Bark Press, "Four Strong Winds" excerpts, printed by permission of Ian Tyson, Slick Fork Music.

Library of Congress Cataloging-in-Publication Data

Names: Martin, Henry, 1983- author.
Title: Agnes Martin : pioneer, painter, icon / Henry Martin.
Description: First paperback edition. | Tucson, AZ : Schaffner Press, Inc.,
 2018. | Includes bibliographical references.
Identifiers: LCCN 2017040812 (print) | LCCN 2017042118 (ebook) | ISBN
 9781943156313 (Adobe) | ISBN 9781943156320 (Epub) | ISBN 9781943156337 (
 Mobi/Kindle) | ISBN 9781943156306 (paperback)
Subjects: LCSH: Martin, Agnes, 1912-2004. | Artists--United
 States--Biography. | BISAC: BIOGRAPHY & AUTOBIOGRAPHY / Artists,
 Architects, Photographers. | ART / Individual Artists / General.
Classification: LCC N6537.M38 (ebook) | LCC N6537.M38 M37 2018 (print) | DDC
 759.13 [B] --dc23
LC record available at https://lccn.loc.gov/2017040812

ISBN: 978-1-943156-30-6

www.schaffnerpress.com

AGNES MARTIN

Pioneer,

Painter,

Icon

Henry Martin

SCHAFFNER PRESS

For my parents, who told me stories—
sometimes without intending to,
and even when I would not listen.

And for Kristina Wilson.

I'd just as soon be discovered 25 years after I'm dead...
that'd really be great...
that would mean so much.
1974, AGNES MARTIN INTERVIEW WITH KATE HORSFIELD

It is better to go to the beach and think about painting than it is
to be painting and thinking about going to the beach.
1987, AGNES MARTIN, SKOWHEGAN

We think we are very mundane, but we are all capable of fugues.
1993, AGNES MARTIN INTERVIEW WITH SALLY EAUCLAIRE

Contents

ICON: (1967–2004) 181

A Note On Artwork

There are hundreds of artworks mentioned in this book. Most, but not all, are by Agnes Martin. It is very difficult to reproduce Martin's work properly—impossible to reduce to five by five inches a canvas that is seventy-two by seventy-two inches in size: few details can be preserved, and only the most general color and form can be communicated.

The following list has been selected to offer an overview of her output. The list is biased because it includes work that is particularly meaningful to the narrative within—work that highlights people, places, or ideas close to the artist. As an overview it includes all the media the artist worked in; sculpture, painting, prints, and film, as well as her different styles; figurative, biomorphic, abstract, geometric and so forth. In these examples, to aid the understanding of what paintings were produced where, "Pioneer" artwork was generally produced in Oregon and New Mexico, "Painter" artwork in New York, and "Icon" artwork in New Mexico.

I hope the reader looks at some of the artwork listed below and that they feel free to reference books, libraries, and online searches for other

work, so that they form their own connections and opinions on the artist and her contemporaries.

There is nothing better than seeing the work in person, and work by the artist can be found in public collections around the world. You may come across a work when you least expect it. If you do, follow the artist's advice and give it at least thirty seconds of your time.

I hope you'll be happy that you do. After all, "Happiness is the goal."

PIONEER

Untitled, 1948
Encaustic on canvas, 18 x 14 in.
Private collection.

View from the Porch, no date
Oil on canvas, 19 ½ x 23 ½ in.
Private collection.

New Mexico Mountain Landscape, Taos, 1947
Watercolor on paper, 11 x 15 ¼ in.
Raymond Jonson Collection, The University of New Mexico Art Museum, Albuquerque, NM.

Portrait of Daphne Vaughn, c.1947–49
Encaustic on canvas, 20 x 16 in.
Peters Family Art Foundation, Santa Fe, NM.

Self Portrait, no date
Encaustic on canvas, 26 x 19 in.
Private collection.

Personages, 1952
Lithograph, 10 x 14 in.
Private collection.

The Expulsion of Adam and Eve from the Garden of Good and Evil, 1953
Oil on paperboard, 48 x 72 in.
Private collection.

Untitled, 1953
Oil on canvas, 34 x 47 ½ in.
The Harwood Museum of Art, Taos, NM.

Untitled, 1954
Black crayon or pastel and oil on paperboard, 36 x 47 ¾ in.
The University of New Mexico Art Museum, Albuquerque, NM.

Mid-Winter, 1954
Oil on canvas, 33 x 48 in.
Taos Municipal Schools Historic Art Collection, Taos, NM.

Dream of Night Sailing, 1954
Oil on canvas, 15 x 22 in.
Private collection.

PAINTER
Untitled, c.1957
Oil on canvas, 34 x 34 in.
Dia Art Foundation, NY.

This Rain, 1958
Oil on canvas, 70 x 70 in.
Whitney Museum of American Art, NY.

The Laws, 1958
Oil and boat spikes on wood, 93 ¼ x 18 x 2 in.
Private collection.

Homage to Greece, 1958
Oil paint on pieces of canvas on wood panel, with nails, 12 x 12 in.
Private Collection.

Dominoes, 1960
Gouache, ink, and graphite on paper mounted on canvas, 36 x 12 in.
Norton Museum of Art, West Palm Beach, FL.

Mountain, 1960
Ink and pencil on paper, 9 x 12 in.
The Museum of Modern Art, NY.

Words, 1961
Ink on paper, mounted on canvas, 24 x 24 in.
Thomas Ammann Fine Art AG, Zurich.

Friendship, 1963
Incised gold leaf and gesso on canvas, 75 x 75 in.
The Museum of Modern Art, NY.

The Wave, 1963
Edition of 4
Plexiglas, wood and beads, 10 ¾ x 10 ¾ x 2 in.
Private collection.

The Tree, 1964
Oil and graphite on canvas, 72 x 72 in.
Larry Aldrich Foundation Fund, Museum of Modern Art, NY.

ICON

Praise, 1976
Edition of 1000, Parasol Press Ltd.
Rubber stamp print on paper, 11 x 11 in.
Museum of Modern Art, NY.

Gabriel, 1976
16mm film, total running time 78 minutes,
Museum of Modern Art, NY.

Untitled #1, 1989,
Acrylic and graphite on canvas, 72 x 72 in.
Marc and Laura Andreessen Collection.

The Agnes Martin Gallery, 1993–1994
A series of 7 paintings,
Acrylic and graphite on canvas, 60 x 60 in.
The Harwood Museum of Art, Taos, NM.

With My Back to The World, 1997
A series of 6 paintings,
Acrylic on canvas, 60 x 60 in.
Ovitz Family Collection.

Affection, 2001
Acrylic and graphite on canvas, 60 x 60 in.
Private collection.

Homage to Life, 2003
Acrylic and graphite on canvas, 60 x 60 in.
Private collection.

Untitled #1, 2003
Acrylic and graphite on canvas, 60 x 60 in.
Private collection.

PROLOGUE

Who was Agnes Martin?

On sunny evenings, Kristina Wilson, aged eighty-five, cycles from her house on Valverde Commons down the street to Sunset Park, a ten-acre swath of land dropped like an artist's ruler at the foot of Taos Mountain in New Mexico. It is not lush like the great city parks in New York, Paris, or London. The desert grasses snap like uncooked spaghetti under the weight of footsteps, and wild coyotes skulk by the fences at night. At seven thousand feet above sea level, the air and earth are dry and the light is sharp. Occasionally among the weeds, patches of mud and short golden grass, a small purple flower makes a home, finding shelter and sustenance. Dragonflies, buffalo gnats, crickets and butterflies move in and out of the grass, while above them crows and magpies perch in the cottonwood trees.

At one end of the park a path winds up to Valverde Street and the Plaza de Retiro, where Agnes Martin lived the last eleven years of her life, close to her studio, Kristina's home, and the Agnes Martin Gallery at the Harwood Museum. Kristina, Agnes's friend, had this path built to make it easy

for people to visit and have "a quiet, beautiful experience" at any time of the day, but especially at sunset when the sky moves through the color spectrum, pulling a red veil over the Taos Mountains. After a snow storm Kristina can see Wheeler Peak, the highest point in the state, where Agnes used to climb, a long time ago.

The two women first met in 1955, a stone's throw from the park, when Agnes resided in a compound next to the Harwood Foundation (it became known as the Harwood Museum in 1998). Agnes lived in a one-room studio with a dirt floor and two rocking chairs—struggling to be an artist. When she returned thirty-eight years later in 1993 to live at the Plaza de Retiro, she had upgraded to a two-room apartment with a studio down the street. Her possessions were still limited: two Boston rockers and some knick-knacks: an award or two. In this last decade of her life Agnes had become, in her own words, "the greatest artist in the world," and, as though to verify this claim, her body and mind were home to the marks of suffering and endurance that the great must bear.[1]

Aggie, Ag, Miss Martin, spent her life dedicated to realizing her potential. She saw this as her greatest contribution to the world. "We are born to do certain things," she wrote, "and we are born to fill a certain need. If there is a bare spot on the ground the best possible weed for that environment will grow," like the purple flower in Sunset Park, surviving and unfolding against the odds.[2]

Agnes's own path in life was not always a smooth one, and she often struggled to know and control her intentions. In this she was not alone. Her oldest and closest friends and lovers, like Kristina, claim to know only a few sides to their friend. Lover. Aunt. Teacher. Lunch date. Philanthropist. Travel companion. Some people even *knew* Agnes, a little, as an artist.

Agnes's desires, her art, her purpose in the world, even the people around her, were threads in her life that she was always at pains to keep untangled. When she failed to keep these threads in order she tore them away, one by one, until in time she was ready to bind the frayed parts together again.

It did not help in Agnes's struggle to know herself that throughout her life she played a role often shaped by those around her. To paraphrase the writer Jill Johnston: people burdened Agnes with their interpretations of her that she, herself, did not recognize.[3] Even after her death, unable to defend herself, many people (with good intentions) hold on to a vision of Agnes as a recluse, an ascetic savant. Agnes was not this. Not always. Not to the full extent of these definitions.

Opinions on the artist are often informed by her sudden escape from New York during the sweltering September of 1967, when she quit painting and headed for a desert mountain. This departure, assumed to be erratic on her part—but which was premeditated, as well as forecast by friends— reinforced to writers, artists, and critics that Agnes Martin was a rarity: an artist who at the top of her game could abandon success to pursue a greater truth and freedom in the wilderness; an artist unwilling to compromise her happiness or her art for the marketplace. From the moment she left New York, Agnes and her art entered into the realm of legend. This is so because legends are "stories to be read," and we shall see in due course the prolif- eration of writing on Agnes, including how she shaped these stories.[4] This is also the case because legend operates within a genre that is simultane- ously realistic, extraordinary and ambiguous, where the facts, events, and characters cannot be finally proven or disproven. In the past, Agnes Martin scholars were at pains to decipher and second-guess a chronology of the artist's life and deeds: very little was known of her early life, for instance. The trajectory of her life from Canadian pioneer plains, to impoverished New York avant-garde bohemia, to rich, reclusive, and iconic desert sage, all brims with romance. It is a rags-to-riches story with the twentieth cen- tury as the backdrop. The reality, we will see, is even more remarkable. One could indeed call it legend, if it wasn't all true.

If Agnes had lived in and left New York in the 1950s the outcome would have been different. Though artistic personality or brand in America had been cultivated since Charles Willson Peale in the late 1700s, it was really not until the 1960s that the artist had become a celebrity, a commodity, a performer. In this Age of Aquarius, mass media and dynamic revolt (racial,

sexual, gendered, political) there was an appetite for intrigue and scandal, heroes, icons, and victims. When Agnes was discovered to be missing, the close-knit art world of New York took note. Immediately rumors and stories about her were swapped at exhibition openings, taverns, and Lower East Side cafeterias where legends about other artists, such as Willem de Kooning and Jackson Pollock, had also emerged.

Even in the desert, removed from the demands of life in New York, the threads of her entanglements pulled to the floor, Agnes still struggled to know herself. Her ongoing struggle with schizophrenia—one reason for leaving New York—continued to take its toll on her happiness and productivity.

It is impossible to fully comprehend the impact Agnes's symptoms and subsequent treatment had on her from the 1950s to the 1980s, and beyond. Electroconvulsive therapy, forceful restraint, talk therapy, medication, and periods of hospitalization kept her away from her studio and depleted her energy. But they also returned her to a functional state where she could work again. How the symptoms of her condition (dislocation, trances, and aural hallucinations) impacted her long life is difficult to fathom, even more so, the impact these had on her art. In addition to hospital admissions, Agnes was regularly distracted at home, overpowered by the voices in her head. Though distracting, Agnes relied on these voices for their opinion on matters related to her career. These voices joined other symptoms that, at surface level, contributed to a romanticized, and therefore problematic, portrait of the artist and her condition. Agnes ran the gamut of emotions and behavior from violent and ranting to silent and subdued. Her friends have been protective of revealing too much of these episodes and symptoms, and for good reason. Not only do they play into the stereotype of a cartoon schizophrenic but also the classic stereotype of an artist as an afflicted eccentric, conversing daily with the muses. Agnes's schizophrenia was not treated with the kind of medical sophistication that schizophrenia is treated today. It is a great testimony to her that she could find a way of living with her condition and achieve success as an artist with so many additional odds stacked against her: bisexual,

female, poor, and an immigrant. While the story of Agnes Martin is an atypical success story, it is not unique. Agnes was just one of many people who, throughout the twentieth century, had to fight and sacrifice simply in order to get by.

Agnes believed in reincarnation; that she had lived a hundred times before as men, women, boys and girls. She believed in the purity of love that children displayed and that the love between adults—beyond the physical—could be of great reward. Despite all of this, although she had wanted children she never had any, and while she had male and female lovers she never allowed herself just one that she could call only hers. Her attitude toward her relationships with women, as we will see, was a product of the time she lived in. The trauma caused by these relationships lead to catatonia, hospitalization, and shock treatment, to the extent that Agnes became conditioned to fear love and flinched at human touch. Instead, art and nature became Agnes's committed lifelong sensual pursuits and partners.

By the end of her life, after years of established routine, carefully selected friendships, wealth, improved medication, and international esteem, Agnes settled into her earthly self. When she looked back on her life the only biography "that is relevant," she told her dealer Arne Glimcher, is a list of jobs she once had and places she visited: tennis coach, cashier, janitor, Scotland, Beirut, Japan. The word artist does not appear on her list. In the same letter, Agnes continued,

"I read yesterday a scholar who discovered that a Chinese painter died in 1256 not 1257. I can't understand scholarship. Just don't get the point."[5]

Instead, Agnes understood and believed in positive universal feelings that we all experience all the time, whether we know it or not. Her art, good art, successful art, is successful if it helps these subterranean feelings rise to the surface. Agnes believed in the universal and not the particular. With this in mind, why should she believe in a biography? Even her own? Why would it matter what year a Chinese painter died? Or where Agnes went in 1967 when she left New York?

Maybe Agnes didn't believe in a biography because in reality, her gender, sexuality, profession, social status, and illness made her a person

whose story would not be recognized or welcomed by the world she grew up in. She also rejected biography because she was a private person and she wanted different compartments in her life to remain separate from the others, and though she was interested in the lives of other artists, she thought her own biography would inform, overwhelm, and interrupt the viewer's experience of her art.[6] This fear is warranted, but it undermines the viewer's ability to separate the two. As an outsider looking in on a life or overhearing a conversation, we do not have to assume the beliefs of those we are listening to in order to learn from them, or in order to show them respect. We can still honor Agnes and view her art with distance even when we disobey her wishes and learn more about her story.

Maybe Agnes would deny she struggled to know herself. Perhaps, finally, there was nothing to know. Only the paintings. Only, as she would say, our response to her work. And yet. Can that be all?

Finally, Agnes's story is also the story of her friends, many of who speak openly about their friendships with Agnes for the first time in these pages. This story, the story of Agnes inspired by her friends, is one way of clarifying Agnes's struggle to know herself. It's one way of filling in the gaps in the legend, while at the same time creating new ones.

PIONEER

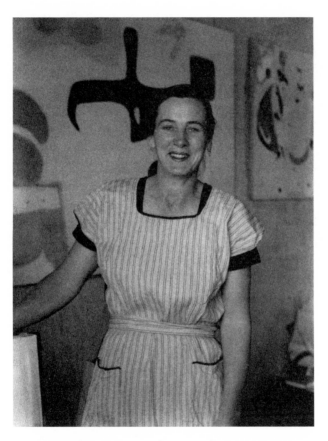

Portrait of Agnes Martin, Ledoux St. studio, Taos, 1954-1955.
Courtesy of the Harwood Museum of Art, Mildred Tolbert Archive, Taos, New Mexico.

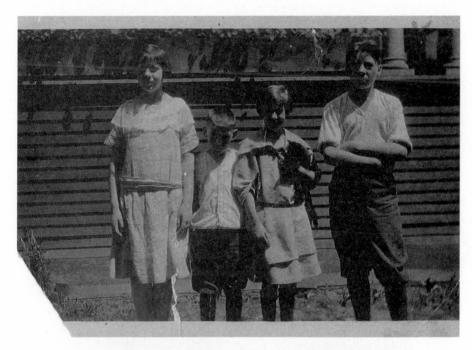

Agnes Martin with her siblings (l to r. Maribel, Malcom Jr., Agnes with cat, Ronald) photographer unknown, date unknown. Courtesy of Christa Martin, Martin Family Archive.

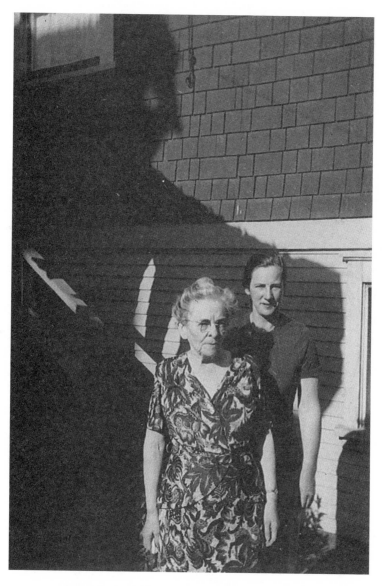

*Agnes Martin with her mother, Margaret Kinnon Martin;
Photographer and date unknown. Courtesy of Christa Martin, Martin Family Archive.*

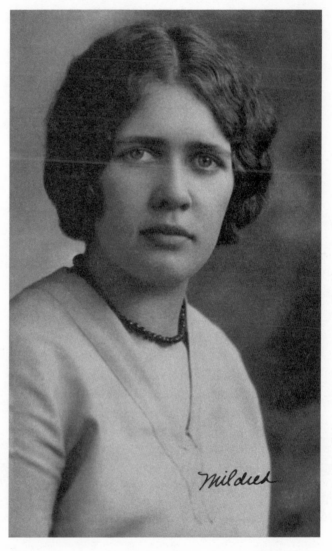

Mildred Kane c. 1939, photographer unknown. Courtesy of Susan Sharpe.

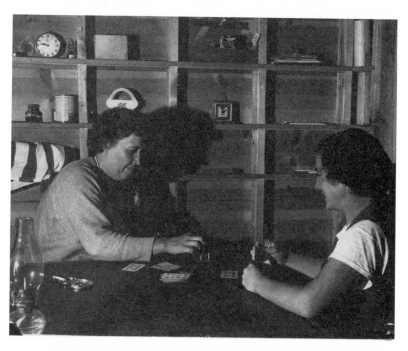

Agnes Martin (rt.) and Mildred Kane playing cards, photographer unknown c. 1954, Courtesy of Susan Sharpe.

ONE

Millet's Horizon

When Agnes was under the age of ten and still small enough that it was acceptable to jostle with boys, she saved her pocket money to buy art postcards. Agnes and her older brother, Ronald, sat together at the kitchen table in the evenings and with a few basic color crayons set about reproducing the postcards on wrapping paper salvaged from the local convenience store. Ronald was a better draftsman, though he had an unfair advantage, being four years older than his sister.

In 1919, when she was seven, Agnes bought one of these postcards, a reproduction of Jean-François Millet's *The Angelus*. Though it had been painted sixty years previously, this scene (a man and woman praying in a field at sunset) could easily have been from Agnes's own early years in the expansive central plains of Canada. As the granddaughter of Scottish Presbyterians, the heads of the laborers bowed in prayer was a familiar profile to Agnes. The young girl would also have identified with the tools of labor and the plain dress of the workers, though it would be some years before

she could put into words the language of Millet's brushwork, the luminosity of the sunset, and the inescapable heaviness of the high horizon line that would resonate with her as an adult.

Agnes was the third child of Margaret Kinnon and Malcolm Ian Martin. Agnes's paternal grandfather was a prosperous wheat farmer and her maternal grandfather, a rancher and fur trader. The Martins and Kinnons were respected families from the county of Kirkcudbright in the southwest of Scotland, and the Isle of Skye. Both families immigrated to Canada around 1875, first settling in Mount Forest, Ontario. Malcolm Martin and Margaret Kinnon later journeyed in covered wagons to Macklin, Sasketchewan, deep in the heart of the Canadian prairie.

To the Martins, Kirkcudbrightshire was wild and desolate and its coast was rocky and gray; it was a dynamic landscape, and it was home. The plains of Sasketchewan by comparison, were foreign and vast: a train that came into view on the horizon at nine in the morning only disappeared from view at noon. For Agnes, this recollection evoked a land that was stable and sublime, but for her mother it signified a land that was static and boring—there was little frivolity in Macklin. If it had not been for its location at the intersection of two Canadian Pacific Railway lines, Macklin may never have had a chance to prosper and achieve town status, which happened just eight months after Agnes was born. Even during the Martin siblings' childhood, the town consisted of little more than imposing wooden grain elevators, hardware stores catering to the homesteaders, and rivers of mud, otherwise known as the road.

Agnes's father arrived in Macklin in his mid-thirties, a survivor of the Second Boer War and a soldier of the British Crown. In traditional accounts of Agnes's upbringing Malcolm is described as a farmer, which is not strictly true. He was a businessman and a successful manager of a wheat elevator and chop mill, and his position, as well as Margaret's upwardly mobile ambition, made the Martins middle class—almost. While Malcolm escaped to Macklin and farther afield for business, Margaret was left on the three hundred and twenty acre farm caring for three children.[1] No sooner

was the first child born than the next was on its way: Ronald was born in 1908, Maribel in 1910, Agnes Bernice in 1912, and Malcolm Junior in 1915.

Margaret was frustrated by Macklin's oppressive landscape, her lack of social standing, and the lack of opportunities to make a better and more comfortable life. These feelings were exacerbated in 1914 with the death of her husband. Suddenly Margaret had to fend for herself and protect her three—about to be four—children; she was pregnant with Malcolm Junior when Malcolm Senior passed away.

There are different and conflicting accounts surrounding the death of Malcolm Martin. One account states that Margaret left her husband before he died and moved with her children to Calgary, Alberta, to the homestead of her father, Robert Kinnon. This version claims she left her husband when she found out he had syphilis, which ultimately killed him.[2] However, most biographical accounts of Agnes suggest that Malcolm died of injuries sustained during the Second Boer War (where he served with his cousin John McCrae, the poet best known for "In Flanders Fields").[3] To complicate matters, Agnes herself refers to both versions in interviews over the years, never offering a clear version of events, possibly because she never knew the truth. Meanwhile, the writer Nancy Princenthal questions the dates surrounding this episode, noting that in official land records Margaret claimed to have lived in Macklin until 1916, moving to Lumsden in 1917.[4]

Perhaps *all* of the above is true? It's possible that Malcolm sustained war injuries, and contracted a disease, and his wife left him, returning to their land after he had died. Whatever the particulars of the family story, Malcolm Martin's death left its mark on the family: Agnes and Malcolm Junior never knew their father, and Agnes developed a fantasy that her father was the only person who ever loved her or had faith in her, even though she had no memory of him.

Agnes's childhood was solitary: she recalls that when she was six she traveled alone on public transportation to a hospital in order to have her tonsils removed. Although she was unaware that she would have to stay the night, she did so without a worry, returning home alone the following day.

When I was two, I was locked up in the back porch, and when I was three, I would play in the backyard. When I came to the door, my sister would say "you can't come in," and shut the door. All day I was out, all day, till five o'clock. When I was four I was in the yard. When I was five, I started walking around the town. Six—when I went to school I didn't come home from school, 'cause I wasn't wanted.[5]

Despite these scenes of neglect, Agnes was happy being alone. When she walked to school with Ronald and Maribel she would trail behind, lost in daydreams, inventing stories or trying to remember the names of flowers and weeds.

In 1919 Margaret Martin moved to Vancouver, a bustling city at the time. Since Malcolm Martin's death she had been dusting off the Macklin cobwebs and re-inventing herself as an industrious businesswoman, buying old homes, renovating and reselling them. Margaret had four children to raise, so in order to be successful she relied heavily on her father for support. Both Robert Kinnon and Margaret Martin believed that children should be left to their own devices to bring themselves up.[6] Agnes interpreted this attitude as benevolence on the part of her grandfather and neglect on the part of her mother:

My mother hated me, because I interfered with her social life...She's a fierce, fierce woman. She enjoyed seeing people hurt. Her favorite television program was boxing, and she got right up close to the television, and just watched them smacking his head...as a matter of fact, she hated me, but I liked her...I liked her because she worked so hard. She made a good house clean, she was a good cook, she sewed, and I felt sorry for her making my clothes when she hated me so much.[7]

Perhaps Agnes reminded Margaret of Malcolm Senior, particularly as she grew up into a young, outgoing woman? As a teenager, Agnes didn't possess the fine fingers of her mother and sister, who would sit together in the evenings knitting and stitching and weaving. Agnes was rustic,

not domestic. She knew how to fish, hike, and chop wood. Maybe she couldn't follow a quilting pattern from a magazine, but she had imagination. As a young girl she would make boats out of apple barrels that she would then try to sail up the Fraser River in Vancouver; an ambition defeated by scale.

The young woman was drawn to water, perhaps inspired by stories of cold black mountain lakes in Scotland, the family voyage across the Atlantic, and tales of illegal smugglers in the Bay of Auchencairn. Swimming was a favorite pastime for the Martin children. Water could either quench your thirst or drown you—to tread it and understand it was a thrill. Agnes competed against her brothers in swimming races, often defeating them with ease. It was not long before Ronald and Malcolm Junior played coach to their athletic sister, keeping a record of her times and testing her stamina. The efforts of the children paid off. Malcolm Junior and Agnes became provincial champions and local medalists, both runners-up in Olympic tryouts (Agnes in 1928) in their teenage years, with their pictures in the local paper. As a result Agnes became known around town as Iggidy Martin, the famous swimmer. Neither Agnes nor Malcolm Junior, however, would realize their Olympic potential: Margaret Martin thought that being competitive was an unattractive trait in a woman, and the family did not have the money to encourage the children's athletic aspirations.[8]

If Agnes's early childhood was solitary her adolescence appears to have been anything but. Agnes was handsome, with thick brown hair parted on the left. She had a long feline brow and high cheekbones. Boys and girls liked her because she flittered between shyness and exuberance. Agnes might dance with you one moment, or beat you in an arm wrestle the next, and just as soon as she had, withdraw to a pier, dipping her toes in the water and ruining her white cotton stockings. The only thing she loved more than swimming was dancing and going to parties. Though a staunch Calvinist, her grandfather was relaxed in his attitude toward his grandchildren. When Agnes would argue with her step-grandmother about what time to come home from a party, her grandfather would intervene, saying she could stay out as late as she wanted as long as she was home before they

woke up the next day. This casual approach to child rearing and discipline made Agnes naïve in other ways. She explains:

> When I was in high school, I don't know what struck me. I was, I guess I was promiscuous. But I got over it. I started young, too young to get into trouble. I didn't menstruate till I was about 16 and a half, and so I never got pregnant or anything, but I just, umm...I didn't care what they thought.But what stopped me was a boy, three boys it was, they called me a slut. And so I stopped dating. I stopped this 'every night out.' But I don't regret it, my gosh, I don't think a thing of it.[9]

Agnes called her behavior "absent-minded," but this does not reflect the dogmatic rhetoric she was accustomed to as a child, which she would use later in life. For instance, Agnes frequently uses the word *debasement* as a substitute for sex in her later interviews and writings. This throws some light on the sermonizing she experienced growing up. It's worth remembering that though her nights were spent dancing at parties, her mornings and afternoons were spent listening to the voice of her grandfather reading Robert Burns, *The Song of Solomon,* and *The Pilgrim's Progress.* At night, Agnes was a teenager of the Jazz Age, but during the day she was a student versed in the philosophy and romanticism of Scottish nationalism and the allegory of scripture. Later in life these influences would resurface in her writings and lectures, sometimes in the form of *The Willie Stories*, a series of spiritual koan-infused parables co-authored with the artist Ann Wilson.

By the end of the 1920s Agnes's world was changing. Margaret Martin remarried in 1928 and was looking toward the future: three of her children were adults and she was eager to start a new life with her new husband, a dashing barber named William Frith. Agnes's friends were also getting married and the Great Depression was debilitating all of North America, including Canada. With no family base, no job prospects and no relationship Agnes moved to the U.S. in 1931 to Bellingham, Washington to help her sister Maribel through a difficult pregnancy. Agnes brought with her

the baggage of her childhood: hardship, solitude, never-ending plains, and a love of swimming—pastimes and experiences that would inform her art and personality the rest of her life.

While in Bellingham, Agnes attended Whatcom High School, where she found the education superior to her high school education in Canada. Upon graduating from Whatcom in 1933, Agnes received a swimming scholarship at the University of Southern California, which she dropped out of after a few months, returning to Bellingham.[10]

While in Los Angeles Agnes became the household cook to Rhea Gore, the mother of soon-to-be film director John Huston. In 1933, when Huston was involved in a car accident that killed a pedestrian, it was rumored that Agnes was, for a short time, his chauffeur.[11] Agnes was twenty-one and John was twenty-seven and it's probable that they took a liking to each other given their hardy and outgoing natures. John, like Agnes, was a sportsperson (he had been a promising boxer in his teens), as well as the earliest known artist Agnes encountered (at that time his career was screenwriting). Agnes, the rough and pretty prairie girl driving around Hollywood during the golden age of silent film—the year Greta Garbo first "spoke," and John Wayne first galloped, on screen—conjures an amusing spectacle of those times. Hollywood, however glamorous, even during the Depression, did not change Agnes's life in any meaningful way and she almost never spoke of it in interviews. Instead, her life would be forever changed upon returning to Bellingham and enrolling in Washington State Normal School (Bellingham Teachers College), where she befriended four exceptional young sisters.

TWO

The Kane Sisters

The Kane family lived in a big house on Tacoma Street in Portland, Oregon, with a large black car in the driveway and a small house in the shadow of the first. Mr. Kane was a greengrocer and Mrs. Kane was a homemaker, and they had four daughters, Margaret, Harriet, Mildred, and Elizabeth. By the time the Depression had swept with force into Oregon in 1929, the Kane family were, in theory, better positioned than most to withstand its impact: Mr. Kane had links to farmers and suppliers in the state and could guarantee his family basic produce. While the Depression was challenging for the country as a whole, the Kane sisters soon had more personal hardships to overcome. In the Depression's early years, Mrs. Kane passed away from cancer, and Mr. Kane died of a heart attack. The sisters were bereft, and the two eldest, Harriet and Margaret, were forced to withdraw from Reed College where they had been studying, and move back to Tacoma Street to put the family affairs in order.

Any other quartet of young ladies might have settled down with the first eligible suitor who sauntered up the sidewalk, but the Kane sisters

were a different breed. The women were raised to be independent thinkers and they had each other to rely on. In order to offset the devastating effects of the Depression they sold the larger family home on Tacoma Street, keeping the smaller house on the property. With the income from the sale of the big house, Harriet and Margaret enrolled in Bellingham Teachers College (today, Western Washington College of Education) to study for certificates in teaching. It was there that they befriended Agnes. The three women sat together in classes and shared lunch while they discussed their lessons. Margaret and Harriet found Agnes intriguing and turning to her one evening said, "You know, we have another sister that we think you might like."[1]

Mildred Kane was studying for her undergraduate degree at Reed College when she first met Agnes. Mildred, like her sisters, was a libertarian with "strong and uncommon views" on the potential of women, and Agnes had never met anybody like her. So often in Vancouver and certainly within her own family, Agnes had struggled to be understood. Smart and excitable, Mildred encouraged Agnes to think for herself; she was always patient and nurturing of Agnes's ideas.

The Kane family became the first of many surrogate families to Agnes, and her studies improved under their influence. Agnes's entrance test results for college were poor despite repeating high school in America. She received a C+ for general aptitude for higher education, C's and D's in spelling, math and history and an F each for English and penmanship. However, with encouragement from Mildred and the Kane sisters, Agnes's grades improved to B's and A's in English and history, and in her one art class she got an A.[2] Subsequently, Agnes graduated from Bellingham in 1937 with a certificate in teaching that allowed her to teach both elementary and junior high schools, which she set about doing immediately.

Agnes's education, of course, extended beyond the classroom. Mildred, with whom she had become close, was a philosopher and activist who was of the opinion that the world was undergoing turmoil and it was important for everybody to face up to this reality and look for a way of coping. This

was 1937, when Hitler, Franco, Stalin and Mussolini were in power and war was being waged between Japan and China.[3] Secluded in Elk Lake, where the Kane sisters retained the cabin their father had built, Mildred cultivated Agnes's view on the increasingly unstable world, discussing philosophy, politics and literature. It was not long until, within this nurturing friendship, a romance developed between the two women.

There is no extant proof that Agnes—outside of her art classes in college—was painting or drawing during her first years in the U.S. Her earliest surviving paintings are dated from the late 1940s, and she frequently stated that she did not think about becoming an artist until she visited museums in New York while attending Columbia Teachers College in 1941.

Even if Agnes was painting for pleasure during these years, to decide to become an artist in the 1930s in the U.S. was seen as an act of madness. The creation, distribution, purchase, and enjoyment of art was, for the most part, the pursuit and domain of the wealthy, and the Western art world was centered on Paris and other European capitals that had a mature buying market and history. To succeed as an artist one needed to be able to travel to these markets to sell work and engage with new styles and fellow artists. In fact, to succeed as an artist, one needed to be a man.

The Harlem Renaissance and Precisionism were arguably the most exciting contemporary art movements in America in the 1930s. But both were closed to Agnes, in the case of the Harlem Renaissance, because she was not part of an African American culture, and in the case of Precisionism because she had no link to Alfred Stieglitz, the movement's primary champion. The content of both movements, the exploration of the roots, culture and identity of African Americans (Harlem Renaissance) and the urbanization and industrialization of modern America (Precisionism) were themes that the young woman also probably didn't identify with. In addition, both movements were also centered in New York, which was not familiar territory to her.[4]

Despite the unique qualities of the art produced by both movements, the market was tiny, and while modernism had arrived in the U.S. with a bang at the 1913 New York Armory Show, it was not one particular movement or exhibition that finally established the American art market for Agnes, but the Great Depression itself.[5]

According to the writer Dore Ashton, the Depression was the start of what we can consider a wholly original American way of art because the Roosevelt administration was the first to be even faintly aware of the arts as a necessary part of civilization.[6]

Franklin Roosevelt's New Deal Program, historically referred to as the First New Deal (1933–34) and Second New Deal (1935–38), addressed problems in housing, unemployment, agriculture and labor standards brought about by the crash in 1929. The First New Deal Program included the Public Works of Art Project, which in one year employed over 3,700 artists who produced over 15,000 works. However, the most important arm of Roosevelt's New Deal Program for the arts came in the Second New Deal Program and succeeded the Public Works of Art Project. This was the creation of the Works Progress Administration, later renamed Works Projects Administration (WPA), which ran the Federal Art Project (FAP) that employed out-of-work artists. The FAP created over 200,000 separate works in public spaces throughout the U.S., ranging from murals to posters. The WPA was also important because it was the first New Deal Program to directly assist women, the majority of other programmes assuming that men were the bread-winners in the family. At its peak in 1938, the WPA employed 3.3 million people, with 8 million employed in total between 1935–1943. Not only did the FAP make American artists feel they had a role to play in society, it suggested to society that homegrown American artists and artworks were valid and worthy of attention.

The image of America that artists portrayed in these public works showed virile and productive communities; Virginia Pitman's *Four Phases of Labor* (1935–1942), is one example. At the same time, studio artists like Grant Wood, Norman Rockwell, Thomas Hart Benton, and John Steuart Curry were finessing what became known as the Regionalist style, focus-

sing on an Arcadian view of American life: family-based, country-based and Caucasian, for example Grant Wood's *Spring in Town* (1941) or John Steuart Curry's *An All American* (1941). While some of these images seem uninviting now, at the time the artists were fervent in their belief in the American idyll.

Grant Wood, in his 1935 essay *Revolt Against the City* argued that artists should "return to their indigenous, self-sufficient, rural traditions rather than seeking inspiration in the art of Europe and in 'the confusing cosmopolitanism, the noise, the too intimate gregariousness of the large city.'"[7]

One could argue that many artists did return to rural traditions, but what they found there offered no solace. The starkly beautiful, and moving photography of Dorothea Lange, such as *Japanese Mother and Daughter, agricultural workers near Guadalupe, California* (1937), was an antidote to the kind of nostalgia Grant Wood and his work typifies. Black families, Mexican immigrants, Japanese internment camps—Lange's journalistic view of America was very different from Grant Wood's.

Lange's gender is not merely coincidental to her chosen art form. Many women were interested in photography, which as a new medium did not have the baggage of the institutionalized and male-dominated traditional arts. The work of early women photographers was no less hard-hitting than that of their male counterparts, but women paid attention to subjects and events traditionally absent in the work of their predecessors. Lange's work refutes the poetry in nature, the poetry in industry, and the poetry in poverty that the FAP and Regionalist artists wanted to believe in.

However, with the social good of art established, and many artists, and crucially, women, earning a proper wage for the first time, the FAP started a new chapter in American art history. If the opportunities for artists, and their status in American culture, had not improved as a result of these new opportunities, it is unlikely Agnes and many other artists would have considered a career in the arts later on.

///

The United States began to emerge from the grip of the Great Depression in 1941 when the war effort began to provide much-needed jobs that bolstered the economy.

At some point during the war, Agnes worked with the Kane sisters at the Kaiser Shipyard on Swan Island in Portland, Oregon. Agnes, Margaret, Harriet, and Mildred toiled in the shipyards, while Elizabeth, the youngest, became a member of the Women's Army Corps. The Oregon Shipbuilding Corporation that operated the yard employed more than thirty thousand people across its four sites, producing over one thousand Liberty and Victory ships, providing employee services, and running amenities.

The Kane sisters were proud to play their part in the war effort, but the majority of jobs for women in the shipyards were low-status and low-wage, ranging from pushing brooms to cleaning tanks and carrying tools for men. Although women were glad to have employment in the war effort, they encountered many obstacles.

Many women were raising children alone while their husbands were fighting overseas. Working long shifts (for less money than men) meant the women had to pay for babysitters, an expense they could barely afford. Meanwhile, married women looking to be involved in the war effort were sometimes met with resistance by their husbands, and the husband-wife dynamic was forever altered when two parents went to work daily.

Sexism during the war years was not simply domestic—it was often policy. State law, created by the Wage and Hour Commission for Oregon, forbade women to lift more than twenty-five pounds or carry more than fifteen pounds: the average two-year-old child weighs over twenty-six pounds, so it was illogical to suggest women can carry a child but not tools. Single women were also vulnerable as easy targets for ridicule and unwanted sexual attention.

Aside from the above, the work in the yards was exhausting. Even for women like Mildred and Agnes, who had no husbands or children to take care of, the six-day week of shift work was grueling. Mildred recalls, "We were just frantic on the seventh day. Sundays we didn't know whether to clean the house and wash our hair or rush off and go on a picnic or rest."[8]

Mildred and Agnes worked at the shipyard day care center, a well-paid job that allowed both women to save money. Mildred worked in the kindergarten while Agnes worked with more disruptive elementary school children. According to Mildred, the children were difficult to deal with, "suffering from unhappy, lonesome mothers" and "uprooted" families. Luckily, the philosophy of the shipyard allowed her to counter this behavior:

> You really do work with the whole child; his whole day; it's like living with the kids. We were really supposed to try to meet individual needs and food needs and not brow-beat kids into shape. Really try guidance and all that instead of punishment. It suited me. You were really free in giving children as many options and choices as you could possibly do.[9]

Agnes, inspired by the older students, often thought of her brother during this time. Malcolm Junior followed in Malcolm Senior's footsteps, fighting for the British Crown, in his case as a pilot during the war. Agnes recalls, "When the British declared war, he went straight to bed and he went to sleep. And when he woke up he went and enlisted. The first Canadian to enlist, I think."[10]

Agnes doted on Malcolm Junior from the time he was a baby. Throughout her life she would describe him as brilliant; a category she often included herself in as well. According to the artist, Malcolm was an unlikely soldier, with a pacifist streak:

> [Malcolm Junior] said that people are like each other and they want to be kind, and they like to help each other, so he called it goodwill, and he said everybody has goodwill towards everybody else, and it's growing, and he said when everybody had perfect goodwill towards everybody else it would be the millennium.[11]

By 1941 Agnes had been in the U.S. for ten years and was eager to see more of the country and continue her education. At the age of twenty-nine it was clear that Agnes was not the marrying, and settling-down kind. She loved the American education system because she felt it catered to the individual spirit. Particularly relevant to her was the way in which students could work through college in order to support themselves financially. Agnes had been surveying universities for a number of years. To every enlightened person she met she posed the same question, "What was the best college in the country?" More often than not the answer was Columbia University; so Agnes decided that's where she would go.

When Agnes finally enrolled at Columbia Teachers College in 1941, she first majored in the teaching of history and social studies, switching then to fine arts and arts education. Mildred, always by her side, was taking a doctorate in early childhood education. Agnes's studies were a mixture of theory and practice. Nancy Princenthal notes that in each term Agnes enrolled in one class "devoted strictly to teaching skills," otherwise filling her hours with studio classes ranging from marionette production and stage design, to figure drawing and clay modeling. Perhaps because she was finally doing something she loved (and something practical rather than purely academic), Agnes was consistent in her grades for the first time, achieving a B+ average.[12]

WWII continued to cast its shadow over New York while the women were there, and Columbia addressed this turmoil with a series of new courses, classes, and extracurricular activities that encompassed everything from poster design for the war effort, to first aid.[13]

In New York, Agnes and Mildred were poor and intrepid. Their favorite pastime was to walk through different neighborhoods observing the various architectural styles on show. Mildred, who knew more about art history than Agnes, gave her guided tours through New York's finest museums, including the Metropolitan. Agnes recalled being amazed that there were entire buildings that existed to show art to the public, often art by the same painters whose postcards Agnes and Ronald had collected as children. It was during these museum visits that Agnes set her sights on

becoming an artist. If you could make a living being a painter, then that's what she wanted to try and do.

Visiting these museums and galleries provided solitude and solace, as well as respite from the war-torn world outside: a world of rationing, casualty reports, and propaganda. Museums offered Agnes a contemplative and uninterrupted experience with artwork. She would walk up to paintings that she liked and she would ask them with her mind what they wanted to say to her, just as she would do with her own art one day. To her favorites, one imagines her passing comments: "Hello, Albert Pinkham Ryder. Sorry, but I'm going to visit Winslow Homer today. I'll come see you next weekend."[14] That Agnes should choose to become a painter, following these visits, is a strange choice when one considers the low rank of the painter in American society at the time, not to mention Agnes's stable career as a teacher—further proof of the impact these museums and their art had on the young woman.

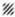

In 1942, after a year at Columbia earning a Bachelor of Science degree with a double major in fine arts and fine arts education, Agnes moved with Mildred back to Oregon. Mildred had bought a little wooden house in a cherry orchard overlooking the town of Monmouth. The house was basic with a wood-burning stove, an outhouse, and a large deck at the front, through which a determined plum tree grew.

Moving back to Portland was a relief for both women, who considered New York a tough city, so dirty that their blouses were always catching coal dust. In Oregon, Mildred established a school and Agnes divided her time between painting and teaching. Between 1943 and 1946, Agnes taught at a range of schools in the Northwest, including in Tacoma and Bremerton in Washington State, as well as back in Monmouth with Mildred.[15] Although Agnes had been teaching and learning about teaching for nearly a decade; it was a vocation and discipline she was often ambivalent about. Sometimes she argued passionately for the needs of students and sometimes she

maintained that nobody could teach anything to anybody. Mildred often struggled to follow Agnes's line of thought but was happy to support Agnes in her pursuit of art, becoming one of her first patrons.

The cherry orchard home was often the inspiration for many of Agnes's first paintings, mostly traditional still life and landscapes in oil or watercolor. She often set up her easel on the deck, painting the landscape and the town below. Her earliest surviving paintings are *Cherry Blossom Orchard*, a bright impressionistic oil painting, and *View from the Porch*.[16]

The view in *View from the Porch* is that of someone looking out across a valley at a mountain range. The brushstrokes are solid and the color rustic: shades of mossy green, ocher, and dark blue. The style is lightly cubist and there is little attempt to convey distance between the fields, hedges, and mountain peaks. In her later watercolors *New Mexico Mountain Landscape, Taos* (1947) and *Untitled (Landscape South of Santa Fe, NM)* (1947), Agnes continued to simplify her forms and shapes, emphasizing the use of lines as markers of space and movement.

Having taken her first steps, if Agnes was going to develop as an artist, and make a livelihood, it was important that she receive proper and sustained training in technique as well as exposure to like-minded peers. Once again, she had her sights set on a university. New York was the obvious choice, but the city was expensive and chaotic. It was also the other side of the country, far away from the Kane family, and although it was the capital of the U.S. art world, there were many more equally interesting art havens throughout the country. One of these was the University of New Mexico (UNM) art department in Albuquerque. New Mexico would be the cheapest state Agnes could study in, and this was her primary reason for applying there. As part of her application to UNM, Agnes painted an encaustic wax still life of tulips. Elizabeth Kane helped Agnes in her task, making sure the heat of the encaustic wax remained at a constant temperature (the wax was in a muffin tin on a pot-bellied stove).[17] Agnes hoped that the result, *Untitled*, would be her ticket to a new life as an artist—the beginning of a long journey.

THREE

All the Way to Albuquerque

When Agnes first visited New Mexico while on vacation in 1942, she expected to find a flat desert. She discovered instead a landscape full of startling colors and vistas. In the northwest of the state, a drive of thirty minutes could take you from snow-heavy peaks to arid dusty sagebrush plateaus. The landscape suited Agnes's sensibility: it was remote, wild and full of adventure. Congress admitted New Mexico as the 47th U.S. State in January 1912. This meant that when Agnes returned to study there in 1946 the state was the same age as she was: thirty-four.

The territories that make up the state had been contentious since Spanish conquistadors had arrived in the 1500s. Since then the region had been fought over by Texans, Mexicans, Spanish, Confederate States, Union States, and Pueblo tribes, who had, as the indigenous populace, the most legitimate claim to the land. By the time Agnes arrived, native tribes had been burning kivas for over a thousand years, sacred mountains were still guarded by tribes, and Indian art was still considered new and exotic—yet to be made ubiquitous by the tourists' desire for souvenirs. New Mexico

was also cheap and the UNM art department was one of the most innovative in the country. Agnes's encaustic still life of red tulips, *Untitled* (started in 1946, but dated 1948), that won her a scholarship at UNM, was left behind in Oregon. In its place was Elizabeth Kane, who enrolled at UNM under the G.I. Bill.

In the first semester "Aggie" and Liz had two boarding rooms in a hovel in Old Town, Albuquerque. They shared the dirt-floor house with a bedridden girl suffering from tuberculosis, and a woman who had had a lobotomy. This situation, to say the least, was not an ideal one for two women used to home comforts. After one semester, Agnes and Liz moved into the more comfortable dormitories on campus. Living on campus was expensive, so in order to earn some extra money the women both worked at the Varsity Grill, where Liz met fellow employee Bill Stuart. A year later Liz and Bill were married, with Agnes standing in as the couple's witness.[1]

Liz and Agnes's first year in Albuquerque was a period of adjustment for both. The women rode everywhere on bicycles, weighed down with paints, artist's pads and books. Agnes always had one eye on the road and one eye on the canyon, looking for rivers to swim in; frequently taking Liz off-track in search of her own naturally occurring *mikvah*. To the frustration of both women, they were mostly met with dry riverbeds. Albuquerque was a modest-sized, dusty community. As a rest stop—a Route 66 pass-through for those making their way across the continent—it attracted a mixed crowd of people.

At the time, Albuquerque and its northern cohorts of Santa Fe and Taos formed a constellation in the landscape of U.S. art that was burning increasingly bright. In the first half of the century the Taos art colony and its different manifestations—Taos Society of Artists (1915–1927) and New Mexico Painters (1923–1927)—attracted many artists to the state. This "colony" was lead by Ernest L. Blumenschein and Bert Geer Phillips, who, without any sense of irony, labeled themselves the Taos Founders. Their art was inspired by (and, in turn romanticized) Native American life, a genre of art that still sells today. However, the appellation of Taos Founders (to many) seemed a little far-fetched for a group of men interloping on

a tradition of native custom over a thousand years old and a Spanish tradition that reached back over four hundred years.

Either way, though Blumenschein was still painting Pueblo Indians when Agnes arrived in Albuquerque, and many people moved to Taos to capitalize on that genre of painting, there were other more dynamic movements and reasons that attracted young people like Agnes to the state. The first was the G.I. Bill and the second was the Transcendental Painting Group.

At the beginning of the 1940s the department of fine arts in UNM had about 450 students enrolled. By 1946 there were 1,100. One explanation for this is that the G.I. bill allowed those who had served in the army during WWII an opportunity to receive a free education. Many veterans who were stationed in Europe had the opportunity to visit museums and galleries there before their return home and they were inspired to contribute to a home-grown American art culture. More specifically, the Transcendental Painting Group (lead by UNM teacher Raymond Jonson) was attracting many progressive students to Albuquerque. The manifesto of this group, to "carry painting beyond the appearance of the physical world, through new concepts of space, color, light and design, to imaginative realms that are idealistic and spiritual," was typically American in the scale of its ambition. Raymond Jonson's *Watercolour #7* (1943) and Florence Pierce's *First Form #2* (1944) are just two works that give a flavor of the Transcendentalist movement, with its geometric, streamlined, and futuristic style. [2]

Agnes and her peers won their place at UNM by submitting traditional still life paintings and landscapes. It must have been confounding to them to be met upon their enrollment with Raymond Jonson's alien and ambitious rhetoric that forced and challenged them to think in entirely new ways. Jonson and his faculty, including Randall Davey, Lez Haas and Kenneth Adams, insisted that their students be audacious and ambitious. Endless quotes from Kandinsky's *Concerning the Spiritual in Art* (1912) opened the students' eyes to the power of color, while Oriental thought forced them to engage with ideas incalculably old by U.S. standards. After a semester at UNM, Agnes and her classmates would never look at their

still life paintings in the same way again; their eyes had been opened.

Many of the students at UNM had never met a proper artist before, that is, an artist with the credentials, conviction, and audacity to *identify* as an artist, still a rare breed in America. In 1946 being an artist was not considered a career in the U.S. (though the Depression, we know, helped change that) and those who considered themselves artists were regarded with indifference by most and suspicion by some. The U.S. art market was small and its artists worked and studied in the shadow and influence of their European forebears. The market for art in Europe was well established and the artist had a more respected role in his and her society but as the rise of fascism and the outbreak of WWII demonstrated, this role was precarious at times. Because of the relative novelty of art as a career choice, Agnes, like many of her classmates, did not consider herself an artist in the proper or European sense. She was a painter with a strong work ethic, who someday *hoped* to be an artist.

After her first year at UNM, Agnes received a working scholarship to the Summer Field School in Taos, where she would oversee a women's dormitory in return for free sleeping quarters and admittance to the summer art program.

Taos was full of larger-than-life characters and home to a coterie of distinguished and eccentric artists. The person most responsible for its credentials as an artists' haven was the formidable Mabel Dodge Luhan: heiress, socialite, salon high-priestess, and patron of the arts. Mabel brought many of her New York and European devotees to seven thousand feet above sea level with the promise of wild parties and exotic day-trips, which she delivered in style. D.H. Lawrence, Marsden Hartley, Willa Cather, Georgia O'Keeffe, and Ansel Adams were just a few of the artists Mabel entertained. As often happened, each of these artists became affected by the unyielding Taos landscape. Georgia O'Keeffe relocated to Abiquiú, Willa Cather was inspired to write *Death Comes for the Archbishop* (1927), and Ansel Adams and Marsden Hartley both produced art in response to the landscape they encountered. In 1942 D.H. Lawrence became Taos's most famous resident when he settled with his wife Frieda and the Bloomsbury Group painter

Dorothy Brett, inspiring gossip and scandal for the locals. Taos, however, did not need to be ordained, or reproduced, by these East Coast and European artists in order to be seen as a legitimate place of beauty and inspiration. These virtues were certainly inherit in the landscape; a greater force of nature than the colorful characters who settled there.

Taos welcomed and valued artists, and such was the hospitable culture into which Agnes entered during the summer of 1947. However, for Agnes, there was something more important than meeting artists and nursing hangovers with them: Taos had more rivers to swim in than Albuquerque, and the highest mountain in New Mexico to climb and explore.

At the Summer Field School Agnes had one-on-one tutorials with the artist Emil Bisttram.[3] Bisttram appealed to the students as a cosmopolitan artist, well read in a variety of strange subjects including theosophy, the occult, and mathematics. In his teaching he promoted the use of geometry as an underlying structure in painting, a philosophy somewhat in vogue at the time. One of Bisttram's teaching subjects was the theory of dynamic symmetry as espoused by the artist and Yale professor Jay Hambidge in the books *Dynamic Symmetry: The Greek Vase* (1920) and *The Elements of Dynamic Symmetry* (1926).[4] Dynamic symmetry asserted that the composition of Greek art and architecture could be broken down into a scheme of squares and rectangles—or the square root of five—which can also be used to deconstruct the design of all organic matter. Hambidge claimed that this formula was a long-lost secret of ancient Greek art. It was a *dynamic* rather than static symmetry because it allowed for individual (i.e. dynamic) artistic refinements once the basic principles were applied.

Hambidge had his detractors, but his writings, lectures, and magazines were eagerly anticipated. His theory was also actively adopted by artists and craftspeople across the U.S. and abroad. A paragraph such as the following, taken from *Dynamic Symmetry: The Greek Vase*, is interesting to consider in relation to Agnes's "grid paintings" produced after 1960 onwards.

Modern art, as a rule aims at freshness of idea and individuality in technique of handling; Greek art aimed at the perfection of proportion and workmanship in the treatment of old, well-understood and established motifs. That this is true is not only proven by the standardized shapes of the Amphora, Kylix, Kalpis, Hydria, Skyphos, Oinochoe and Lekythos, but by the accepted forms of temples, theatres, units of decoration, treatment of drapery, grouping of sculpture forms and even proportions of the figure. The opportunity for individual expression existed only in superlative workmanship, in refinement, precision and subtlety. To win distinction as an artist it was necessary for the Greek to be a veritable master.[5]

Years later, Agnes was obsessed with attempting the impossible: mapping onto the canvas a perfect geometric grid conceived in the mind. Agnes dedicated her career to this task, exploring a range of geometries and techniques. Much like a Greek craftsperson (the word artist, as understood today, didn't exist in ancient Greek), Agnes achieved "individual expression," refinement, and subtlety in the rigor and repetition of basic geometric forms. At first glance many of these artworks look similar and perfectly geometric, but upon close examination each has, through its errors and deviations, what the writer Dore Ashton called, its own "distinct climate."[6]

It is likely that Bisttram, who was also a devotee of Plato, had an effect on Agnes's thought in these formative years—not only was he her teacher at the time, he also lived next door to her.[7] Later in life Agnes would come to see herself as an artist in the classical tradition, in particular as a Platonist with her "back to the world," but during her student years, along with her classmates, her pursuits were more conservative: watercolor landscapes and portraits in oil.[8] The geometric grid she would become so well known for was twenty years away.

By the end of her summer in Taos, Agnes got a taste for success when a painting of hers was included in the UNM student show at the Harwood Foundation. The local newspaper *Taoseño and the Taos Review* wrote, "Among the more advanced students, Agnes Martin and Earl Stroh have

turned out some excellent work."[9] Agnes's efforts were rewarded in other ways too. Not only did she win her first award for painting; she was elected, without any solicitation, an adjunct faculty member of the UNM art department back in Albuquerque. This was a pragmatic appointment: Agnes and many of her classmates were often the same age or older than university faculty, and staff was desperately needed to cater to the continuing influx of new students who had enrolled there under the G.I. Bill. This, along with Agnes's degrees in teaching, made her an obvious choice to join Raymond Jonson's UNM stable of influencers.

One student Agnes taught in Albuquerque was the artist Stanley Landsman, who had recently relocated to the state while visiting his father. A New Yorker through and through, Stanley's sojourn in New Mexico was the first time he had been away from his home on 92nd Street, between Columbus Avenue and Central Park West. "I got off the plane," Stanley recalls, "it was about five o'clock. There was this big red sun in the sky over purple mountains and the yellow desert at the airport. I couldn't believe it. I just looked at that and I said, 'My God, those picture postcards were real!' And it took me four years to leave the town."[10]

Being seventeen, Stanley had no real idea of what he wanted to do with his life. When he was a young child, his father had taken him to scenic points in Central Park where they would sit doing "English" watercolors. When his father left New York and Stanley was too young to go to the park alone, he continued doing watercolors of the park from his bedroom window. On that first visit to New Mexico, Stanley decided to stay in the West a little longer, and sent his father back to New York alone. Believing that watercolors were the only thing he was good at, he made his way to the UNM and asked if they had classes in watercolor painting. They did.On his first day of class his teacher "a big, terrific woman," took an immediate liking to him. "I'm going watercoloring with you every day," she told Stanley. "We go together and the rest of the class follows us."

And so it was that for the next semester Stanley and Agnes painted watercolors together in the mountains surrounding Albuquerque. Stanley recalled with fondness Agnes's encouragement:

I have this little pad of watercolor paper and my brushes. And Agnes would be out there with sheets like 36 by 50 [inches] and she had a brush that looked like a housepainter's brush; it was this big. And she had big buckets of water and she carried sacks full of paint. She'd spread it out on the desert. She was working in about three-quarters of a mile area. Everything was like...blowing. It didn't matter. And I was working on this really fine delicate little English watercolor...She'd say, 'Stop with that already! Stop with that! Paint! Paint big. Get it all out.'

Agnes's instruction brings to mind the Abstract Expressionist approach, an in-vogue and growing art movement in America at the time. The large pages, their placement on the ground, and Agnes's encouragement to purge emotion and leave a dramatic gesture on the paper, mirrors the approach of such painters as Jackson Pollock (*Mural*, 1943), Arshile Gorky (*Water of the Flowery Mill*, 1943) and Hans Hofmann (*Idolatress I*, 1944). Agnes was Stanley's first art teacher, though by no means was her method of teaching the most unorthodox: Adja Yunkers, who taught at the school in the same period, served beer in his class. Stanley took classes with many other teachers at UNM at the time, including Randall Davies, Bill McGee and Richard Diebenkorn, another popular Abstract Expressionist.

Despite the unavoidable desert sun and drought, UNM had a cosmopolitan feel. Many of the teachers and students had lived and studied in the major art hubs of the country—Chicago, Boston, Philadelphia, Washington, and New York— and they maintained contact with the artists they had befriended there. Students also frequently moved between UNM and Black Mountain College, the famous liberal arts college in North Carolina where Josef Albers, the German ex-pat and Bauhaus artist, taught from 1933 to 1950. Though short-lived, Black Mountain would, in subsequent history, overshadow many of the other art schools and departments active in the U.S. at the time, including UNM Albuquerque.

Many students saw the art department at UNM as more democratic than other art schools. At UNM there was no single overriding philosophy or dominating personality as there was with Josef Albers at Black Moun-

tain, or Clyfford Still at the California School of Fine Arts (now the San Francisco Art Institute). Indeed, Black Mountain College students came to the UNM to unwind, and as Stanley put it, "for their sanity."

After he finally left New Mexico, when he wasn't busy in the Navy or with teaching, Stanley continued to create art. Later in the 1960s he was a habitual attendee at the Cedar Tavern and the members-only art salon The Club, both famous artist haunts in New York City. His most memorable work, *Walk-in Infinity Chamber* (1968), shares similarities with his contemporary, the artist Yayoi Kusama. Yayoi was developing mirror rooms at the same time as Stanley, though her work such as *Infinity Mirrored Room-Filled with the Brilliance of Life* (2011) would achieve greater attention.

Stanley's infinity room, a glass room, twelve-foot cubed, is a complex arrangement of six thousand dotted lights reflected by mirrors that extend below and around the occupant, creating as it were infinity in all directions. Stanley's aim was to create a transcendental experience in which the viewer is weightless and taken away from the world. Years after New Mexico, the year he was working on *Walk-in Infinity Chamber*, Stanley bumped into Agnes in New York sitting in the window of a Horn and Hardart automat.

"Agnes, you lied to me," Stanley said, sitting down at her table, "You told me art was fun." Evidently he was deep into the intricacies and challenges of creating infinity.

"I know," Agnes replied, herself undergoing an artistic labor similar to Stanley's, "I've been fooling myself too."

FOUR

Daphne Cowper Vaughn

After teaching watercolors and telling students like Stanley to "paint big," Agnes decided that the pay at UNM didn't meet with her expectations, so she took a job at the John Marshall School in Albuquerque, teaching writing and art to young boys considered to have discipline problems. Agnes was in saving mode because she needed all the money she could get to pay off the bills accrued while building her first home.[1] Though she had only been in New Mexico a year, Agnes had already decided to put down some roots. Mildred may have been waiting in the cherry orchard cabin in Monmouth, but there was no sign of Agnes returning. Besides, her new friend Daphne might miss her.

Agnes met Daphne Cowper in 1946 when Daphne was an English and drama student at UNM. Daphne, like Agnes, was the daughter of a Scottish Presbyterian. William Cowper, however, was more cosmopolitan than Robert Kinnon: he was a converted Buddhist, a sympathetic Fabian, and rumored to have been the private physician of George Bernard Shaw, once upon a time.

If Mildred educated Agnes on art, Daphne may have nurtured Agnes's interest in Buddhism. Agnes was exposed to Buddhist thought from an early age. Vancouver, her primary home, had a large Chinese community who were employed in the sawmills and logging camps that Agnes also worked in as a teenager. In addition, Malcolm Junior meditated frequently as a young man, which must have impressed his doting sister. While Buddhism, "Oriental" thought, and Zen Buddhism did not yet have the following or cultural heft in the U.S. that they would in later years, in the aftermath of WWII, Eastern religions were desirable for the alternatives they offered to the accepted, and somewhat fractured, traditions and philosophies of the West. For instance, one aspect of Buddhist thought that particularly appealed to Agnes was the philosophy of nonaggression.

After a year together, Agnes and Daphne decided to build a house—the news of which reached Mildred through Elizabeth Kane. Since her arrival in New Mexico, Agnes wrote to Mildred often. It was because of Mildred that Agnes was able to go to Albuquerque in the first place. Before she had left Oregon, Mildred had given Agnes her war bonds so Agnes would not go starving and could work towards her dream of being a painter. How would Mildred respond to the news that Daphne and Agnes were building a house together? Most likely, Mildred knew that it was impossible to hold Agnes back from anything she had set her mind on. Agnes's art hung in Mildred's cabin in Monmouth, the small house on Tacoma Street in Portland, and in the Kanes' weekend cabin on Elk Lake. If Mildred felt angry, hurt or betrayed by Agnes's relationship with Daphne, she would have to deal with it. Agnes was the fifth Kane sister, and she was going nowhere.

The Cowper-Martin house was built on Avalon, a spur of land that begins at 52nd Street and runs parallel to Central Avenue in Albuquerque. Once the foundation was laid and the adobe bricks were dry, the house was assembled in four weekends, completed by New Year's Eve in 1947.

Agnes recruited Stanley Landsman and her students from UNM to help with the construction, telling them they needed experience laying adobe (though Agnes herself wasn't too familiar with the technique). Elizabeth

Kane who frequently stayed with Agnes and Daphne remembered the "adobe parties" where fifteen to twenty people arrived to slap on mud and straw. As the house was being built Agnes and Daphne lived in a tent on the land. Daphne documented the building process with her little camera. When Agnes saw the photographs she remarked that she and Daphne looked like "poor whites"—perhaps the simplicity and Spartan life Agnes lived had never been reflected back to her until Daphne annoyed her with the little camera. Daphne also took pictures of Agnes posing with her paintings outside their Avalon home, as well as painting *en plein air*. In one image Agnes stands in her workman's jacket and jeans facing her easel and the Sandia Mountains. In her hand she holds a small tray of paints and a big imposing paintbrush: every inch the artist.

Building the Avalon home was a dream for Agnes, who was very proud of the accomplishment later on. Margaret Martin might have been a successful interior decorator and saleswoman but Agnes could erect a temple from the humble dirt of the earth.[2] However, even with the unpaid manual labor of UNM students and friends, the Avalon house remained an expensive project. Early on, Agnes lobbied for a swimming pool, but eventually Daphne persuaded her it would be impossible to maintain with the dusty desert winds.

Daphne, like Mildred, was supportive of Agnes's art, often posing as her model. Although Agnes told her students to "paint big" and her own watercolors were approaching abstraction, her portraits were decidedly figurative, though still with modernist influences, such as that of the artist Amedeo Modigliani.

Although there are photos of Agnes posing with a number of portraits, the ones that have survived are a self-portrait, a portrait of Daphne, and a nude portrait of Barbara Pullens, a professional model described by Daphne as "part Scottish and part Blackfoot."[3] The portraits are photographic, flat, and cropped, with a reduced color palette and a striking use of expressive line. They are noiseless like a still life, but looking at these portraits, one can tell that the subjects of these paintings have strongly held opinions.

Agnes, however, was never satisfied with portraiture, and in subse-

quent years she worked hard to buy back her early work in order to destroy it. Many of these portraits were painted as part of applications for artist residencies and scholarships and as such catered to the conventional taste of the time; a taste dictated by the committee boards of colleges and trusts, and a middle-class art market indifferent to artists and hostile to women artists in particular.

Agnes's women, dressed in their Sunday best, coiffed hair, and red lips, were very different from the artist herself, whose "look" was a tad old-fashioned and somber. Her hair was thick and she wore it like a head-mistress, piled high on each side of her crown, and her broad build and ath-letic appearance made her come across as severe, disguising her fun-loving personality. Daphne, on the other hand, was more modern and carefree, with bouncy brown curly hair and a generous smile. Agnes captures these differences in two portraits, a *Self Portrait* (undated) and *Portrait of Daphne Vaughn* (c.1947–49). In her self-portrait Agnes is placid with a blush on her cheek. Her shoulders are slender, accentuated by the red stripes stream-ing down her navy top; the broad and heavy brushstrokes give texture to her face and hair. Her portrait of Daphne in comparison is more sen-sual. Daphne's arms are folded across her chest. Her right hand is tucked beneath her arm. Her head is tilted up to stare at her audience; as a student of drama, Daphne knew the value of a striking pose. A dark shadow runs down her neck, drawing our attention to her skin, exposed and bronzed. Her face seems weatherworn, burnished or hot, warmed by the fiery red background behind her. The portrait of Daphne is the Mediterranean Sea; Agnes is the North Atlantic Ocean.

Agnes and Daphne lived together for three years. The tacit bylaws to romantic relationships between women during that time (apart from "keep it hidden") were indistinct. Though Mildred and Agnes were accepted by the Kane sisters (though not necessarily their husbands) and had some friends, for the most part their relationship was sustained by what was unspoken. What could both women hope for from a relationship? There were no stages to go through, no ceremonies to aspire to, no mark-ers in their lives that showed them what they could aim toward. Agnes and

Mildred had no culture to belong to, even though as teachers they were shaping and enabling a culture they often felt removed from. The same was true of Agnes's relationship with Daphne. Without any parameters or milestones to work toward, these women were, on the one hand, free to make their own rules, and on the other, imprisoned by a lack of choice. Because it was unlikely they could ever exist publicly as a unit, breakups were inevitable. Agnes's ambition was to be a great artist and not a housewife. In the past she had moved where she needed to in order to achieve her goals. Relationships, ultimately, did not hold her back. Despite the Avalon home, Agnes could not change her stripes. After three years, with a degree of inevitability, Daphne and Agnes ended their relationship.

Agnes wanted Daphne to be happy, but Agnes's view on happiness for other people was surprisingly traditional requiring just two ingredients: marriage and children. Agnes, increasingly bossy (some might say controlling), told Daphne to marry John Vaughn, a mutual friend whom Agnes had introduced Daphne to during a road trip to New Orleans. Daphne complied.

Agnes, by now an American citizen, was keen to return to New York City, excited by the stories she was hearing from the artists there. To fund a return to Columbia Teachers College, Agnes sold her share of the Avalon home to Daphne and left Albuquerque. Daphne remained, had a short marriage, and raised two children in the home she built with Agnes.

Agnes was responding to a clarion call from NYC. In 1951 there was a change happening in American art that did not escape her attention. With the increased power of the mass media, artists were becoming visible for what seemed like the first time in America. Society as a whole was still reserved toward and suspicious of artists—but at least they were no longer invisible. Indeed, the reverse was true: artists were now under a spotlight, and they were ill-equipped to cope with this newfound notoriety.

For Agnes, in order to move forward at this point in her life, New York was, once again, the place to be. But first she had an old friend to call on. Mildred was waiting.

FIVE

Personages

Agnes and Mildred drove from Oregon to New York in 1951, found a small apartment to rent in Morningside Heights, and enrolled once more at Columbia Teachers College. On this occasion, for Agnes, the primary attraction of returning to Columbia was the free studio space.

At Columbia, Agnes took a variety of jobs to help pay for her education, including riding school buses as a chaperone. Her favorite job at the time and perhaps the most useful was the role of kitchen manager. When this job was described to her Agnes was told that she would be responsible for overseeing 45 unruly boys in a college canteen. With some trepidation and channeling Margaret Martin's disciplinarian side, Agnes turned up at the canteen to be met with 45 well-behaved law students: "I got three meals a day, got paid by the hour and I never did anything."[1] It was Agnes's favorite part-time job because it brought her close to the food. Louise Sause, a close friend of Agnes and Mildred at the time, recalls that during the holidays the two women also worked as cleaners at Bellevue Hospital because it paid double wages.

Agnes's return to Columbia Teacher's College was a continuation of her education at UNM, but instead of being in Albuquerque hearing art-world stories at a remove, in New York she could experience the immediacy of the increasingly vibrant scene, the latest gallery openings and (more importantly) the studio parties. Many of the teachers and artists in Albuquerque had close ties to New York and provided introductions for Agnes there. The exhibition 15 *Americans* at the Museum of Modern Art in 1952 for instance, included the work of Edward Corbett whom Agnes knew from UNM. Agnes would tolerate the lamentable soot on her blouse to be surrounded by the gossip, art magazines, lectures and artists' clubs—this relentless call to life in the name of art.

Louise Sause's apartment was on the fourth floor of an old corner brownstone on 125th Street and Amsterdam. The building had an elevator; an added touch that Louise's friends appreciated when they visited her after a long day schlepping around Morningside Heights. Louise and Mildred, who lived nearby, walked home together after their classes. Both women were passionate about early childhood education, and Louise, who was two years younger than Mildred, was impressed by the descriptions of Mildred's school back in Oregon. On one of these walks Mildred mentioned Agnes to Louise, going so far as to caution her friend: "Remember, Agnes has unusual abilities. She's a person to watch."[2]

One day, when Louise was visiting Mildred, this "person to watch" arrived in from class with a new small print entitled *Personages* (1952). Without any preamble Agnes offered the print to Louise, not seeming to care for it very much herself. Louise immediately accepted it and the women wrapped it in the paper Agnes had just unpacked it from. *Personages* depicts four angular elongated figures in a sparse desert landscape. Its title, and its expressionistic (and biomorphic) characters, bring to mind the classes in marionette-making that Agnes took when she first studied Columbia.

In time *Personages* became a memento to Louise of her friendship with Agnes and their many evening strolls together. Walking provided breathing space for both women and Agnes was adept at turning it into an adventure. "Agnes had a sense of humor," Louise recalls,

And I remember so well in taking walks with her, she could always find humor wherever we went. And she would invent characters in all our surroundings and greet them as personages very much as she did in this picture...the objects she saw became personages...and the people she saw became particular kinds of personalities...just to walk around the block with her was fun. And interspersed with her comments about the characters was much of her philosophy about life and people in general. So it was more than just a walk. It was really listening to somebody who had very definite and very interesting opinions about many, many topics.

Agnes could unburden herself with Louise. She spoke about her disappointments and struggles, and the inspiration other artists gave her, as well as the inspiration she sought from exhibitions. Agnes also spoke at length about adolescence. While Mildred and Louise had an academic and practical focus on early childhood education, Agnes had always identified more with teaching older students:

Agnes spoke about young teenagers and their real needs, and the inevitability of their exuberant, forceful and sometimes fearful natures. The fact that as they grow and develop we should accept and look for radical changes especially in their view on life.[3]

Here, Agnes mirrored the views of her Columbia mentor Arthur Young who would, in a few years, provide a reference for her on a scholarship application. Young believed fervently that each child should grow according to his or her potential and develop, what Agnes called their unique "sensibility." Young also believed that the aesthetic principle is embedded

in humankind and is a source of wellbeing. Agnes also believed in this, arguing that beauty was in the mind and could be awakened by certain kinds of art, bringing pleasure and increased awareness to the viewer.

Agnes's attitude to teaching and nurture remained ambiguous. Later in life, though she lectured widely, particularly to students, she also believed that teachers could be a hindrance to the young, who ultimately had to find their own way in the world. Although she herself was, and would come to be, influenced by those around her, in her lecture *The Untroubled Mind* (1972) she questions influence, casting her story in a romantic glow, writing "the little child sitting alone, perhaps even neglected and forgotten, is the one open to inspiration and the development of sensibility."[4] Agnes could never decide if the best nurture was something society could give, or like the little child sitting alone, something the individual must develop themselves.

This second stay at Columbia was an inspiring and fertile time for Agnes; a time when she began to develop and refine her views on life and art. Occasionally she struggled with the philosophies she encountered, and her peace with how these philosophies should impact on her in the real world was hard won. Later, friends would argue that Agnes was close-minded. Indeed, her unbending nature and unwillingness to compromise lead to rifts in friendships. During her Columbia years, however, just shy of middle age, Louise remembers Agnes as open-minded and hungry for knowledge. Martin Ryan, another friend during her Columbia years, also supports this view. Martin remembers Agnes frequently sitting in the campus cafeteria, nibbling on a sandwich, while she listened to Martin and his friends (other WWII veterans) recall their wartime experiences and discuss Sartre and the existentialists. "Agnes was full of the joy of living at Columbia," Martin recalls. Indeed "joy" would become one of her artistic preoccupations later in life.[5]

Although Columbia University only allowed male students to enroll, Teachers College students were free to sit in on lectures. Agnes, Louise, and Mildred frequently made use of this concession, attending lectures by Jiddu Krishnamurti, Thomas Merton, and Ad Reinhardt, who was soon

to become a friend and guide. (As a side note, it was Krishnamurti's adoptive mother Annie Besant who espoused the theosophy that Agnes's UNM teacher Emil Bisttram so admired and taught: a sphere of influence coming full circle.)

Louise recalls that the teachers at TC were "delightfully individual with different styles and approaches." The lecturers at the University, by comparison, were "traditional and uninspired." Teachers College saw the whole metropolitan area as a basis of learning, encouraging students to use it as a key source in their personal development, an attitude of enquiry that Agnes embraced fully. Agnes's neighborhood of Harlem was culturally rich though economically impoverished. Segregation was still the accepted norm in the school system across the U.S. and it was not until 1954 that it was formally deemed unconstitutional in the landmark case, *Brown v. Board of Education*. As a further reflection of the times, Columbia would only officially become coeducational in 1983. Before 1983 several schools, such as Teachers College, enrolled women, while nearby Barnard College (founded as a women's college in 1889) had been affiliated with Columbia University since 1900. Though Agnes later refused to acknowledge an art that was divided into genders, the world she lived in for most of her life was strictly divided along wealth, gender, and racial lines. Teachers College was a beautiful aberration in the educational landscape of the time instead of: Black students and teachers from the South who were refused further education in their home states journeyed there to enroll in summer programs where they were welcomed openly.

Teaching in nearby Harlem was disenchanting for Agnes: "Those children don't need discipline, they need freedom to explore."[6] Agnes grew up fishing, climbing, dancing, and swimming, and she wanted these things for the children she taught in the local schools. Despite her ongoing disillusionment with education, Agnes graduated in 1952. Margaret Martin, now Margaret Frith, or Mrs. Frith as her children and grandchildren came to call her, took her first airplane flight ever to see Agnes graduate. Despite Agnes's later unfavorable account of her upbringing, she frequently kept in touch with her family, and even though Agnes was unmarried and likely to

remain so (she was now forty years old) graduating from Columbia Teachers College with an M.A. in Education (and a concentration in fine arts) was something worth celebrating, even by Mrs. Frith's estimation. Agnes, however, did not share her mother's sentiment. When Margaret was seated in the audience at the graduation ceremony, she hurried Agnes to take her place with the other graduates on the stage. "Mother, do you see that man, second from left on the last row," Agnes said, "Pretend that's me." Agnes had decided she would not spend good money to stand on a temporary outdoor stage with her classmates for a photo opportunity, even if Mrs. Frith had come all the way from Vancouver for that precise reason.[7]

Margaret's unexpected visit to New York might have been spurred by another major event in Agnes's life that took place the year before. In July 1951, during a routine operation, Malcolm Junior passed away from kidney failure. He was thirty-six years old, leaving behind a wife and two young children: John was six and Christa was two, the same age as Agnes when Malcolm Senior died in 1914. After Malcolm Junior's death, Agnes became further separated from her siblings and her mother. She was an adult of thirty-nine but she felt as powerless and alone as a child. Perhaps this was on Mrs. Frith's mind when she decided to visit her temperamental daughter soon before her own death.

The years after Columbia, between 1952 and 1954, were unstable for Agnes, who flitted between Oregon, Taos, and again Columbia for a seminar in "Social Living," a short course connected with the New York City public schools program.

In the fall of 1952, Agnes moved back to Oregon to teach at Eastern Oregon College of Education (EOCE), today known as Eastern Oregon University. One course Agnes taught was Art for the Elementary Student; a required module for teachers studying elementary education, and a popular class. According to her student, Elinor MacDole Moroney, she was fired after one year at EOCE for being "too progressive."[8] It seems the freethinking encouraged at Columbia was discouraged when it came to preparing the elementary teachers of tomorrow for a teaching career in the Northwest.

At this time her style of painting had moved away from heavy encaustic portraits, and landscape watercolors, toward more muted abstract and biomorphic paintings; often reimaginings of Biblical subject matter. One such painting, *The Expulsion of Adam and Eve from the Garden of Eden* (1953), hung over Mildred's bed in the cherry orchard home in Monmouth. Agnes's dramatic re-imagining of the Bible's first juicy transgression showed Eve kicking Adam out of Paradise. According to Mildred's niece Susan Sharpe, Agnes used to laugh at Adam's knees locked together in fear. This new work including *Untitled* (1953), *Untitled* (1954), and *Untitled* (1955) looked anachronistic in the rustic setting of Monmouth. The paintings grew bigger, more abstract, and paler; some included stick figures, while others included orbs, strange instruments, and pools of color.

It was not only Agnes's work that was out of place in the cabin. Agnes and her ambition were becoming too big for the little house. For two years she lived off and on with Mildred in Oregon, and was becoming sullen and frustrated with her work, which was not progressing in the way that she'd hoped. The pattern she established (which in part accounts for her peripatetic lifestyle) was to work fulltime, save money, take time off, paint, and repeat. When she had a daytime job, painting in the evenings and the weekend—mere crumbs of time—was not enough. In 1954, not knowing what else to do or where else to go, Agnes enrolled once more in Teachers College to take advantage of the free studio space. It would be Agnes's first time in New York without Mildred.

There is no way to know the exact nature of Agnes and Mildred's relationship during these years. Close friends? Lovers? Platonic friends? A blend of these? Mildred was where she wanted to be in her career, getting huge satisfaction from her teaching. It's likely that she knew it would be unfair to hold Agnes back in anyway, and—who was she kidding—nothing could hold her back once she had made her mind up. Even their relationship, which had lasted twenty years, could not quench Agnes's thirst for fame and success as an artist. The day she left for New York, Agnes and Mildred took a large portion of Agnes's paintings and put them in a trunk for storage. Once Agnes had turned the corner in her Ford Model T, Mildred took *The Expulsion of*

Adam and Eve from the Garden of Eden from her bedroom wall and relegated it to the sitting room. Mildred looked at Adam banished from the garden and probably knew how he felt.

It was during her third and final stint at Teachers College, this time alone, that Agnes got a real flavor of what living the life of an artist in New York could be like. Agnes was no longer a country bumpkin, though she retained her sweet Canadian accent. One person she got to know during this time was Betty Parsons, one of America's most influential art dealers. Fortunately for Agnes, Betty liked her work, but not enough to give Agnes her own exhibition. Despite this, Betty was encouraging, and any encouragement, especially from someone like Betty, buoyed Agnes up.

Agnes was inspired by Abstract Expressionism, the prevailing art movement at the time, and a movement Betty played a powerful role in promoting.

Abstract Expressionism was as much a cultural phenomenon as it was a delineated movement, and the twists and turns of its evolution are many and complex. Agnes may have experienced work by Abstract Expressionist artists when she first studied in New York in 1941–1942. Her later work *Autumn Watch* (1954), *Dream of Night Sailing* (1954), *Untitled* (1954), and *Untitled* (1952), for instance, suggest the influence of Arshile Gorky and Adolph Gottlieb. The work of both painters was included in the Whitney exhibition *Paintings By Artists Under Forty* in November 1941, and Gottlieb's "pictograph" paintings (which *Autumn Watch* seems inspired by) were first shown in May 1942 at the *Second Annual Federation of Modern Painters and Sculptors* in the Wildenstein Galleries. As another artist under forty—in 1942 she was thirty years old—Agnes had a vested interest in attending such exhibitions during her first year of study at Columbia.

The movement had gained momentum by the time Agnes attended Columbia again, in 1951. In 1950, for instance, Willem de Kooning, Jackson Pollock and Arshile Gorky all featured in the American Pavilion at the Venice Biennale, and by 1951 Betty Parsons had presented solo exhibitions of Abstract Expressionist artists including Mark Rothko (1947, 1948, 1949, 1950), Ad Reinhardt (1946, 1947, 1948, 1951), Theodoros Stamos (1947, 1948, 1951), Hans Hofmann (1947), Jackson Pollock (1948, 1949, 1950, 1951), Rich-

ard Pousette-Dart (1948, 1949, 1950, 1951), Hedda Sterne (1947, 1948, 1950), and Clyfford Still (1946, 1947, 1951). These twenty-six exhibitions, taking place between 1946 and 1951 shows the rate of promotion of the individuals and the movement at the time.

In its simplest form, Abstract Expressionism was a nonrepresentational art that prized feeling and individual expression over traditional subjects or styles. As with all art movements it was informed by its omission and embrace of the characteristics of previous movements. Existing on a continuum with other modernist movements including Tachisme, Suprematism, Vorticism, Futurism, Orphism, Cubism, and (further back) Impressionism, the movement became at first, defiantly American, and then symbolically American, becoming, if not the first home-grown American art movement, then at least the most widespread, ubiquitous and enduring one.

Many factors contributed to its initial rise. The Abstract Expressionists were apathetic towards the apparent "reality" of institutions, nationalism and grand narratives, which were all called into question in the aftermath of WWII. As a result, like many people, the artists suffered from a spiritual malaise. According to the critic and Abstract Expressionism champion, Harold Rosenberg, once faith in political action and programmatic movements had been eroded, all that was left to artists was the "action" on the canvas, and the "extremist faith in sheer possibility."[9]

This "extremist faith in sheer possibility" as the only escape from spiritual malaise manifested itself in the art as "an original gesture, harsh and without charm." To paraphrase the philosopher René Descartes, it wasn't so much "I think, therefore I am" as it was "I paint, therefore I am." This original gesture might be a blob, a splash, a drip, or a scrape, but according to Rosenberg it tapped into the "terrible drama of human history" that the west was reeling from after the war.[10]

This approach to art, and the art itself, challenged and confused the majority of people. Time, however, heals most wounds, and the artwork was eventually, not only tolerated, but welcomed as a brave and necessary evocation of the human condition.

Photography, meanwhile, was beginning to show its diversity in advertising and journalism, replacing painting and illustration as the medium *par excellence* to document the outward appearance of things. Contemporary artists, therefore, undertook a journey to redefine the qualities, potential and purpose of the painted canvas, interrogating the fundamentals of painting. Each artist did this in different ways, at different times, and toward individual aims, though the critics, dealers, and artists often sectioned the work into "action" or "gestural" painting and that of "Color Field" painting.

Action painting embraced the accidental and individual mark making in painting as seen in the work of Jackson Pollock and Willem de Kooning. Pollock, famously, painted on the floor, dripping, pouring, and throwing paint on the canvas. Meanwhile, other artists including Ad Reinhardt, Mark Rothko, and Barnett Newman explored the emotional and physical qualities of color relationships, and the application of paint on the canvas, in what became known as Color Field painting. Though Ad Reinhardt labeled Abstract Expressionism old moody German Expressionism in a neo guise, he was devout to the philosophy behind the movement, promoting it through his lectures and writings, of which Agnes was a devoted fan.[11]

Both Color Field and action painters often worked on huge canvases that were confident and irrefutable. The artists' feelings, it is implied, needed large canvases to give these feelings room to breathe. The flat "all-over" composition without foreground or background, without the hierarchy of competing objects, and with the potential for color to evoke emotion, were trademarks of the movement that presented new opportunities to artists such as Agnes, who was particularly inspired by the scale that the artists achieved in their work. The action painting of Jackson Pollock (*Full Fathom Five*, 1947), the Color Field work of Helen Frankenthaler (*Mountains and Sea*, 1952), the gestural mark of Willem de Kooning (*Woman I*, 1950–52) and the emotional color palette of Mark Rothko (*No. 10*, 1950) were just some of the individual signatures that came to represent the movement.

Aside from the differences and similarities of their aims and methodologies the Abstract Expressionists were also united by their lowly status in

society and their ties to New York. A vibrant culture, and intellectual argument and exchange (not to mention competition), was cultivated by the artists at exhibitions, lectures, and social clubs, as well as in public spaces including the Waldorf Cafeteria, and the Cedar Tavern in Manhattan. The new ethos in art was also institutionalized in the university sector. However, despite all of this activity, the Abstract Expressionists encountered enduring prejudice, captured here by Adolph Gottlieb in 1954:

> The artist in our society cannot make a living from art; must live in the midst of a hostile environment; cannot communicate through his art with more than a few people; and if his work is significant, cannot achieve recognition until the end of his life if he is lucky, and more likely posthumously.[12]

In the mid-'50s, when Abstract Expressionism was at its peak, exhibitions by the leading artists including Gottlieb and Mark Rothko frequently closed without sales. Gottlieb sounds despondent because not only was there a natural lack of interest in abstract contemporary art, there was active political antagonism toward the artists at the time. Although the movement "emerged without manifestos, collective identity, pooled stylistic approach or even a name," Abstract Expressionism was not completely apolitical.[13] Many historians have identified that Abstract Expressionism was, in fact, a way out of political confrontation, a way in which to resist mass culture and the artists' place in it, though this did not stop politicians from suggesting other nefarious political goals. Michigan Congressman George A. Dondero, for instance, delivering a speech to Congress in 1949, captures some of the antipathy towards abstract and expressionist art in America at the time. "Art is a weapon of communism," writes Dondero, "and the communist doctrinaire names the artist as a soldier of the revolution." For Dondero, all modern art and its movements are "weapons of destruction." Expressionism, for a start, "aims to destroy by aping the primitive and insane," while abstractionism "aims to destroy by the creation of brainstorms."[14]

Dondero's observations were not always far off the mark, though the *conclusions* he drew from them—informed by the paranoia of the times—were.The Abstract Expressionists did embrace primitive art—particularly that of the Native Americans—searching for universal symbols, myths, and totems.Many of the shows of Native American art at the Betty Parsons Gallery organized by Barnett Newman "were designed to bring out the ritualistic aspect of primitive painting and above all, its tendency to abstraction."[15] In addition, Native American sand painting of the Southwest was a particular fascination for many of the artists at the time.

When Dondero writes of "germ-carrying art vermin," and "foreign art manglers" who have invaded schools, colleges and universities to sell "young men and women a subversive doctrine of 'isms,'" he is speaking of the many European émigrés who settled in the U.S. before, during, and after WWII, in particular Josef Albers (Black Mountain College), Hans Hofmann (The Hofmann School of Fine Arts) and Meyer Schapiro (Columbia University).[16]

One can derive a useful point from Dondero when one deconstructs his lofty xenophobia. Abstract Expressionism is often touted as the first indigenous art movement in America, but this claim dilutes the important influence of European artists and movements on the first wave of Abstract Expressionists—an influence Dondero was highlighting to find fault with. The concept of the Uptown Group or the New York School—an early moniker for Abstract Expressionism—not only diluted the importance of European influence but also the important work produced outside New York City at this time, particularly in California.

It was all much worse than Dondero had anticipated. Abstract art was spreading to all corners of the continent, and far from being a passing fad or communist weapon, it was there to stay—positively American in its determination. As a result, the movement was not tied to New York (though New York, of course was an important center). New Mexico, for instance, also continued to be an intensely productive and influential hub of talent and inquiry, and this is just one reason why Agnes returned there in 1954.

Compared to New York, New Mexico was a safe haven where Agnes could explore her own abstractionist painting without coming under attack from George A. Dondero or the everyman on the street.

SIX

Taos, New Mexico

In 1954, after completing her seminar at Columbia, Agnes returned once more to Taos, this time as recipient of a Wurlitzer Artist Residency. Prior to the formation of the residency in 1954, Helene Wurlitzer (née Billing), who had married into the eponymous musical instrument-making dynasty, had been supporting artists on an ad hoc basis. Earl Stroh for instance, a classmate of Agnes in 1947 at the Taos Summer Field School, was able to live in South America and Europe for years with Wurlitzer's financial assistance. It was Earl who encouraged Wurlitzer to set up her foundation and to approve Agnes's application. In addition to having Earl's support, Agnes had four strong referees to hand: Arthur Young, Clay Spohn, Lez Haas, and Betty Parsons. Arthur Young taught Agnes at Columbia Teachers College, Lez Haas taught Agnes at UNM Albuquerque, Clay Spohn was a Taos painter and teacher at the California School of Fine Art, and Betty was a force unto herself.

Agnes's application letter for the Wurlitzer residency reflects a new-found confidence among American artists in their aspiration to represent "the expression of the American people." In the aftermath of WWII and with the rapid emergence of mass media, industrialization and existentialist and "Eastern" thought, American artists felt compelled and equipped to respond to what appeared to be a new zeitgeist. It also reflects a new-found confidence from Agnes herself, showing how dedicated she was to her career as an artist and, specifically, an "American" artist.

Agnes's first letter to the Wurlitzer Foundation was more timid than the second. In these letters Agnes presents herself as just one artist out of many currently representing a new direction in art.

According to Agnes, she and her *compadres* are "at the beginning" of American art, a choice of words that reflects both their attitude to their forefathers as well as the giant undertaking Agnes and her contemporaries saw ahead of them. In order to underline her upstart status, Agnes took two years off her age in her application.

November 8th 1954

Art Committee, Wurlitzer Foundation,

In making application for assistance as an artist I would like to say that my efforts and interests as an artist are directed toward assisting in the establishment of American art, distinct and authentic, that I feel we, myself and other artists, will very soon succeed in making not only a successful but an acceptable representation of the expression of the American people with the help of patronage such as the Wurlitzer Foundation. And I feel that it is very thrilling to be 'in' almost at the beginning as we are.

I have been painting fifteen years and working at the same time as a teacher. In February this year Betty Parsons Gallery offered to show my work in New York.[1]

Agnes soon followed up her first letter with a second, showing both her determination and maybe even desperation,

December 5th 1954

With this application I want to state as in my previous letter that if I could receive assistance of sixty dollars a month for one year from the Wurlitzer Foundation I feel sure that I could get a show of twenty paintings or more ready and placed in the Betty Parsons Gallery in New York, which gallery has already accepted some of my work and indicated that they would accept a whole show. When this goal is achieved I shall be in the position of one of those contributing to art expression in this country...[2]

The Wurlitzer residency gave Agnes a *casita*-studio for a year as well as a stipend of $40 a month for food and materials. It was the first time in her life that Agnes was allowed to concentrate on her work without any distractions and imminent financial worries. Nevertheless, throughout the year she continued to give classes in portraiture to earn extra money.

By the end of 1955 Agnes was achieving some of her goals. She was in a two-person show in Santa Fe that was "quite successful in its expressions," as well as a three-artist show in the Albuquerque Museum of Art with Alfred Rogoway and Wolcott Ely, a close friend of hers at the time.

I also contributed to the State Fair and the New Mexico Artists Show in the Santa Fe Museum and to two traveling shows from the latter. I painted all together one hundred canvases of which I had a good opinion and sold seven.[3]

By all accounts, Agnes's year with the Wurlitzer had been productive, but Betty Parsons did not offer Agnes an exhibition. Writing to Helene Wurlitzer, Agnes remained hopeful,

I am grateful for the assistance I received...it gave me the materials I needed and a certain amount of security and enabled me to make a very

good try for my New York show. This did not succeed but Miss Betty Parsons, whose gallery I will eventually show in, assured me that in one more year she thought I could make it which is not discouraging.[4]

At this time Betty was a frequent visitor to New Mexico, in particular Santa Fe and Taos, where she had many friends including the photographer Eliot Porter, his wife Aline, and D.H. Lawrence devotee, artist Dorothy Brett. Like Agnes, Aline Porter also had a long courtship with Betty. According to Aline and Agnes, Betty would only show artists that lived and worked in New York. The pragmatist in Betty defended this stipulation on the grounds that it was beneficial to send a prospective collector down to the artists' studio. The romantic in Betty (and Betty was more romantic than pragmatic) defended the condition on the grounds that she wanted artists where they could help her fight the battle against the conservative taste of the public and critics. For Betty always maintained that the world was against her: a latent streak of paranoia that would also emerge in Agnes in later years.

The cultural constellation comprised of Albuquerque, Santa Fe, and Taos continued to burn bright when Agnes remained there in 1955 immediately after her Wurlitzer residency. Though she was based in Taos, Agnes and her fellow artists visited and exhibited in Santa Fe and Albuquerque, both towns a hub for talent and discourse due to the university. While each had an individual ecosystem of commercial and cooperative galleries, the artists moved freely up and down the Rio Grande valley between them to party, paint, and publicize their work. A brochure for Albuquerque at this time refers to its central plaza as a "Greenwich Village of the West."[4] This echoes a 1921 *New York Times* article that describes Taos as "the Provincetown of the Desert."[5] Be they Provincetown or Greenwich Village, Taos and Albuquerque were certainly overrun with Anglos.

Culturally New Mexico was a mix of Indians, Spanish, and Anglos.

Anglos only properly settled in the state in the late 1800s and they were still a minority in numbers. Just as she had done in Harlem, Agnes embraced the diversity of the community. When she first moved to Taos in the 1950s she visited the Pueblo and attended the Native American ceremonial dances, often the only Anglo there. When Louise Sause visited Taos in 1955, Agnes confessed shyly that on Sundays she went to a Spanish-speaking church to try to learn some of the language. It seems that she was committing to Taos, the Taoseños and the various ethnic communities in a way she had not done in Oregon or New York.

There was a long tradition of New York artists settling in New Mexico. Robert Henri and John Sloan visited Taos and Santa Fe back in the early 1920s and the artists who arrived in the '40s and '50s carried with them an experience of the Great Depression and WWII, as well as a more liberal art education and liberal values. Beatrice "Bea" Mandelman and her husband Louis "Lou" Ribak were two such artists that formed a close, nourishing friendship with Agnes at the time. Lou was an established artist whose work was seen at the Whitney Studio Club (the predecessor to the Whitney Museum of American Art) and the Venice Biennale in 1934 and Bea had taken part in the Federal Art Project during the Depression and studied with Fernand Léger in Paris. Bea also studied at the Art Students League in New York where she met Arshile Gorky and Willem de Kooning. Bea and Louis divided their time between Taos and New York, where they kept a property in the city. Though Agnes was only a year younger than Bea, the Ribaks took what could be considered parental care of this unusual Canadian blow-in.[6]

Agnes spent her days in relative isolation in her studio and her evenings at the dinner table of the Ribaks, usually with another artist or two dropping in. Bea and Lou were a highly productive couple and Agnes admired their work ethic greatly. *Turnips* (1954) by Bea and *Times Square* (1953) by Lou offer a taste of their abstract work during the period.

Agnes was suspicious of artists who didn't work and who had come to Taos to piggyback on the success and enterprise of others. Louise Sause remembers Agnes relaying an anecdote about a man who once asked to

use a telephone. Agnes allowed the man use of the phone but not before making sure he was a working artist. "You can't be a drifter, you better be working," she warned him.[7] As somebody who had toiled all her life and had yet to make it, Agnes demanded that those around her share her hard work ethic.

This attitude was shared among her friends. There was practically no market in Taos for competing artists and the tourist season only lasted from the summer to early autumn. As it was, the work produced by Agnes and her contemporaries was considered too alternative for what remained a conservative state with conservative tastes—the result is that the majority of the artists were very poor. This was particularly true of Agnes, who was dependent often on the kindness of those around her. One patron early on in her life was the artist Lesley MacDougall Brown.

SEVEN

Kristina Brown Wilson

Lesley MacDougall Brown's love of nature was instilled in her from a young age. She grew up in Surrey and Oxfordshire in England and spent her holidays in the Lake Country, Devon, and Cornwall. Her father, William MacDougall, was a renowned professor of psychology at Oxford, and he brought Lesley to Switzerland, on work trips, to climb mountains with the Jung children while he studied with their father Carl. Lesley moved to Boston in 1920 when her father replaced William James as the chair of psychology at Harvard. Then aged nineteen, Lesley enrolled at the Boston School of Fine Arts where she studied with William James Junior. After her university education, Lesley raised four children with Paul Brown in New Hampshire. The Brown family ran the Brown Company, a pulp and paper company that at one point had more than six hundred patents for a range of products from Nibroc paper towels (the first paper towels in production) to the Ferrand Rapid Rule, now commonly referred to as the tape measure. When her marriage to Paul Brown ended, Lesley moved to Taos with her youngest son, Bruce, to be close to her brother

Angus, who was then working at the Harwood Foundation. Lesley's three eldest children, Kristina, Malcolm, and Eric also made Taos their home when they returned from university, and military service in the case of the two young men.

Agnes got to know Lesley through Eric and Malcolm, whom she studied with at UNM Albuquerque. Malcolm had also studied with the émigré Abstract Expressionist Hans Hofmann in Provincetown, Massachusetts, and at the New School in New York. Both women hit it off when they first met, so much so that Lesley offered Agnes a room in her home. As a founding member of the Taos Center for the Arts, Lesley was supportive of artists like Agnes. Agnes, however, tested the limits of Leslie's philanthropy. Agnes was intense, needy, and demanding as a tenant, and Lesley never had a moment's peace with her constant chatter. Lesley was an artist and had commitments: she too needed her quiet time to create and think. It was apparent immediately that this new arrangement wouldn't work, and within weeks Lesley kicked Agnes out.[1]

Agnes, it could be argued, ultimately came off the better for her brief encounter with Lesley. It was while having tea with Lesley one day that Agnes met Lesley's daughter, Kristina, a "lovely blonde girl," "tall" and "shy."[2] Kristina had returned to New Mexico from New York, where she had studied occupational therapy. She was hoping to emigrate to New Zealand, but in the meantime was living in San Miguel County, where she was stationed at the Las Vegas State Mental Hospital, in part reviving a weaving program for the patients. Kristina described herself as twenty-five going on twelve when she first met Agnes:

> She came along and, oh my God, I flipped right over my head. She asked me my opinion on something. I was totally mute at the time. I was so shy I didn't talk to anybody. And then somebody asked my opinion. I can't remember what the subject was. I was head over heels. Crazy. Totally crazy.

Despite the years separating them, Kristina and Agnes began a friend-

ship followed by romance. On weekends Kristina eagerly returned to Taos and Agnes took her camping. "Camping," Kristina muses, "gets you into a lot of trouble." After a spell Kristina moved to Taos, ostensibly to work in the Welfare Department, but also to be close to Agnes. She rented a small apartment near the compound where "Aggie" lived next to the artists Arthur and Ursula Jacobson, Ted Egri, and Emil Bisttram. The compound was very basic and, though it had some running water, the artists shared an outhouse. Agnes's home was a small goat shed with an end wall removed and replaced with a door and window that she rented for $15 a month. Kristina remembers the compound vividly: "When I first knew her she was nobody. Absolutely nobody. Lived in a one-bedroom studio with a dirt floor, a big cooking stove, a couple of army cots, a table and two rocking chairs."

Agnes was not alone in her poverty. Life for many people, including Kristina, was challenging in Taos, and this continued beyond the 1950s. However, Kristina later observed that this lack of finance and resource was not always negative. On "sacrifice" she said,

> I never thought of it as giving up anything. I thought it was tremendous gain. How lucky we are we can live in this way...we were so focussed we didn't know what was going on in the world...we didn't have radios... didn't read the newspaper...didn't know anything. We were living a pioneer life which is pretty rare to be able to do...the struggle was a very creative struggle, and a very, as you say, honest, down to earth [life].[3]

But Kristina didn't want to romanticize this poverty, noting that this was poverty by choice, poverty in order to achieve another goal, adding "there's a tremendous difference between chosen poverty and the other kind." Kristina acknowledged that "everybody was educated" and could choose to change career and location and say goodbye to the "very distinct path" that Taos offered.[4]

Despite this, in Kristina's recollections, Agnes does come across as poorer than her contemporaries. Agnes was innately ascetic; she didn't

own trinkets or accumulate clutter the way an ordinary person did, perhaps the mark of her peripatetic life to date. Her home in Taos practically erased any signs of ownership, except for the occasional painting hitched to the wall that had passed Agnes's judgment and high standards. A surviving photograph from this time shows Agnes sitting in a rocking chair, her abstract painting *Mid-Winter* (1954) on the wall next to her kiva fireplace.

Friends often worried about Agnes's poverty. When one friend gave Agnes two rabbits, she bred them and cooked the forebears, displaying the pragmatic resilience of her pioneer background. Agnes also spent evenings rummaging through discarded vegetables and fruit behind the local Safeway store, telling staff that the food was for her rabbits when really it was for her dinner; a simple, and according to Kristina, tasty casserole. Although Agnes was fiscally impoverished she took nourishment from the surrounding landscape, taking every opportunity to enjoy it. If she heard that someone new had arrived in town, she would drive over, introduce herself and whisk them up the mountain for a hike. As a teenager in Canada Agnes had worked in lumber camps and had a short-term job running pack trips in the Canadian Rockies, one time with William O. Douglass, the longest serving Supreme Court justice in the U.S. She recalls, "The big thing, when you've got William Douglass on, you have to take three extra burros to carry the alcohol."[5]

Agnes appeared otherworldly to many people. She had a disdain for expensive clothes, and deliberately dressed in a certain way as a kind of rejection of the norm. As far as clothing was concerned she always wanted to be very simple, so she dressed the part of a serious artist: workman's clothes, basic print dresses, white blouse, cardigan, moccasins. To earn money she took a part-time job working for the Taos Red Cross. The position came with a car, which attracted her to the job in the first place. Agnes always took pride in her cars throughout her life, and driving around the Enchanted Circle in New Mexico (a scenic route) would become a favorite pastime. Louise Sause recalls that part of Agnes's responsibilities involved driving to remote mesas delivering news from service men overseas. When

Agnes eventually left Taos for New York (again) in 1957, she persuaded local photographer Mildred "Millie" Tolbert to replace her at the Red Cross. "Start saying yes to things," Agnes lectured.[6]

Mildred thought Agnes was "way out in left field," but the two remained friends for many years; Mildred produced the only widespread photographs of Agnes as a young woman, and Agnes, in addition to teaching her friend's daughters how to swim, frequently went climbing with the Tolbert family.[7] The artist Mary Fuller McChesney also recalls one of Agnes's expeditions up Mount Wheeler at this time:

> I remember one time we were at the Ribaks' at this big party and everybody got absolutely loaded. And we were supposed to go on a hike with [Agnes] early the next morning, Mac [Mary's husband] and I. Really early the next morning, we were going to hike up to Mount Wheeler, which at that time, there was no ski resort, so it was really a wilderness area. I think it's the highest mountain in New Mexico. It's a beautiful thing. So, we were going to drive up and then hike up. And she knew the way and everything. And the deal was we were going to leave the next morning. Well, everybody got so loaded that we thought well...we slept there at the Ribaks'...We were awakened the next morning by Aggie pounding on the door. And she had slept right outside the door in the hollyhock bed, hadn't even made it back to her place, which was about a block away. And she was ready to go. And go we did. It was absolutely amazing. And I remember this horrible hangover going up this trail just like that. And I remember these waterfalls. And then when we got up to the top, it was the three of us. And she had brought this coffee and a coffee pot. But I don't know how she ever got in her gear, but it all unfolded. And she's got a fire going and she's making coffee. It was weird. She was amazing. I was impressed with her. I thought she was amazing.[8]

At 13,161 feet, Mount Wheeler was not a hike that many could do easily, in particular hungover new arrivals not yet acclimated to the altitude. Even Agnes, apparently indomitable, once fainted on the route; her friend,

the artist John DePuy, had to carry her downhill until she regained consciousness. "Agnes Martin," DePuy recalls, "was one of the most beautiful persons I ever met, not only as a woman, but because of her mind. She had a spiritual side that was just glowing. To me she looked like a strong Greek goddess."[9]

John was not the first, nor would he be the last, to describe Agnes as a Greek goddess. But if Agnes was a Greek goddess in looks, she was also a Greek goddess in temperament. Kristina recalls arguments like thunderclouds: sudden, dark, and frenetic—one argument ended when Agnes punched a hole in the wall.[10] Agnes was paranoid, demanding, obsessive and headstrong and "could be as mean as anything." Kristina did not know it at the time, and indeed, Agnes may not have known it, but these fulminations, erratic mood swings, and marathon lectures were all symptoms of schizophrenia, yet to be diagnosed. The stress of concealing her sexuality and living hand-to-mouth very possibly exacerbated her condition, and her behavior, as we see in the following incident, was often extreme.

John DePuy recalls, one evening Kristina and Agnes were getting a ride home from a party with John and Alfred Rogoway. Everybody was a little drunk and Alfred was fooling around, hitting on Agnes, unaware that she and Kristina were involved. Kristina notes, "I never knew what anybody knew. We were all so secretive." Ignorant, unsure, forgetful, drunk, or maybe disdainful of Agnes and Kristina's relationship, Alfred continued to flirt until, without warning, Agnes sunk her teeth deep into his thigh, drawing blood. John laughs at the memory. "You don't do that with Aggie. She grew up in a rough Canadian lumber town, and she could take care of herself. I'll never forget that. It was hilarious."[11] It may have been hilarious to John but Alfred's wife Marjorie probably wasn't too impressed when she found out the reason he was staying in the hospital emergency room that night.

Many of the male artists Agnes socialized with in Taos came from cities where their female counterparts pandered to and idolized them, ultimately forsaking their own careers. Agnes, by contrast, had no desire to put someone else's career before her own or to become a man's bit on

the side. Having said this, and despite her ongoing relationship with Kristina, Agnes often slept with men. For Kristina these "tumbles in the hay" were never serious, but instead, a way for Agnes to prove to herself that she could be "normal," a loaded word that suggests that Agnes considered herself, in some way abnormal. In line with these "tumbles," Mary Fuller McChesney believed that Agnes was, at one point, "madly in love" with the artist Edward Corbett:

> Well, I think she had a—I think she suffered a sexual ambiguity, whatever that means. She was madly in love with Corbett. That was so obvious. And she was a very attractive woman. And she seemed—although she was very rangy and big, she was really a beautiful person. And guys were attracted to her. She wasn't at all a kind of, you know, unattractive gay person. But I think she was already sort of ambivalent sexually.[12]

Edward was a handsome man with a lean face and a French fold upper lip. He lectured his students on Sartre and Kierkegaard, had an exceptional artistic talent, and hugely influenced his contemporaries and students. Ad Reinhardt fully acknowledged his debt to Edward in their playful correspondence. Edward's black compositions such as *Untitled #3* (1950) and *Number 9* (1951) inspired Ad to paint his more famous "ultimate" or "last" paintings, such as *Abstract Painting* (1963), paintings that took a strong hold on Agnes when she eventually moved to New York in 1957. However, it seems that it was Edward (who also sporadically taught at UNM) who may have influenced Agnes before she became close with Ad Reinhardt later on.

Edward's paintings of the 1940s, such as *Untitled* (1947) have been described as "starkly geometric in style," with a focus on grid work; a precursor to Agnes's own grids yet to come.[13] In his own words Edward sought to "discover expressive values in painting without the recourse to subject matter," something Agnes would also attempt to do.[14] At this moment in time, in the early 1950s Agnes moved away from narrative subject matter towards abstraction. Gone are the portraits and landscapes that she

painted at her Avalon home in Albuquerque only seven years earlier, and in their place are muted works, large in scale, and sparse.

Very little of Agnes's work from the early 1950s survives, though some pieces were photographed before they became lost or destroyed. *Autumn Watch* (1954), *Two People in Moonlight* (1954), *Untitled* (1953), *Men and Their Gods* (1954), *Mid-Winter* (1954), *Dream of Night Sailing* (1954), *The Bluebird* (1954), *Untitled* (1955). Each of these works has a modest color palette and an interest in open and closed spaces. Hewn props—squares, orbs, and asterisks—compete for attention: jigsaw pieces unable to find a home.

The Bluebird (1954) is a rare example of a work for which title and image are both illustrative. Sitting in the bottom right corner of the canvas is indeed the form of a bird, appearing all the more blue in contrast to the saturated grey of the backdrop. A year later with *Untitled* (1955), Agnes appears to be painting an entirely different climate. This "landscape," dazzling white, with almost primitive scratches and stains on the canvas, shows how her work had evolved in such a short space of time. In 1955 Agnes was forty-three, the same age and generation of the Abstract Expressionist artists she admired, but a decade behind in terms of artistic maturity. Agnes was still experimenting with materials, themes and styles, while Pollock, Newman, Rothko, Reinhardt, and de Kooning were each producing the signature work we associate them with today.

Taos gave Agnes freedom to explore and experiment without being under the watchful eye of New York contemporaries and tastemakers. In Taos she subsumed the developments of the artists she admired such as Adolph Gottlieb, Arshile Gorky, and Mark Rothko.[15] Reviewing Agnes's *Autumn Watch* (1954) and *Two People in Moonlight* (1954) alongside Gorky's *Nude* (1946) and Rothko's *Untitled* (1944), one starts to see the influence in tone and composition. Agnes's subject matter had finally moved away from the purely representational and figurative, and embraced abstract art. Agnes's painting *Father and Son* (since destroyed) was awarded first prize at the Taos Art Fair in 1951. Kristina recalls that the subject matter was that of a father worrying that his son was not masculine enough. The theme of this painting hints at the direction and scope of the artist's inter-

ests at the time.[16] It also shows the huge challenge Agnes faced in her work, i.e. how to represent complex interior states or situations via biomorphism and abstraction.[17]

In a biographical file that Agnes submitted to the Museum of New Mexico in 1955, she was offered the following categories in which to place her art:

Objective
Expressionistic
Impressionistic
Abstraction
Non-Objective fantasy

Agnes saw herself as doing something entirely unique, and wrote underneath the list, "Modern Realism," which in 1955 was neither a movement nor a style.[18] If nothing else, it reveals that she did not want to subscribe to one movement only and that she had yet to find (or create) a category she might identify with.

Though Taos was host to many independent, strong-willed and creative women, Agnes stuck out from the crowd. According to Kristina, Agnes could not hide her light (or desires) under a bushel, "She was intriguing. How can anybody put a finger on that? People were spellbound around her...she was a very sexual person and she would try and deny it."

Perhaps because of this attention, Agnes was careful to toe the line. Though Taos was a Wild West town where women could be unconventional—the slang "going to Santa Fe" alluded to gay women—it was still, for the most part, conservative.[19] When Agnes arrived for the Wurlitzer residency in 1954 McCarthyism had, over the past sixteen years, created a landscape of paranoia and suspicion in the U.S., targeting a cross-section of society including artists and homosexuals. According to Kristina, Agnes

was "in denial," "very secretive," and experienced "tremendous conflict" and "guilt" because of her sexuality. Kristina explains:

> Nobody understands. The prejudice in those days was unbelievable. You had to keep everything under a stone. Agnes was terrified. She thought it would ruin her career if it got out of the closet and that's why I felt so secret about it all those years. In those days it was a project to keep it absolutely as undercover as you could. She was so determined that the world not know. She was sure that she could never be famous if people knew she was gay. I put it to her to one time that Gertrude Stein was famous and she wasn't secretive.

Kristina soon learned that it wasn't possible to reason with Agnes on this topic. Whether Agnes acknowledged it or not, the underlying inference was that her relationship with Kristina—firstly, a woman and secondly, a woman nearly twenty years her junior—jeopardized her ambition to "make it" as an artist. It pained Kristina that their relationship was seen by Agnes as a barrier to success. If Kristina had known she was just one in a line of women that Agnes would leave, maybe she would not have taken Agnes's rejection so personally. At the same time, it must have been painful for Agnes to be entrapped in a cycle of love and loss that she knew she could not escape from.

During this time, Agnes started a tradition she would continue every year for the rest of her life: she would routinely destroy the artwork she was unhappy with, destroying many at this juncture "because they weren't abstract enough."[20] In Taos she created a bonfire of her work, though in later years a simple box cutter became a less dramatic and equally effective alternative. Most artists, where possible, tried to reuse their canvas, but destroying canvases was a luxury Agnes felt she needed to have despite being poor. Agnes's paintings were becoming more and more personal:

statements or reflections of who she was as an individual and of what was going on inside her head. They were extensions of her and it wouldn't do to have anything other than the most accurate representation of her talent and her artistic persona available in the market. Despite this annual cull, and the feeling that she was not achieving her best, she kept going: "I would have inspiration after inspiration. And I could see that I was getting ahead, but so slowly."[21]

When Agnes wanted to paint she would ask her mind for inspiration; it did not flow forth instantly, and sometimes she had to wait days, weeks, or even months. She talked endlessly about inspiration throughout her life. Inspiration was not something that artists did or had. It was more democratic. Like a soul or will, inspiration was a fundamental cog in our mind and body. It was an unconscious permanent gift from the mind, but it had nothing to do with intelligence. In fact, thinking was a definite interruption to inspiration. Agnes believed that every decision we make as humans is inspired whether we know it or not. In Agnes's case, inspiration told her what to paint, and often, what to do or where to go. Some people might call this instinct, gut feeling, or intuition, but for Agnes inspiration summed it up.

Sensibility. Response. Perfection. Beauty. Joy. Intellectualism. Innocence. Love. Happiness. Devotion. Agnes developed very specific definitions of, and beliefs in, each of these subjects. Mostly they were discussed in relation to art, but not always and again, by no means were they the rarified possessions of artists. Once Agnes refined an idea to the definition she was happy with, she committed the definition to memory, repeating it to whoever would listen, over glasses of Campari in the Taos Sagebrush Inn or rocking in her chair by a sweet-smelling piñon fire. As Agnes refined these definitions she became staunch in defending them. Indeed, once she had committed to an idea, she lost the capacity to view arguments from another person's perspective. This inability to be swayed infuriated Kristina, in particular during their personal arguments. In a sense Agnes gambled her life on these concepts. Agnes had sacrificed comfort, stability, family, friendships and love in order to be an artist. If she could not hold on

to and defend the fruits born of this toil then all her sacrifices were futile. Or perhaps Agnes's refusal to see an argument from another's point of view was another symptom of her schizophrenia?

Agnes's doggedness had consequences for her life professionally as well as personally. Even when she was starving, she refused to compromise her beliefs. Kristina recalls that on one occasion Agnes won a prize of $100 in an art competition. Agnes went to collect the prize money from the donor, but after a short conversation decided that the woman had not really seen, appreciated, or understood the work. Agnes thanked the lady for the gesture and, to the lady's shock, rejected the money.

Even if Agnes's purse was not getting any larger, her ambition was. In 1955 she commissioned Mildred Tolbert to take black and white publicity photographs of her work, which she paid for in installments (she had previously exchanged a painting in return for other publicity portraits taken in her studio). The artist Mary Fuller McChesney, who visited Taos, also recalls Agnes's ambition at this time:

> She was painting these kinds of funky surrealist paintings. And she said, 'I'm going to make it. I am going to make it. And I don't care who I have to fuck or how I have to do it. I'm going to make it...'And she was not kidding. And she was a real drinker, too. And she was so curious. I liked her a lot. She was very interesting, very strange...I think artists usually, the ones that I've known, just kind of flop around. And if it happens, it happens. And they try to do the best they can for themselves in their careers, quote unquote, but to have this kind of orientation toward the career that these two [Agnes Martin, Clyfford Still] had that early is really, I think, amazing. Because artists at that time—I think they do more now, but at that time, artists hardly ever even thought about art I think in terms of a, quote, career.[22]

The writer Dore Ashton and the artist and critic Elaine de Kooning might be likely to disagree with Mary Fuller McChesney's claim.[23] Both have suggested that ambition was a common trait in artists based in New

Mexico, and not something unique to Agnes. Visiting Albuquerque in the early 1950s, Dore recalls "being impressed by the ambitious plans of just about everybody [she] met, ranging from artists at work at the University to patrons."[24] Elaine, a guest lecturer at UNM in 1958, attributes the "ambitious plans" Dore writes of, to one person—Raymond Jonson:

> [Raymond] Jonson is probably the factor most responsible for encouraging the intense productivity and high level of professionalism (not characteristic of university towns) of the young Albuquerque artists by offering them one-man shows at his gallery. In his generosity and ability to stimulate other artists, Jonson is comparable to Hans Hofmann, and would undoubtedly be a nationally known painter if he had been working on the East or West Coast all these years.[25]

Jonson, who elected Agnes to the UNM faculty back in 1947 remained a strong supporter of her work, selecting it to be included in the 1956 *Taos Moderns* exhibition at the Jonson Gallery in Albuquerque. Jonson had previously organized exhibitions by artists such as Josef Albers and Arshile Gorky, and his stamp of approval was important to young artists and had weight in the art world. It was because of Jonson's exhibition that Agnes found herself labeled a Taos Modern, a name that loosely connected her with her contemporaries and a name that loosely connected each of the artists to the ancient landscape and culture that surrounded them.[26] The writer David Witt, in his book *Modernists in Taos*, observes some loose similarities between these artists: firstly, the artists banded together in their rejection of urban life, secondly, they evoked Taoism when they described the relationship between the land and their art and thirdly, they held that art was in service to life and not the marketplace. Agnes felt at home in the wilderness, described her work and inspiration in Zen koans and, as we have seen, fervently rejected rewards and commercial advancement.[27] In this way, and during these years, her behavior and her art fit the definition of a Taos Modern as David Witt describes it.

It was easy for Agnes and the Taos Moderns to hold that art was in ser-

vice to life and not the marketplace. The truth is the marketplace (especially in New Mexico) was so minimal that the artists didn't have to make a choice between the two. Throughout their respective histories Taos, Santa Fe, and Albuquerque all had various cooperative galleries where exhibitions were mounted and strong whiskey consumed, but these enterprises were mostly short-lived because of the lack of a suitably intrepid, mature, or moneyed audience. One venture that did play an important role for Agnes in 1956 was the Ruins Gallery in Ranchos de Taos, a couple of miles south of the Taos town center.

The Ruins Gallery was headed up by Lou Ribak and Bea Mandelman and included the work of Dorothy Brett and Clay Spohn. Aline Porter, in the same position as Agnes (that is, continually strung along by Betty Parsons), recalls her excitement when she was invited to join:

> The Ruins Gallery—the most interesting gallery in Taos—have asked me to be one of them. As far as I know I'm the only painter from Santa Fe. The artists run it and choose who belongs. I can hang my large new pictures there. They tell me I was voted in unanimously and one person said, 'we hear you're doing some very sensitive painting.'[28]

Even though the artists knew that it was unlikely that their work would sell, showing their work was an opportunity to feel they were moving forward in some small way. Agnes, meanwhile, still had the support of Mildred Kane. Though the women's romantic relationship was well and truly over, Mildred visited Taos often, returning to Oregon with a batch of Agnes's artwork each time: a much-needed and welcome charity for the artist.[29]

In later years, Kristina, although she was involved with Agnes at the time, has no memory of ever meeting Mildred, or hearing Agnes mention Mildred by name; another sign of how hard-working Agnes was at keeping the different threads in her life resolutely separate.

In the summers of 1956 and 1957, Betty Parsons and the artist Kenzo Okada visited Dorothy Brett in Santa Fe, and Eliot and Aline Porter close-by in Tesuque. Agnes was eager to show Betty her new work and mounted an exhibition in Ranchos de Taos village to woo her. After a four-year courting period, Agnes's efforts were rewarded: Betty finally accepted Agnes into her stable of artists and offered Agnes a show at her newly opened Section Eleven gallery in New York. There was, however, one condition. There could be no compromise: Agnes had to return and live in New York.

In later years Agnes would tell journalists that the reason artists "go to New York is to establish our markets," and "to meet [our] own kind."[30] Despite these claims, and her ambition to "make it," Agnes was torn between leaving Taos and staying.

Taos had a stabilizing affect on Agnes and the landscape was a balm. New York might bestow success on Agnes, but she and her friends wondered at what cost. John DePuy had strong doubts about Agnes going to New York. He worried that the city would be too much for her. He recalls Agnes "close to tears" when faced with the decision. Kristina was also concerned and on a personal level she felt unable to compete with Betty and the lure and excitement that New York offered. Once Agnes had decided that her future lay in New York she took Kristina aside and explained to her that she should get married and forget about their relationship. Agnes was doing to Kristina what she had done to Daphne; marrying her off. Kristina was hugely controlled and guided by Agnes, and acted on her every word. Kristina was twenty-eight at the time and Agnes was forty-five, which accounts for some of the hold Agnes had on her young girlfriend. Kristina had not yet learned to stand on her own two feet. She took Agnes's advice and married, with Agnes part of the wedding party.

Getting what you want is a peculiar event and even while you are feeling elated there is the suspicion that perhaps a cruel trick is being played on you or the moment is just a waking dream soon to end. The occasion when fantasy and desire are made reality requires a shift in mental processing. One moment you are Agnes, staring into a mirror. Another moment, after a conversation with Betty Parsons, you are Agnes staring into a mirror in the

process of being changed: already the Rio Grande Gorge—the dramatic canyon slicing through the Taos plains—has been replaced with the long, straight avenues of Manhattan.

Turning to Kristina on her wedding day, Agnes said, "If it doesn't work out, you can always come back to me." Kristina wished Agnes had never said those words.

PAINTER

Agnes Martin, 1978. Portrait by Dorothy Alexander. Courtesy of Dorothy Alexander.

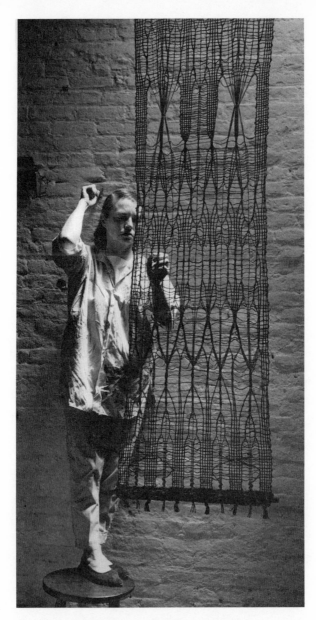

Lenore Tawney with "Vespers," South Street studio, New York, 1961.
Photo: Ferdinand Boesch.
Courtesy, Lenore G. Tawney Foundation.

Oct 25, 1963

Dear Lenore
 I am not going to be able to tell
you anything really. You have made
this day the turning point in my
life. It means an enormous opportunity
for me. Now I can take my time and
really get to work. The whole scene is
changed. There is no way to grasp the
size of it. There is no way for me to get
hold of it at all.
 I do not think you will be able to
imagine even a small part of the
enormous changes in my position.
 Any expression of gratitude is like
the soundless sound. It is going to be
like the waves over and over again.—
Forever is not to long.
 I think it is the "real thing"

 Agnes.

Letter from Agnes Martin to Lenore Tawney, October 25, 1963.
Courtesy, Lenore G. Tawney Foundation.

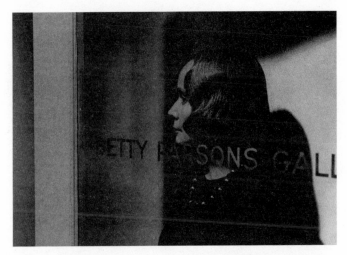

Betty Parsons at entrance to Betty Parsons Gallery, New York, 196-.
Photographer unknown. Courtesy of Smithsonian Archives of American Art.

Chryssa, c. 1968, photograph by John Foote,
Courtesy of Smithsonian Archives of American Art.

Untitled Agnes Martin in Coenties Slip, New York, c. 1967, photographer unknown.
Courtesy of the Harwood Museum of Art, Taos, New Mexico.

EIGHT

Betty Parsons

When Agnes moved to New York in 1957 the city was flush with artists. In the aftermath of WWII, the American economy had vaulted over that of its allies, and increasingly, its minorities, in particular women and African Americans (who had both played a role in their country's wartime success) were slowly beginning to ask for their rights, becoming more visible in the public eye. Everywhere there was a sense of possibility, and hope for the future. Enabled by the G.I. Bill, 50% of the U.S. population was college-educated, a success since unmatched. Despite this, a chill had settled between the U.S. and its allies, and a Cold War of smoke, mirrors, and iron curtains captured the imagination of the ordinary American family. On TV children watched "Bert the Turtle," a cartoon character, show them how to "duck and cover" in the event of a nuclear attack, and adults took time out from their bomb shelters to stare at the sky, eager, yet dreading, to see a Soviet satellite orbiting the Earth's atmosphere.

Back on *terra firma*, on the asphalt streets of Manhattan, artists were lining up outside galleries, holding their paintings aloft like personal shields, hoping to have their work exhibited. In the press, at drunken social clubs, in cafes and automats, with words and paintbrushes they waged a war against the status quo.

When Betty offered to show Agnes's work in her new gallery, she accompanied the offer with the purchase of numerous paintings, giving Agnes enough money to settle herself in the city. Initially Agnes lived with Betty, as her "cook," though it was apparent to all who knew Betty that Agnes was more than that. The women were an odd couple. Betty was from old money, born into a rich and aristocratic family. When her family (and the family of her first husband from whom she was separated) lost their wealth in the economic crash, Betty spent the 1930s living off the charity of her rich friends. When Agnes was studying with the Kane sisters in Oregon and living austerely, Betty was attending Hollywood parties with Greta Garbo, Tallulah Bankhead, and Dorothy Parker, enjoying forty-eight hours of heavy drinking and nursing a forty-eight hour hangover. When Agnes was starving, Betty's loyal dog Timmy was eating a birthday cake of hamburger and whipped cream.

Betty was small with pursed lips, a square chin, and a high forehead with a fountain of gently waving hair parted in the middle. She took joy in being mistaken for Greta Garbo, but the two women could not have sounded more different; Garbo's heavy vowels were stones compared to Betty's short, clipped, English-sounding pebbles. She was thirty-six when, semiretired from Hollywood parties, she got her first proper job, working on commission as a gallery assistant at Alan Bruskin's Midtown Gallery (following an exhibition of her artwork there). On the tenth anniversary of this momentous step into adulthood, Betty founded her own gallery, the Betty Parsons Gallery in 1946.

The number of art dealers in New York was relatively small in the 1940s, which is an important fact when one considers the success that women had in the profession, in particular as arbiters of the avant-garde. Edith Gregor Halpert ran the Downtown Gallery (1926–1973) showing the work of

Jacob Lawrence, and erstwhile Stieglitz artists Charles Demuth, Marsden Hartley, John Marin, and Georgia O'Keeffe. Edith also championed African American art, showcasing *American Negro Art, 19th and 20th Centuries* in 1941, the first show of its kind held at a commercial gallery.

A little farther uptown on West 57th Street, Peggy Guggenheim's personal art collection, Art of This Century (1942–1947) was inspiring, confusing, enraging and titillating its patrons with the work of Salvador Dalí, Leonora Carrington, Yves Tanguy, Pablo Picasso, and Wassily Kandinsky. Peggy's quirky gallery with concave walls, unorthodox hanging apparatus and—for the kinetic artwork—encouraged viewer interaction, must have made much of the art appear more bizarre than it was.

Peggy was no less eager to show contemporary American art, including work by Mark Rothko, Joseph Cornell, Willem de Kooning, Robert De Niro Sr., Hans Hofmann, and Clyfford Still. The gallery also showed what became known as the Uptown Group: Adolph Gottlieb, David Hare, Robert Motherwell, Ad Reinhardt, Richard Pousette-Dart, Theodoros Stamos, and Jackson Pollock. After WWII, when she decided to return to Europe, Peggy thought that Betty was the only dealer who might be able to handle Pollock, her Wyoming wild child. And so it came about that Pollock and his colleagues landed in Betty's lap.

Betty was overjoyed at inheriting Peggy's menagerie of artists, because, as she put it, the artists themselves had chosen her. Unlike Peggy, Betty had no wealth and certainly little business acumen. What Betty did have was connection to the rich, as well as bohemian credentials that compensated for a lack of a formal education in art. By the end of her life in 1982, Betty Parsons and the Betty Parsons Gallery had achieved a legendary status in the history of postwar American art. Her strength drew from her passion for new talent and not any skills at balancing the books. When she should be in the gallery pushing sales, Betty was busy painting in her own studio. Unsurprisingly, this irked her artists and became one reason why some left her roster. But what Betty lacked in business acumen she more than made up for in passion, and though some artists such as Walter Murch and Kenzo Okada stayed with her long term, Betty believed her function was

to discover and nurture new talent. Above all else, Betty prized "the new," taking risks on promoting artists and art based on her personal idiosyncratic taste and fancy.

When Betty first started out as a dealer the New York gallery world catered to very distinct markets. Regionalism sold in one gallery, Impressionism in another, the Ashcan School in another. In 1947 when Betty inherited Peggy's troupe, Abstract Expressionism antagonized the public and the establishment, both indifferent to most modern art and not only abstraction. For instance, the Metropolitan Museum of Art, though it was founded in 1872, did not acquire any modern artwork created after 1900 until 1930, when it began to acquire work by Cézanne and Van Gogh who had died forty years previously: the establishment was slow to admit contemporary work into the canon. Likewise, the Museum of Modern Art and the Whitney Museum of American Art, founded in 1929 and 1931 respectively, initially focused their efforts on modernist art and not contemporary art, though this had changed by the end of the 1950s.

The public was also vocal in its disdain for contemporary American abstraction. Visitors to Betty's gallery punched holes in paintings, penciled "shit" on artwork, and started arguments with gallery staff and artists—the audience in NYC was much more vocal than the audience Agnes was used to back in Taos. As a result, Betty developed a low opinion of the art public and became protective of her artists and installations. She railed against the establishment; all too familiar with the power it wielded over her various freedoms. Speaking of her sexuality, she said, "You see, they hate you if you are different; everyone hates you and they will destroy you. I had seen enough of that. I didn't want to be destroyed."[1] Betty applied this resistance to the art market, though not all pundits were against abstraction. Elsa Maxwell, the colorful writer, captures the attitude of the time in her charming review of the inaugural Betty Parsons Gallery Christmas Show:

> Now I am not an authority on painting and don't profess to be, particularly on American painting. But anyone who wants to spend $100 or $150 for a picture by one of the younger American Abstractionists

may eventually own a masterpiece. Who can tell? Don't turn down our own artists, no matter how silly or funny you think them. Their dreams are real and their aspirations pure. Miss Parsons's 'Christmas Show' should attract a much larger audience (in number) than your old roving reporter, who just happened to pass 15 East 57th and noted that there is a little show really worth looking at, particularly because it is American. Some dissenters scream 'Hang the abstractionists.' I echo 'Certainly, but why not on your walls?'[2]

Betty was a new breed of dealer who was not interested in pandering to the masses. The Peggy Guggenheim Art of This Century gallery was a personal playground for her, and her uncle Solomon's Museum of Non-Objective Painting (later, the Solomon R. Guggenheim Museum) was a retreat: plush carpets, draped walls, calla lilies, soft lighting, and the music of Bach and Chopin. The Betty Parsons Gallery, in contrast, was stripped bare, with white walls, wooden floors, no seats, no music, and no attempt to interpret the artwork for the spectator. The lack of decoration was intentional: the Betty Parsons Gallery was a serious place with serious art that challenged and confronted its spectators, whether they were serious or not. Throughout its existence, Betty's gallery showed a variety of work by artists in different mediums and belonging to different schools. Though the artworks differed, each choice was the result of Betty's adopted philosophy on art:

What I look for, and it's subtle, believe me, I vibrate to it when I find it: this is Willa Cather, who I think is one of our great writers, 'What is any art but an effort to make a sheath, a mold, in which we imprison for a moment a shining elusive element which is life itself.'[3]

The rhetoric of the "shining elusive element which is life itself" might sound equally elusive today, but at the time would have been understood immediately. Many of the artists Betty represented were trying to capture or rediscover essential human feelings and symbols that belonged to a world before fascism, capitalism, industrialism and mass-consumerism:

the ailments of modern life. The only means through which they could hope to express a primitive essence, as we have seen, was through nonfigurative and nonrealistic work, i.e. abstraction. Agnes's art followed this pattern moving through different styles: figurative, semi-figurative, biomorphic, and finally, abstract (and within that, geometric).

It was impossible not to be influenced by Abstract Expressionism either as a proponent or reactionary. In 1957, Aline Porter, Agnes's New Mexico neighbor and fellow Ruins Gallery associate, was warming to abstraction. As Aline indicates here, to paint abstractly was a leap of faith into the unknown; an attempt to unlearn the rules of painting in order to connect with a personal style:

> Another thing I have arrived at here is that I can finally really approach painting abstractly. Always up to now I have had to start with some visual image. It has been very difficult—often it seemed hopeless— and as Betty [Parsons] says it takes a great deal of courage to free yourself. I don't want to be an abstract painter because it is "the thing" —but it does seem more interesting—and is really more fun because you have an endless fund inside yourself to draw on instead of depending on a still life or landscape you have to find first.[4]

By 1957, when Agnes had returned to NY, Abstract Expressionism had gone from a non-movement to the most celebrated movement and style in U.S. history. Aline Porter was not the only convert to abstraction. Young men and women from all over America, hearing of a "real movement" arrived in New York to set up studios in cold-water flats. These students attended classes at the Art Students League, and hoped to catch a glimpse of their artistic heroes at the Cedar Tavern or Romany Marie's Café and, maybe if they were lucky, get invited to the (Eighth Street) Club, a private salon for Abstract Expressionist devotees.

A sea-change in opinion had occurred by the end of the 1950s when American politicians, including George A. Dondero fading in the shadows, began to hold the movement up as a beacon of liberalism and freedom of

expression in opposition to the proscribed and censored art produced in the Soviet Union.

The gallery world too, was changing. According to Dore Ashton, in 1951 there had been only about thirty respectable galleries in New York, including the Betty Parsons Gallery. Within ten years there were more than three hundred managing to stage over "4,000 exhibitions a year."[5] In true American fashion, art production, display, and purchase became a competitive business.

Media too had its role to play in making New York the center of the art world. *Art News* in the 1950s and *Artforum* in the 1960s became important outlets for artists to create debate and defend their work, while *Time* and *Life* began to profile artists, even making Georgia O'Keeffe and Jackson Pollock their cover stars. For those who would not get to see new work they would at least get to see reproductions and reviews in magazines. The result of this is the emergence of a new art-literate audience, and with it a breed of critics, writers, and academics to push art appreciation—and business—even further. The artists were always driving the discussion: publishing statements and taking part in debates. Indeed, many artists and critics acknowledge that talking about art had become the primary creation of the artist at the time. All these changes in U.S. culture—the increased media attention towards artists, an increase in confidence in the artists themselves, the solidification of an American art identity in the form of Abstract Expressionism, and an improved art market—all coalesced at the perfect moment to benefit Agnes as she prepared for her NYC debut as a bona fide artist.

By the time Agnes had arrived in New York in 1957, many of the artists she had looked up to and viewed at the Betty Parsons Gallery had moved on to other dealers. Betty, despite her fervent support for her artists, lacked much needed business skills. Saturday, for instance, was the most important day of the week for an art gallery, as it was the day that the heads of the Museum of Modern Art, the Whitney, and the Metropolitan were most likely to drop by. Betty didn't care. The weekend was her time off, and every Friday Betty would disappear to Long Island to paint; a poor busi-

ness move that affected her ledger book. When her artists complained that their sales were low, Betty would persuade her rich friends to buy the work or give her the money to buy it herself, thereby placating the artists—a divisive and untenable strategy in the long-term.

In the early years, Betty had pet names for her artists. Barnett Newman was the Great Statesman, Mark Rothko was the Painter of the Sublime, Clyfford Still was the Stallion (and the Eagle), and Jackson Pollock was Nature. This changed in 1951 when Betty branded them the Four Horsemen of the Apocalypse following their intervention into her way of running her gallery. Betty recalls:

> They sat on the sofa in front of me, like the Four Horsemen of the Apocalypse, and suggested that I drop everyone else in the gallery, and they would make me the most famous dealer in the world....But I didn't want to do a thing like that. I told them that, with my nature, I liked a bigger garden.[6]

For Betty, the biggest tragedy was not in eventually losing Rothko, Still, Pollock, and Newman; it was that a rift formed between the artists themselves, and, as she ruefully remarked, "I always said it turned from love to hate."[7] With success the artists became difficult to manage. Still and Rothko frequently refused to take part in exhibitions, and Rothko, when he acquiesced, demanded to arrange his own lighting and artwork, often judgmental of the curators and other artists on display: "It just drags you down; you don't drag them up."[8]

These artists, who once were starving, now decided to whom they would sell their work—a behavior Agnes would adopt later in life. For years the Abstract Expressionists had been ignored by society. When they finally became the establishment they were confused and conflicted; their claws were clipped.

Norman Mailer, in the *Partisan Review* in 1953, argues "the artist feels more alienated when he loses his sharp sense of what he is alienated from." By the end of the 1950s this was the case for the first Abstract Expression-

ist generation. The spiritual crises experienced by the artists had been replaced with a healthy economy and mass culture that existed to distract and indulge. As the Abstract Expressionists became further isolated by feuds and success, a new generation of artists emerged eager to embrace the symbols and energy of America the superpower. Such artists, including Jasper Johns and Robert Rauschenberg, would be more savvy about the media, the role of the artist in society, and what today we would call their "brand."

For Marie Harley, an assistant at the Betty Parsons Gallery, the 50s were intense, "Everything was intense. Betty was intense. All the artists were intense. Critics were intense. Her gallery just attracted intense people and intense ideas and intense paintings."[9]

Betty was not as sensitive as Marie. For Betty the 50s were a "fantastic period...of great drama."[10] Betty remained on good terms with Rothko, Pollock, Still, Reinhardt, and Newman, who returned to show with her and help her set up her new space, the Section Eleven gallery, where Agnes would show in 1958.

Betty had bought five of Agnes's paintings, which provided Agnes with the finances to make the journey to, and start a new life in, New York. Agnes was so poor that she made the journey by bus; a distance, from Taos, of almost two thousand miles. A friend's mother cooked her an entire ham to take on the bus so she would have something to eat on the long journey.

When Agnes arrived in New York, Betty threw huge parties to help launch her into the art world stratosphere. Betty recruited Barnett Newman and his wife Annalee to be guardians for Agnes, a surrogate family replacing Bea Mandelman and Louis Ribak back in Taos. Betty took Agnes to the Cedar Tavern, painting in Long Island, to queer afternoon tea dances in Times Square, and to late-night dinners in the apartments of artists and occasionally well-to-do society dames. Betty made it clear to everybody that Agnes was important to her.

After a few months of living with Betty it was time for Agnes to get a studio and a home of her own. Betty contacted the artist Ellsworth Kelly, whom she was representing at the time. Ellsworth lived down on Coenties

Slip in Lower Manhattan in a neighborhood full of empty lofts and stores. Betty knew that these lofts would suit Agnes, the rent would be cheap and the space large, large enough for Betty to join Agnes to paint when the mood struck. Betty was already a mobile studio—her purse was full of small watercolor pads, paints, and vials of water: items she shook out in parks, in taxis, and in restaurants when she decided it was time to be creative.

Down on Coenties Slip, the lofts were cold, with no heating or running water, and patches of sky exposed where the ceiling beams met the walls. For someone who had just moved from a small, converted goat shed, a large, abandoned shipping chandlery was a step up.

Agnes had always lived a spare and simple life on the surface, and that's exactly what Coenties Slip offered—on the surface.

NINE

Coenties Slip, New York

Coenties Slip was an East River inlet—home to tugboats and trade ships—until it was filled with land in 1835. Today, it bisects a rectangle of roads that include Hanover Square to the north, Broad Street to the south, Water Street to the east, and Pearl Street to the west. In 1957, when Agnes arrived, the Slip looked like the stem to Jeannette Park, which opened like a bloom onto the waterfront. In the 1950s many of the buildings in the area, some dating to 1825, were derelict and empty. This abandonment, accelerated by the removal of the Third Avenue elevated railway made the area difficult to access, causing rental prices to drop. Over the years the buildings had been tattoo parlors, boarding houses, brothels, and ship chandleries. Nails, stencils, rope, spikes, lanterns, and paperwork had been left behind as though their previous owners had departed in a hurry.

The area was old, Dutch immigrant, New Amsterdam old. Nearby Wall Street was at one time the location of the New York Slave Market, and the Fraunces Tavern, built in 1719 on Pearl Street, hosted George Washing-

ton and his Confederation offices of foreign affairs, finance and war in the 1780s. In the mid 1820s the slip was a dock for Canadian barges that had traveled from Lake Erie through the Erie Canal from upstate New York. If Agnes had met these bargemen at the time one imagines they would have traded advice. Agnes was a keen sailor, after all.[1] However, by the time Agnes had moved to the slip, only the ghosts of these barges and their bargemen remained.

Coenties Slip had watched time pass for more than a hundred years. Some buildings had survived the fire of 1835 that burned much of the South Street Seaport to the ground. These squat red warehouses saw tall skyscrapers propelled upwards into a canopy of sky, offering views of the city previously only imaginable. Across the water they saw the Brooklyn Bridge heave into place. New York was expanding quickly around these old, cold artifacts, many of which would be destroyed by the end of the 1960s.

Living in a commercial property was an entirely novel concept in 1957. When the artists moved in they usually had to empty the loft of refuse from generations of occupants. Many of the buildings were derelict. Undesirable characters—including local sailors—frequently became squatters, with trouble trailing close behind. What the lofts lacked in domestic comfort they made up for in other ways. They were big enough to offer living and studio space, they had large windows offering the artists good light, and most importantly they were cheap.

Agnes was not the first artist attracted to the Coenties Slip area. Beginning in 1954 with Fred Mitchell, artists flowed in and out of the area until many of the buildings were bulldozed at the end of the 1960s. At 27 Coenties Slip Agnes lived with Jack Youngerman and Ann Wilson and at 3-5 Coenties Slip with James Rosenquist, Ellsworth Kelly, and his partner Robert Indiana. The artists Barnett Newman, Charles Hinman, Jasper Johns, Robert Rauschenberg, Cy Twombly, Rolf Nelson, Chryssa, Ray Johnson, the poet Oscar Williams, the composers John Cage and Morton Feldman, and the dancer Merce Cunningham—all lived or worked close by. The artist Lenore Tawney, who would be instrumental in Agnes's life, lived briefly on the Slip with Ann Wilson and Agnes before moving to

South Street, where she was joined by Agnes in 1961. Agnes, reflecting on her immediate community, recalls, "We all lived the same kind of life and we all had the same kind of velocity you might say. We all agreed and so it was very very pleasant to be with people when you don't feel the competition or resistance."[2]

In her new home Agnes found a work ethic that she had never experienced before. Though she was middle-aged, she was exploring her craft with the abandon of a radical upstart:

> I thought I was on my way in Taos, but I never felt that I was doing exactly what I wanted to, not until I was in New York. It's pretty hard out West, the pace in New York is so much faster, I mean the pace of living. Out West you have to pull yourself up by your own bootstraps. Everybody else is leaning on walls. When I got to New York, I really flew at it; I worked hard in Taos, but in New York I just painted and threw them away and painted and threw them away, but I finally got at the place where I felt I was doing what I should.[3]

Agnes's apartment was a long, rectangular loft that faced the East River and the Brooklyn Bridge. The walls were brick with cracked white plaster, and the floors were wooden and unsanded, but smoothly worn by long-gone feet. Agnes had a claw-foot bathtub in her bedroom that she found on the street and the remainder of her furniture consisted of two rocking chairs set up by the window, an old acorn cast-iron kitchen stove, a table, stools, bed, benches, and cupboard that Agnes repurposed from the walnut furniture left behind in the flat. Her loft was on the fifth floor and had no lock on the door. Visitors keen to conserve their energy on the stairwell yelled up from the street to check if she was in. Agnes usually was.

During the day the area was bustling with sailors from the gothic Seaman's Church Institute on South Street. The institute was run by the Episcopal Church and was a hostel and social hub for sailors, though the artists would go and avail themselves of the hot water in the showers. The artists called it the doghouse because of its foreboding look. On top of the insti-

tute was a Titanic memorial lighthouse that illuminated the night. Agnes used to stand at her window watching the faces of the sailors, wondering where they had come from. By five thirty in the evening the area was quiet, except for the noisy seagulls.

The residents of Coenties Slip threw famous loft parties on the weekends, though Agnes claimed they were "dull" compared to the parties in Taos.[4] The loft rats, as the tenants were known, made sure that friends brought their own bottle of booze and requested that everyone arrived with discarded street debris: fuel to burn in the stoves. It was at one of these parties that Agnes met Jill Johnston. Jill was a writer for the newly formed *Village Voice*, an outgoing women's activist and one of the first publicly gay journalists in the U.S. Jill was a thorn in the side of respectable feminists and an out-and-out show-off, using her legs to dangle from ceiling beams at parties. Many considered Jill a formidable character as well as a formidable pain in the ass. She felt intimidated by very few people, but Agnes was one of them. Jill encountered Agnes reading Gertrude Stein to a small group of people in a loft antechamber, and the two became friends. On one occasion Jill brought several people to Agnes's apartment. Once there, the group sat in a circle as Agnes spoke to them, putting them into a meditative state and posing Zen-inspired riddles. Jill recalls (without punctuation):

> She went right on talking and asking us all what sort of a wall or body of water we imagined in our minds eyes and when we saw the wall or the body of water would we cross it or could we and if so how would we do it she went right on with this exercise testing us i imagined for correct answers...

Jill, it seems, found the correct answer to this riddle, which was that walls of water are transparent and so can be walked through: what is on the other side is the same as what is on this one. Water, a recurring motif in Agnes's life, became the perfect symbol for passing from life to death.

The Slip was full of colorful characters, and Agnes was no exception.

Agnes, older than her neighbors and more spiritually inclined, played the role of a matriarch. Ellsworth Kelly recalls, "You'd go to talk to her and she'd soothe things. Sometimes she would correct us because of our follies, like a parent would, in a way."[5] Ellsworth lived in the loft above Agnes at 3-5 Coenties Slip, and the two frequently shared breakfast in his apartment at the time. Ellsworth brewed coffee and Agnes baked her famous blueberry muffins.

Though Agnes identified with the Abstract Expressionists, the younger men and women around her were moving away from the movement (Kelly, for instance, produced Hard-edge abstract paintings). The Abstract Expressionists had escaped Europe and wanted to avoid European influence and American cultural influences; the artists down on the Slip did the complete opposite. Jasper Johns, Ellsworth Kelly, Robert Rauschenberg, Robert Indiana, and Jack Youngerman had all served in the military, and not only did they accept the American iconography that distressed their predecessors, but each artist, except for Johns, took art classes in Europe early in their careers before returning to the U.S.

These young artists felt free to draw inspiration from whatever culture interested them. Though their art would progress in different ways, what united them was a sense of experimentation and a serious work ethic. The same was also true of Lenore Tawney and Ann Wilson, who both worked in what was then known as the craft tradition. Tawney, a weaver and fiber artist, became a huge influence on subsequent generations of artists for extending the possibilities of weaving and textiles in sculpture. Ann Wilson, who was influenced both by Lenore and Agnes, lived in the apartment below. She was a quilter who also painted on found fabrics, something for which Robert Rauschenberg garnered more fame for *Bed* in 1959.

The Coenties Slip community was aware of itself as an artistic enclave. It consciously separated itself from the uptown world of the Abstract Expressionists and the Union Square populism of Andy Warhol's factory, and marketed itself accordingly.[6] In the 1959 Seaman's Church Institute Christmas newsletter *The Lookout*, the writer Faye Hammel, in her article *Bohemia on South Street,* praised the Coenties Slip artists for their seriousness:

"Refreshingly unlike the residents of most Bohemias, they spend little time talking about their work, most of their time actually engaged in it."[7]

Faye's interview puts "Indiana farmboy" Bob Clarke and Jack Youngerman in the spotlight. Bob, who was Ellsworth Kelly's partner at the time, would become known as the artist Robert Indiana, whose famous four-letter emblem of LOVE was conceived in 1964 and turned into a statue in 1970. Jack, who was also acting as the landlord, was married at that time to the French actress Delphine Seyrig, star of *Last Year at Marienbad* (1961).

Bob and Jack held art classes at number 27 Coenties Slip in what they called the Coenties Slip Workshop. For three dollars they offered the students the opportunity to "explore the adventure of today's vision...in either a realistic or abstract approach." While Bob, Ellsworth, and Jack were not exactly Abstract Expressionists, they explored abstract art, often informed by the locale and waterfront: "Although none of the serious artists do marine scenes—they consider themselves abstract painters—they feel that living near the waterfront has a definite influence on their work."[8]

Living near the waterfront most definitely had an influence on the work of these artists. Ellsworth Kelly's *Atlantic* (1956), Ann Wilson's *3–5 Coenties Slip* (1958), Lenore Tawney's *Dark River Wall Hanging* (1961), Jack Youngerman's *Coenties Slip* (1959) and Agnes's *Harbour I* (1959) and *Night Sea* (1963) all commune with the neighborhood of their origin. Much of the work of Robert Indiana, including *Ginkgo* (1957) and *The Slips* (1959–1960), was greatly influenced by the history of the area. The "Slip" also affected the artists in unexpected ways, for instance, Robert created *Law* (1960–1962), inspired by being arrested for washing windows on a Sunday. On another occasion, Agnes and Ellsworth were having breakfast. As they were talking, Ellsworth was playing with the metal lid to a coffee container. He had folded the lid and was rocking it back and forth on the tabletop, tapping it with his finger. Agnes, nodding to the rocking lid, said "You should do that." This humble coffee lid became the start to Kelly's successful series of sculptures known as the *Rocker* series, which includes *Pony* (1959).

Coenties Slip also had a material impact on the artists and their work.

Agnes, Jasper Johns, James Rosenquist, and Robert Rauschenberg all scavenged the shoreline and streets for materials that could be turned into art. Brass stencils, nails, advertisements, beams, and street rubbish: every item was worthy of consideration. Agnes used boat spikes and wood in her sculpture *The Laws* (1958), while Rauschenberg used street rubbish and quilts in his combine painting/sculptures such as *Monogram* (1955–59) and *Bed* (1959).

Though the artists displayed the seriousness and work ethic of established artists, they were, for the most part, relatively unknown and impoverished. Abstract Expressionism remained the dominant trend and the work of Jasper, Ellsworth, and Lenore was divergent to the norm. Hidden away downtown, these artists enjoyed a kind of freedom that was no longer available to their Abstract forebears. This freedom was not only artistic. The Coenties Slip artists also created without premeditation an environment that was, if not sexually free, at least a sexually alternative community, with women and gay people at its heart.[9]

Abstract Expressionism was a movement broadly dominated by men. Chain-smoking, whiskey-drinking, womanizing, chauvinistic, tormented, brawling, philosophizing, gifted men—so the cliché goes. Women had a role to play as wives, girlfriends, patrons, dealers, and fans, but very rarely were women accepted as serious artists. There were thousands of women artists working with abstraction, but only a handful achieved any notable recognition.

For instance, in 1950, twenty-eight artists signed a protest letter addressed to the director of the Metropolitan Museum of Art. The artists were protesting what they considered to be a conservative jury chosen by the Met to judge an upcoming competition. Only four of these progressive twenty-eight artists were women: Louise Bourgeois, Mary Callery, Day Schnabel and Hedda Sterne. Schnabel and Sterne, as it happens, were Betty Parsons' artists, as were ten of the male signatories.

In reply to this petition, seventy-five artists wrote a letter in *support* of the Metropolitan jury, relayed here by *The New York Times:* "The artists who rejected your exhibition presumed to speak for all advanced artists...

we the undersigned, disagree." The thirty-five of the seventy-five artists listed in *The New York Times* were all male.

This battle between artists (as well as the invisible sexism that wasn't considered a topic) continued in 1951 when *Life* magazine commissioned a photo of the original protestors with the caption, "Irascible Group of Advanced Artists Led Fight Against Show." Hedda Sterne was the only woman among the now infamous *Irascibles*. Standing on a table, taller than the men, Sterne's tiny, shiny purse draws the eyes away from the somber ties and grimaces of her fellow artists. Sterne recalls, "They all were very furious that I was in it because they all were sufficiently macho to think that the presence of a woman took away from the seriousness of it all."[10]

The men, it seems, were irascible about women too. Or some women. Stern's fellow artists had a problem with Sterne but no problem with Nina Leen, the photographer, or Dorothy Seiberling, the *Life* commissioning editor of the piece. The *Irascibles* may have been petitioning against the conservatism of the Met, but who was petitioning against the conservatism of patriarchy?

In the same year, when Rothko, Newman, Still, and Pollock suggested to Betty Parsons that she drop other artists and focus her attention solely on them, they were talking primarily about dropping the women artists Betty was showing. The work of these rich female artists, who were often close friends of Betty's, was considered objectionable by the self-appointed watchmen of the movement. Betty said no, and increased the number of women artists she represented.

It comes as no surprise that Betty went on to socialize with, paint among, and represent the Coenties Slip artists that sought to supplant Pollock et al. starting with Robert Rauschenberg in 1951, Ellsworth Kelly in 1956, Jack Youngerman and Agnes in 1958, and Chryssa in 1961.

In 1957 the women's liberation movement, spurred on by the publication of Betty Friedan's opus, *The Feminine Mystique*, was six years away, and the gay rights movement, instigated by the Stonewall riots, was a decade away. The Coenties Slip artists, Betty, and the gay artists at Betty's gallery may have had no movement to join, but they managed to find ways to

take small steps away from established art forms and entrenched societal norms.[11] One way of doing this was to move downtown and create a community there, the other was through their artwork, as the following anecdote shows.

In 1953 Robert Rauschenberg bought and lovingly erased, stroke by stroke, a drawing by Willem de Kooning. It is difficult not to see in this action a small victory won for Rauschenberg as a queer artist. De Kooning was, at the time, the most emulated, lauded and respected abstract artist in New York. Men flocked to the city inspired to follow in his footsteps and siphon off his success. By erasing de Kooning's drawing Rauschenberg was asserting himself as an artistic replacement. The erasure was also a small defense of women. De Kooning's women paintings were more spoken about in the art world than real women artists (and of course their work). Many critics and many artists, including Agnes, thought the work misogynistic. De Kooning acknowledged some of the figures were scary but he denied he was a misogynist. Rauschenberg had specifically asked de Kooning for one of his women drawings and explained to de Kooning what he would do with it. Rauschenberg, in erasing the drawing, wrested from the establishment at least one dominant and negative image of the female at the time. De Kooning, to his credit, complied.

The artist Lee Hall, who first showed with the Betty Parsons Gallery in 1974, gives her view on the gender dynamics within the art world in the 1960s:

Abstract Expressionism was spoken of often in terms of military images, sports images, which is the way that everything is spoken of in American culture now. It was a very masculine language. Talking about muscularity, aggression, fighting and struggle. The joke was that every woman should find a good man and get to work under him and work her way up. And women who went into the Cedar Bar for instance were assumed to be there to pick up artists and all that. The women artists who were coming to prominence were gaining recognition not so much as artists but more so as fellow travelers of the guys—as their wives—like Elaine de

Kooning and Lee Krasner. Joan Mitchell and Helen Frankenthaler were somewhat different but they were still very much attached to the masculine world.[12]

For Hall, there weren't any female artists to look up to "in either history or in the contemporary scene. You were just on your own." This bleak outlook is shared by Betty Parsons and the artist Marcia Olivier. Marcia, who would one day be a close-friend of Agnes, recalls visiting New York to try and find a woman artist she could look up to and study with. One evening, in the Cedar Tavern, Marcia was on a date and noticed a lot of people stalling at a nearby table to say hello to two women. Marcia turned to her date and asked him who the women were. "Oh, that's Betty Parsons and Agnes Martin." Agnes had just opened her first show and the reviews were positive. Marcia thought, "Maybe I can study with her." She asked her date what kind of art Agnes did. "She does lines," he said. Marcia was disappointed. "What can I learn from someone who does lines?" Despite her search Marcia could not find an elder female artist to take her under her wing.[13]

One inherent obstacle to equality, according to Betty, was that "in those days women didn't really respect each other."[14] This is an interesting observation from a woman in Betty's position. Though there are many examples that prove her theory wrong, particularly down on Coenties Slip where Agnes's work was mutually supported and encouraged by Lenore Tawney, Ann Wilson, and by Betty herself. Yet, perhaps, once again, Coenties Slip was an anomaly.

It is mutually agreed by the artist, Agnes Martin, and the dealer, Section Eleven, Betty Parsons Gallery, that the artist is a member of the Gallery from September 29th, 1958 to September 30th, 1960. The dealer will, during this period be responsible for promotion of the artist and the art-

ist will be responsible for any additional expenses such as advertising, catalogs, photographs, etc. The dealer will have full control of all works of the artist for possible sales and promotion until the expiration of this contract.

It is further agreed that the dealer is entitled to thirty three and one-third percent of the selling price on all sales of pictures and commercial assignments. On any sales of pictures made by the artist herself in her studio to clients outside the gallery's clientele, the dealer is entitled to a commission of fifteen percent. Signed by Agnes Martin, October 2nd 1958.[15]

Thus began Agnes's commercial relationship with Betty Parsons. Her Section Eleven gallery had opened just three days previously with an exhibition of four artists. Dore Ashton published a review of the exhibition in *The New York Times* the following day, outlining the scope of the venture, and signaling Agnes out as the more "assured" painter,

Betty Parsons, one of the most adventurous dealers in New York, is off on a new adventure with Section Eleven, at 11 East Fifty-seventh Street, an extension gallery that Miss Parsons hopes will serve to introduce the work of talented but as yet little-known artists.

Her opening show presents four painters—Sidney Wolfson, David Budd, Judith Godwin and Agnes Martin. They are radically different in style. Sidney Wolfson is a sternly geometric painter, cleanly dividing his compositions in stark, often compelling color contrasts, David Budd is a vague, and probably uncertain younger painter whose forms, made furry by many palette knife strokes, float lifelessly in ill-defined backgrounds. Judith Godwin is also young and hesitant, but in her thinly painted, sometimes calligraphic canvases a delicate feeling for light and tone emerges. Agnes Martin is a more assured painter with a personal style. Her canvases are pale, luminous studies in which square and oval forms float in spacious areas of diaphanous off-whites. Her quiet, dreamlike mood is consistent and well articulated.[16]

Each artist contributed four works to the exhibition. Representing Agnes was *The Field* (1957, $750) *Pacific* (1957, $750) *L.T.* (1958, $650) and *Monument to Mountains* (1954, $650). *L.T.* was later renamed *Dancer No. I* and is most likely dedicated to Agnes's new neighbor on Coenties Slip, Lenore Tawney, well-known locally for her love of dance. Just three months after this opening show Agnes had her first one person show from the 2nd to the 20th of December 1958, with her next one person show booked in for the following year from December 29th 1959 to January 16th 1960.

Betty and Agnes's commercial relationship got off to an acceptable start: by the beginning of 1959 Betty had sold seven paintings. As was common, Betty persuaded many of her rich friends, the Katinkas (or the powerful Katinkas as Betty called them) to buy some of Agnes's work. The Katinkas were Betty's nearest and dearest rich friends who came to Betty's aid throughout her life, supporting her financially and buying work by her artists in order to keep the gallery account solvent. The word *Katinka* was a hybrid word inspired by the Indian kachina dolls and the Powerful Katrinka, a children's character from the *Toonerville Folks* comics popular in newspapers up to the 1950s. Agnes's work, however, was not sold exclusively to the Katinkas; in the following year many artists began to purchase it, including Lenore Tawney, Ethel Schwabacher, Tony Smith, and Jeanne Reynal.

Despite her positive reviews and middling sales, Agnes was always poor. A letter from the gallery to Agnes, dated February 6th 1959, makes the economics of being a Parsons artist abundantly transparent. From the sale of seven paintings totaling $1,500, Betty takes $316.65 commission and another $630.14 to cover advertisements, photographs, transport, and two advance payments to Agnes. Agnes is left with $553.21, which does not cover her annual rent of $600 at Coenties Slip, and her next exhibition is not due for another ten months. What did she do for money? The following year her takings were even worse, $173.79 out of a sale value of $1150.05: the gallery was frequently giving Agnes advances that were not recouped from the sales of the work. In her 1961 exhibition that ran from September to October, Agnes sold only three works amounting to $450. In this collec-

tion, there is a noticeable increase in the price of many of the paintings. Up to this point the most expensive painting by Agnes on the market was $750. In her 1961 exhibition there were six paintings priced at $1,500. None sold.

Agnes's work was not selling and she knew she had to leave Betty's gallery. Working with Betty made Agnes anxious and paranoid: "Betty, she'd wait until I was starving, then reduce the prices and buy them up herself."[17] For most of her time with the Section Eleven gallery, Agnes had been asking her mind if "today was the day I leave Betty?" For years, her mind said "no," but when it finally said "yes," she marched uptown to Betty's gallery and freed herself from Betty's one third commission.

Agnes and Betty were very different women, and their backgrounds and circumstances suggest they were as incompatible in love as they were in business. Betty had an active social life in New York and in the summer she vacationed in luxurious surroundings, living off the generosity of her friends. It's very unlikely that Agnes wanted, or shared, this lifestyle with her.

Both women had a strong personality, which often lead to arguments. According to Betty, Agnes was a "fighter" who "disliked a lot of things" and "had a great many hostilities....If she didn't like something, she came right out and said it."[18] Betty was a confident woman, but she was still a society debutante with Edwardian finishing school manners. In the dynamic of their friendship it's likely that Agnes was the more controlling partner, but this was probably reversed in their professional arrangement.

According to Hedda Sterne, "[Betty] liked to dominate or to be totally dominated. All of her relationships fell into those categories."[19] The same was true of Agnes, who once broached the dominant/passive paradigm with Jill Johnston. Agnes asked Jill of her experiences of "domination" and "dominating," and Jill understood intuitively that Agnes was "alluding to women as role players." Jill, however, was too intimidated by Agnes to respond, which itself suggests the power Agnes had on women, whether she realized it or not. Both Betty and Kristina suggest that Agnes enjoyed her romantic relationships. Kristina described Agnes as "very sexual," and Betty claimed Agnes's "whole life" was "to enjoy whatever relationship she had."[20] This indicates how important relationships were to Agnes, while

also suggesting the huge expectation she had of her partners. In Taos, it might have been possible for Kristina to accommodate every wish Agnes had, but in New York, Betty was much too busy to do so.

In her letters to her husband Eliot, Aline Porter questioned—not always for selfless reasons—Agnes's hold on Betty. In June 1960, on a holiday back in New Mexico, Agnes was monopolizing Betty's time and Aline was getting worried:

> Betty is off camping for the night with Agnes Martin. I don't know when they'll be back—as Agnes likes to 'take over.'
>
> It's all been so confusing. I don't feel as if I'd seen Betty and she acts very grim anyway. I guess she is older and worn out. We are never peacefully at home—always something going on.
>
> She seems to like my pictures, likes some I didn't even put in show and I guess is all set to give me a show, but she doesn't act as excited as last year. But I think that may be <u>her</u> and not the pictures fault. I wonder what Agnes will say to her. I always feel Agnes is jealous of other painters. At least she won't let Betty look at Taos painters. I wanted Betty to see Oli Sihvonen—but probably won't be able to. Agnes has been in Taos until yesterday when she came down and got Betty. Betty's supposed to come back today—but I don't know what Agnes will do. I have to drive them to Albuquerque Sun. morning at 7.[21]

Of course Agnes was jealous of other painters and possessive of Betty— Betty's time and attention were precious to all artists. Betty was busy running two galleries, full of artists each believing that their work should be paid more attention than their neighbors. On weekends, Betty was busy with her own painting, and during the week had a full diary of social lunches, dinners and events. Agnes didn't like to share and she was concerned about failing in New York, particularly after so many of the Taos artists cautioned that she might. Furthermore, Agnes had ended her relationship with Kristina and put her wellbeing on the line to "make it" in New York. She could not risk failure or increasing competition, even from

old Taos friends. When Agnes was in Taos before NY, she used to hang her artwork on the back of the kitchen door in the Stables Gallery to avoid competing for wall space with her contemporaries. Perhaps she had this in the back of her mind as she protected her new hard-won position in Betty's roster—finally her work was center stage and she didn't want to go back to the kitchen door. [22]

Meanwhile, Aline was also jealous. Aline was supposed to be a Parsons artist before Agnes, and now Agnes had achieved the success that should have been Aline's. Agnes's competitive streak toward Taos artists comes across as uncharitable when one considers that many Taos friends were her first patrons. Aline, for instance, supported Agnes early in her career when she purchased Agnes's now-lost paintings *Night* (1954) and *Four Youths* (1955). Aline, again:

October 15th 1960, New York

Agnes Martin got me all worried about Section Eleven gallery and told me I should not show there. I got so worried that I had terrible cramps and diarrhoea all one night—I think from nerves. Luckily I thought of seeing Fairfield. I thought I should get outside advice. I called him at Long Island and he was coming in the next day so we had lunch. He was wonderful. He said he thought it couldn't be better as a gallery and was full of encouragement. I'll tell you more about it when I see you. So that was a relief. I know Agnes is unbalanced and queer but I thought she knew what she was talking about. [23]

Agnes knew that Aline had long hoped for a New York exhibition of her own. It is not certain if Agnes was cautioning Aline because of her paranoia, or because Agnes knew from experience that Betty would not be able to generate good sales for Aline. Or perhaps the reason is more personal? Perhaps the competition between the women was not exclusively professional. In her letters to her husband Eliot, Aline recalls a courtship between her and Betty that took place the same time that Betty was grooming Agnes for the Section Eleven Gallery,

January 19th 1956, New York

Betty may be interested in me. But she knows how I feel—and she has so many friends and such an active life that it is unimportant. Unfortunately, I think she does have a reputation and I have probably been foolish to see so much of her, but I guess I needed companionship and I have certainly enjoyed her company—even though she is obviously difficult in many ways because she seems so un-real. I will miss her if I leave but it might be just as well for her not to get too used to me.

In her letters to Eliot, the Porter marriage comes across as unconventional. In one paragraph Aline is telling Eliot of her confused feelings for Betty and in another she is encouraging her husband to marry another woman. In the letter dated May 1957, a triangle emerges. Aline is interested in Betty, Betty is interested in Aline, and Aline seems to suggest Agnes is interested in her also:

May 8th 1957, New Mexico

There is also the problem of Betty, which perhaps we should face. She is more than ordinarily interested in me—and me in her I suppose—but so far I haven't been able to see anything wrong in it as I did with Agi. Betty is a different type from Agi—not a neurotic like Agi is—and much more sophisticated—and also interested in the world. However, I don't think I could go and live with her—which really would be fun, if I could.

Aline did go and stay with Betty in New York for a period, but found the pace of life frantic. While she eventually signed with the Betty Parsons Gallery (for twenty years), her work only showed there a few times. Her son Stephen Porter had more success, showing his sculpture with Betty, which he did for the first time in 1976, at the young age of twenty-eight.

Aline was surrounded by successful artists in her family: her husband Eliot, her brother-in-law Fairfield, and then her son. Her relationship with Agnes, despite the competition, resumed a friendly tone in later years, and

both artists saw each other again when Agnes returned to New Mexico at the end of the 1960s. Many years later in her old age, when Agnes had few material possessions of any description, she hung some small floral paintings by Aline on her wall. Agnes must have no longer felt threatened by Aline and vice versa.

In her first four years in New York with the Section Eleven gallery, though she didn't enjoy financial success, Agnes had a varied social life and garnered positive reviews from critics and her fellow artists. Despite selling work Agnes had reservations about the content and her style. Many of her friends favored the sculptures she created: *Kali* (1958) is comprised of painted black and white boat spikes on wood, arranged in a geometric pattern; *The Laws* (1958), bought by Lenore Tawney, was a long plank of wood, one half painted blue to represent water, the top half looking like a night sky with boat spikes as stars; *Burning Tree* (1961) was a scary-looking metal and wood construct with twelve talons.

Up until 1960 many of Agnes's paintings depicted repeated circles (*Reflection*, 1959) squares (*Desert Rain*, 1957), and triangles (*Untitled*, 1959). In 1960 Agnes began a group of small works measuring twelve by twelve inches that depicted dots arranged in lines. Over the next three years Agnes would increase the scale of these works, from twelve inches to seventy-two inches, and join the dots to form lines, thereby producing her first mature body of work that would be grouped together to become known as "grid paintings."

Agnes was feeling more confident under the stewardship of the Robert Elkon Gallery, whom she had signed with after Section Eleven. Elkon, who had bought Agnes's painting *Prospect* (1958) at her first one-woman show, was an excellent champion and promoter of her work for the next seven years. Through Elkon Agnes started to show in group exhibitions in major museums in the U.S. including the Whitney (*Geometric Abstraction in America*, 1962), Guggenheim (*American Drawings*, 1964), Museum of Modern

Art (*The Responsive Eye*, 1965) and in 1966 in her busiest year, the Whitney, Guggenheim, and Jewish Museum with the *Whitney Museum Permanent Collection Exhibition, Systematic Painting,* and *The Harry N. Abrams Family Collection,* respectively. With Elkon, Agnes began to sell more work. No longer was she dependent on the charity of Betty's Katinkas; her art was selling to notable collectors and institutions including Sam Wagstaff and the Museum of Modern Art.

According to Agnes, her most important artistic breakthrough came in 1964 when she completed her painting *The Tree*:

> One day when I was waiting for inspiration I was thinking of innocence and a grid came into my mind and I thought, well, I guess I'm supposed to paint it—it didn't look like a painting to me, but I painted it, 6 by 6 feet tall and it looked like innocence very much. I called it a tree.[24]

Although *The Tree* wasn't Agnes's first grid painting, she singled it out as the painting that established her artistic maturity, adding, she wasn't sure if anybody else would consider the painting art. Either way, she offered the painting to the Museum of Modern Art who, to her surprise, bought it immediately; it was the first painting of hers to be purchased by the museum. Of course, Agnes was not the first artist to paint a grid, nor the first to paint geometrically. After the action and gestural allover painting of Abstract Expressionism geometry had emerged as an attractive subject for artists. Lee Hall remembers,

> There was a lot of very serious talk about several different things. One was always "the search" and there was always the shadow of science as the kind of ur-discipline. A lot of the language of science got picked up, such as "experimentation." [Josef Albers] was doing formulaic things with the recipes on the back, and there was a group that was beginning

to go toward *that* as the reality, as the truth, y'know, that everything is essentially geometric; you only have to discover it. And then there's another group saying "everything is a matter of emotion, of feeling," then there are people who fell different places on the spectrum.

Agnes's "vision" of the grid undermines every effort to position this breakthrough (if it was indeed that) within a linear narrative that would take into account her early work, and the various influences on her development over the years. Unsurprisingly, Agnes didn't "believe" in influence, though she did admit that if she were forced to acknowledge an influence it would be the work and words of the Abstract Expressionists. Abstract Expressionism, however, was not the only "influence" on the artist. Many factors—not all of them in the field of art—affected her personal sensibility.

Agnes believed that painting had nothing to do with the colors a painter selected for a canvas, or where the paint was positioned. The act of painting started when one was thinking about painting, which was inextricable from the artist's sensibility. In this way, the sensibility the artist brings to the canvas is a combination of individuality and influence.

We have seen how various people and philosophies in Agnes's past may have developed her way of thinking about life and art, including Emil Bisttram and Ed Corbett. With a little exploration it is also possible to see both the obvious, and not so obvious imprint of Buddhism, Greek philosophy, the Bible, and Lenore Tawney on her work and life in New York.

Agnes meditated daily and believed that it was necessary to have an empty mind for inspiration to come: "In NY, I would stay in bed until the late afternoon sometimes waiting for inspiration so I could get up and paint."[25] What did Agnes's inspiration look like? It came in the form of an image. Once Agnes had received the image, she worked out on graph paper the dimensions of the artwork, deciding how many vertical and horizontal lines were needed and how to express the tone of the piece with her materials and chosen colors. If sitting still in a cold loft studio waiting for inspiration appears willfully passive, creating the artwork was the oppo-

site. Arithmetic was the first hurdle Agnes needed to surmount in order to create the work. Agnes wasn't good at math and her high school grades reflect this; if she got any of her calculations wrong while preparing a work it would affect the geometry and balance of the entire painting and Agnes would be forced to throw the work out because it was not possible to erase and redraw on the canvas without leaving obvious and distracting marks behind. The next hurdle Agnes faced was drawing her lines. Agnes could not use a ruler because it would weigh on the canvas and affect how straight the line would be. In order to avoid this, Agnes used string and a T-square as a tool to guide her hand across and down the canvas. The physical poise and mental concentration needed to create lines equal in width and pressure should not be undervalued. For Agnes, the act of creating the artwork was a physical meditation similar to that of her neighbor Lenore Tawney, who describes her own line drawings as follows, "Every line is made with my mind being right on the line—I kept making these drawings for a whole year. They were like a meditation, each drawing, each line."[26] The association between the line (be it woven or hand-drawn) and Zen practice runs deep: both *sutra* and *tantra* come from Sanskrit verbs associated with sewing—*sutra* means "thread" or "string" in the sense of continuum, and *tantra* refers to threads that are woven into a fabric.[27]

The reality of drawing straight lines is that they will always—despite practice, talent or instruments—be failures. The human hand and eye, try as they might, cannot work together to create perfect geometry. It is these small mistakes and variations in her lines that give Agnes's work its more human or *gestural* touch, to use Abstract Expressionist parlance. This human touch, or failure to eradicate human error, suited Agnes well. Agnes saw all art, and the role of the artist as one linked to failure. Failure was the necessary state for an artist. Life and art were open to chance and accident, and when and where this appeared it needed to be acknowledged, not ignored. At the same time, if the scale of the work or its execution was too far removed from her initial inspiration, she would destroy the canvas. Only error in small doses was allowed.

Agnes's approach to her work was increasingly informed by her read-

ings in Zen Buddhism, in particular the work of Japanese writer D.T. Suzuki. Suzuki lectured at Columbia University between 1952 and 1957 when Agnes was attending Teachers College and it's possible that she heard him lecture there, perhaps spurred on by the remembrance of Malcolm Junior's early experience with meditation. Certainly Ad Reinhardt, who championed Agnes and whose "last paintings" Agnes admired, would have conversed with Agnes on Suzuki's writings. Reinhardt took Suzuki seminars at Columbia and was a close friend of Thomas Merton, the Trappist monk, who corresponded with Suzuki and endorsed his work publicly. Eastern or "Oriental" thought was a fashionable pursuit in the U.S. at that time, in particular for such creative individuals as Beat writers Allen Ginsberg and Jack Kerouac, and composer John Cage. Buddhists in traditional robes were a frequent sight on the streets of New York and down on Coenties Slip Robert Indiana, Jack Youngerman, and Ellsworth Kelly were doing I Ching readings together, while Betty Parsons was practicing Subud.

Aside from D.T. Suzuki, Agnes attended lectures by Jiddu Krishnamurti and read from the ancient philosophers: "My greatest spiritual inspiration," she wrote later, "came from the Chinese spiritual teachers, especially Lao Tzu. My next strongest influence is the Sixth Patriarch Hui Neng. Chuang Tzu was very wise and very amusing."[28] Agnes was also a fan of the Santa Fe writer Wittner Bynner's translation of Lao Tzu.

Zen impacted Agnes in many ways but by no means was it the sole influence on her thinking, as many scholars have been keen to argue. Zen alerted Agnes to the dangers of ego, pride and destruction: impulses Agnes would battle with throughout her life. Zen also helped Agnes clear her mind, but when it came to inspiration itself, Agnes held a classical view of inspiration as something bestowed on the maker by an outside or higher force. Agnes saw herself as the vessel through which her work flowed, and as such, once it was completed, Agnes was no longer responsible for it. This chimed with the role of the artist in ancient Greece. Art, *techne* in Greek, was the making of things according to rules, which we now call technique. For the Athenians nature was perfect and it was the *maker's* role (there was no word for creator) to discover and relay this perfection found in nature.

Agnes was attracted to the Greek idea of perfection as a thing that exists in the mind but cannot be found in reality. The Greeks could conceive of a perfect circle or a straight line, but these were ideals, and not real things. These ideals, however, gave humans something to strive toward: one could conceive of the perfect man, but one could not create or find him in reality. "My work" according to Agnes, "is not what is seen. It is what is known forever in the mind."[29] Take *The Tree* (1964) as an example. Innocence as a state is not something that we can easily point to or observe in reality—but it is something we can talk of theoretically and believe to exist.[30] But how do Agnes Martin's lines help us do this? How can we see innocence when we stand in front of *The Tree*? The reality is that maybe we can't, and yet people often do. To represent innocence Agnes could have painted a child reaching out for its mother, or children happily playing games. However, if Agnes had painted these she would have been *illustrating* innocence and feeding us images. Instead, by removing all narrative from the canvas, she is asking the viewer's mind to go similarly blank. When one stands in front of *The Tree*, following the lines, trying to see through to what might be behind them, one is brought to a state of frustration, curiosity, confusion, wonder, and maybe peace, innocence, satisfaction, and joy.

The Abstract Expressionists presented the turmoil, uncertainty and violence of the '40s and '50s in the monumental scale of their work and the all-over gesture or action upon the canvas. These artists tried to evoke universal feelings through their intense, heavy, and often wild work. Agnes made her work quieter, lighter, more restrained, but also strove for universal experiences. If you hang *The Tree* next to Jackson Pollock's *Number 28* (1950), Agnes's work looks like a balm: order next to chaos; a whisper next to a scream.

Abstraction manifested in a number of ways in her art. Some paintings such as *Beach* (1958), *Heather* (1958) and *Wheat* (1957) were close to the work of Mark Rothko, Barnett Newman, and Ad Reinhardt, expressing chromatic fields of color. Other work, the more overtly grid-like and "geometric" work such as *Morning* (1965) is more "gestural," but always more controlled than that of Jackson Pollock or Corinne Michelle West. In a

sleight-of-hand, these grids, even up close, resemble chromatic fields; the small squares are so tightly packed together that one fails to see the lines clearly, and the effect is one of distortion and fog: *The Rose* (1964) has over thirty-three thousand squares, while *A Grey Stone* (1963) and *White Stone* (1965) have even more. As always with Agnes, there is a blur between what the work shows, and what it suggests. This connects firmly with Agnes's belief that through abstract forms universal feelings can be summoned.

However, despite Agnes's best efforts, narratives and the real world make their way into this abstract, and geometric work. Aside from the early sculptures inspired by Coenties Slip, the Bible was often a source of inspiration. *The Expulsion of Adam and Eve from the Garden of Eden* (1953), still hanging above Mildred Kane's desk in the cherry orchard cabin in Monmouth, Oregon, and *The Islands* (1961), based on a line from Isaiah 60:9, "surely the isles shall wait for me," are two examples. As this quote from *The Untroubled Mind*—one of Agnes's most famous writings—suggests, there are likely to be many more covert Bible references in her work,

I painted those rectangles
From Isaiah, about inspiration
'surely the people is grass'
You go down to the river
you're just like me
an orange leaf is floating
you're just like me
Then I drew all those rectangles. All the people were like
those rectangles
they are just like grass.[31]

It turns out, all these years later, that the granddaughter of Robert Kinnon found a place for the good word in her own daily endeavors.

Agnes wasn't alone here. Lenore Tawney studied the Bible and Alban Butler's *The Lives of the Saints* (1756—1759) with Agnes, with a view to gaining some familiarity with concepts of devotion and sacrifice. Both women

particularly liked Saint Theresa d'Ávila, whose devotion to ecstasy and rapture might have held a particular fascination for Agnes, who, we shall soon see, was often found in a trance-like state in her loft and neighborhood. Though Agnes would frequently visit churches and later admired the Rothko Chapel she did not side with any particular faith. Writing to Lenore in 1976 Agnes showed where her sympathies lay:

October 5th 1976

I guess I just go along with Mind, like Zen Buddhists. I really can't see any contradiction in any of them. But the Old Testament & Judaism and Paul's Christianity are hard to take.[32]

Creed would only take her so far. For Agnes, "Religion is concerned with spiritual advancement, about trying to be better for some reward." Zen, on the other hand, doesn't believe in achievement.[33] It is for this reason that Agnes prefers Zen as a mode of living; it was also an antidote to her own chronic ambition.

Agnes's interest in Eastern philosophy was manifest in *The Willie Stories*, short parables she wrote with Ann Wilson, her first neighbor on Coenties Slip. One such parable is the *Parable of the Equal Hearts*,

Once there were two lovers that had equal hearts.

One would pursue one,

the other would pursue the other.

Then the angels looked down and said:

"What a waste," and made them perceive each other.

Their hearts melted into one.

They had no use for the world

so they leaped into the swift river.

This heart was always restless

and the only place where it had any rest at all was on the beach.

But even on the beach one said:

'I wish we'd never been made one.'

And immediately one half flew up in the sky
and the other half into the sea.
But they yearned for each other.
And when it rained the one in the sea said:
'This is a message from my other half in the sky.'
And when the water was evaporated from the ocean and rose up, the
 other said:
'This is a message from my other half in the sea.'
The angels were stumped.
There's one thing that God is not able to endure—
a suffering heart.
He felt one half in the sky and one half in the sea.
God thought what to do.
So the one in the sky fell down into the sea
and immediately both turned to sea water.
Ever since that time when the water is drawn up from the sea
and it rains this is not an ordinary rain. It's the rain that affects
people and softens them. I painted a painting called *This Rain*.[34]

The core lesson suggested in this parable is that God will guide you through your suffering. The human hearts did not know what they wanted. Together they were restless. Apart, they were suffering. It was only when they were changed by God did they have peace. But what is the rain that affects people and softens them? Divine rain? Rain that is brought on by peace? The triumph of love? The union of equal hearts? Maybe there are no definitive answers to these questions, and maybe Agnes did not, as a writer might, think through every word or image to its logical meaning. The *Parable of the Equal Hearts* is first and foremost a love poem, and *This Rain*, an emblem of that love. Perhaps it is no surprise to learn that Betty Parsons bought *This Rain* privately in 1958 for $1,500, the most Agnes had ever made on a painting at that point in her career. Money isn't love, but as someone who did not have very much money herself, it is a charitable show of affection and protection from Betty towards her struggling lover.

Though these hearts are equal they are nonetheless, like Agnes, struggling. Pursuing. Perceiving. Melting. Leaping. Flying. Falling. Raining. The hearts struggle to keep still. They are part of the same self but are divided, united, divided again. *This Rain* picks up on this split self. In the painting the viewer is confronted with two rectangles of equal size—the top blue, the bottom off-white—centered within a white space. Even though they are separated, these two rectangles look like they belong together.

In the catalog of Agnes's work, *This Rain* is not unique. Much of Agnes's work since the late 50s presented divided plains that mirror each other: *David* (1958), *Untitled* (c.1957), *Wheat* (1957), *Desert Rain* (1957), *The Spring* (1958), *Unknown Title* (c.1959), *Untitled* (1959), *Untitled* (1960). This mirroring is seen in *Dream of Night Sailing* as early as 1954 and appears in her final works such as *Untitled #1* (2003); and it's difficult not to read Agnes's character into this. There was in her personality a definite split or divide that friends were finding increasingly difficult to ignore. Agnes saw this split as a positive. Throughout her adult life, she spoke about the conversations she had with the voices in her head, which she referred to as a kind of guide. Her voices (she also called them her "mind") would tell her when it was okay to leave Section Eleven or if she should accept an award, or have an exhibition catalog. Sometimes her voices took over and Agnes was locked inside her body unable to control her actions or her words, or, even, to remember her name.

Though Agnes could not control the viewer's response to her work, she was secretly happy when people reacted the way she hoped they might. Agnes offered her work as a kind of therapy to the onlooker. Much later Agnes said "I tell 'em to hang 'em in the bedroom and when you wake up in the morning, before daily care strikes, take a trip."[35] Agnes definitely intended her work to be transformative or at least, according to the last quote, transporting. In her letter to the Helene Wurlitzer Foundation back in 1954 Agnes defined her aim as making an "acceptable representation of the expression of the American people." By 1958

she was not representing the American people, she was trying to *heal* them.

The Abstract Expressionists sought to represent and confront a tormented postwar American mentality—Agnes was out to pacify it. Years later Agnes spoke to Marcia Olivier about her grid paintings, telling her that she got the idea of making grids from watching children playing hopscotch in the playground. Agnes made the grids so "people can put their troubles into those little squares."[36] This account differs from the more publicized and romantic "vision" Agnes alludes to when she refers to the genesis of the *The Tree* (1964), but it supports the more practical function she envisioned for her art. Indeed, Agnes painted two grid paintings, *Play* and *Play II*, in 1966, and may have had hopscotch on her mind when she painted them.

Seen in this way, Agnes's paintings shift from being artworks to becoming tools in the everyday sense of the word—a utensil to make living and labor easier. In this manner, Agnes's work connects solidly with that of her neighbors Lenore Tawney and Ann Wilson. Lenore and Ann both worked within (and broke away from) the accepted female-lead tradition of crafts, the first as weaver and the second as a quilter. Where Agnes was subverting the potential of a canvas, taking something that is passive and making it almost utilitarian, Lenore and Ann were taking utilitarian crafts and asking for them to be seen as art, also subverting their accepted functional parameters.

A lot of critics consider influence a negative word that suggests a weakness on the part of the person influenced, as if they are in some way unoriginal and derivative. Really, influence is just a way of being in the world, where the recipient is open-minded and sensitive to the surrounding reality. How the artist processes this experience and expresses her own vision makes her contribution unique. Agnes was most definitely influenced by Coenties Slip, Lenore Tawney, Zen, Greek philosophy, Bible studies, and much more besides. It is not possible to understand every effect these had on her art or her thinking, but exploring them can yield rewards and help

us understand how her craft developed over time. The paintings should always stand on their own, and the viewers' thoughts and feelings towards them are paramount, but, in order to properly represent her journey, it is important to explore what inspired Agnes in New York and beyond.

TEN

Lenore Tawney

L enore Tawney was fifty years old when she arrived in New York from Chicago in 1957 with a small bed, refrigerator, weaving loom, and her cat, Pansy. As an art student at the Chicago Institute of Design, Lenore had studied with László Moholy-Nagy and Marli Ehrman, Bauhaus expatriates who saw no hierarchy in merit between arts and crafts. Lenore was different from many of her peers. She had a steady income from her husband's family—she was widowed in 1943 after two years of marriage—and was creating art without the added financial stress. Her life in Chicago was stable. She owned property and had a loyal coterie of friends, but, like Agnes in New Mexico, Lenore was mostly dissatisfied with her artistic output. In moving to New York, she sought "a barer life, closer to reality, without all the things that clutter and fill our lives."[1]

Lenore knew upon arriving in New York that she wanted to live close to water. Her friend, the filmmaker Maryette Charlton, told her of a loft close to the East River available for rent. Within a few months of each other, both Agnes and Lenore moved into the same building; Agnes was forty-five, Lenore an even fifty.

It was natural that the two women, middle-aged and almost twice as old as their neighbors, would be drawn to each other. What was more serendipitous was that both women shared many similar passions: meditation, water, reading, and dancing.

Exactly how close the two women became remains an unsolved mystery. Agnes and Lenore's relationship was intimate, but was it romantic? The main source to suggest the latter was Ann Wilson, who lived with both women in 1957. Lenore's friends tend to disagree, citing Lenore's relationships with men during the same time period.[2]

The truth, like all things in Agnes's life, would appear to be more complex than simple. If Agnes and Lenore had ever been romantically involved, the affair was likely short-lived. Firstly, because Lenore had male partners throughout the time Agnes lived in New York, (and Agnes had at least one other serious relationship with Chryssa, a younger female artist), secondly, because Agnes was generally drawn to younger women, such as Kristina, Daphne, and Chryssa (though Mildred was older by a year, and Betty by twelve), and thirdly, because the dynamic between Lenore and Agnes was different from Agnes's previous relationships. Lenore and Agnes engaged intellectually, spiritually, and artistically—their art, process, and inspirations at times even reflected each other. Lenore was on equal footing with Agnes in temperament and artistically, in ways that Mildred, Kristina, Daphne, and Betty were not. More than anything, Lenore and Agnes were soul mates in art, informing each other's work and even defending it, as the next story shows.

In 1959 Lenore was commissioned by the new Interchurch Center on the Upper West Side to create a tapestry for the narthex of their chapel. Lenore accepted the commission with the understanding that she would not submit her design for approval in advance. The Center, meanwhile, would have the right to refuse the final product, which is exactly what they did.

Enraged by this decision, Agnes wrote a letter to the selection committee, not defending the work, but *explaining* its merits. It is unknown if

Lenore was aware of the letter at the time—though it was forwarded to her from the church in February 1962. Agnes's letter hints at what her teacherly tone may have been like in earlier years:

Explanation of the tapestry by Miss Tawney

This tapestry illustrates how Christ came into the world as Holy Spirit and light and love as by miracle. Nature in its heavy dark mystery is penetrated from above by heavenly blessing accompanying the spirit of love.

Mary is a not a mortal only but a spiritual being already lifted out of nature.

This tapestry emphasizes the miracle of the direct penetration of the spirit of God into the world.

Religious art through the Renaissance (approximately 700 years) has accented the importance of human response to nature. This tapestry is to be considered as post-Renaissance, the content being nature illustrated by holy spirit.

That which is new with the support of those who can appreciate it, slowly gathers force.[3]

Lenore's tapestry, as Agnes suggests, is an unconventional vision of the Nativity. It is a waterscape dominated by birds, where Mary appears shimmering under the surface of the water and the child Jesus appears as an orb of light. In the original draft of this letter Agnes had included another line to come after the third paragraph: "with a consistent quality marking it with the mark of mature deep inspiration." Is Agnes writing about Lenore's work, or her own? The "response to nature," the "deep inspiration" are all Martinisms that Agnes returns to throughout her life.

What does feel different in this early letter, however, is the rallying cry at the end: "That which is new with the support of those who can appreciate it, slowly gathers force." In this sentence one is reminded of Agnes's Columbia conversations with Louise Sause, about teenagers, "as they

grow and develop we should accept and look for radical changes especially in their view on life."

To judge by her letter to the Interchurch Center committee, Agnes clearly felt that the status quo was not open to, and encouraging of, new and young voices. In both quotes she argues that the young and the new, in order to flourish, are dependent on the encouragement of the establishment; the artist remains vulnerable and at the mercy of review panels and established thought. The words of Charlotte Perkins Gilman, writing in the beginning of *Our Androcentric Culture* (1911) come to mind:

> If a given idea has been held in the human mind for many generations, as almost all our common ideas have, it takes sincere and continued effort to remove it; and if it is one of the oldest we have in stock, one of the big, common, unquestioned world ideas, vast is the labor of those who seek to change it.

Gilman was writing about the work women must do to recalibrate the world along lines that acknowledge a woman's experience of it, but Agnes saw the same challenge in the world of art; the struggle to change people's perception of what art could be.

At the advice of the chapel's architect and perhaps thanks to Agnes's "sincere and continued effort," the committee finally accepted *Nativity in Nature* for the chapel where it remains on view.

After seven months in Coenties Slip, Lenore moved out. She found the building and street too noisy and instead rented an apartment on South Street, a block away. Facing the East River and the Brooklyn Bridge, Lenore's apartment was a three-floor loft with a large, domelike skylight. In this large space, Lenore's work and ambition increased in scale. Lenore was pushing at the boundaries of what the craft of weaving was capable of achieving, making free-hanging "woven forms" such as *Seaweed* (1961) and *The King* (1961) full of "empty space."

Lenore used her steady income and early success in New York to sup-

port Agnes financially, purchasing *The Laws* (1959) for $1,000, *Kali* (1958) for $300, and *Homage to Greece* (1959) and *The Field* (1957) for $750, often positioning the work close to her weaving loom so it was never out of sight for long. In 1961, the year Agnes left the Section Eleven gallery, she moved to 28 South Street, next door to Lenore at 27. In November that year Lenore had her first solo exhibition in New York at the Staten Island Museum. Agnes wrote for the catalog—it was the first and last time Agnes would write about another artist.

Lately we have been seeing expression in many new media, and that is expected; but to see new and original expression in a very old medium, and not just one new form but a complete and new form in each piece of work, is wholly unlooked for, and is a wonderful and gratifying experience.

With directness and clarity, with what appears to be complete certainty of image, beyond primitive determination or any other aggressiveness, sensitive and accurate down to the last twist of the smallest thread, this work flows out without hesitation and with a consistent quality.

It is impossible to describe the range of expression in this work. The expression in one square foot of any piece cannot be hinted at. But it can be said that trembling and sensitive images are as though brought before our eyes even as we look at them; and also that deep, and sometimes dark and unrealized feelings are stirred in us. But most of all, considering range, we must remark that the image is complete in each piece of work—nothing is ever repeated, not a color not a pattern not a twist.

There is penetration.

There is an urgency that sweeps us up, an originality and success that holds us in wonder.

Art treasures indeed, this work is wholly done and we can all be proud.

Agnes Martin

Painter

Parsons Gallery

New York.[4]

This gushing statement on her friend's work hints at what Agnes considers successful in art: penetration, urgency, originality, directness, clarity, certainty, completeness. According to Agnes, when we look at Lenore's work images appear before us that stir dark and "unrealized feelings." Agnes's own mission to awaken the unconscious feelings of her audience suggests that Agnes sought in her own work what she found in Lenore's— the transformative power of art. Likewise, Agnes, watching Lenore weave the vertical warp and horizontal weft with her loom, came to understand the meditative concentration needed to build up a woven grid. As it happens, the root to the word grid, in both Latin and Greek, the art historian Richard Tobin writes, denotes wickerwork, which forever links Agnes's work to the textile tradition.[5]

The influence between Lenore and Agnes was not one-sided. Sid Sachs, the author of *Lenore Tawney: Wholly Unlooked For,* observes that Agnes's "romantic abstraction...seems to have facilitated Tawney's evolution away from pictorially expressionist weaving" towards more abstract compositions.[6] It is also possible that Agnes encouraged Lenore's reading of Gertrude Stein, who would make an appearance in Lenore's mail art later.

As an experimental writer, patron of modernism, bestselling author, and gay woman, Stein was admired by many artists in the 60s. Though Stein died in 1946, Agnes heard first-hand stories that spoke to her character; Stein was an acquaintance of Betty Parsons and a close friend of Mabel Dodge Luhan, the Taos arts patron. Agnes was so devoted to Stein that she was known around the slip as "a walking Stein seminar."[7] It was through Stein that Agnes came closest to outing herself as a lesbian. In the 1960 announcement for her Section Eleven exhibition Agnes chose to quote Stein's 1922 poem "A Valentine to Sherwood Anderson" or "Idem the Same," written by Stein for her lifelong partner Alice B. Toklas. The announcement was published as follows,

In which way are stars brighter than they are. When we have come to this decision. We mention many thousands of buds. And when I close my eyes I see them.[8]

The poem in Agnes's catalog ends here. It was a titillating invitation to go to a bookshop or library to read the remaining lines:

If you hear her snore
It is not before you love her
You love her so that to be her beau is very lovely
She is sweetly there and her curly hair is very lovely
She is sweetly here and I am very near and that is very lovely.
She is my tender sweet and her little feet are stretched out well which is
 a treat and very lovely
Her little tender nose is between her little eyes which close and are very
 lovely.
She is very lovely and mine which is very lovely[9]

Many of the recipients of this exhibition announcement would have immediately recognized the lines published and did not need to go to a library to recall the romantic direction of the poem. Aside from contributing to the gossip, rumor, and conjecture around Agnes's sexuality at the time, her use of the quote also begs the question of how or why Stein's "stars," and "the buds" relate to Agnes's new work (aside from her painting *Buds* (1959))? What is Agnes, by publishing this quote, asking her audience to consider in her art? Can we find in Agnes's work, as we can in Stein's writing, coded references to same-sex love or a parable of more equal hearts?

Stein was also an icon for Agnes's neighbors Jasper Johns, Robert Rauschenberg, and John Cage as well as the inspiration for Diana Epstein and Millicent Safro's Tender Buttons button shop that Ray Johnson, Jasper Johns, and Lenore frequented in the mid-1960s to take part in art "happenings." Lenore sent her collaged mail art to Epstein and Safro through-

out the '70s and referenced Stein in her cards to Maryette Charlton.

When Lenore and Agnes were not influencing one another they were under the spell of the East River. Lenore recalls that in the winter of 1962 she worked solidly from January to June to produce work for her 1963 exhibition at the Museum of Contemporary Crafts (now The Museum of Arts and Design). During this time she did not see Agnes much, although they lived next door to each other. Lenore recalls telephoning once and Agnes saying "I'm doing a river." Lenore replied "I'm doing a river, too."[10]Lenore produced *Dark River*, *Fountain* and *River*, while Agnes created *Dark River* (1961).

In addition to these shared interests, and the inspiration Lenore and Agnes seemed to provide each other, Lenore's most important and enduring mark on Agnes was not intellectual or practice-based, it was, as we are about to see, much more practical and heart-warming.

Robert Elkon showed Agnes's work in the Fall of 1962 and 1963 but not in 1964, as Agnes had not produced enough new work. What had happened to Agnes in 1962 and 1963 to temporarily stop her fountain of inspiration?

It is worth remembering that in her early years in New York, Agnes was still struggling to find her vision. There was a lot of pressure to be successful, which she was particularly sensitive to. Her artwork was moving towards the "breakthrough" of the grid, but her paintings such as *Little Sister* and *The Wall*—the titles of both being nods to Lenore—were still versions of *Homage to Greece* (1959) from four years earlier. Each of these paintings, and in addition, *Blue Flower* (1962), included tiny nails hammered into the canvas in straight lines. However, looking at an overview of Agnes's work one notices a lull in output between *The Islands* in 1961 and *Falling Blue* in 1963. This lull was most likely the result of a severe mental breakdown.

Though exciting, New York was very challenging for Agnes, in fact, challenging for most artists. The city moved at a tireless pace, recalled here by

Aline Porter. Aline arriving from Taos, gives us a sense of what a country artist like Agnes might have felt living in such a radically different environment: "New York seems so exhilarating...I rush every minute and there's never time to wash a pair of stockings. I stay up late every night...never rest."

Agnes loved the energy of New York when it encouraged her to work, but she could never control it and tame it. Every so often when she was at breaking point she would return to New Mexico to catch her breath and see her friends, concealing her turmoil by treating them to entertainment and meals. These return holidays, however, were a luxury that Agnes could not always afford. In New York, she tried to unwind by visiting Jacob Riis Park with Ellsworth Kelly, visiting Betty in her studio in Long Island, and by camping upstate on the weekends with friends such as Jill Johnston and Thalia Poons. However, these forays into nature, the same valleys and rivers visited by the Hudson River painters, only offered momentary peace from the incessant beat of the city.

According to Agnes, New York was "chaotic" and "materialistic," and her working day had "too many interruptions and distractions."[11] Agnes was not the only artist distraught in New York at the time. Yayoi Kusama viewed the city as "a fierce and violent place." Yayoi writes,

> The struggle for survival was such a powerful component of everything. The city was saturated with the possibility of great good fortune but also harbored a bottomless quagmire of shame and blame. And the heartless commercialism of many art dealers was too terrible even to joke about; it was a cause of real agony for many creative artists.[12]

Yayoi, like Agnes, was "mired in neurosis."[13] It was a struggle to get food and scrape together cash for canvas and paints. New York was "hell on earth," a "mechanised...standardized...homogenous environment."[14] As a result of the environment, poverty, and social pressure, Yayoi experienced bouts of extreme "depersonalization," hallucinations, arrhythmia, tachycardia, and a split of body and soul where "all sense of time is lost."[15]

Yayoi's psychosis—her split self—was connected to her art: "Before and after creating a work I fall ill, menaced by obsessions that crawl through my body—although I cannot say whether they come from inside or outside of me."[16]

In order to pull through her circumstances, Yayoi painted the same "white net" or "infinity net" image over and over. This process, what she called "obliteration," created one work thirty-three feet wide; "I make them and make them and then keep on making them, until I bury myself in this process."[17]

Agnes too, buried herself in her process, repeating lines of nails and graphite, where Yayoi repeated dots. If Yayoi painted until she felt obliterated, what impact did Agnes's lines have on her sense of place and self? Maybe in painting her lines Agnes, like the swimmer she was in her youth, was able to submerge herself.

Agnes's frustration with life in New York was as much to do with exterior influence as it was interior fracture. "People say 'pay attention to me,'" she wrote, "and if you do that...you will soon feel as though you are terribly lost and frustrated." This loss and frustration in turn leads to "complete helplessness," driving the artist to "frantic extremes." While Yayoi had a process of obliteration that helped her survive, Agnes struggled to find a similar refuge or solution. Agnes tried a variety of approaches "from reading religious doctrine and occult practices to changing [her] diet...from absolute self-abasement or abandonment to every known and unknown fetish." No matter what she did, the result was the same, "The feeling of calamity and loss covers everything."[18]

Abasement. Abandonment. Calamity. Loss? Agnes had lost her footing and plunged into the abyss. Helpless wasn't an adjective people associate with Agnes, and yet the reality is that she frequently found herself in the position she describes above. It was difficult for her to ask for help especially because she never knew whom to turn to. Agnes thought that her obstacle to achieving clarity and balance was spiritual—in reality it was psychiatric.

According to Arne Glimcher, Agnes's dealer from 1975 until her death

in 2004, Agnes was frequently hospitalized in New York to manage her schizophrenia, and Agnes intimated to Marcia Oliver that these periods of hospitalization were the result of trauma brought on by romantic relationships. It's uncertain when Agnes was first diagnosed as having schizophrenia, though she showed symptoms in New Mexico. Aline Porter called Agnes "unbalanced" in 1960, and Kristina Wilson was subjected to thirteen-hour lectures from Agnes in the 1950s. Symptoms of schizophrenia often develop later in women than men—any time from their mid-twenties onwards. This might have been the case with Agnes, though stories of her as a child suggest behaviors that, while understandable in context, might also point towards her later diagnosis. When Agnes talked about her family it was rarely with fondness. Agnes's mother hated her. Agnes's mother and sister were stupid. Agnes was locked out and forced to play in the yard as a child. Agnes walked alone behind her brother and sister on the way to school. Agnes took herself to the hospital to get her tonsils removed. In each example she shows herself as a victim or orphan within her own family. What Agnes doesn't talk about is that she was unruly as a child. Excitable. Troublesome.

Agnes created in her mother the perfect nemesis. Kristina recalls her telling a story about stealing a nickel and hiding it in her shoe. As Agnes bounded up the stairs, her mother grabbed her by the ankle and exposed the nickel in her shoe. Agnes had no idea how her mother knew the coin was there. The preternatural instinct Agnes bestows on her mother in this story aligns with the wicked mothers (and stepmothers) in fairytales such as *The Three Spinning Fairies, The Raven, Snow White* and *Hansel and Gretel*. However, it very well may be that Agnes, herself, was more of *A Little Red Riding Hood*, ignoring her mother's well-intentioned discipline? Many children create narratives that place themselves in opposition to their parents, but they grow out of it eventually. Agnes never did. "My mother was a masochist about life," she told a friend, "and turned my brothers and sister against me."[19] Agnes claims her mother and family were against her, but research does not corroborate this. According to her file at the Betty Parsons Gallery, Agnes's sister Maribel was her first patron, buying

Agnes's fledgling artistic efforts, *The Foundry* (1940), *The Ravine* (1940), and *Indian Girl* (1947). Agnes's niece was also a patron, purchasing three more paintings including *Mia* (1948) and *Personages* (1951). These works, some of Agnes's tentative first steps, consist of portraits and landscapes and include watercolors, lithographs, and oils—showing Agnes's early eager experimentation in different mediums. This familial support undermines Agnes's verbal portrait of her family as indifferent to, and disdainful of, her choices and efforts.

A genetic condition triggered by social variables that include trauma, poverty, and stress, schizophrenia is a broad clinical term under which very diverse symptoms are grouped. Today we think of clinical disorders displayed along a spectrum but in the 1950s and '60s, psychiatry was much more black and white and the treatment of the disorder much more formulaic. In the 1960s the treatment for schizophrenia involved anti-psychotic drugs such as chlorpromazine, electroconvulsive therapy (ECT) (commonly known as shock treatment), and insulin coma therapy (ICT).

Agnes's symptoms manifested in psychotic episodes that involved violence, mania, hallucinations, memory loss, and catatonia. Agnes was also hypersensitive to music, which often acted as a trigger, inducing trances. Agnes recalls on one occasion visiting a church on Second Avenue to hear Bach's *Passions*, and falling into a catatonic state after three notes. On another occasion, Agnes wandered the streets of New York for nine days not knowing her name. In this instance, and probably in other occurrences, she was picked up by police and brought to the violent ward of Bellevue Psychiatric Hospital.

Throughout its history, Bellevue was renowned as a groundbreaking hospital for medical research and treatment. It is also equally infamous in popular culture for housing the criminally insane and those at risk to themselves and society, including occasionally, "celebrity" patients such as Eugene O'Neill, Norman Mailer, Mark David Chapman, and Edie Sedgwick. Billy Wilder's *The Lost Weekend*, winner of the Best Picture Academy Award in 1946, was partially shot at Bellevue, implanting into the public

memory the image of an institution filled with the deranged and desti-
tute. Agnes had seen the inside of Bellevue before, when she worked shifts
with Mildred on their holidays from Teachers College. These later circum-
stances were a tragic echo of a happier time.

It is not known for how long Agnes was hospitalized throughout her
time in New York, and in particular in 1962–1963, but Agnes mentioned
to Marcia Olivier she was given electroshock therapy, a treatment that
can last over six weeks and be administered two to three times a week,
followed by a doughnut and a cup of coffee. Agnes also told Kristina she
had more than one hundred rounds of treatment. At the time electroshock
therapy was more established and clinically more favorable than chlor-
promazine, which had only recently been brought to the market by Smith
Kline in 1955. Electroshock was considered a successful treatment but one
of the side effects—memory loss—had a huge impact on Agnes for the
rest of her life. While most hospitals were giving muscle relaxants, mouth
guards and general anesthesia to ECT patients, this was not guaranteed in
Agnes's case, because poor unknown women who responded violently to
detention often received a more brutal treatment.

Kristina, as part of her training as an occupational therapist, saw the
inside of Bellevue Hospital in the 1950s and it wasn't pretty. Jacob Riis,
the Ashcan photographer, whose namesake beach park Agnes frequently
escaped to, described Bellevue as "the hospital of the poor." This was no
different in 1963 when Agnes was admitted.[20] The patients brought to Bel-
levue were some of the most disadvantaged, vulnerable, and poor people
in New York. Many patients, once admitted, were forever lost to their
friends, family and, indeed, history.

This almost happened to Agnes later in 1967, when she was picked up on
the streets of Manhattan during a violent episode and taken to Bellevue.
Placed with severely disturbed patients, and with no link to the outside
world, she could have been incarcerated or moved to a facility outside of
New York. She was, however, saved from this fate by a tiny scrap of paper,
bunched up in her pocket.

Unfolded, this scrap of paper contained a number for Robert Indiana,

whom the hospital staff managed to contact. Robert came to Agnes's rescue with Lenore. When he saw the unsanitary environment Agnes was held in, sedated and restrained, he contacted an art collector he knew, the psychiatrist Arthur "Art" Carr. With Carr's help Agnes was removed from state care and transferred to the Columbia Presbyterian Psychiatric Institute. Under proper observation, Agnes was given a realistic diagnosis and prescribed antipsychotic drugs. According to Art, the treatment made Agnes feel like "a very special person," adding, "They treated her royally."[21]

Very little is known about Agnes's 1962–1963 episode, though it might have been very similar to her 1967 one. What is known is that after she was treated, in order to reduce her anxiety and remove future triggers, Agnes saw a psychiatrist paid for by Lenore. As the following thank you letter suggests, Lenore may also have offered some financial assistance to Agnes to cover her living costs during this time.

October 25th 1963

Dear Lenore,

I am not going to be able to tell you anything really. You have made this day the turning point in my life. It means an enormous opportunity for me. Now I can take my time and really get to work. The whole scene is changed. There is no way to grasp the size of it. There is no way for me to get hold of it at all.

I do not think you will be able to imagine even a small part of the enormous changes in my position.

Any expression of gratitude is like the soundless sound. It is going to be like waves over and over again—forever is not too long. I think it is the "real thing."[22]

Despite the trauma of hospitalization and electroshock therapy, Agnes promptly returned to productivity and with a newfound sense of security, confidence, and maybe even peace, produced an extraordinary group of paintings that were unlike anything she had made before. These paintings (all dated to 1963) *Falling Blue, Night Sea, Friendship, A Grey Stone,* and *Milk*

River were rich, lush, mature, and life-affirming. At seventy-two by seventy-two inches they were the largest canvases she had ever produced. As if to celebrate this newfound vision, Agnes used gold leaf in *Night Sea* and *Friendship*—an expensive material.[23] Finally Agnes had emerged from twenty years of artistic struggle, and quite a few years of mental struggle, a fully formed artist—she had painted her first grids.

Agnes had explored working on the concept of a series in her drawings but never before on canvas. Keeping to the same canvas size, materials and grid *theme* must have been a relief for her. Finally she had found a style and vision that she felt was authentic to her. It is worth remembering that the grid did not flash, fully formed into Agnes's mind, as she has described over and over. It had a very particular development from dots in space (*Untitled*, 1960) to a centralized grid plane surrounded by blank canvas—or unmarked border—(*The Islands*, 1961) to the "all-over" grid that reached to the edge of the canvas surface (*White Stone*, 1965).

The curator (of London's Tate Modern) Frances Morris suggests that in Agnes's early New York drawings and paintings, "the grids function as containers for marks—dots or dashes and ticks often likened to stitches," suggesting the influence of Lenore's work on Agnes at this time. However, Morris also suggests that Agnes used the grid as a way of exploring some of the most basic fundamentals of painting practice ("illusion," "depth," "surface," and "movement") thereby not exclusively mimicking the use of the grid in weaving.[24]

The grid was not the only subject Agnes explored in series form. Immediately after her hospitalization Agnes—keeping her hands and mind active—created a whimsical sculpture called *The Wave* (1963). *The Wave* is a shallow wooden box with a blue Plexiglas top. When turned side to side, the blue balls in the box roll over an incised grid creating a rumbling sound that brings to mind the swash and backwash of pebbles across a stony beach. To evoke the sea, the box was painted blue and the balls (pilfered from a Jewish haberdashery on Canal Street) were also blue. The finished object looked like a three-dimensional version of her paintings and its underlying purpose was the same.

The Wave was created for *Toys by Artists*, a Christmas exhibition at the Betty Parson's Section Eleven gallery in December 1963.[25] The challenge set by Parsons was for artists to create toys children could play with. Robert Indiana, Ellsworth Kelly, Chryssa, Marisol, Alexander Calder, and Andy Warhol were just a few of the artists who responded to the challenge. To reverse an art-world norm, at certain times only adults accompanied by children were admitted to the gallery. Agnes must have judged *The Wave* a success because she went on to create more. Identical versions of *The Wave* fell into the hands of Lenore, Betty, and Mildred. At $300 *The Wave* wasn't a toy for a child, it was a toy for close friends to remember Agnes by. In 2007 *The Wave* owned by Robert Elkon sold at auction for $540,000. The toy, three years after Agnes's death, had finally joined the world of the grownups.

Agnes continued her close friendship with Lenore after her breakdown, even naming Lenore's work for the exhibition *Woven Forms* in 1963—Lenore had previously named some of Agnes's paintings for her debut exhibition at the Robert Elkon Gallery, including the painting *Night Sea* (1963).[26]

The King, The Queen, The Bride, The Virgin, Mourning Dove, The Queen's Sister—Agnes created for Lenore's exhibition a strange and emblematic cast of characters that sound as though they are plucked from the Middle Ages or her puppetry class at Columbia Teachers College. Agnes's own work refrained from suggesting characters—though nature was always a lodestar.

In 1964, Agnes began using acrylic paint in her work, exclusively using the Liquitex brand from 1966 until the end of her life. Acrylic was a relatively new paint that was water-based and water-soluble, and which dried more quickly than oil. With Liquitex, Agnes was able to water down her paint to a thin consistency, the application of which became closer to a watercolor than a traditional oil painting. The quick-drying Liquitex allowed Agnes to work faster on each canvas and to build up thin layers of paint carefully. Though the finished work presented what looked like

a refinement of line and color—the act of creation was one of addition rather than subtraction.[27]

January 1964 marked the opening of the important exhibition *Black, White and Gray* at the Wadsworth Atheneum in Hartford, Connecticut. Curated by Sam Wagstaff—a dashing and rich art collector—*Black, White and Gray* is frequently touted as the first exhibition of Minimalist art in the U.S. Agnes was one of three women, including Anne Truitt and Jean Follett, selected for the show. It also included nineteen men, among them Pop artists (Andy Warhol, Roy Lichtenstein) Minimalists (Dan Flavin, Frank Stella) and Abstract Expressionists (Ad Reinhardt, Barnett Newman). Wagstaff chose and commissioned black, white, and gray art to "advocate a new, severe look," an attitude that he felt was prevalent in the work he was seeing in the artists' studios. Though there is more that separates these artists than unites them, *Black, White and Gray* was important for the reason that it "helped to launch the minimal look into circulation" as "a style of elegant refusal, of geometric contours and monochromatic hues."[28]

In 1964 Minimalism didn't exist as the historical category it is now. ABC Art, Rejective Art, Cool Art, Primary Structures—critics in the early 1960s were searching for labels that could denote this evolving aesthetic. While many Minimalist artists rejected the emotionalism of Abstract Expressionism they were nonetheless inspired by the "all over" and refined Color Field work of Rothko, Newman, and Reinhardt as well as the bold new work of Jasper Johns, Robert Rauschenberg, and John Cage. The writings of Newman and Reinhardt were equally important to the new Minimalist artists. As such, Minimalism, as a movement, was more about artistic evolution rather than outright rejection. As a further antidote to Abstract Expressionism, Minimalism became typified by its sculptors (where Abstract Expressionism was typified by its painters) including Carl Andre, Sol LeWit, Donald Judd, and Eva Hesse.

Throughout the 60s and beyond, Agnes would continue to be shown with, what we now call, the Minimalists. Agnes was sympathetic to these young artists but never saw herself as one of them. Minimalist philoso-

phy espoused "wood as wood," and "steel as steel." Minimalists believed that there is "no underlying meaning to things, no truth apart from one's immediate encounter with empirical reality."[29] None of these statements holds true with Agnes or her work. Agnes fervently believed in positive underlying universal emotions that her art could unlock. She also believed in the labor of the artist, the artistic vision, human expression, and a painterly aesthetic that was at odds with the factory-assisted work of many Minimalist artists.

ELEVEN

Leaving New York

In 1965 Agnes had enough money to embark on a world cruise. She had once considered taking a cruise with the artist Georgia O'Keeffe whom she met when she was a student in Albuquerque in 1946 (though she cites meeting O'Keeffe as early as 1941).[1] O'Keeffe was the most famous American female artist of the twentieth century and a household name for most of her adult life. Though Lee Hall, Betty Parsons, and Marcia Olivier suggest there was no woman artist to look up to, Georgia O'Keeffe is the artist most likely to fill the role as grand dame of American art, modernist or otherwise. O'Keeffe was supportive of young women artists including Agnes. In 1955, when Yayoi Kusama, aged twenty-six, wrote to O'Keeffe from Japan, she was stunned to get a response, "I was amazed that a person of her stature would respond in such a kind and heartfelt manner to a young person she did not know, from a country so far away."[2]

Georgia went beyond offering advice to the young Yayoi. She took the watercolors Yayoi had included in her letter to a number of galleries, even selling one to the dealer Edith Halpert. As a result Yayoi cites O'Keeffe as

one of her first benefactors and one reason she decided to move to the U.S. Later when Yayoi had moved to New York and was finding it tough, Georgia invited her to stay at her home in Abiquiú, New Mexico.

Georgia had first traveled to Taos in 1929, where she spent five months as a guest at the home of Mabel Dodge Luhan. Subsequently, she summered in New Mexico, finally moving to Abiquiú permanently in 1949.

As well as supporting Yayoi, Georgia took a liking to Agnes, perhaps because the women had much in common. Georgia was a farm girl from Wisconsin, a high school teacher, and a graduate of Columbia Teachers College, where she taught as early as 1915. Inspired by nature and in particular the landscape of New Mexico, O'Keeffe believed it was not enough to paint objects; artists must also reveal their feelings toward their subject in the painting. O'Keeffe was also friends with many Taos artists, including Eliot and Aline Porter (Georgia and Eliot traveled to Mexico to meet Diego Rivera and Frida Kahlo in 1951).

It was unavoidable that Agnes would be attracted to Georgia as America's preeminent female painter and a strong-willed woman with a fluid sexual orientation. Despite their similarities, Agnes found Georgia exhausting and "over-stimulating" to be around: usually with Agnes, it was the other way around.[3] "It was exhausting. Georgia was like that—very intense and exciting to be with, but she drained me...When she left the room for a few minutes...I just had to lie down, right then and there."[4] In the 1940s Agnes had no money and definitely not enough stamina for a cruise with Georgia, "I don't know how I ever would have sailed around the world with her. I would've been asleep."[5] Eventually Agnes did take a world cruise and the letters she wrote to Lenore Tawney show a woman high on adventure and drunk on life.

July 20th 1965
 Dear Lenore,
 I have been wishing everyday that I had been writing to you but the fact is that I have been absolutely overwhelmed by this trip, especially Pakistan and India.

It seems to me that even if I were telling you face to face I would have a difficult time conveying this experience. With every glance it is more than I can take in. I would particularly like to describe the beggar boys in Karachi—so clean—hopeful and persistent. They seemed like Angels to me. My Scotch spirit prevented any extravagance even with Angels.

It gives me great pleasure to think of your work from here.

My held opinion is that everything is just right with you. I expect (I don't know what) I have so much confidence in you that I cannot imagine your doing anything that is not just right in work or in play.

Love and best wishes,

Agnes

July 26th 1965

I have found that I have a passion for the sea...

I almost flipped in Karachi. I was so very fond of the people. They wear fantastically full cut clothing and sleep just anywhere in the streets.

I thought that the beggar boys were begging for love instead of money and I got going on listening to the heart etc.—but have recovered and am listening to the mind if listening at all.

It is a very smooth boat and just goes on and on really carrying us. It is too romantic really. In ports I go ashore by myself. In Genoa I climbed a mountain and picked 22 varieties of wild flowers. They lasted a long time in water. All the people are nice both Spanish and Italian and all others. They do not overcharge me. I even get to feeling a little guilty for even thinking they would. I am looking forward to the rest of the trip as though it were beginning. I am outside all the time by myself on a top deck and enjoying it beyond words. Romance is getting the upper hand. I am as though moving in it—the wave upon wave, the rocking the adventurous ship (I call it the happy ship and the good ship...).[6]

These letters are bursting with exuberance. Agnes is "overwhelmed," "enjoying...beyond words," and the trip is "too romantic," "more than I can take in." "*All* the people are nice"; "There are *twenty-two* varieties of

wildflowers." It is a letter of emotional excess, a letter that struggles to contain itself and is childlike in its reportage. It is a picture-book image: Agnes standing at the bow of a ship, twenty-two varieties of wildflowers bunched in a fist by her side, watching the sun set or another coastline disappear from view.

Unfortunately, Agnes failed to contain this exuberance and heightened stimulation in India. As often happened, her emotions overwhelmed her. Her friend David McIntosh recalls that Agnes believed that the other passengers on the ship "disliked her" and wanted "to exclude her."[7] It is possible that the loneliness she describes above, to Lenore, once a source of joy, lead to her paranoia and eventual breakdown on the trip. As a result, Agnes spent two months in a hospital in Bombay with amnesia, though she could later recall the nurses singing her Scottish ballads. Once again, Agnes was rescued by a friend who, on this occasion, traveled to India to escort her back to New York.

It was no longer a secret that Agnes had extreme ups and downs in her mental wellbeing. Taos friends returning from New York reported on Agnes living in a white cave, spending her money on a psychiatrist and frequently descending into panic. It must have been a blow to Agnes's pride to rely on friends at this time, to allow them to see the weaknesses and vulnerabilities that were under the surface of her strong will. We do not have to imagine what Agnes looked like in New York: two seated portraits of Agnes, one by Peter Moore taken in the early 1960s and another by Diane Arbus taken in 1966, both show a woman not very comfortable in her own skin.

In her old age, Agnes once told a reporter that she does not photograph well because her face was too expressive. She was not wrong. An early photograph of Agnes, taken in 1931, shows a young, slender, broad-shouldered girl in a pleated skirt and white stockings. Taller than her aunt and cousin, who share the frame, Agnes tilts her head down slightly as if trying not to tower over her family. As an older subject, as most have come to visualize her, Agnes looks both cherubic and unconcerned. The portraits of Agnes in the 1960s, however, show a different side. Moore's portrait shows Agnes at

her most vulnerable, her eyes puffy, wet and tired looking. Diane Arbus's portrait, taken in 1966, shows a similar character. In a formal pose, this Agnes is hesitant, her hands resting on inward-turning knees, the tips of her paint-splattered moccasins touching defensively. Ten years previously, Mildred Tolbert, in her series of photographs of Agnes, presented to the world, and prospective clients, a fierce, confident, and assured woman in her early forties.[8] Within ten years Agnes looked like a different person. Thinner, severe, frayed: the toll New York had taken on her could not be ignored.

It was not just New York that took its toll on Agnes. It was also her ongoing electroshock treatment, psychiatric counseling, and her romantic relationships, in particular her on-off relationship with the Greek artist known as Chryssa.

Chryssa Vardea-Mavromichali settled in New York in 1956, becoming friends with Agnes in 1957 after Agnes relocated with Betty Parsons. Chryssa was twenty-four, Agnes was forty-five, and the younger artist said she had never met anyone like Agnes before.

In her first years in New York Chryssa was exploring different styles and media. The Cycladic Books (1957), which the critic Barbara Rose claims precede Minimalism by seventeen years, are minimal sculptural reliefs inspired by Cycladic art; smooth, symbolic sculptures of humans and animals from 3300–2000 BCE. The Cycladic Books and Agnes's painting Window, from the same year, share an affinity for simplified forms and symmetry as well as the balance between "visibility and legibility," something Chryssa admitted she was particularly inspired by in Agnes's art.[9]

Chryssa was an assertive, opinionated young woman, heavily versed in her country's philosophy and art. If Chryssa was influenced by the balance Agnes achieved in "visibility and legibility" in her art, Agnes was equally influenced by their discussions on Greek art and philosophy. This dialogue made its way into the women's artwork, in particular Agnes's Homage to Greece (1959) and Chryssa's Arrow: Homage to Times Square (1958). Agnes cites Homage to Greece as the beginning to her "lines."

I began the lines ten years ago, lines in pigment. I cut up squares of can-vas and pasted them on a small rectangular canvas. They are not exact squares. These were painted white, then I nailed down nails in a slight arch line near the top. I called it *Homage to Ancient Greece*, just the edge of an arch across the top.[10]

Homage to Greece is a line and collage grid painting with sculptural ele-ments, perhaps inspired by her talks with Chryssa on Greek art and phi-losophy. Chryssa's *Arrow*, meanwhile, pursues a modern geometric and minimal, Agnes-influenced resonance.

Consisting of painted aluminum arrowheads arranged to create a pointed arrow shape, Chryssa's homage, like Agnes's, brings a sculptural element to a two-dimensional form. Times Square for Chryssa, much like the grids for Agnes, would be an obsessive subject for years to come. At first glance it's difficult to see exactly how *Arrow* relates to the "vulgarity of America" that Times Square represented to Chryssa.[11] That is, until we learn that this vulgarity, for Chryssa, was based in poetry and not reality, something *Arrow* picks up on. In time Chryssa would depict Times Square in a less poetic and more realistic way, incorporating neon into her ground-breaking sculpture. *Arrow*, however, is more dreamlike in approach. It almost looks industrial, repetitive, anonymous and lonely but it doesn't. Instead *Arrow* achieves an otherworldly quality that seems modern and antiquated, timeless and pure.

In 1959 Chryssa underwent her own grid phase with the creation of her *Newspaper* series. These large works predate Andy Warhol's 1962 experi-mentation with repeated images such as *S&H Green Stamps* (1962), *Red Air-mail Stamps* (1962), and his own 1963 newspaper-inspired *A Woman's Sui-cide, Suicide (Fallen Body)*, and *Race Riot*. In a 1967 interview Chryssa talks about the paintings in ways that recall Agnes's discussion of her own work:

There wasn't any beginning, any end. Therefore they were something endless to me...first designed with a pencil on the canvas—it looked like an architectural plan of some sort. Each little space was exactly drawn to

fit the size of the stamp I would use at the time...I didn't want to have any emotion about it—no parts darker or lighter. I wanted the whole thing to be equal and as quiet as possible...[12]

It was upon Agnes's recommendation that Chryssa had her first New York show at the Betty Parsons Gallery in 1961, the same year that Chryssa had a solo show at the Guggenheim Museum, an accolade almost unheard of for a woman artist at the time, even for a woman whose name translates as "golden one." By 1961 Chryssa's work was in the collection of the Katinkas, Betty Parsons, Lenore Tawney, Robert Elkon, the Whitney, the Museum of Modern Art, and the personal collection of the Museum of Modern Art curator, Dorothy Miller.

Despite all this success, Chryssa's relationship with Betty was not particularly smooth: the artist was demanding and needy, and she developed an infatuation with the dealer. In her rambling letters to Betty in the early 1960s, there is more than a whiff of desperation and paranoia. Lee Hall recalls Betty referring to Chryssa and Agnes's relationship as "a mess." Both artists were burdened with psychotic episodes and both needed frequent hospital stays to attend to their symptoms. Urban legend grew around the destructive tendencies of the two women: Chryssa, it was said, broke Betty's arm in an argument, and Agnes cherry-bombed phone booths to collect quarters.[13] Both stories are fabrications though they contain a grain of truth: Chryssa's behavior was often infused with violence and Agnes was poor—poor enough to steal materials for The Wave (1963). In a 1974 biography of the artist, the author Sam Hunter describes Chryssa as a "dark, handsome...mercurial woman...who can make strong workmen and artisan assistants blanch by her eruptions of cold fury."[14] Hunter does not sugarcoat his subject:

With less provocation, she frets and fumes at the frustrations of urban life in New York, and often overreacts to petty rivalries, real or imagined slights and the internal politics of the art world.[15]

Hunter goes on to write that Chryssa's "normal state" is of "anxiety and creative tension...a habitual state of emergency...a high-risk environment."[16] It all sounds exhausting, and exhausting for those around her. But not for Chryssa, who needed the drama in order to create: "I feel that out of all this turmoil and experiences works of art are made."[17] Turmoil may have made Chryssa creative, but this was not the case with Agnes; turmoil made Agnes anxious and it put her on edge.

Chryssa and Agnes's relationship was intermittent over the years. Like Agnes, Chryssa needed to be alone and found relationships disruptive, "I find it easier to be alone because I find it very difficult to spend a great deal of energy disagreeing or spending too much energy on unpleasant things or small things."[18] Despite this, it is widely believed—though unbroadcast—that problems between Chryssa and Agnes forced Agnes to leave New York in 1967.

Agnes was "lost," "distracted," and "frustrated" living in New York, a city she had always considered expensive, chaotic, and materialistic.[19] Various accounts state that she left New York shrouded in mystery and, apparently, unexpectedly. However, for those who knew Agnes well, there was nothing unexpected about her decision to leave. For one thing Agnes's world was literally being torn down. The neighborhoods south of the Brooklyn Bridge were undergoing major development, and entire streets were being demolished. To walk around South Street, Fulton Street, Beekman Street, or Chambers Street was to walk around an abandoned film set. Shops were boarded up, doorways chained shut, and not even dogs or cats remained behind. For years the Coenties Slip artists had been in and out of court trying to save their beloved studios from the inevitable, but one by one they were forced out. By the early 1970s Ellsworth Kelly had relocated to Spencertown, New York, Jasper Johns to the Caribbean island of Saint Martin, and Robert Rauschenberg to Captiva Island, off Florida's Gulf Coast.

Though she had few belongings that kept her anchored in New York, Agnes had other, deeper ties to the Coenties Slip area. The slip was spiritual sustenance in a world of material excess and moral deprivation. Agnes was drawn to it like the men from *Moby Dick*, pulled there by a magnetic virtue:

Circumambulate the city of a dreamy Sabbath afternoon. Go from Corlears Hook to Coenties Slip, and from thence, by Whitehall, northward. What do you see?—Posted like silent sentinels all around the town, stand thousands upon thousands of mortal men fixed in ocean reveries....

Nothing will content them but the extremest limit of the land; loitering under the shady lee of yonder warehouses will not suffice. No. They must get just as nigh the water as they possibly can without falling in. And there they stand—miles of them—leagues. Inlanders all, they come from lanes and alleys, streets and avenues—north, east, south, and west. Yet here they all unite. Tell me, does the magnetic virtue of the needles of the compasses of all those ships attract them thither?[20]

The ships docked less and less at Coenties Slip when Agnes lived there. Nautical trading activities, like long shadows, subsided until one evening the sun went down on them for the last time. Even the Seaman's Church Institute, a building of foreboding resoluteness, soon came crumbling down. The dislocation caused by the demolition she saw around her gave Agnes pause to reflect:

I think it is more important to figure out where you want to be than it is what you want to do. First you have to find out where you need to be, and then you can do what you need to do.[21]

Agnes had always sacrificed comfort, friendships, material goods, and relationships in order to get closer and closer to realizing her goal of being an artist. At the age of fifty-five, was Agnes learning that putting down roots was more important than following your dreams?

It's the prerogative of a successful artist to suddenly alter her priorities in this way. Among the many reasons Agnes offered for leaving New York, she notes she had established her market and was, consequently, free to leave. As well as establishing her market, Agnes had also attained a reputation in the art world and larger cultural landscape: in 1967, she was selected by *Harpers Bazaar* as one of their 100 Women of Achievement. Agnes, dressed in a blouse, wrinkled skirt, and moccasins, turned up to the awards ceremony at a fancy hotel in Midtown. The security personnel took one look at her, refused to believe she was an award-winner, and turned her away. Agnes shrugged, and went for a walk.

Following on from group shows at the Jewish Museum, Guggenheim Museum and Whitney in 1966, 1967 was set to be even busier with more shows lined up, including the 30ᵗʰ *Biennial Exhibition of Contemporary American Painting* (Washington), *Mid-Twentieth Century Drawings and Collages* (Florida), *Selected N.Y.C. Artists* (New York), *Form, Color, Image* (Detroit), *10* (L.A.), *A Romantic Minimalism* (Philadelphia), *The Helen W. and Robert M. Benjamin Collection* (New Haven) and the Whitney's *1967 Annual Exhibition of Contemporary Painting*.

Painting. Promoting. Loving. Fighting. 1967 was a busy year for Agnes, and she was feeling the effect: "I came to a place of recognition and confusion that had to be solved. I had to have time and nobody's going to give you time where I was. So I had to leave."[22]

What brought Agnes to this place of recognition and confusion? Was it artistic? Personal? Professional? A combination? One possible source of clarity in all this confusion was Mildred Kane—who called on her friend in January 1967.

Mildred's return to New York happened in a bittersweet, roundabout way. When Agnes was in New Mexico with Elizabeth Kane in 1946, Mildred had given Agnes her war bonds so Agnes wouldn't go starving and could afford to eat. When Agnes had sold her first few paintings she returned the value of the bonds to Mildred, who donated the money to the Quaker organization The American Friends Service Committee, which in turn nominated Mildred to their company board. It was while visiting Philadelphia

at a board meeting in January 1967, that Mildred decided to visit Agnes and clear the air. Mildred brought a buffer, her twenty-one-year-old niece, Susan, whom Agnes had last seen as a young girl.

Susan recalls with fondness, Agnes and Mildred visiting the Elk Lake cabin where the Kane sisters (with husbands and children in tow) escaped on the holidays. Agnes and Mildred shared an army tent behind the cabin, and Agnes was first up with the children in the mornings, making coffee and taking a morning dip. Elk Lake captured Agnes's imagination. *Untitled* (1949) and *I Dream of Night Sailing* (1954) depict mountains on a lake, inspired by the nearby snowcapped Mount Bachelor and The Three Sisters range, evocatively named Faith, Hope, and Charity.

In New York, Susan recalled Agnes's enormous studio with its racks of paintings. Agnes wore her trusty quilted jumpsuit, the one that Alexander Liberman photographed her wearing in 1960. Agnes was excited to have the two women in town and was eager to show them the sights, including Ad Reinhardt's retrospective at The Jewish Museum. "I could tell that Ad Reinhardt for her was magic," Susan recalls. The big treat of the day, however, was waiting at the Museum of Modern Art, where Agnes showed them her painting *The Tree* (1964). This must have been a special moment for Agnes and Mildred to share. Mildred was Agnes's earliest supporter, but also, at times, probably an unwilling barrier to Agnes achieving her goal as an artist. Mildred must have felt gratified to see Agnes succeed. After all, Mildred was part of the Agnes Martin story going back to the start. Her influence on Agnes was unquestionable, although Agnes never spoke of her to others. Mildred had offered Agnes a stable family to join, a friendship, and a romance. Agnes was, Susan recalls, anxious at the Museum, standing in front of the painting, waiting for Mildred to say something—anything—like a child waiting for approval.

After thirty-one years of friendship, could any words capture what the women felt?

Agnes left New York in the late summer (or early September) of 1967, during a week of sweltering heat. Throughout the U.S. the Summer of Love was in bloom, and the counterculture of the flower children was beginning to go mainstream. For Agnes, however, love was not in the air. Her behavior and relationship with Chryssa were increasingly unstable. Someone, or something, had to give. When Agnes was leaving Chryssa (or the other way around) it is unlikely that she passed on the advice she gave to Daphne and Kristina , i.e. to go get married and have children. If she had, no doubt Chryssa would have wreaked a Hellenic form of retribution on Agnes.

Agnes increasingly felt the demands of being a successful artist prick her like a needle, and she knew she would be locked up in Bellevue again unless she got out of the city while she could. Her ticket to freedom came in the form of $5,000—an award from the National Endowment of the Arts—which Agnes spent on a pick-up truck and camper in Detroit.[23] Close friends knew she was planning to leave and many felt relief, for her sake. Agnes gave away her paints, paintbrushes, and canvases to dealers, including her own dealer Robert Elkon and a young dealer named Arne Glimcher, who by then was representing Chryssa, with all the challenges that the role entailed. Agnes's anguish had accelerated recently with the death of Ad Reinhardt, whose work and opinion she had always valued.[24] Painting, which had always been a release for Agnes, was now the source of her discontent:

> Everyday I suddenly felt I wanted to die and it was connected with painting. It took me some several years to find out that cause was an overdeveloped sense of responsibility."[25]

Responsibility to the market, to her dealer, to the people in her life, and to herself.

New York and American culture in 1967 was very different from 1957, when Agnes settled in the city. The rise of Second-wave feminism, a nascent gay liberation movement, the Civil Rights movement, the commercialization of the art market, the war in Vietnam, civil unrest, nuclear testing, and

various new social groups including the teenager, the Beats, and the hippie created a pluralistic confusing zeitgeist that probably left Agnes feeling out of place (in 1967 she was fifty-five). The art world, meanwhile, had its own new movements, many of which irked her. Agnes hated "isms" and every week it seemed a new "ism" had superseded Abstract Expressionism (Land Art, Video Art, Fluxus, Photorealism, Conceptual Art, Happenings, Mail Art and so forth). With the old world order diminished, and the rate of change accelerating, Agnes must have felt adrift in the world.

Agnes chopped off her long hair, packed up her new pick-up truck and camper, destroyed some paintings, put others into storage, and quit town, stopping in a Howard Johnson's and sleeping for two days before heading for West Virginia.

Tundra, her last painting completed in New York, was bought by her friend Sam Wagstaff. Writing to Wagstaff soon after, Agnes says, "I think my paintings will be around quite a while as I perceive now that they were all conceived in purest melancholy."[26] Agnes had come to New York to be an artist, and although she had succeeded, she got more than she bargained for. She was met with love, fame, friendship, and trauma. In the end, her art achieved the balance that her life could not.

In later years her psychiatrist Donald Fineberg noted that Agnes displayed signs of "psychotic ambivalence," keeping parts of her life in separate boxes.[27] In 1967 this behavior was tested when all her loves descended on New York within months of each other. Mildred visited with Susan, Kristina visited the Ford Foundation (a donor to her weaving school in New Mexico), and Betty, Lenore, and Chryssa were already close by.

All these narrative strands coming together at once did not allow Agnes time to compartmentalize her life and feelings as she had so easily done before. The different lives and loves she had in Oregon, New Mexico, and New York collided within her already tumultuous multi-voiced mind.

Though these women heartened her, Agnes needed to escape and stand on her own two feet. She needed to try to process fifty-five years of ambition and an ongoing search for belonging. Betty, who had brought Agnes to New York, and to whom Agnes would always feel beholden, blessed Agnes's next unknown step:

> May the leaves of yesterday not follow you.
> May the birds of the future guide you,
> and the voice of the wind inform you
> and the rays of the sun embrace you.[28]

Agnes was closing a chapter in her life, unsure what the next one would be—it probably did not dawn on her that, by leaving New York she was in fact inviting the kind of scrutiny and fame she was trying to escape.

ICON

Agnes Martin, 1996. Photo by Paul O'Connor. Courtesy of Paul O'Connor.

Agnes Martin in Taos, NM Studio. 1993. Photograph by Dan Budnik.
Courtesy of the Dan Budnik Archive.

Agnes Martin, 1993. Photograph by Dan Budnik. Courtesy of the Dan Budnik Archive.

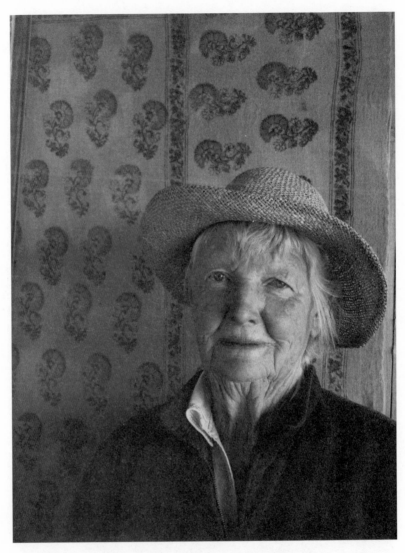

Kristina Wilson, c. 2010. Photographer unknown.
Courtesy of Ian Wilson and the Wilson Family Archive.

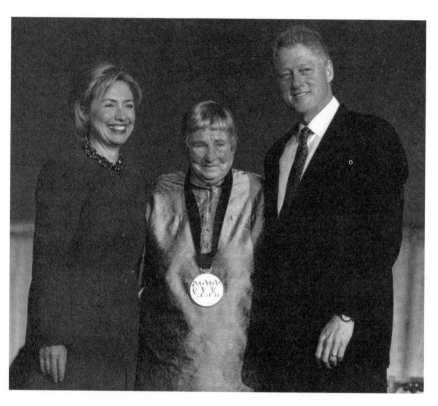

*Agnes Martin accepting National Arts Medal from President Bill Clinton
and First Lady Hillary Clinton, Washington D.C., 1998, photographer unknown.
Courtesy of the Harwood Museum of Art, Taos, New Mexico.*

TWELVE

Becoming Someone Else

A fter Howard Johnson's in New York, and her stopover in West Virginia, Agnes was next heard from at the Grand Canyon, writing in a letter to Lenore Tawney, dated November 17th 1967,

> Dear Lenore,
> I must give independence a trial. I will have to have more time. I am thinking about you too with love, Agnes.[1]

Agnes may have separated from New York, but she had not separated from her friends, regularly writing letters to Sam Wagstaff, Mildred, Kristina, Lenore, and her family. She wasn't alone for long, however. When she reached Big Sur, Lenore flew out to join her and together the women made their way through Death Valley—the hottest, lowest, and driest point in North America—and via Route 66, to Flagstaff, Arizona. Agnes spent the winter in Canada (where she drove six thousand miles) staying in empty snow-buried forest camps that during the summer would be swarming

with up to three thousand people. Although her life was at that point permanently off season, and her days no longer held the distraction of art or friends, she did manage a certain level of career control in her letters to Sam Wagstaff. As far as Agnes could tell, she had given up painting forever and was searching for the next thing to do. Writing to Wagstaff during this period, Agnes recalls two primary aims: not speaking and not staying still, "I am staying unsettled and trying not to talk for three years. I want to do it very much."[2] One has to ask the question: why did she choose silence? What had Agnes said (and to whom) in New York that warranted such drastic action? Or, was this intriguing self-censorship created as a stunt to build on the mystery of her sudden departure from New York?

Christa Martin remembers Agnes visiting Canada in the late 1960s (where she did not maintain a vow of silence). Since Malcolm Junior's death, Agnes had kept in touch with his widow, Mary Pearl, who had also occasionally visited Agnes in New York. Agnes and Pearly, as she was known within the family, had been close when Malcolm Junior was alive, but after his death, Pearly moved back to Vancouver to be nearer to her family. Pearly thought that Agnes was troubled and different, but according to Christa, no one in the family suspected that Agnes was hiding a clinical condition.

Christa recalls that her father's "untimely and abrupt death was very difficult for everybody in the family to bear."[3] It lead to less contact between Agnes, Ronald, and Maribel who were not particularly close to begin with, and had an immediate effect on Pearly, John, and Christa, who would spend their lives battling with their loss.

After Canada, Agnes returned to Oregon to visit the Kane sisters and Mildred. She traveled through Florence and Pendleton in March and September, ending up in Boulder City, Nevada, in November. Writing to Sam Wagstaff, she says,

> I do not feel very far away almost not at all as I write to you. I have been enjoying myself. I have a canoe that I put on the lakes and some rivers. Sometimes camping out and packing. Being alone and not talking I rec-

ommend. Heading for the desert and Lake Powell in S. Utah. I'm sure there is no one there. Don't worry about money but every bit helps because I want to follow the discipline (not religious) I am in now.

Best wishes,

Always,

Agnes[4]

It's likely that Agnes took on work as she traveled the Southwest and Canada. In interviews, she often listed jobs she had taken to survive, stating that when she was starving she always took a job as a dishwasher to get closer to the food. Agnes considered the work she did, whether as a painter or as a milkmaid, the only necessary biography of her life. "I consider this to be all that is relevant," she wrote.[5]

From a personal list of thirty-five jobs she had during her life, the following fourteen suggest the kind of work Agnes picked up on her year and a half traveling,

> Playground director
> Tennis coach
> Managed cherry pickers
> Hamburger stand
> Butcher shop
> Baker's helper
> Janitor
> Cook
> Receptionist
> Running an elevator in a parking garage
> Packing ice-cream
> Managed five Hindus baling straw
> Also raised rabbits and ducks."[6]

After a year and a half of traveling, reconnecting with family and friends, working odd jobs, canoeing, and camping, Agnes had a vision of an

adobe brick and considered it a sign that she should return to New Mexico and build a home. New Mexico had changed since Agnes last lived there: English had replaced Spanish as the most commonly spoken language, and fences had sprouted up between homes and land—a small symbol that many of the old ways and freedoms of New Mexican life had been replaced.

Driving to Albuquerque on Route 550, Agnes stopped at Cuba, a small, dusty village with little more than a gas station and a dirt track full of road-runners, "I asked a man if he knew of anybody who had some land outside of town up on a mesa that had a spring of water and he said his wife had such land."[7]

So it came to pass that Agnes drove her pickup and camper through the sagebrush, in the direction of the Mesa Portales. Here Agnes was surrounded by land that was beautiful, remote, desolate and sacred: including the Jicarilla Apache Nation Reservation, Navajo Nation Off-Reservation Trust Land, and Valles Caldera National Preserve. These protected lands were fitting company for Agnes while she herself unwittingly became a national treasure.

The art critic Robert Hughes, in the introduction to his book *American Visions, a History of American Art*, argues that, "The core American experience is that of officially becoming someone else: becoming American. Starting over, leaving behind what you once were."[8]

As soon as Agnes had arrived in Bellingham, Washington in 1931, she knew she wanted to become an American citizen and leave behind what she once was. Although she had to wait until 1950 to become a citizen, one could argue that her first act of reinvention was when she became a de facto member of the Kane family in 1936.Leaving NYC was simply another moment, of many, where Agnes reset the clock.

Mildred. Daphne. Kristina. Betty. Lenore. Chryssa. Each relationship was another opportunity for Agnes to start over. Unfortunately Agnes always fell into the same trap of obsession followed by flight. Agnes had always marched from one relationship to another, but she could no longer grapple with companionship or art. At this moment in time she needed solitude, believing that "neither consciousness nor self-knowledge can be

pursued socially. In groups we can compare our observations of life, but life itself is lived by individuals."[9] So it was she became an individual, with her back to the world.

New Mexico was no stranger to women establishing their independence and individuality. Georgia O'Keeffe, referred to as "the lady over the mountain," lived in Abiquiú, an hour's drive from Agnes, her onetime admirer.[10] In 1968 Georgia was on the cover of *Life* magazine with her work *Cow's Skull: Red, White and Blue* (1931). The painting and the strapline, "stark visions of a pioneer painter," enforced the commonly held view that Georgia was the artist most associated with the Land of Enchantment. Agnes had no wish to dethrone Georgia in that regard. Her return to New Mexico was quiet and without pomp. While Georgia lived in her rustic and comfortable home at Abiquiú, with bed sheets that matched the John Marin artwork on the walls, Agnes lived in an Airstream trailer, often snowed-in and without electricity, food supplies, and comforts.

"She talked a lot about solitude and she certainly got a lot when she moved over to Cuba." Kristina notes,

She had seven years of it. Hardly anybody saw her over there. That was soon after she had gotten out of the mental hospital. She was smart in that way, I think. She was living in New York. She completely lost her sanity. She was thrown into Bellevue hospital and found by some miracle by some friends of hers. She knew, I think, that the only road to sanity was to get away from New York, get away from painting, give up everything. She gave up New York, she gave up coffee, she gave up smoking, she gave up reading, she gave up people, camped around the countryside for a couple of years in her camper and settled on that remote godforsaken mesa above Cuba. She knew that she had to have that.

When asked what she did in Cuba, Agnes replied, "I got up every morning and built."[11] A home, storage sheds, and finally a studio in 1974, made up the small, mostly self-sufficient world Agnes had erected bit by bit during her seven years there. Agnes had first built with adobe in 1947 when

she built her Avalon home with Daphne Cowper and her UNM students. Adobe bricks, composed of sand, silt, and dung, had been used by native tribes for thousands of years. Making the bricks was a cheap, time-consuming, traditional, and laborious undertaking that whiled away the hours. Agnes hired a farm boy to help her lug wooden beams into place, and the architect Bill Katz, a friend of Georgia O'Keeffe, visited to offer his assistance.

Upon arriving back in New Mexico, Agnes reconnected with some of her friends including Kristina and her son Ian, now twelve years old.

When Agnes left for New York in 1957, Kristina, newly married, moved to Albuquerque with her husband—but within the year her marriage was over. Her friend Joan Potter Loveless recalls Kristina at this time, "recently divorced, shy, and decidedly lonely." Kristina was also pregnant, waiting "for her child to be born."[12] Isolated and lonely, Kristina lived in a "little house," described as "just a small rectangle," on a quarter of an acre her brother had gifted her.[13] To pass the time and quell her loneliness, she turned to weaving. Kristina had first used a loom at Columbia Teachers College, where she studied occupational therapy for three years and was required to take classes in art. After her degree, although she continued to teach weaving at the Las Vegas State Mental Hospital, Kristina never fully explored her own vision for the craft, something she finally found time to do during her hour of darkness:

> I was living in one room with that loom—no lights, no electricity, not really a road, even. I'd work half the night because I couldn't sleep; I was desperately lonesome and that loom saved my life.[14]

The loom saved Kristina's life in many ways. The medium was therapeutic but it was also a source of much-needed income, and Kristina could weave pillows and bags quickly, and bring them to market. Friends soon joined Kristina in her endeavours, and eventually a cooperative of craftspeople was formed in Taos. The studio Kristina shared with her friends was called the Craft House. It was a lively environment where children

watched the adults weave during the day, and artists gathered in the evenings for poetry readings, exhibitions and dances.

Kristina and Agnes lived very different lives in New Mexico. While Agnes was living a solitary life in Cuba, Kristina was also rebuilding her life and becoming someone else. Shy and single, Kristina had learned to stand on her own two feet, stepping outside of her comfort zone, and raising her son on her own. She was entrepreneurial, and working within Indian and Spanish communities she set up cooperatives, summer schools, and local businesses. Over the years, Kristina often travelled for work in and around New Mexico, as well as farther afield to the Bahamas and San Francisco. On at least one occasion Agnes became Ian's babysitter.

Agnes had always been intrigued by children, and, aside from Malcolm Junior, Ian was the closest she came to seeing a person grow from a baby into an adult. In 1970, Ian spent more than three weeks in Cuba with Agnes while Kristina was traveling for work. There was little to do except take treks, have picnics, read, shoot squirrels, swim, and drive to another spot where you would trek, picnic, read, shoot squirrels, swim, and drive home. Agnes loved having Ian around. She was enthralled by children and believed she could tell exactly what career each child was destined for. Six years later she made a film based on one boy's experience of trekking in the wilderness. She called the boy and the film Gabriel, but one can fancy Ian as her inspiration.

In 1970 Agnes also learned of the deaths of Mark Rothko (in February) and Barnett Newman (in July). The deaths of both men were sudden: Rothko committed suicide and Newman died of a heart attack. In an interview with John Gruen in 1976, Agnes publicly announced that she believed Rothko had been "done-in" by people hoping to profit from his death.[15] Elsewhere Agnes commented that Rothko died from remorse and the pressures of conformity to the art market. In the same year, she told Kate Horsfield, "they killed Judy Garland, they killed Monroe...public demand made their lives so unlivable that they died of it. And so did Pollock."[16] This fear of succumbing to public demand was one reason Agnes escaped to the desert, though it did not quell demand for her work. New York and the art

world had not forgotten her. She had exhibitions at the Nicholas Wilder Gallery in Los Angeles, the Robert Elkon Gallery in New York in 1970 and 1972, and the School of Visual Arts in New York in 1971. Agnes was also included in multiple group exhibitions from 1967–1973, including at the Whitney, the Museum of Modern Art, Kunstahus Zürich,the Tate Gallery, London, and *Documenta 5* in Kassel, Germany, famously curated that year by Harald Szeemann—where one of her works was vandalized. With such a high profile and continued exposure, it felt as if Agnes had never gone away.

"She made a very smart move," says Kristina,

I don't know if she knew that. In a sense she died. And when you die you get famous. And then she came back to life. She never made a mistake. Every move she made. It all lead to building up this mythical being.

THIRTEEN

Cuba, On a Clear Day

It is not possible to stay hidden forever, especially when the world is trying to track you down. In 1973, after six years of living remotely and refusing to see most people, Agnes rose like a phoenix from the ashes. This resurrection took the form of new paintings, the publication of her writings for the first time in art magazines, the first retrospective of her work in the U.S. (including an exhibition catalog), and an in-depth profile in the *Village Voice* by her old friend Jill Johnston. This whirlwind of activity firmly repositioned Agnes in the national art scene, especially as variations of her retrospective traveled across America, and then abroad.

Agnes also started welcoming people to Cuba, though she was picky. In a letter to Sam Wagstaff, dated December 20th 1971, she gives her reasons for denying one particular guest:

Dear Sam,

Thank you for lending your paintings. I feel as though the students should thank you too. I wish Mr. ? would send me a list of the paintings shown. I don't understand anything about the whole business of paint-

ing and exhibiting. I enjoyed it more than I enjoyed anything else but there was also a 'trying to do the right thing' a kind of 'duty' about it. Also a paying of the price for that 'error' that we do not know what it is. What we 'owe!' Now I do not owe anything or have to do anything. Fantastic but even more fantastic I do not think that there will be any more people in my life. With about thirty years to go that is very odd. Do not think that it is sad. It is not sad. Even sadness is not sad.

About the boy that wishes to come and see me I say 'no' to this particular one, because of 'friends of friends.' That is a pernicious business. It is hard enough to see one's path (of destiny) but if one keeps wandering off on others' paths it is impossible. For his own sake then I say 'No.' Tell him that I say he should try hard to know himself and what he wants. Put the need for knowledge about <u>himself</u> before <u>anything else</u>. For this he has to "see" his own thoughts accurately (not others).

If you are going to make a change I am sure it will be in the right direction.

Agnes.[1]

Earlier in 1971, Agnes had welcomed the young curator Douglas Crimp and his friend, the artist Pat Steir, to her home. Although Douglas had organized a small and well-received exhibition of Agnes's work at the School of Visual Arts in New York in April, he was nervous about meeting Agnes in the flesh. When he arrived in New Mexico he got cold feet, rang his friend Pat and offered to pay her plane fare if she could take the next flight out and join him for the trip. Pat was a huge fan of Agnes's work and joined Douglas willingly.

Agnes's compound on the mesa was not easy to find. On one occasion, friends from New York came all the way to the mesa and had to turn back because they could not locate Agnes's plot. Pat and Douglas were destined for a similar fate. Pat recalls,

We got lost for 12 hours. Thirsty. Sunny...finally we went to the post office and asked if they knew how to get there, and they told us again.

And we couldn't find it. And finally, we just sat at the bottom of the mesa. And sooner or later she came down in a pickup truck...But like 12 hours later...[2]

The long and frustrating search inspired Pat's painting *Looking for the Mountain* (1971), a cartographic and abstract homage to the trip and Agnes. Agnes was twice the age of her guests and unaccustomed to entertaining strangers. Nonetheless, Pat recalls a dedicated host,

> I sat up most of the night talking to Agnes in her room. She was—it was so beautiful. There was a fireplace on one side and a rocker. She sat in the rocker. By the window, there was a table that—she had cooked fried chicken and had white wine for us, so we had a big dinner with her that she made. And then Douglas went to sleep after a while...Agnes and I talked about love. And Agnes said she once fell in love with a cow, but it was very difficult because she could only look into one eye at a time."[3]

Agnes may have been a dedicated host, but she had limits and expected the host's prerogatives to be met: Pat and Douglas's trip was cut short in an embarrassing manner when Pat refused to show Agnes her sketchbook:

> I said no because she was my hero, and I thought the work wasn't good enough. And she got upset because she was a hermit and hadn't seen anybody but Sam Wagstaff for a number of years, and here I refused her...so in the morning she asked us to leave, even though we were supposed to stay and help her chop down trees and do some things for a few days. And I cried all the way to Salt Lake City. My nose started to bleed. I got my period. And Douglas kept saying, 'What's wrong? What's wrong? Why did we leave?' In fact, our car wouldn't start, and she fixed it for us just to get rid of us.

Robert "Bob" Feldman from Parasol Press had a more successful (and less embarrassing) result from his visit the same year. Bob was in Cuba

to encourage Agnes to create a set of prints, which he hoped would be etchings she could do at Crown Point Press in California. Agnes, however, wanted to produce a set of silkscreen drawings that she felt could straighten her hand-drawn line and bring the work closer to the Platonic ideal of perfection.

Bob sent Agnes's initial drawings to Luitpold Domberger at Edition Domberger in Stuttgart, a press that had already collaborated with a number of artists on their work: George Baselitz's *Figuration* (1967), Cy Twombly's *On the Bowery* (1969–1971), and Robert Rauschenberg's *Revolver* (1970). In 1972 Agnes visited a snowy Stuttgart with Kathan Brown from Crown Point Press to work out the specifications of the project. Kathan recalls,

> [Domberger's] method of operation was to trace artists' drawings and cut them into film that they adhered on screens printed semi-automatically by a machine tended by people. There was no artist's studio, but the director loaned Agnes his office so she could pin up proofs and look quietly at them. The only place to pin them was the back of the door, which occasionally opened, but it worked out all right.[4]

The final result was a portfolio of thirty prints entitled *On a Clear Day* (1973) made in an edition of fifty, with fourteen added artists' proofs. Each print measured twelve by twelve inches and was printed on Japanese rag paper. *On a Clear Day* is perhaps the most mechanical looking of Agnes's output and her most reductive and grid-based. In a comment on the work written in 1975, Agnes says,

> These prints express innocence of mind. If you can go with them and hold your mind as empty and tranquil as they are and recognize your feelings at the same time you will realize your full response to this work.[5]

On a Clear Day was the first work of art Agnes had created since abandoning painting in 1967, and upon its completion in 1973 it was shown

at Galerie Yvon Lambert, Paris and the Museum of Modern Art, New York. The series of prints would prove popular throughout Agnes's life. The Scottish National Gallery of Modern Art, the Fine Arts Museum, Santa Fe, Chinati Foundation, Marfa, and Gallery N. von Bartha, London, would each host *On a Clear Day* exhibitions in 1974, 1991, and 2000, respectively.

As well as visiting Germany, Agnes welcomed Ann Wilson, her old Coenties Slip neighbor, into her home to notate her lectures and compile her writings, which were submitted to the University of Pennsylvania archives and a forthcoming exhibition catalog. Agnes also wrote to Sam Wagstaff telling him that her "small log" guesthouse, amid a "landscape like Chinese paintings," was now open "to any one who wishes to come."[6] As part of her return to the world her moratorium on receiving guests had been lifted.

When, as Kristina says, Agnes came "back to life" in 1973 it was in spectacular fashion. The most important event of the year, in January, was a retrospective exhibition of her work at the Institute of Contemporary Art (ICA) at the University of Pennsylvania. This exhibition, organized by Suzanne Delehanty, traveled to the Pasadena Art Museum—now the Norton Simon museum—in California in April. In addition to this, Agnes's first solo show outside the U.S. was also held in Germany at the Kunstraum München (November 1973), moving on to the Kunsthalle Tübingen (January 1974), and the Kaiser Wilhelm Museum, Krefeld (March, 1974).

Suzanne Delehanty was a graduate student in art history at the University of Pennsylvania and part-time employee of the Institute of Contemporary Art when she was first "filled with wonder" by Agnes's work *Adventure* (1967), *Desert* (1967) and *The City* (1966). These three paintings were included in the exhibition *Romantic Minimalism*, organized by the ICA director, Stephen Prokopoff, in September 1967. Suzanne recalls,

> I visited the galleries every day to see Agnes's painting. It was delicate and at the same time powerful. Her pencil lines were alive; they were both firm and quivering. Amazing contradictions.[7]

Suzanne wanted to know more about the artist, who happened to be the only woman in the exhibition, as well as much older than the men. An organized student, always, Suzanne began a file. Her interest in Agnes and contemporary art took her by surprise because she was, in practice, a scholar of Roman art. However, bit by bit, Suzanne's attention was migrating away from Ostia Antica and Leptis Magna towards the works of Joan Snyder, Richard Paul Lohse, and Agnes. As a result, Suzanne started visiting galleries and artist studios in New York and Philadelphia. Whenever Agnes's name came up, usually in admiration, Suzanne would make a note of where a work was located or where she might find out more about the artist. Suzanne had the opportunity to put this research to good use in 1971 when Stephen Prokopoff moved to Chicago's Museum of Contemporary Art and Suzanne was appointed the director of the ICA. The first two shows she suggested, with some timidity, were *Grids* and an exhibition of Agnes's work. Suzanne recalls,

> *Grids* opened in early 1972 and featured the work of a wide range of artists, among them, Ellsworth Kelly, Richard Paul Lohse, François Morellet, Pat Steir, Joan Snyder, and, of course, Agnes Martin. At the same time, I began planning a solo show for Agnes Martin with the full support of the ICA's wonderful advisory board members, including—I discovered—two of Agnes Martin's earliest collectors, ICA founder Lallie Lloyd and Daniel W. Dietrich.

In late 1971 Suzanne wrote to New Mexico and asked if the ICA might create an Agnes Martin exhibition. Agnes said yes, allowing Suzanne complete freedom in planning the show, selecting the artwork and commissioning the catalog. "As a very young curator, this was an immense privilege and responsibility," and one that Suzanne embraced fully:

> My aspiration was to present the work in a way that was meaningful to Agnes and to the people who came to see the show. The exhibition focused on her work from 1957, when she moved to New York and settled

on Coenties Slip, to 1967, when she left New York and stopped painting. I knew that my time would be best spent on tracking down works, securing key loans for show, planning the installation, and serving as the publication's editor. In order to learn as much as I could about Agnes's art I visited public and private collections around the United States to see her work first hand. All the private collectors I met cherished their 'Martins' and were excited about the project. Many were also Agnes's friends who cared deeply about her wellbeing. When the exhibition opened in January 1973, there were thirty-seven big paintings, thirty-five watercolors and drawings, and three constructions from more than forty lenders from around the country.

True to form, Agnes was not totally absent from the preparations. When she drove down to the Cuba village to collect her mail once a week, she rang Suzanne from the public pay phone to discuss the progress of the show (Agnes was otherwise distracted, building her Cuba studio). Suzanne was sensitive to the fact that the exhibition was Agnes's first major solo artist show, and the first major exhibition of her work since she'd left New York in 1967. With that in mind, great care was given to the exhibition catalog as a permanent manifestation of the content and essence of the exhibition. Suzanne invited Lawrence Alloway, the noted English art critic, to write the main essay and Ann Wilson agreed to visit New Mexico to work with Agnes on her writings. Eugene "Gene" Feldman, the artist and founder of Falcon Press in Philadelphia, undertook creative direction of the publication. Suzanne recalls spending many Saturday mornings at Gene's press considering typefaces and studying papers.

We decided that the best way to give the reader a sense of the delicate textures of Agnes's work was to show close up details of her big paintings as full-page bleeds. From the get-go, we knew the catalog's format needed to be a square and debated between an eight- and twelve-inch-square format. Through Ann Wilson, I learned that Agnes would be in heaven if the catalog were nine inches square like her drawings. This was

the only time Agnes ever whispered a suggestion. It was on the mark and Gene made it happen.

After hours of telephone calls and many letters forward and back, Suzanne and Agnes met for the first time after the exhibition opened in February 1973. Agnes loved the show and her lecture *The Underlying Perfection of Life*, was a standing-room-only success. The catalog, publishing *The Untroubled Mind, Parable of the Equal Hearts* and *Willie Stories* for the first time, became an immediately coveted publication. Agnes was enthused,

> Dear Suzanne, if this catalog is an accurate indication of the composition of the show—it is hard for me to wait to see it/ I thought your introduction just right and the choices beyond my hopes just right...very happy Agnes.[8]

Suzanne found Agnes kindhearted and forthright throughout their collaboration and the two kept in touch throughout the following years. Before Agnes left Cuba in 1977, Suzanne had the opportunity to visit the studio she had heard described over the telephone in 1972. Agnes also took her to the kivas of the Anasazi, hiking in the Sangre de Cristo Mountains, and to a quarter horse race.

In 1975, when Agnes had her debut show at the Pace Gallery showing her first new work since she had stopped painting, she invited Suzanne to a celebratory lunch in New York. At the lunch Agnes told Suzanne that the ICA show had given her the courage to paint again.

"The Agnes Martin show holds a very special place in my heart," Suzanne reflects, "because it encouraged one of the most talented artists of the twentieth century to continue working for three more decades. That is a gift for all of us."

The next time Agnes met the Cuba-banished Pat Steir was at the Pasadena Art Museum, for the Californian leg of the ICA tour. Pat was recruited as Agnes's guide for the opening, and upon seeing her Agnes disclaimed, in jest, "You're just like a bad penny. You turn up."[9] After the opening, Agnes invited Pat to Cuba again, and Pat accepted the invitation, this time traveling with the sculptor Elyn Zimmerman. Elyn and Pat stayed with Agnes for four days, after which the three women went camping up the Rio Grande and the dunes north of Taos. Elyn recalls that Agnes was on a strict diet of yogurt and canned fruit to lose weight, but her spirits were good. Agnes was spending a lot of time in her studio where she had started to paint again, and she was forthcoming in her conversations, talking about her breakdown in India, her competitive brothers, her need to be alone, her life at Coenties Slip, and her plans to shoot a movie about a young boy. Pat's second visit to Agnes was a resounding success and Pat would continue to develop her friendship with her "hero" on annual visits over the next thirty years.

1973, the year of Agnes's return to the world, also saw the publication of a number of important interviews and reviews that increased the profile of the artist at both a local and national level. In *Artforum* (April), the critic Lizzie Borden delved into Agnes's early work, while in the *Village Voice* (September) Jill Johnston wrote one of the best profiles on Agnes: 'Agnes Martin: Surrender and Solitude.' Other reviews and profiles in *Studio* (February), *Art News* (May), *Art in America* (May), *Flash Art* (June), *Vogue* (June) and *Santa Fe New Mexican* (July) combined to bring Agnes back to the public eye.

Perhaps the most important rebrand that took place in 1973 was that of Agnes as a writer. More than anything, it was Agnes's writings that secured for her the place of guru and oracle in American art, a role she had first cultivated at Coenties Slip with her Gertrude Stein seminars and solidified in the desert: her home a site of pilgrimage. With the publication of her writings, Agnes continued to cultivate this persona, and to garner a legion of new and young fans.

Agnes always maintained that her work existed independent to the art-

ist and that the only thing that mattered was the viewer's response and not the artist's intention. However, with Agnes's writings, it was more difficult, in fact, almost impossible, to separate the artist from her words. Agnes wrote in the first person and her intimate discussion of beauty, perfection, inspiration, struggle, pride, disappointment, and defeat influenced the audience's perception of her artwork and her character. The function of writing in her life was explained to one interviewer when he asked Agnes what she hoped to accomplish through it. Agnes replied, "Oh, I was just staying sane...I think that anybody who goes to live a solitary and simple life would naturally write a journal to keep you company," while later adding that "I wouldn't want to publish all of my speeches. After a while I get so I don't like them so well."[10]

One piece of writing that became widespread over the years is her lecture *The Untroubled Mind*, first published in the ICA catalog in January 1973, in *Studio* magazine in February, and *Flash Art* in June the same year. *The Untroubled Mind* is an instruction manual for life and art, as well as being Agnes's personal manifesto, touching upon her preoccupations with beauty, inspiration, sensibility, nature, and classicism. The untroubled mind is the free state an artist must occupy in order for inspiration to come. To be free it is necessary to be "detached and impersonal,"

> If you don't like chaos you're a classicist
> If you like it you're a romanticist
> Someone said all human emotion is an idea
> Painting is not about ideas or personal emotion
> When I was painting in New York I was not so clear about that
> Now I'm very clear that the object is freedom
> not political freedom, which is the echo
> not freedom from social mores
> freedom from mastery and slavery
> freedom from what's dragging you down
> freedom from right and wrong
> In Genesis Eve ate the apple of knowledge

of good and evil
When you give up the idea of right and wrong
you don't get anything
What you do is get rid of everything
freedom from ideas and responsibility
If you live by inspiration then you do what comes to you
you can't live the moral life, you have to obey destiny
you can't live the inspired life and live the conventions
you can't make promises...[11]

It takes concentration and rereading to decipher Agnes's writings. The style in *The Untroubled Mind* is declamatory, circuitous, aphoristic, and disjointed. Agnes's references gallop at the reader: Saint Augustine, Sylphs, William Blake, Genesis, Isaiah, and Plato, to name a few. *The Untroubled Mind* is the opposite of the Socratic dialogues Agnes admired, which are more moderate, more easily digestible. The lecture is not literary in the sense that it was written to be read. Nor does it heed the architectural plan of an idea and the building blocks of language. Many of Agnes's writings were not intended to be read. They were written to be listened to in a specific context: among visiting friends illuminated by candles in the dead of night, or during a road trip through New Mexico, and occasionally a public lecture.

Aside from her precepts for artists, *The Untroubled Mind* is interesting as a source for exploring Agnes's schizophrenia, which was not public knowledge at the time.

I am constantly tempted to think that I can help save myself
by looking into my mind I can see what's there
by bringing thoughts to the surface of my mind I can watch them
dissolve
I can see my ego and see its intentions
I can see that it is the same as all nature
I can see that it is myself and impotent like nature

impotent in the process of dissolution of ego, of itself
I can see that its main intention is the conquest and destruction of ego,
of self
and can only go back and forth in constant battle with itself
repeating itself
It would be an endless battle if it were all up to ego
because it does not destroy and is not destroyed by itself
It is like a wave
it makes itself up, it rushes forward getting nowhere really
it crashes, withdraws and makes itself up again
pulls itself together with pride
towers with pride
rushes forward into imaginary conquest
crashes in frustration
withdraws with remorse and repentance
pulls itself together with new resolution...[12]

This description of internal battle between two selves (that ultimately pulls itself together again) appears to be a personal account that has come about through reflection and an admirable honesty that leaves the speaker exposed and vulnerable. If we are to understand that the artist has experience of what she writes then it seems fair to argue that Agnes's writings confront a reality that her paintings cannot. According to Agnes, her paintings are about innocence, joy, happiness, and love, but her writings on the other hand confront conflict, defeat, ego, and salvation.

It is by dividing herself that Agnes can do battle with the ego and suppress its desires—*her* desires. The dualism—which we first saw in the *Parable of the Equal Hearts* and *This Rain* (1958)—created a way of thinking and acting that would serve Agnes throughout her life. Agnes waited for her voices, waited for her inspiration, and asked her inspiration for advice. The concept that there is a source of logic within her—or a higher level of intelligence that her ordinary self must turn to—created a fracture in her character but also offered a kind of safety net.

Destroying the ego isn't possible, nor is it preferable. The ego, in popular parlance, denotes a person's self-esteem, and in psychoanalysis is the mediator between the conscious and unconscious. In the broadest sense the ego plays an important role in achieving balance in mood and behavior. What Agnes seems to be suggesting is that the ego is dominating the other sides to her personality and life and needs constant monitoring. The artist could only find balance by shrugging off the world and letting the weight of responsibility fall to the floor. It was only then, when she no longer had the trappings of a personality—"no more conquests, no longer an enemy to anyone, no longer a friend, master slave"—that she could be at peace.[13]

Descriptions of this kind would certainly have surprised and confused both established fans of Agnes's work as well as new audiences. Writing so laden with visual images and literary conceit must have seemed unusual from a person whose own visual output contained no worldly images or emotional highs or lows. These writings also provide a glimpse into the kind of sermonizing Kristina experienced in her relationship with Agnes; lectures that lasted hours upon hours, where the listener struggled to keep up with Agnes's words, so heavy, they appeared, with meaning.

In the same year as the publication of *The Untroubled Mind*, *Reflections* was published in *Artforum*. *Reflections* is a more accessible piece of writing, and one that speaks, in particular, to young artists. Taking into account the success Agnes was having in 1973, the piece is a humble one (extolling humility), which explores the relationship between the artist, the piece of art, and the viewer.

> The bad paintings have to be painted
> and to the artist these are more valuable than those paintings
> later brought before the public.
> A work of art is successful when there is a hint of perfection
> present—
> at the slightest hint...the work is alive...
>
> The responsibility of the response to art is not with

the artist.
To feel insufficient,
to experience disappointment and defeat in waiting
for inspiration
is the natural state of mind of an artist.[14]

Lizzie Borden, in her appraisal of Agnes's early work in the accompanying article, picks up on the "long periods of trial and error," and "the slow and painful struggle," that Agnes experienced in order to achieve her vision. Through Borden, we learn just how harsh a critic Agnes was of her own work, in particular at Coenties Slip. Borden writes, "Agnes destroyed almost all of a series of dark paintings with rows of circles done in 1959, such as *Lamp*," as well as destroying in the early 60s "one series of paintings, with horizontal lines and diagonal rather than vertical cross lines."[15] Borden goes on to describe several paintings "with hieroglyph-like elements in a grid, but clustered in configurations toward the center of the canvas."[16] All of these early paintings were lost or, more probably, destroyed by Agnes.

Creativity did not come easily or naturally to Agnes, who carried with her a sense of failure throughout her life. However, failure was not always a negative state, it could often be the starting point to the creative act. It is worth remembering that Agnes was forty-six when she had her debut one-artist exhibition in New York (1958) and fifty-two when she painted *The Tree* (1964), which she considered her artistic breakthrough. Many artists, including Barnett Newman and Lenore Tawney, were middle-aged when they had their first solo exhibition, but comparisons didn't soften the personal frustration Agnes felt when her own career failed to progress.

Her return to painting, as we can expect, was not an easy path. Writing to Sam Wagstaff from Cuba, Agnes discloses her first attempts at painting in six years, "[I]Think I will be able to make the little paintings. Still terrible slow pace of one a month."[17]

Meanwhile, Lizzie Borden, writing in 1973, mentions that Agnes had recently destroyed "almost a year's work" before completing what became

On a Clear Day. As always, Agnes was editing out her work to the point of nonexistence.

In 1973, Agnes was also looking forward to her studio construction being finished: "When I finish my studio I'm going to paint again, but the new paintings will be happiness paintings...I don't think people will like my new paintings, but they'll be quite a kick."[18] It turns out Agnes was wrong about this, people very much enjoyed her happiness paintings and it was a theme she returned to over and over throughout her life. "There are an infinite number of different kinds of happiness," she said, "so I'll never run out of what to do."[19] Agnes was true to her word.

Another thing that was "quite a kick" in 1973 was Jill Johnston's serialized portrait of Agnes for the *Village Voice*. Nearly ten years previously, in 1964, when Jill was a reviewer for *Art News*, she sought out Agnes after seeing an exhibition of the artist's work at the Robert Elkon Gallery. Sitting in Agnes's cold loft on South Street, a mug of tea cupped in her hands, Jill was given star treatment as Agnes presented her work, hitching and unhitching her paintings onto the wall for Jill to view and contemplate. Jill was impressed by the artist as well as the art. "I knew she was one of the great women," writes Jill in the *Village Voice*:

> It was a pleasure finding a great woman in new york city during the terrible times of the 60s during every terrible decade it's a pleasure finding a great woman...one way you knew agnes martin was great was because she lived decisively alone and that this was an active irrevocable choice and because she put very little stock in people at all and another way you knew she was great was because her paintings were.[20]

When they first met, Agnes welcomed Jill with "no makeup or hairdo or any female appurtenance or for that matter mannerism."[21] This impressed Jill, who consciously costumed herself in opposition to the then, feminine norm. In the early 1960s women's popular fashion (not to mention behavior) was strictly defined. Jackie Kennedy. Shift dresses. Fitted waists. Pearls. Stilettos. Pumps. By the end of the decade there was no fashion,

only *fashions*. These fashions were reactionary, delineating social stand-points (the Hippie, Mod, Single Girl), identity (Afro, Beehive, androgyny), and the aesthetic (PVC, miniskirt). In the early 1960s Agnes dressed like she was stuck in the 1940s and Jill dressed like she had fallen into an Eastern Bloc bazaar: aviator sunglasses, flared jeans, army boots, tailcoat, cravat, military insignia.

The two women became unlikely acquaintances, meeting at parties, at Agnes's studio, and occasionally camping together with friends. Despite their surface differences, they had much in common. Both women had schizophrenic episodes, both had identity issues rooted in their sexuality, and the biography of both—including their sacrifices and their philosophies—made its way into the fabric of their work, albeit in different ways: Agnes was a classicist with her back to the world; Jill was an anarchist, baring her breasts to it.

Jill started at the *Village Voice* as a dance critic. She was a groupie in the experimental dance and art scene that centered around the Judson Dance Theatre in Greenwich Village in the early 60s. By the 70s, Jill had become a kind of modern-day Samuel Pepys. Her articles revealed as much about the writer as they did the times she documented. Jill's style was notable. She sidestepped punctuation and capitalization, had a fondness for stream-of-consciousness prose, and was the queen of malapropisms as her book's title, *Gullibles Travels*, shows.

Jill's discussions on women, lesbianism, feminism, mothers, daughters, travel and, occasionally, men, always came back to Jill herself. However, if Jill's writing was indulgent, it was an indulgence with an aim toward exposing the challenges of living in a world where women were not an equal sex, and gay women even less so. Jill struggled, like Agnes, to belong. She was political, but nobody wanted her on their side: she was too unpredictable, too outspoken. The feminist factions were scared of her; the radicals thought her too radical.

Jill was a free spirit in a way that Agnes was not. In 1970 she came out in the *Village Voice* in her article "Lois Lane Is a Lesbian," and in 1973 she rolled around on the stage floor of New York's Town Hall in a faux orgy,

during a debate with Norman Mailer, Germaine Greer, Jacqueline Ceballos, and Diana Trilling. Agnes and Jill were worlds apart. What exactly would they say to each another?

Jill arrived in Cuba in 1973, a week after hearing Agnes give her talk, "The Underlying Perfection of Life," at the Pasadena Museum in Los Angeles, where she had bumped into Agnes by chance.

Jill was nervous about meeting Agnes alone, so, like Douglas Crimp, she brought along a friend. Also like Douglas and Pat Steir, Jill got more than a little lost trying to find Agnes on the Portales Mesa: "We had passed the half-eaten carcass of a cow right long the side of the road and that seemed to create an adage in my mind that when you see a dead cow you should turn back."[22]

Visiting Agnes was a pilgrimage for Jill, who was often in need of making pilgrimages. Agnes, in particular, was a soothsayer for the young writer: during a camping trip in Haverstraw, New York in 1966, Agnes had "divined" Jill's future, telling Jill she would "go insane again," which Jill did, at the end of that Summer. Jill recalls the breakdown in Massachusetts, and ringing up Thalia Poons and Agnes, who arrived in a borrowed Volkswagen Beetle to rescue her.[23]

Agnes knew of Jill's battles with her condition, but Jill never entirely understood Agnes's, and she was too afraid to ask. When Agnes asked Jill, out at a canyon, in the glow of sunset, if she had experienced "domination or being dominating," Jill assumed Agnes was referring to lesbianism and "alluding to women as role players," but Jill did not have a sense of the full extent to which Agnes subscribed to this paradigm in relationships. In fact, Betty Parsons also saw relationships along the line of passive and active, creating a dynamic of what Agnes called "enslavement," a pattern of behavior that Agnes, by exiting New York, was trying to leave behind.[24]

Jill was afraid to answer Agnes's question. Perhaps it hit too close to home. Jill was in awe of Agnes—and intimidated by her—and she had no wish to talk about lesbian dynamics, reasoning that Agnes was "better off in the desert throwing mud at her adobe" than with Jill pursuing women with nothing in common other than their objections to patriarchy. Jill

tread carefully in her answer. Gender was at the heart of Jill's life and discourse, whereas Agnes denied that she had a gender, and claimed that gender had no role to play in art. To Donald Woodman, Agnes said, "No, I am not any of those stereotypes that are placed on women. I am an old woman, but I insult the male ego so men don't like me around. Neither I nor Georgia O'Keeffe nor Louise Nevelson are women's Liberation oriented—they and I just do as we need and want to do."[25]

The consciousness-raising feminist artists and queer artists of the seventies would find Agnes's genderless art standpoint difficult to digest. Despite this, Agnes became a secret gay icon for a whole generation of women artists, perhaps encouraged by Jill's *Village Voice* piece.

Agnes later said that "I'm not a feminist the way some people describe it," which begs the question, in what way, if any, was she a feminist?[26] Subsequent critics would read into Agnes's art and lifestyle a feminist refusal to perform a role and produce a kind of art that conformed to traditional views of womanhood. The former, Agnes might agree with, but the latter, definitely not. In Cuba when Jill made the suggestion that Agnes was curtailed by her gender, Agnes was defensive:

I read a hilton kramer review she had there of her retrospective in philadelphia and couldn't help saying the reason she doesn't have the reputation hilton kramer says she should have is because she's a woman. But agnes knows exactly who or what she is or isn't she shot back I'm not a woman and I don't care about reputations. I said well I wouldn't come to see you if you weren't a woman. She concluded the argument saying I'm not a woman, I'm a doorknob, leading a quiet existence.[27]

Agnes reviewed her stance on gender a year later, saying,

The female sensibility is a conditioned response, a learned response. We can all remember the suggestions we accepted and the examples we followed. We struggled to be finer grained, more delicate, more sensitive. We limited our thoughts and actions. The result was an

appearance of insecurity and defenselessness—an absolutely sure dependence. Independence is the most necessary trait in an artist. The concept of a feminine sensibility is our greatest burden as women artists.[28]

This, from a woman who refused to be labeled as such, is a giant statement and, arguably, Agnes's most overtly political. It was inevitable that the feminist discourse of the era should surface somewhere in Agnes's interviews and lectures. Agnes had known many strong and uncommon women in her lifetime, including her own mother, and while she may not have wholly identified with second-wave feminists such as Jill, she nevertheless, as this statement shows, identified with the broader "burden" on women and women artists. Perhaps Agnes's refusal to identify as a woman or woman artist was a way for her to move the conversation beyond differences and more towards similarities—from the particular to the universal?

Jill's portrait of Agnes is one of the most personal, evocative and fun pieces of writing on Agnes in print, perhaps because of the simpatico relationship between the two women. Most writers are too reverential toward Agnes, portraying her as a kind of sexless desert oracle. Jill was equally reverential (even maybe more so) but she was not afraid of showing the contradictions in Agnes's character and talk. Jill questioned the guru status and the expectations of the pilgrim:

do we have to give honor in person to our sages standing outside the affairs of the world. Or bother them with ideas of themselves that they don't have themselves and be bothered ourselves by ideas of ourselves they may have that we don't or bother at all.[29]

Jill also captured Agnes's complex attitude toward people, in particular her indifference to them. On the latter, Jill explains that on one occasion, a sonic boom knocked Jill, and the chair she was sitting on, to the ground. Agnes, reprising her lecture "The Underlying Perfection of Life," didn't notice the sonic boom, or Jill tumbling after, and continued speaking with-

out a break in her delivery.

However, there was also a side to Agnes that loved entertaining people. Most people explain that when they visited Agnes she had always prepared a meal and baked goods to welcome them, and when she had social commitments, she sat patiently (and maybe nervously) waiting for guests to arrive. If Agnes was truly a hermit she would never have given so many lectures over the years, and there was probably a side to her that enjoyed dressing up and keeping her public appearances.

Jill hits the nail on the head when she says Agnes was "delighted to see people but her fear of being disappointed by people is intense."[30] Being disappointed is one thing. Agnes can weather disappointment. What Agnes struggled with was the demands—however trivial—created by people's expectations. In order to protect herself, Agnes had moved to a remote mesa, where she could control whom she met and for how long. Even with short visits Agnes could become overwhelmed by her guests. One morning during Jill's visit, Agnes woke up, indignant, claiming she had had bad nightmares that didn't belong to her. Jill admitted she had a nightmare the night before and Agnes explained that this was why she couldn't be around people; she takes on their pain.

In many of her earlier interviews Agnes was free with her thoughts and her time. As she aged and became successful, she tended to wear the guru mantle too often, repeating the same script for each interviewer. This changed toward the very end of her life when her interviews suddenly became fun, personable, and a little revealing. Agnes was also a very generous interviewee, frequently asking her interviewer questions, in particular when they were younger than her (which was mostly the case as she aged). She even acquiesced a point or two. In 1993 when Sally Eauclaire suggested to Agnes that she was "a hero to many women," Agnes responded, laughing, "a heroine at least." Agnes gave Johnston no quarter on the topic of her gender, choosing to be called a doorknob instead of a woman, but in 1993, it seemed important for her to correct Sally Eauclaire's gender-specific choice of noun.

Back in 1973, for most readers, in order to really know something of

Agnes, only Jill's portrait would do. Agnes's "cosmic giggle" and "twinkling blue eyes," her "full" body, "solidly there yet shy and a little retreating at the same time," were all small details that brought Agnes to life for a whole new generation of artists and admirers.[31]

It was unforeseeable that *On a Clear Day*, the first project Agnes completed since quitting painting in 1967, would involve a new medium. Working on screen prints highlighted her ongoing curiosity about form and technique that she had so willingly explored in her early years in Coenties Slip, and it was also a way for her to explore how perfect and straight she could make her hand-drawn line to produce, as it were, the geometric Greek ideal that had always fascinated her.

Though Agnes's experimentation in the medium was brief, *On a Clear Day* gave her the confidence to explore different forms of art. Already Agnes was incubating the idea for her film *Gabriel*, as well as a Zen garden inspired by the land art of the time as promoted by Walter De Maria (*Desert Cross*, 1969), Dennis Oppenheim (*Time Line*, 1968), Michael Heizer (*Rift*, 1969), Robert Smithson (*Spiral Jetty*, 1970), Christo and Jeanne-Claude (*Running Fence*, 1972–76), and Nancy Holt (*Sun Tunnels*, 1973–76). The American Southwest, Utah, Nevada, and New Mexico were often the locale of these excavations/ installations/ manipulations, which intrinsically communed with the surrounding landscapes. In terms of her location, Agnes was well positioned to contribute to this new form of art.

Agnes's land art vision was to build a garden, forty yards squared, surrounded by an eight-foot wall. It would be an atypical garden, containing no living plant or animal: "nothing in it but stones."[32] Aside from the obvious inspiration she found in Japanese and Chinese Zen gardens (themselves abstract in design and very often evoking rivers and water), Agnes's garden might also have been inspired by the local Anasazi kivas that she visited with friends. These subterranean stone pits, including the nearby Chaco Canyon kivas, were created for Native rituals, though their full

purpose remains a mystery. Agnes, we must remember, had experience manipulating physical material, including adobe, when she built her Avalon and Cuba homes, so a garden, by comparison, seemed an achievable feat for the artist. It is interesting that Agnes saw in the real world, in the bare earth, the potential to move people to abstract thought. Although the medium had changed from painting to raw earth, Agnes's objective was the same: to solicit universal feelings.

For Agnes, scale was a very important component of a building or structure (and of course, a painting). "If this room we're sitting in," Agnes told an interviewer once, "was the wrong scale, you'd feel bad." She then added "responding to the Parthenon lifts you into a happy feeling."[33] For Agnes, architecture, like painting, had the potential to evoke sublime universal feelings—though through very concrete, formalized means. When Agnes speaks of her home or studio, she is always compelled to give their measurements. Her Coenties Slip studio was one hundred and twenty-five feet long, thirty feet wide, and fourteen feet tall, and her Cuba mesa was nine miles long, eight miles wide: the right dimensions, for Agnes, determined wellbeing and freedom, as well as the right conditions in which to be creative. As a person who created her own surroundings, Agnes was active in shaping her world, much like her parents had been when they first arrived in Macklin, and her mother was when she renovated homes to earn a living. It's not surprising to learn that Agnes was friends with many architects including Donald Woodman, Bill Katz, Robert "Bob" Parker, and Ulrich Franzen. Creating a space, in particular the artist's studio, was hugely important to her.[34] In her notebooks, preparing her lecture *I want to talk to you about the work,* Agnes in a riff on inspiration and architecture notes, "You must have a studio no matter what kind of artist you are. A musician who must practice in the living room is at a tremendous disadvantage. You must gather yourself together in your studio all of your sensibilities and when they are gathered you must not be disturbed."[35] Agnes's Cuba garden would offer a visitor something similar to what a studio offers an artist: a space to develop a response.

For the Cuba garden, Agnes envisioned one person entering at a time. If they responded positively to the silence within, Agnes would consider the "construction" a success, adding, "I hoped that it would be a restful experience for anybody to see it."[36]

Though Agnes constructed a "Chinese garden" for a later project called *Captivity*, her Cuba construction never came to fruition, possibly because she realized if she made it, her mesa would become a go-to destination for people; a distraction she couldn't welcome. It is, however, refreshing to see how far Agnes was willing to develop her practice during this new artistic renaissance.

In an interview in 1989, plucking from the list of reasons she left New York in 1967, Agnes said "I was sort of driven away by the lust of the young painters wanting to be so successful. I thought, I'll just go away and let them be successful in my place."[37] Agnes's return to painting in 1974 was prompted, again, by these "young painters." Agnes explained, "I wasn't satisfied with what they did so I had to start again."[38]

It appears that Agnes's competitive spirit had returned, but it took her a while to feel happy with her output. What she was feeling her way toward, when she returned to painting, was a working process that she would repeat for the rest of her life. At the start of every new series of paintings, Agnes was "in a very low, unproductive condition," because "the first paintings don't mean anything—nothing."[39] Gradually, with intense concentration and the removal of all distractions, Agnes produces enough work that she can edit down, using a box cutter to destroy the work that falls short of her high standard. Agnes repeated this cycle of failure/endurance/completion/success throughout her life.

Producing *On a Clear Day* suggested to Agnes the idea of creating work in themed series form. From 1974 onwards, Agnes produced and labeled paintings to suggest an overall series. Her grid paintings became her "joy" paintings and in 1974 she began planning her "happiness" paintings. These

"happiness" paintings were created with a shared inspiration and aesthetically they share a palette of soft blue, pink and white, which suggests the feeling or buoyancy that happiness delivers.

What did happiness mean to Agnes? According to Betty Parsons, for Agnes, "Happiness is a worldly thing," as opposed to joy, which is "a spiritual thing."[40] Agnes herself says that her grid paintings were about joy and her later paintings about happiness, which—if we follow Betty's definition—suggests Agnes explored the spirit in New York, and the world in New Mexico. This is a facile interpretation, though Agnes gives plausibility to Betty's statement in an interview with *Vanity Fair* magazine. In this interview Agnes explains the relationship between happiness in the world and the human endeavor in it:

> To confine the idea of beauty to nature and art is terrible. There's beauty in people and their gestures and their characters and their attitudes and their actions, beauty in situations too, and every kind of beauty is responded to with happiness.[41]

After she had built her Cuba studio and completed her first happiness paintings—such as *Untitled #17* (1974)—Agnes contacted the Pace Gallery in New York.

In 1963, the same year he moved the Pace Gallery from Boston to New York, Arne Glimcher, the gallery owner, met Agnes at a party in Jack Youngerman's loft in Coenties Slip. Arne was tall, and skinny, and twenty-five. The Pace Gallery was one of one hundred (or so) new galleries opening in New York in the early '60s. Artists, galleries, exhibitions, sales, and auctions had accelerated New York to the top spot as capital of the western art world. With this newfound position came newfound pressure on the artists and on the dealers to continue growth, profitability, and output.

Agnes wanted no part in that culture when she called into the Pace Gallery with some painting supplies in 1967. As she was preparing to leave New York, Agnes was doing the rounds to different galleries, handing over her paint, paintbrushes, and unused canvases—a symbolic donation to the

young artists vying for celebrity, notoriety, and the opportunity to have their view of the world observed. Agnes had introduced the Pace Gallery to Chryssa, who proved impossible to represent, for which Agnes felt some responsibility. Reparations were one reason she approached the gallery in 1974, to ask if they might be interested in representing her new work. Agnes probably knew that she could walk into any gallery after the success of her 1973 show at the ICA in Philadelphia and the ongoing interest in and display of her work. Fred Mueller, Arne's business partner, assured Agnes they would be "honored to show her new work"—a smart move that proved lucrative for both artist and gallery.[42]

Agnes began her relationship with the gallery by saying "Remember Arne, we are not friends—I have no friends—no use for sentimentality, we are toilers in the art field together."[43]

Her first exhibition with the Pace Gallery opened in March 1975. Over the next twenty-nine years she had twenty-one solo shows. It was not a partnership without challenges, but both sides recognized the mutual benefits of their collaboration. Agnes made the Pace Gallery rich, and the Pace Gallery made Agnes even more famous.

FOURTEEN

Gabriel

In 1976, Agnes shot her first independent movie, *Gabriel*, "a silent film," in the artist's words, "about a little boy that climbed a mountain and saw beautiful things."[1]

It is surprising that at the age of sixty-four Agnes decided to approach an entirely new medium; further proof of her ongoing inquisitive nature. Film was a more expensive and male-dominated art form than painting and one with ample distractions and hurdles to achieving the finished product. Agnes, with just cause, was nervous about struggling in the "atmosphere of necessary social relations," that making a movie would entail.[2] After leaving New York, in part because of the pressures of social interaction, she was now about to put herself at the center of a project that involved other people, albeit a small group: one actor and a post-production team.

By 1976, when Agnes filmed *Gabriel*, there was precedent for film within different artistic movements, including Pop Art (Andy Warhol, *Sleep*, 1963), Abstract Expressionism (Shirley Clarke, *Bridges Go-Round*, 1959), Fluxus (Yoko Ono, *No. 4.*, 1966), Earth Art (Robert Smithson, *Rundown*, 1969),

as well as in earlier movements such as Surrealism (Salvador Dalí and Luis Bunuel's, *Un Chien Andalou*, 1929, for example). In addition, experimental film by Jonas Mekas, Stan Brakhage, Willoughby Sharp, and Jack Smith emerged in a robust underground culture in New York that included screenings, magazines, independent cinema, and cooperative organizations, of which the Film-Makers' Cooperative is extant. Other artists, such as Nam June Paik, Vito Acconi, Bruce Nauman, and Dennis Oppenheim were more interested in video as their medium, and TV as their sculpture of choice. It wasn't until the 1970s that video equipment became affordable for wide consumer use, following which it became a popular choice for artists to experiment with. Film, by comparison, remained an expensive medium.

There were a few female forebears in art and independent film; Maya Deren (*Meshes in the Afternoon*, 1943), Shirley Clarke (*Skyscraper*, 1960), Barbara Loden (*Wanda*, 1970), Yvonne Rainer (*Lives of Performers*, 1972), and Valie Export (*INTERRUPTED LINE*, 1971) all created independent film work, some along narrative lines (*Wanda*), some experimental (*INTERRUPTED LINE*). The film industry and studio system had utilized women as actors, designers, cinematographers, and sometimes producers, but, much like the art world of the 1950s and 60s the industry was male-dominated, feeding the "male gaze," to use a term Laura Mulvey freshly coined in 1975. The writings of women film critics in the early 1970s, such as Marjorie Rosen, Molly Haskell and Mulvey, had yet to galvanize a new generation of women filmmakers that would challenge and suggest an alternative to this gaze. It's not likely, however, that Agnes thought much about the role of women in the film industry, or of her accidental role as an early pioneer of independent art cinema in the U.S.

The critic B. Ruby Rich wrote that *Gabriel* would "confound both the art-knowledgeable and film-wise audience."[3] In Agnes's personal view of art, neither the artist, nor the object itself was important; only the viewer's response mattered: "that's the reality in art, the response made by the observer."[4] Film, unlike fine art, is the medium where the broadest audiences feel qualified and entitled to offer criticism on the product and

their experience. As such, Agnes was exploring the response-generating art medium *par excellence*. Though she admitted she had no responsibility toward, or control over, the audience and their response, she did hope to appeal to their finer sensibilities in how she shot *Gabriel*:

> You see, people respond very, very far beyond what they think they can respond; you see, they respond to the least little thing, the least change of wind, the least change of temperature, the least thing they see, the slightest movement. And I don't just mean they see the slightest movement, but they actually make a response, a definite response to all of it. And that's why I think the movies are so wrong in thinking that only with the absolute, top, explosive sensationalism are the people responding. Because they respond to the least thing, the tiniest little movement of a butterfly wing, or something like that. I mean, it really means something to them—to all of us, you know?[5]

Despite its ties to art film, *Gabriel* is unusual for its grand aspirations. It is a seventy-nine minute movie intended for cinematic release and to be viewed in conditions that reflect this: an auditorium rather than a gallery setting; cinematic projection rather than video monitor display. "I want it to be distributed," Agnes told Arne Glimcher, "through Hollywood— through commercial film theatres. My voices told me that."[6] The film also bears few of the marks of artist film, which so often had its roots in documenting artwork or performance art. *Gabriel* does neither. It is, as Agnes suggests above, a movie magnifying "the tiniest little movement of a butterfly wing" and soliciting a response from the viewer.

Gabriel was made as an antidote to studio-produced films that Agnes believed promoted negativity because they were focused on "deception and deceit and violence." Agnes's movie would champion "happiness and beauty and innocence" thereby synchronizing thematically with her artistic oeuvre.[7] The movie follows the little boy's trek from the sea, up a mountain. The camera sometimes takes Gabriel's point of view, and other times is a wandering companion meditating on the flowers, trees, fields,

and rivers that Gabriel passes en route. The boy is not an angel, but the name was chosen to evoke the innocence of angels, which are outside of this world. Climbing a mountain too, for Agnes, was about getting "out of this world" to a place of freedom.[8] While there is no particular story arc, Agnes remarked that Gabriel did get to the top of the mountain at the end, which suggests some sense of a complete journey taken by the character and the audience.[9]

Shooting the movie took five months; three months shooting in California, Colorado, and New Mexico, and two months shooting and editing in New Mexico. The actor playing Gabriel was a fourteen-year-old "little hippie boy" from Cuba named Peter Mayne who, Agnes worried, "was way under size" because "he hadn't had enough to eat."[10]

Childhood, for Agnes, was a golden age when our responses to the world are unmediated and not yet fraught with conditioned responses that we inherit from those around us. Agnes always retained this romantic view of childhood despite (or because of) her own lonely childhood, and her experiences working in Harlem in the 1950s and at the Swan Island shipyard school during the war. Though Agnes enjoyed spending time with Peter, she found him unruly and "rather odd," an instance of the pot calling the kettle black.[11] One wonders if Gabriel, or Peter, reminded Agnes of herself as a young girl, swimming with her brothers in the Fraser River in Vancouver, or more recently, of wandering Grand Canyon National Park, or collecting wildflowers in the Swiss Alps on her unsuccessful trip around the world.

In California and Colorado, Agnes lugged the heavy camera equipment, and her 35mm Aeroflex camera around for the duration of the shoot. It was, she later said, one of the happiest times of her life, wandering around nature, filming whatever took her fancy. Agnes wasn't a natural cinematographer in the way that she was a natural hiker. The technology was new to her, and she often worried about the cost of the film and whether or not she would get the right results. When she filmed the wildflowers up close, her hands began to shake. She didn't understand why this happened until her voices told her she was trembling with joy.

If you want to watch *Gabriel* along traditional narrative lines, you might wonder: who is this boy, where is he walking to, is he walking for pleasure, or to achieve something? Because we never see Gabriel's face (he is always walking away from the camera) the lack of reaction shots means we are not sure what he thinks about this landscape, where it is eternally day, and where the same images, with slight variation, are presented to us, over and over.

Maybe this is because the real protagonist of *Gabriel* is nature itself: water, in particular. Agnes's camera returns to water over and over again: the sea and crashing waves are the opening and closing moments of the movie, and the river is a recurring character, effusive and juxtaposed with the desert landscape.

To capture water on film is to represent a lush, life-giving force. In some frames, we see water, but cannot hear its noise: even the milled, churned brook, when silent, is mesmerizing and peaceful. In nature, in particular with rivers and sea, we tend to see water as a constant flowing entity, often without beginning or end, impossible to contain, unless we are seeing a mountain tarn or a small lake. When water is framed by a camera it is easier to focus on the shapes and color contained within that frame. Water is tamed by the choices the director makes; the duration of the shot, the angle, how close-up the camera is, the lens used. At the same time, even as the camera gives the illusion of control, we know that the river or the sea is an indiscriminate, perpetual force. What we are seeing is the camera's, and the director's contemplation, not Gabriel's. The boy, it dawns on us, has disappeared.

At the end of the movie, Gabriel sits down, as though he has found his resting place. The returning shot of the sea suggests that rest, even for the innocent, is just a mirage. Nature churns on and repeats itself, like the movie, like the horizontal lines of a grid, over and over.

Gabriel, Agnes frequently stated, was about the same thing as her paintings. Not landscape or flora, as the movie seems to indicate, but rather our emotions and feelings toward what nature represents. Of course, Agnes loved nature and was happiest in her life when outdoors

surrounded by the natural world. It would seem farfetched to think that Agnes was only ever responding to a universal idea of nature and not the individual fields, flowers, and rivers that her handheld camera trembled over.

Agnes loved flowers, swimming, trekking, and sunsets. She loved these things individually as events in themselves, but also for their evocation of beauty and happiness. The flowers can wilt, the streams run dry or freeze, and the sunsets give way to darkness, but the sensation of hearing a stream run unseen in the distance, the sensation of feeling the glow of the retiring sun on your face, the sensation of seeing a purple wildflower in Sunset Park—these individual feelings of joy and happiness toward the world harmonize with the preexisting idea of perfection and beauty in our minds.

Overall Agnes's experience with filmmaking was positive; she described the "sensitivity of photography" as exciting, adding, "it lifts you up."[12] When it came to editing the movie, she was sad to edit the footage, and found it difficult to shed her filmed flowers and rivers onto the cutting room floor: "The ones you have to throw away come hard...the physical effort of making film and then throwing it away...but I got used to it."[13] The reception, or "response" to the movie, also satisfied Agnes. At one screening, the movie finished, a woman next to Agnes turned to her and said "I just feel like running outside, into nature."[14]

During the same year as *Gabriel* Agnes produced her second print series, *Praise* (1976). Produced by Parasol Press and distributed by the Museum of Modern Art in New York, *Praise* was an engraving on thin Dalton Natural Bond paper limited to a print run of 1,000 editions. Printed by Triton Press and stamped by Unity Engraving Company, *Praise* is much more colorful than *On a Clear Day* (1973). Nine wide and ten slim vertical bands are given shape by nineteen firm lines pulled across a field of soft pink. At eleven by eleven inches it is a smaller almost-inversion of her painting *Untitled #2*

(1975), while tonally similar to *Untitled*, a work on paper from 1977, the following year.

In a 1976 interview with Kate Horsfield for Video Data Bank, Agnes reveals how *Praise* inspired her larger canvas paintings:

> But now I know what I'm going to paint about and I discovered it when I was making a print. I'm going to be painting a lot about praise; I'm looking forward to it...for the next year or maybe two or five I will think about nothing but praise—like the birds praising in the morning, and the sun on the wall praising, and the earth praising, and the stones praising and all of that.[15]

This quote is interesting for a number of reasons. Firstly it shows the way in which Agnes's smaller scale work inspires her larger paintings. It also reveals how far Agnes can stretch a theme or find its wingspan. Like the personages in her early work and her walks with Louise Sause in New York, the birds, the sun, the earth, and the stones are anthropomorphized into characters that praise other natural elements.[16] While Agnes would never paint a bird, a stone, a sun, or the earth, they were certainly in her mind as inspiration.

Following *Gabriel* and *Praise*, Agnes undertook a series of new paintings in 1977 in a gray palette, that differed considerably from her previous series of pink bands in 1975. One might deduce that actually, Agnes's inspiration of praise did not last that long. The paintings from 1977 were closer to *Trumpet* or *Adventure* of 1967, the paintings she completed immediately before leaving New York, a dark period in her life. Looking at Agnes's work across a timeline, we see that her paintings frequently refer back to earlier pieces or ideas. Agnes's pink bands, for instance, would return in *Untitled #7* (1991), and, with modulation, in *Love and Goodness* (2000): all variations on a theme.

In 1977 Agnes had her first major one-artist show in the U.K. Organized by the Arts Council of Great Britain, the exhibition opened at the Hayward Gallery in March and traveled to the Stedelijk Museum in Amsterdam,

which would host Agnes's work frequently for the rest of her life. Dore Ashton, who had reviewed Agnes's very first show at the Section Eleven gallery in September 1958, wrote the lead essay for the catalog. Dore was well placed to write the essay, she was an authority on Abstract Expressionism and contemporary art, and she knew Agnes as a young, struggling artist, when she visited New Mexico to stay with the artist Adja Yunkers (who she later married).[17]

Ashton's introduction to Agnes's work draws on a range of sources and analogies including Chinese Zen parables, musical notation, Paul Klee, Paul Cézanne, Charles Baudelaire, Octavio Paz, Le Corbusier, Amédée Ozenfant, and Leon Battista Alberti. The list of sources Dore refers to is somewhat ironic considering Agnes's ongoing renunciation of the intellect in art. She tackles the popular writings about Agnes's work, noting that the "technical talk" by critics on Agnes's early grids is "tedious." Unlike her fellow critics, she argues against the grid as a purely geometric construct. In her opinion, "the sense of form" in Agnes's work "does not generate grids...but rather, visual illusions that express a confluence of values."[18] For Dore, the critics and viewers who look at Agnes's work and see balance (or perfection) rather than the imbalance (and imperfection) are missing out or mistaking "the rules of the game for the game itself." She writes,

> These symmetries are of a different order. Anyone who has ever known children's games, and the framework of rules children spontaneously invent, will understand that it is in the revisions and deviations from the rules that the game lies.[19]

It is interesting that Ashton uses children's games as an analogy for discussing the variance that creeps into Agnes's seemingly repetitive forms. Agnes herself told the artist Marcia Oliver that she got the idea for the grids from watching children play hopscotch. The women, however, would disagree on other points, such as Dore advocating biography and location as a meaningful referent for understanding Agnes's artwork:

In the long way from Taos, and the mortal attempt to record its towering mountains, to these recent paintings, often not even titled, Martin has found the spaces of the imagination, and specifically, the spaces between words and silence. I think it is what she is painting. But never can we separate her from that mesa and the radiance, harmony and measure that emanates from it. This is not the desert of sagebrush and Indian arrowheads and kivas and coloured bluffs in bizarre shapes. This is the desert whose light is between words and silence and whose image resides in the imagination.[20]

Ashton's observation on "deviation" shares much with the theory of dynamic symmetry as taught by Emil Bisttram, one of Agnes's early UNM teachers. In dynamic symmetry slight deviation and embellishment of the formula or rules is what distances the master artist from a humble craftsperson. And while Agnes would not be entirely happy with Dore's suggestion that biography has any part to play in her art (even though she did at times admit this), she would have liked Ashton's overall conclusion that the nature that feeds through into the work ultimately "resides in the imagination." Agnes could receive no better compliment.

FIFTEEN

Galisteo

In 1977 Agnes was evicted from her compound on the Cuba mesa when she refused to pay an increase of $350 on the rent for which she had originally negotiated a lifetime lease of $650 a year. It transpired that the property Agnes was on belonged not to the woman she was renting from, but the woman's brother, who then evicted Agnes when she refused to pay, denying her most of her belongings in the process, including her clothes. When asked how she felt about this, Agnes was optimistic, "I felt like I got rid of a lot of stuff I didn't want."[1]Agnes took the eviction as a sign she had been living too grandly on her mesa, which by all accounts was still a primitive compound, with some electricity, a newly installed wind-powered generator, and a well she had dug herself.

Agnes moved from her adobe wonderland to a strip mall outside Albuquerque, living in a commercial unit with fluorescent lighting and a gray vinyl floor. Four azaleas, one white, one red, and two fuchsia, gave this industrial space some color.

In January 1978 Arne Glimcher visited Agnes in her new space. Agnes presented him with seventy-seven watercolors, each nine by nine inches, painted over the past five months. Speaking of these untitled works in pink, blue, yellow, and gray, Agnes said, "It was good to get back to my grids at last because they are a rest—they tranquilize me." Agnes considered the watercolors on par with her paintings and their theme was the same: "joy and happiness."[2] In this series, Agnes painted multiple versions of the same image, intending to edit the final amount to fifty works for display at the Pace Gallery in March that year.

Meanwhile, the preceding August, Agnes had already begun work on her second movie, *Captivity*.[3] Based on the story of the Qicheng Princess Qi, daughter of Jin Emperor Wanyan Yongji, *Captivity* was more ambitious than *Gabriel*. Told from the perspective of the princess, the film used dance as a primary means of communicating each character's desires and feelings. "You know there's an old true story in China about Genghis Khan," Agnes explains,

> When Genghis Khan occupied northern China, he saw this princess in a garden, and he said if they'd give him the princess as a hostage that he wouldn't destroy Peking. And so they give him the princess. And my movie was about when the sons of the generals went to go and pick up the princess and bring her back to Mongolia.[4]

To play the Mongols, Agnes hired local Jemez Indians, and for the Chinese princess and her court, Agnes flew to Japan to audition Kabuki dancers. In Japan, the only Kabuki dancers Agnes found were men, so she returned to the U.S. and to Japantown in San Francisco, where all the performers were women. Agnes managed to cast the role, but to her dismay the leading lady was also a princess in personality, refusing to do everything she was asked. Introducing Kabuki dance, and Jemez Indians into the story is incongruous and inaccurate on every level, but historical accuracy was not a concern for Agnes. According to Donald Woodman, who was her landlord at the time, the final scene was filmed at the Butchart Gardens in

Brentwood Bay, close to where she grew up with her grandfather near Victoria on Vancouver Island.[5]

Agnes paid her actors well, bought vehicles for transporting cast and crew, and spent $9,000 (equivalent to $34,000 in 2016) on a cutting table alone.

Dance was the primary language of the movie: the Moguls dance fear and terror when they arrive in Zhongdu (the Lin Dynasty name for Beijing), the Princess danced in the garden she loved, her maid danced fear and terror because the Moguls had arrived, the Princess danced goodbye to the Garden, and then the Princess and the Moguls traveled back to Mongolia, where they were met by Genghis Khan, who performed a dance of love for the Princess. "And then," Agnes said, laughing, "they walked off into the sunset."[6]

Unlike *Gabriel*, *Captivity* never made it to the silver screen. When the project was finished Agnes threw away the footage in the Galisteo town dump, perhaps because she lost her inspiration along the way.[7] When asked about it she simply said, "The woman got me down"—a recurring theme in her life, for sure.[8]

If *Gabriel* is about innocence, what is *Captivity* about? Agnes was known for alternative readings of established stories. The *Song of Solomon*, which Agnes first read as a teenager, is not about sexual love as one commonly believes it to be. For Agnes its verse is "a mental experience...a heart/mind experience."[9] How might Agnes define *Captivity*? Was Agnes interested in the gender roles? Was she interested in the power and conquest at the root of the story? Or did she bring to *Captivity* her own unique interpretation?

Princess Qi, we know, is a captive in the sense that she is forced to marry in order to save her city. But the word "captivity" also brings to mind what Jill Johnston called Agnes's "enslavement" to love and relationships.[10] Agnes told Ann Wilson that the movie was about sorrow, fear, acceptance, love and a fence. It is through a hole in a fence that the Princess and Genghis Khan can witness the performance of the other: "When the Kabuki dancer saw his dance of love, she did a dance of acceptance. It was then that the two held hands, through the fence."[11] Agnes went on to explain

that the film "illustrates how we are all separate. Our sorrows are separate, and our joys are separate too. It was about what one sees is what they need to see and we cannot claim to have had an influence on anyone."[12] In other accounts, Agnes told Arne Glimcher the movie was about "the mental attitudes of surrender," which Agnes saw as akin to happiness and "the surrender of the intellect to fate."[13]

Whatever the overall theme of the movie, dance appears to have been a powerful medium for Agnes. Agnes loved dancing as a young girl and found an equally passionate dancing partner in Lenore Tawney. Before her Coenties Slip days, Agnes used to attend Pueblo ceremonies outside Taos, often the only Anglo there. Her interest in Indian culture reached far back to the place of her birth in Macklin Saskatchewan where most immigrant families, including her own, had an ambivalent relationship to the Assiniboine and Cree natives who had been dispossessed to accommodate these new settlers.

Since her return to New Mexico, Agnes continued to visit local Pueblos such as the Taos Pueblo and the Zuni Pueblo, where she took part in the *Salado Ceremonial*, a nocturnal dance with masked figures that blessed homes and commemorated the dead. In *Captivity*, Agnes used dance as a means of communicating deep feelings of attachment and acceptance. Throughout her life, she frequently spoke of the failure of words and images to communicate our most universal feelings. Music was, for Agnes, the greatest art form, because it was the purest, and the range of emotions it could solicit was vast. It was for this reason that she used Bach's *Goldberg Variations* as the sporadic soundtrack to *Gabriel*, and possibly why dance was her metaphor of choice for *Captivity*, though of course the soundtrack to the movie is unknown.

Elsewhere in her writings and interviews, Agnes spoke of music and its practice as the appropriate metaphor for the goal of art. Agnes believed music was the greatest art because it was the most abstract and therefore could solicit the widest range of emotions from the listener. "The response to music is about ten times the response to visual arts," she wrote.[14] At the same time, Agnes clearly strove, and in her own words failed, to incorpo-

rate the musical experience into her work. On this matter, Agnes wrote to Nancy Princenthal,

> In *On a Clear Day* I wanted them to recognize the composition in scale as carrying the meaning. Just like in music the composition in silences and notes carries the meaning. But it was not recognized, but the response is made and that is enough.[15]

It is worth mentioning as an aside that many of the titles of her work evoke sound directly or indirectly, including *Desert Rain* (1957), *This Rain* (1958), *Night Sea* (1963), *Milk River* (1963), *The River* (1965), *Trumpet* (1967), *Song* (1967), *The Sea* (2003). *The Wave* (1963), too, as we have seen, is an artwork that was designed to produce sound when tilted forward and back. Unsurprisingly, many of these titles evoke water; the element Agnes was most devoted to.

Agnes used music as metaphor not only when discussing her individual works but also when it came to describing her practice. Writing to her old friend Bea Mandelman in 1974, Agnes compares herself to a composer, "When I made [*On a Clear Day*] I worked 3 months and made 500 paintings before I was even on the track...there has to be pace and a gradual working up to what you have to do. A fast pace...It is composition like the musicians."[16] If Agnes felt a work did not evoke the theme she had settled on she destroyed it, again establishing a link between herself and her favorite composers, "Bach, no doubt sat at the piano and he could play three notes and could say, now that's not joy. And then he'd play something else and say, now that's better."[17] Perhaps Agnes believed that music was the greatest art (and subsequently sought to align herself and her work with this medium) not because it allowed the widest range of response, but because it was the form that most affected the artist.

Music affected Agnes beyond what might be considered normal; it displaced her, overpowered her, and pulled her away from the everyday world. As a woman who heard voices and could slip in and out of this world and the aural landscape in her head, Agnes was prone to be oversensitive to

music, which could be both affliction and cure. Beethoven "makes me so joyful that I weep," Bach "keeps me balanced," or not balanced at all: "I once went to hear one of the Bach passions at a church on Second Avenue. With the first note I passed out...I went into a trance."[18]

In a 1993 interview with Sally Eauclaire, Agnes picks up on the relationship between the body and music: "We think we are very mundane, but we are all capable of fugues."[19] This is a lovely statement, but one wonders if Agnes chose the word "fugue" freely or carefully, as its definition is subject to change. In the first meaning, a fugue (one of the most famous is Bach's *Toccata and Fugue in D Minor*) is a melody with two or more voices that repeats throughout, often at different pitches. In the second definition, a fugue is a dissociative disorder in which a person can lose sense of her identity for long stretches of time. Although Agnes probably only meant that we are not mundane but capable of beauty, the specific choice of the word fugue gives us something to think about in relationship to the artist's own life and work, whether it is the multiple voices in the first definition, or the dissociative state in the second.

Music also made its way into her work in other ways. Many people saw music in the repeated lines of her grids. Agnes's friend Ted Egri failed to "understand" her new grid work, until a friend of his likened it to Gregorian chant, a fixed musical mode that repeats over and over: "One fluctuating note...just like her paintings."[20] Agnes would have liked this analogy very much. However, not all music was championed by the artist, "That piece of music called *Flight of the Bumblebee* is really terrible." Even for Agnes music could be too literal at times.[21]

By March 1979, after the shoot of *Captivity*, Agnes was traveling between her strip mall studio and a new property in the small village of Galisteo, just south of Santa Fe. Galisteo was a family-oriented community, with a few amenities including a post office, some stores, and a church. Its patron saint was Our Lady of the Remedies. Fitting company for Agnes.

Agnes's new home was to be built close to an old Spanish *hacienda*, itself a construct among the ruins of an ancient native Pueblo. Like Taos and Cuba, Galisteo was a mixture of cultures, both ancient and modern. The

Galisteo basin was home to the Comanche Gap, a volcanic dike that contained petroglyphs depicting Pueblo warfare and animal imagery dating back to the fourteenth century. The area was also home to cattle and horse ranchers, generations of men, their faces sweating in the shadow of their wide-rimmed Stetsons. In years to come, Galisteo, because of its proximity to Santa Fe, would become an expensive locale, home to many notable artists. In the early '70s it was still inexpensive and relatively remote. Agnes recalled her move back to civilization: "I decided that human beings are herd animals. And I decided that to live properly you stay with the herd."[22]

In an interview in 1989, there is an element of regret when Agnes talks about her ten years living in Cuba:

A lot of people withdraw from society, as an experiment. So I thought I would withdraw and see how enlightening it would be. But I found out that it's not enlightening. I think that what you're supposed to do is stay in the midst of life.[23]

For Agnes, staying in the "midst of life" was not an easy thing. She valued and needed solitude, something she considered essential for achieving the creative life. From 1978 onwards the artist achieved this balance in her life, feeling part of a community and at the same time removed enough not to be bothered by the demands of it. New Mexico had been a haven for Agnes in the past, as well as for many other artists including Andrew Dasburg, Georgia O'Keeffe and Agnes's college friends from the 1950s. Some of the more documented artists who moved to the state include Bruce Nauman, who moved to Pecos, east of Santa Fe in 1979 and Galisteo in 1989; Nancy Holt, who moved to Galisteo in 1995, Danny Lyon, who moved to Bernalillo in 1970; and Fritz Scholder, who lived in New Mexico on and off beginning in 1964.

Danny Lyon's documentary photographs could not be more opposite to the work of Agnes: his accounts of his life in Bernalillo and the people he knew are often tragic and violent. New Mexico for Agnes was balance, calm, and nature in abundance to inspire and rejuvenate. However, for

many people, living in and growing up in New Mexico brought them closer physically, and sometimes in circumstance, to poverty, legal and illegal drug abuse and addiction, human trafficking, drug-related crime, and alcohol- and drug-related road fatalities. While for Agnes New Mexico was an escape from turmoil, this was not the case for everybody. It was also the home to the atomic bomb, and erstwhile German, Japanese and Italian POW camps. Did Agnes, a long-term resident, overlook the military history, the endemic racism, and the less savory realities in favor of the Indian ceremonies, the sunsets, and the ravines? Or was Agnes aware of New Mexico's failure to keep a balance of the scales, much like the artist herself? In repeating the same lines over and over again, was Agnes disavowing the outside world or merely rising above it? Was Agnes really, as she said, "in the midst of life?"

As she had done in Cuba, Agnes went about creating an adobe world for herself in Galisteo: a studio, a house, a storage shed, and a chicken coop. Her plot of land was littered with trucks and trailers of different descriptions, including a horse trailer (from the *Captivity* shoot) and two yellow Ford pickup trucks. As she was building her new adobe abode, she was painting at the strip mall. Some days Agnes stayed in bed for hours waiting for inspiration to come. Sometimes she waited months at a time. Often she hoped inspiration might direct her toward paintings with more variance. In 1979, for instance, Agnes was hoping she might do colorful paintings, which she attempted over and over, until, finally, her inspiration told her blue was the only color she needed: "I took myself completely out of these paintings and let them happen...almost no colour...almost no line. I just love the blue and white...when I was young my mother had Willow Ware china—you know—blue and white, landscapes, pagodas, little Japanese people—I just loved it."[24] Despite not publicly endorsing interpretations of her work—lest it reduce or destroy the experience for others—Agnes disclosed her own interpretations privately to friends. When presenting her pale blue 1979 series, she deciphered each piece for her attendant dealer, "these paintings are inspired by the Northern Isles," one painting is "a still day in the islands—no wind, no weather," another is "a wonderful day—so

much contentment," another is "so tender, like Ming pottery," and another, for Agnes, shows boats "just heading out of the harbour."[25] What Agnes is seeing is an image in her mind that the canvas has evoked. The image would be different for each viewer, but the feeling might be the same. Despite the artist's interpretation of individual paintings, working in series form, to quote the curator Tiffany Bell, "spread meaning over the perception of a body of work, rather than in a single image." In a sense this means there are very few "key" Agnes Martin paintings, such as one might find with other artists, i.e. paintings that signal a radical shift in style or intention, or might be called the artist's masterpiece. Instead, when people think of her work they are left with a visual impression or feeling rather than one specific image; there is no *Guernica, American Gothic, Nighthawks, Mona Lisa* or *The Scream*. After all, individual artworks are beside the point—the unseen is what matters and brings value to the work.[26]

As well as being prolific with her artistic output, Agnes's reputation continued to grow throughout the 1970s. In 1978 she was awarded the Skowhegan Medal for Painting and in 1980 an exhibition of her 1979 paintings traveled to nine important regional North American museums and galleries, bringing her work to an even wider audience and buying market. Despite her apparent hunger for fame and acknowledgment, Agnes did not always make wise career choices. In 1980, when Tom Armstrong offered her a retrospective at the Whitney in New York, she only agreed to proceed if there was no catalog to accompany the show. When the Whitney refused to yield to this request the negotiations ended. In an open letter to the museum, Agnes defended her stance on the grounds that there is no such thing as an artist: only the response to the artwork is real, and only the response needs to be preserved. Agnes was completely effacing her role as an artist and the work itself, transferring all the responsibility to the viewer, who would preserve the work in memory. Agnes refused the catalog (but not the exhibition itself) on the grounds of pride and achievement: "The idea of achievement," she wrote, "is based on the error of thinking that we own and are creating the world."[27] Walt Whitman and Friedrich Nietzsche are just two people Agnes shakes her finger

at, who succumbed to believing their own self-worth and grand purpose: writers who took credit for their work, when life was the real author.

The Whitney affair was just one moment where Agnes wasn't aware of the contradictions in her character: her willingness to have an exhibition but not a catalog and then lecture the museum on pride and achievement. It also points toward the arbitrary decisions her voices passed down to her, and how, for better or worse, they controlled many important events in her life.

In 1982 Agnes contracted a company to build an outdoor swimming pool on her land in Galisteo for the local children. For a time Agnes was satisfied by the finished result, until she found the distraction of having children around too intense, and the pool was filled in.[28] Distraction was not limited to noisy children; Agnes also avoided unnecessary distraction by limiting her diet to just a few foodstuffs: bananas and coffee, cans of fruit, and yogurt.

After completing a painting, Agnes waited for two days to decide whether or not the painting lived up to her vision. If it did she moved on to the next painting in the series. If it didn't, it was burned or slashed. Once Agnes had completed a series, she rewarded herself by spending a few days in a Santa Fe motel to unwind. Occasionally, to focus on her writings or lectures, she would drive farther north to Kit Carson Park in Taos. During summer months she would travel to see family and friends. On one occasion Agnes sailed up the Mackenzie River in Canada, accompanied by her landlord, Donald Woodman, whose accounts de-romanticize the pilgrimage (they ate Chinese food, went to movie theatres, and Agnes tried his patience with her relentless talk). One of her favorite spots to visit further afield was Monterey, California.

Agnes lived in Galisteo until 1992. Her work throughout the 1980s concentrated on the horizontal line, sometimes collecting colors together, as with *Untitled #3* (1981) but mostly focusing on a reduced and monochrome

palette ranging from the apparently empty—*Untitled #4* (1987), *Untitled #11* (1988), *Fiesta* (1985)—to the charcoal-saturated—*Untitled #3* (1983), *Untitled #12* (1984), and *Untitled #2* (1988). Between 1980 and 1985 Agnes produced seventy-five paintings, averaging fifteen paintings a year, so just over one painting a month.[29] This might not seem like a lot for someone who had no distractions and painted fulltime, but it must be remembered that many paintings, even at this stage of her life, were destroyed in the making because she got the measurements wrong, or because she was not be satisfied with the end result.

Agnes's life in New York must have seemed like a lifetime ago. Slowly, many of the people that she looked up to and knew, the older generation of Abstract Expressionists and their dealers, passed away: Clyfford Still (1980), Ruth Vollmer (1982), Robert Elkon (1983), Sam Wagstaff (1987), and her University of New Mexico student Stanley Landsman in 1984.

In 1982, Betty Parsons, (aged eighty-two) after a series of strokes, died on a summer's morning, at her home in Southold, New York. Agnes's first New York artwork *The Garden* (1958), a construction of wood and found objects, still hung in Betty's New York apartment. Agnes had once asked Betty about death, to which Betty replied that life was the ride from New York to New Haven. "So short," Agnes replied.[30] Later, Agnes recycled this metaphor when she told Arne Glimcher,

> I don't believe in religion at all, but I do believe in fate and I know that I was meant to paint these pictures and that you were meant to show them. I believe that our consciousness continues, we don't die. It's like taking a train from Grand Central to Connecticut, we get off in Connecticut and it's something else. It doesn't stop with death—that would be getting off too easy.[31]

Despite her wealth and her accolades, Agnes had periods of mental unrest during her Galisteo years. Kristina recalls at least two occasions when Agnes closed off the world. On one occasion, Kristina and Ian called on Agnes for a friendly visit, following which Agnes wrote,

Dear Kris,

I have tried existing and I do not like it. I would like to give it up. Please pretend that I am dead. Agnes.

Kristina did the opposite of what Agnes requested, jumped in her car and drove to Galisteo to see what was happening. Agnes was happy to see her, showing no signs of distress, like the child who cried wolf. Another time Agnes wrote a note to Donald Woodman, "I think I am dying, please call ambulance to take me to Albuquerque crematorium immediately, if you find me dead, call Arnold as note on bank account details."[32] On yet another occasion, Agnes had been lying in bed for days, refusing to get up or accept any food. As a result, Donald rang Kristina asking for help. Kristina drove to Galisteo, collected Agnes, and brought her back to Taos, but with no clear plan on the best course of action. Kristina was frantic, asking neighbors for advice, and trying to get Agnes to talk, and wash, and get out of bed. Finally, Agnes provided the answer herself. One rainy day she got of bed and asked Kristina to take her to a psychiatrist she knew in Santa Fe where she could be treated. Kristina deflated with relief.

At one point, later in life, Agnes decided she wanted to die like her grandfather who, she claimed, just lay down and died when the time was right. Agnes decided she would do the same so she went to the hospital, lay on a bed, and refused to move. Kristina's son Ian had to talk Agnes out of the bed, explaining to her that the hospital staff was there to help people get better, not worse. Accepting Ian's logic, Agnes sprang out of bed and suggested they go for lunch.

In interviews and in writings, Agnes only occasionally spoke of death, which she believed was nothing to be afraid of. During her time in New York she certainly found herself in situations where her health was at risk, particularly when she wandered the streets in a catatonic state. The following quote suggests that death may have been a recurring motif in her darker periods in Galisteo as well as in her final months in New York:

I left New York in 1967 because everyday I suddenly felt I wanted to die

and it was connected with painting. It took me some several years to find out that cause was an overdeveloped sense of responsibility.[33]

Is this why thoughts about death consumed Agnes in Galisteo? Was she again feeling an overdeveloped sense of responsibility, now that she had once again returned to painting? Could this have been brought on by her increasing wealth and success—success that was not going away (in 1989 Agnes was inducted as a member of the American Academy and Institute of Arts and Letters)? Or were the deaths of her friends a contributing factor to her unease? Perhaps the greatest loss was the sudden death of Mildred Kane in September 1989. With this death, Agnes had lost her oldest friend and patron. As one decade ended and another began, it's likely Agnes was looking towards the future with the knowledge that her best days were past.

By the end of the 1980s Agnes continued to receive awards (American Academy of Arts and Sciences), give lectures (Carnegie Museum of Art), tour work, premiere work, and teach (Skowhegan). One indication of her growing stature at home and internationally, and perhaps the biggest compliment an artist can receive, was a forgery of her work sold in 1985.

In December 1985 Dr. Herta Wittgenstein, the granddaughter of the Viennese philosopher Ludwig Wittgenstein, asked the Linda Durham Gallery in Santa Fe to sell two watercolors by her friend, Agnes. She wanted the works sold quickly and was happy to settle for $4,000 as the combined total for both pieces, though one piece, *Wheat*, from 1960, was reportedly worth around $8,500. The Linda Durham Gallery approached the Museum of Albuquerque, notifying them of this excellent sales opportunity and the Museum's foundation duly purchased the work. After the sale, the heiress approached the museum and the Linda Durham Gallery for more money, threatening the latter with litigation if increased funds were not forthcoming.

Dr. Wittgenstein lived outside Santa Fe and had in her collection work by Diane Arbus, Louise Nevelson, R.C. Gorman, Fritz Scholder, as well as Georgia O'Keeffe and Agnes, all bought with the trust fund from her illus-

trious grandfather. At the same time that she was requesting more money from the Linda Durham Gallery, Dr. Wittgenstein was selling works by O'Keeffe and Alexander Calder to noted local artists, doctors, lawyers, and art dealers.

The art patrons of sunny, sleepy Santa Fe had been conned. Within a year Dr. Wittgenstein was indicted on 15 felony charges, including six counts of fraud, two counts of attempted fraud, three counts of practicing medicine without a license and one count each of tax evasion, bribery of a witness, and concealing her true identity. A buzz of gossip spread across the local art community. Who was this woman? How much money had she made? Where had she come from? The events and the facts seemed to spring from the pages of a mystery novel.

Herta Wittgenstein, aka Herta Hilscher, aka Herta Spitzweiser was an Austrian national and illegal alien evading deportation by the U.S. Immigration and Naturalization Services. Spitzweiser (her maiden name) had a long history of fraud that was not limited to the art market, and which involved banking institutions and property. Herta was a talented fabulist. Not only was she not the granddaughter of Ludwig Wittgenstein (he had no children), she also did not study medicine at either the University of Vienna or Rutgers Medical School, and she did not know intimately the artists whose works she claimed to own.

In September 1986 Agnes traveled to the Museum of Albuquerque to review the two works bought from the Linda Durham Gallery. With the museum director, James Moore, and curator, Jackie Cunningham in attendance, Agnes examined the works and declared them fake.

In the affidavit for criminal complaint and arrest warrant issued to Herta Spitzweiser, Agnes cited the following as proof that the works were fakes: the quality of paper, the asymmetrical lines, the use of pencil instead of ink, the color, and the presence of squares and not rectangles. Aside from this, Agnes had no recollection of ever painting the works, though she admitted *Wheat*, a pink painting, was closely based on earlier work she made in pale golds and pale blues.

Spitzweiser was not the most conspicuous of con artists and her legal

disputes continued well into the 2000s. A 1977 published autobiography, *Scratches: A Picaresque Autobiography*, outlined how Spitzweiser lured victims into her confidence in order to use their reputations and good intentions for financial gain. This memoir of her exploits was used as evidence to arrest and indict her, a twist that even Agnes, a fervent reader of Agatha Christie novels, might have chuckled at.[34]

SIXTEEN

I Came Home

By the end of the 1980s Agnes was preparing for two major events in her life. The first was relocation from Galisteo to Taos, which took place in 1993 (at the age of eighty-one) and the second was the largest retrospective of her work to date, at the Whitney Museum of American Art in New York, from November 1992 to January 1993.[1]

For the Whitney exhibition, Agnes relented on her anti-catalog stance, partly because the curator Barbara Haskell had gained her trust. Barbara first met Agnes in 1973 when she was a young curator at the Pasadena Art Museum, coordinating the touring *ICA Agnes Martin* exhibition. Barbara had always responded to the "serenity" and "egolessness" of Agnes's work and the two women met on the occasion of Agnes's accompanying lecture. Agnes was so nervous that day that she sat in a car during the lunch held in her honor. When she later took to the stage, she delivered her speech twisting a handkerchief in her hands like a "security blanket."[2] Barbara was also present at the Whitney when Tom Armstrong first attempted to negotiate Agnes's retrospective in 1980, explaining:

Agnes was going through a very difficult period back then and her voices told her not to do it...during the seventies and eighties Agnes was more stressed and less in tune with the world.

The 1992 Whitney retrospective came about when a planned *Agnes Martin* exhibition at the Walker Arts Center fell through. Barbara judged that Agnes was open to presenting her work again and made contact, hoping that Agnes's positive memories of the Pasadena exhibition would dispose her toward Barbara's plan. Without much persuading, Agnes agreed. Her sole request was that her biomorphic work of the 1950s not be included. "She wanted," Barbara adds, "to start with what she considered her mature work." Barbara complied. As with Suzanne Delehanty, Agnes gave Barbara free reign on the planning and execution of the show. Barbara visited New Mexico for a short trip, but most of their correspondence was through telephone. "The exhibition," Barbara noted, "was not something [Agnes] wanted to worry about."

The exhibition catalog contained essays by Barbara and the academics Anna Chave and Rosalind E. Krauss. Agnes did not entirely approve of the content or claims of the essays within, but that would ever be the case for a woman hostile to academia, despite her own pedagogical history and writings. The publication was the first major critical work on Agnes, and made an attempt to relay the detail of the artwork in full-page close-up reproductions. The catalog was published by the art publisher Abrams Books, an apt association given that publisher Harry N. Abrams owned work by Agnes. The catalog was also the first attempt to present a coherent biography of Agnes, as well as the first book to provide a wide-ranging context for Agnes's artwork, pulling threads from different traditions and impulses: Abstract Expressionism, Minimalism, Feminism, Classical philosophy, the grid, and so forth. The retrospective at the Whitney bore particular significance for Agnes, who, in her Wurlitzer application letter had chosen to assist in "the establishment of American art." The Whitney retrospective was the affirmation that after a lifetime of dedication to her craft, Agnes had been accepted into the American canon.

Both Agnes and Barbara found the exhibition extremely rewarding. "It allowed Agnes to see something in the pictures that she hadn't quite codified herself," Barbara remembers, and "the outpouring of affection" for Agnes meant a great deal to the artist. The Whitney exhibition (and Agnes) also traveled to Houston's Contemporary Arts Museum (CAM) in Texas, where Suzanne Delehanty, was director. In addition, an in-depth profile of Agnes by Benita Eisler appeared in *The New Yorker*. An evocative overview of Agnes's life, Eisler's profile is noteworthy for, among other things, its excavation of the dynamics of the Coenties Slip artists. On this topic, Eisler is critical of the lack of support for Agnes by her peers, particularly during her time of need. She suggests that the social mores of the time made Agnes's contemporaries powerless to intervene in, and somewhat accountable for turning a blind eye to, her obvious turmoil: "The conventions that governed their tight little community—respect for privacy, solitude, distance—served also to isolate and imprison her."[3]

Eisler's profile is also critical of the double standard within public discourse that acknowledges and validates the sexuality of the male artists at the time, while smoothing down an invisible cloak on lesbianism, though Eisler herself does not do much to tear this cloak away. When the profile was published, Agnes was eighty-one—a grand dame of American art— and she was happy to wear a mantle of silence when it came to her sexuality, which Pat Steir described as a "toxic subject" for the artist.[4]

As an octogenarian, Agnes's health, both mental and physical, wavered. At times she was heavily medicated, barely able to keep her eyes open, and her words slurred. At other times, when she forgot to take her medicine, she became disoriented, panicked, or abusive. Agnes also had long-term memory loss on details involving her own life; the result of the electroshock treatment she received in New York in the 1960s.

Kristina had encouraged Agnes to move to Taos, where her friends could take care of her, and where she would feel included in the commu-

nity. Agnes relocated to the Plaza de Retiro, on Camino de la Placita, a short walk from the Western-style adobe plaza. The Plaza de Retiro was a retirement community consisting of a small medical center and modest apartments that facilitated continuing care. John Himes, co-owner of the facility at that time, recalls first meeting Agnes in 1990. "She asked the price of a contract that carried lifetime care in a two-bedroom two-bath apartment. I quoted her $60,000 and she said 'I will give you a check.'" The same day, Agnes walked a few blocks from the apartments to a conveniently located commercial space and signed a check for $100,000 to purchase the property for her studio space. The space was worth significantly less.[5]

When she eventually relocated in 1993, Agnes brought along a few bits of furniture including the iconic rocking chairs that she placed in every home she lived in. Her new home was Spartan, with just enough fixtures to house her practical belongings and some notable awards, tucked away out of view. Despite the name of her new residence, Agnes showed no signs of retiring.

Agnes's apartment was only a short walk from the Harwood Museum, her first home in Taos. Thirty-nine years earlier at the age of forty-two Agnes lived in a dirt-floor shed, scavenging waste food outside supermarkets for her evening home stew. Now, she was a multimillionaire—though her possessions, aside from her white Mercedes truck, did not betray a millionaire's indulgence. One luxury Agnes did afford herself was hiring two gardeners to tend to her new studio garden.[6] Delighting in mischief, she told visitors she cultivated the garden herself.

Agnes's return to Taos was more than practical. "I didn't come out west," she said, "I came home."[7] Kristina agrees, "Taos is the only place that she ever felt was home. Ever." Kristina recalls that persuading Agnes to move back to Taos contained a seed of selfishness on her part. Kristina also relocated to town to be closer to Agnes, abashed at her own sentiment at the youthful age of sixty-four.

As well as acceding to a Whitney catalog in 1992, Agnes authorized the publication of her writings with Edition Cantz in Stuttgart, Germany.

Agnes Martin: Writings/Schriften was published to coincide with the exhibition *Agnes Martin: Paintings and Works on Paper, 1960–1989* at the Kunstmuseum Winterthur (January to March, 1992) in Switzerland.

The Winterthur exhibition was arranged by the Kunstmuseum director, Dieter Schwarz. Dieter first had the idea of hosting an Agnes Martin exhibition after he saw *Agnes Martin: Neue Bilder-Zeichnungen* at the Annemarie Verna Galerie in Zurich in 1986. When he became director of the Kunsmuseum Winterthur in 1990, he was eager to build a collection of contemporary abstract American painting from such artists as Robert Mangold, Brice Marden, and Agnes. When the museum purchased Agnes's *Untitled #8* (1988) in 1990, it seemed like the perfect sign to schedule an exhibition of her work.

Dieter wanted to do something different for the Winterthur exhibition catalog. The catalog to *Agnes Martin: Paintings and Drawings 1974–1990* which was touring Europe throughout 1991 and the pending Whitney catalog *Agnes Martin* were both illustration-heavy publications. Dieter knew it was impossible to capture the subtle colors of Agnes's art in reproductions, and thought a publication of Agnes's writings might be a unique contribution to offer the market. *Writings/Schriften* was also an important publication because it allowed German readers the opportunity to engage with Agnes in their own language, freeing her from an American-centered art discourse to which she had always been confined. As a result, the conversation about Agnes and her work was moving away from the small pool of critics in the U.S. The door had been opened, symbolically, to a larger audience.

In 1991 Dieter started collating Agnes's lectures into one volume. In the fall of the same year, accompanied by Annemarie and Gianfranco Verna from Zurich, Dieter made a pilgrimage to see Agnes in Galisteo. "It was very moving," Dieter recalls, "to spend a little time with this wonderfully quiet and concentrated old woman who was so simple and straight in her ways."[8] The Swiss party stayed in New Mexico a few days, visiting Agnes's studio, and taking long drives to far-off restaurants.

Writings/Schriften would be a bilingual edition in English and German,

translated by Dieter and his assistant, the curator Marco Obrist. As well as containing Agnes's most famous lectures, such as *The Untroubled Mind* (1972), the book also includes written ephemera found on scraps of paper. One scrap reads like a diary entry:

> Good criticism by Robert Coates in the New Yorker Magazine, Sept. or Oct. 1961. Comparison with Albers who was showing in Janis G. at the time.[9]

Here, Agnes is writing about her third (and last) exhibition at Betty's Section Eleven gallery, and the Josef Albers exhibition across the hall at Betty's rival, the Sidney Janis Gallery. At times Agnes was so confident and otherworldly that it seems difficult to imagine her as an insecure, struggling artist. It is touching in *Writings/Schriften* to see her noting her reviews and jotting down lines from books, like an ambitious and hopeful student, insecure and very much possessed of human frailty.

In his introduction to the collection, Dieter notes that Agnes brought her self-critical attitude to bear on her writings as much as she did her paintings. He also relays Agnes's skepticism toward the printed word as some kind of definitive testimony. One could imagine Agnes arguing that, as with her paintings, only the response to the words mattered, and not the words themselves.

How would critical reception, and personal individual response to Agnes's work have differed if *Writings/Schriften* had never been published? The book was reprinted five times, translated into French in 1993, and distributed widely in all reprints. In fact, many people had read Agnes's writings before they saw one of her works in person. As a result, not only did the book play a large role in expanding the artist's reach, it also contributed to the dilemma that her new audience could not separate her work from her words. Then again, maybe that was always the case? For as long as Agnes had been painting, she had been lecturing, interviewing, and holding forth at loft parties; pinning people down with the ferocity and speed of her delivery. One symptom of her schizophrenia was her ability to speak

for hours, without interruption, to the point of exhaustion. Interior locution made exterior was part of her character, so it makes sense that this found its way into her writing. Later in life Agnes repeated stories and aphorisms often, but could also be silent in the company of others. Perhaps by that time she had said everything she wanted to say?

What Agnes spoke out loud and what her voices told her were one and the same thing—Agnes would say that her decisions in life were handed down to her by her voices. What was it like for her to have those voices in her head, like a separate being?

When Agnes sat, rocking in her chair for hours, she was talking to her voices and the conversations were not always pleasant. Her friend David McIntosh recalls, "She had pleasing exhilarating conversations with the voices. It seemed quite a good social life for her, although at other times they were malevolent and frightening."[10] Donald Woodman elaborates on this, recalling that Agnes couldn't get the voices in her head to stop talking; voices that were often "deafening in volume" and "confusing as to their instructions."[11]

In her book, *Agnes Martin: Her Life and Art*, Nancy Princenthal recounts a conversation with Donald Fineberg, a psychiatrist who treated Agnes from 1985 to 2000. Fineberg: "[Agnes] has a relationship, in her medicated state, to the voices, where she has what you might say is an observing ego—a capacity to look at them so as not to be overwhelmed by them."[12] Here Fineberg echoes, somewhat, Arthur "Art" Carr, the psychiatrist who helped rescue Agnes from Bellevue in New York. Carr suggested to Kristina that Agnes had a bicameral mind—a controversial hypothesis in psychology that suggests the mind can be divided in two: one part that instructs, and another that listens and follows instructions. Whatever the theories, what is clear is that Agnes's voices had more power over her than they should have had.

In published facsimiles of her notebooks we can see that Agnes was not indiscriminate with her words as she could be in conversation: she edited her work, underlining words, erasing paragraphs, making multiple attempts to get lectures just right. When she wanted to focus on a lec-

ture she drove to Kit Carson Park in Taos to sit on the grass and relax and write. In this regard, she was a writer with a process. She was also a teacher, accustomed to being heard, listened to, and trusted. These lectures were directed largely to other artists, in particular younger artists. But they also played a publicity role in promoting Agnes as an icon. Certainly, when Agnes was in New York in the 1960s, like the majority of her Abstract Expressionist forebears, the common pursuit was to spend as much time talking about art as creating it. Agnes emerged from this tradition of movement manifestos, the precursor to the artist statement that is so commonplace today. When Agnes was creating her personal manifesto, it was in the context of defense against hostile senators, confused museum-goers and reluctant critics. The hostility that artists faced in the '50s and the '60s as well as the hostility toward the aberrant, the nonconformist, the lesbian, the female, should not be forgotten. Seen in this way, talking and writing and lecturing as Agnes did, was a way to make her presence felt in a society that tried to enforce her absence. Or maybe she just wrote, as she said, to keep herself company, to stop herself from going insane.

Writing was not the only way in which the icon of the artist was established. Other artists and writers, in magazines and books, did much to create intrigue around Agnes and reinforce the hermit-guru icon status she had tried to shrug off after moving back to Galisteo in 1978. Diane Arbus, Hans Namuth, Alexander Lieberman and Ray Jonson all featured Agnes in their work throughout the 1960s while Chuck Close, Annie Leibovitz, and Mary Ellen Mark each immortalized Agnes after her return to Taos. In the case of Annie Leibovitz, Agnes was featured in her exhibition *Women* (Corcoran Gallery of Art, 1999) and the eponymous monograph written by Susan Sontag and published by Random House the same year. In this collection, a portrait of Agnes taken in her bedroom at the Plaza de Retiro is included alongside those of Hillary Clinton, Betty Ford, Louise Bourgeois, Frances McDormand, Marion Jones, and Eileen Collins, as well as victims of domestic violence, coalminers, showgirls, and political activists. Agnes's world was now much smaller than that of many women in the book—though no less extraordinary.

Interest in Agnes's life was also shared by documentary filmmakers resulting in *On A Clear Day* by Thomas Luechinger in 2000, *Agnes Martin: Between the lines*—shot 2002, released 2017—by Leon d'Avigdor, and Mary Lance's *Agnes Martin: With my Back to the World*, that was shot between 1998 and 2002. The Agnes in Mary Lance's documentary, soft and calm, is a world apart from the Agnes, severe and solemn, interviewed in 1974 and 1976 by Kate Horsfield in her pioneering work for the Video Data Bank. Agnes was not unintelligent about how she was seen by others. She refined her character as much as Andy Warhol cultivated his, but in her case without the need of a wig. Agnes destroyed her juvenilia, erased signs of her sexuality, and ended friendships that she found challenging. She wanted people to think that she arrived in the world, and in her art, fully formed. Some of what commentators find so fascinating in Agnes's work is this implied contradiction in her canvas. Agnes was producing the immaterial through a material form. While she was trying to draw perfect lines with an imperfect hand and trying to hide the human effort and her individual signature, she was also trying to conceal aspects of her life and story, an erasure that contributed to her icon status.

It would be wrong to call Agnes pretentious or an innocent. She knew that by going into the desert she was adopting the hermit status: "Just say that I am a hermit,"[13] she told Suzanne Delehanty. She also knew she was following in the footsteps of women before her, role models like Mabel Dodge Luhan and Georgia O'Keeffe, living off the grid, rending the conventions of what a woman was allowed to do, or capable of doing. Agnes was working toward an ideal. She was trying to become the Greek goddess her old friend John DePuy had seen in her, back in 1954. But Agnes, however hard she tried, was only mortal; she could not lead a self-sufficient life.

When Agnes writes, "we are born as verbs rather than as nouns. We are born to function in life, to work and do all positive actions that will carry out our potential," she negates the support she received from many "nouns": Kristina, Mildred, Lenore, and others.[14] It is one thing to attain a sense of self through work, but it is another to deny the self entirely. It was nouns that rescued Agnes from Bellevue's violent ward, nouns that

sang her songs in a hospital sickbed in Bombay, and nouns that welcomed her back to Taos, when she returned there to put herself back on the Enchanted Circle, her favorite driving route that brought her always closer to nature—the flowers, rivers, and mountains, those *nouns* that gave her happiness.

///

In 1993 when Agnes returned to Taos she rekindled friendships with a number of people, including Bob Ellis, the director of the Harwood Museum. Bob had originally seen Agnes's artwork at the Pasadena Art Museum in 1973. "Bowled over" by the artwork in Pasadena, he used his contacts at the museum, got his hands on the artist's address.[15]To Bob's surprise the artist lived close to him in New Mexico, though his first attempts to make contact with her fell on deaf ears; Agnes was busy building a studio and, being reclusive, didn't want any more distraction than was necessary. Bob, in turn, thought that Agnes was better left alone, and besides, he was busy being an artist himself, and teaching at Agnes's alma mater, UNM. Then, out of the blue in 1975, Agnes contacted him, inviting him to visit her. Despite spending a pleasant afternoon together in Cuba the friendship did not take off. The next time the two met was upon Agnes's return to Taos.

There was only a ten-year age gap between Agnes and Bob, who was born in Cleveland in 1922. Like many of Agnes's friends on Coenties Slip and at UNM Albuquerque in the 1950s, Bob had entered art school on the G.I. Bill (he had been a Seabee and a naval navigator during the war). By the time he officially became the director of the Harwood Foundation in 1990, he had behind him an illustrious career as a teacher at the University of Southern California and UNM, as well as a curator position at the Pasadena Art Museum and the UNM Art Museum in Albuquerque.

Bob looked like he could be Agnes's younger brother. He had a full head of fine grey hair that, combed across his crown, gave him the look of a well-behaved schoolboy, someone loyal and trustworthy: attributes he lived up to. When Bob, softly spoken, reminisced about Agnes, he said

her name lightly, the vowels delivered in a short patter, disclosing his Ohio roots.

Reunited in Taos, Bob and Agnes began a weekly ritual of having lunch together—what Agnes called her "brush with society"—some years Bob and Agnes had as many as forty-six meals together out of fifty-two weeks.[16] Agnes's favorite spot was the Trading Post, an Italian restaurant moments away from the boardwalk storefront where she held the exhibition of her work that bagged Betty Parsons back in 1956. Close by was the San Francisco de Asis Church made iconic in Ansel Adams's black-and-white photography and Georgia O'Keeffe's painting.

Bob and Agnes alternated treating each other. Agnes enjoyed a glass of wine when she paid, but declined this luxury when the bill was destined for Bob. Agnes didn't like to speak too much about art during the meal, though she would open up about her upbringing, something she was very vocal about with her friends. Agnes loved hearing about what was involved in running an art museum. In this regard Agnes was naïve, a child trying to comprehend the working life of an adult. Robert "Bob" Parker, the artist and architect, also joined Bob and Agnes, often taking Agnes out for lunch alone. Robert recalls lunches with Agnes where she might not say very much for the first twenty minutes, the two sitting in silence as they ate their food. Finally Agnes would pluck a memory out of thin air and a conversation would develop. Robert never hurried Agnes for conversation, knowing it would unfold as and when Agnes wanted it.

It was from Bob Ellis's lunches with Agnes that the idea for an Agnes Martin Gallery was born.

The Harwood Foundation in the early 1990s was a small gallery above the town library, parochial compared to the New Mexico Museum of Art in Santa Fe or the Albuquerque Museum of Art and History. When Bob asked Agnes if she might be willing to exhibit some paintings locally before they were shipped off to New York to be sold, Agnes must have thought it was a good idea, because she offered Bob seven of her most recent paintings, the first series produced in her new Taos studio.

In order to display the works, Bob and his team emptied a square room

of its contents and assembled panels across each corner, creating a nearly octagonal space. When the paintings arrived, Bob set up a rocking chair in the middle, from which Agnes conducted the paintings and the art handlers as if they were musicians and instruments: "the Whitney doesn't let me do this," she chuckled. The resulting show lasted for a month, during which time Arne Glimcher visited and substituted two paintings. When asked why Agnes had chosen to offer seven paintings for display she answered that seven was a good number, not too few, not too many. Temperance. Always.

Concurrent with the exhibition, the town library was moving to a purpose-built location just next to the Plaza de Retiro and plans were underway to expand the Harwood Foundation into the newly vacated space. Without conferring with the University of New Mexico (who had owned the Harwood since 1935), Bob offered to build a gallery for Agnes's seven paintings if she donated them to the museum. Agnes thought about the proposition for a few weeks and agreed to Bob's proposal. Bob began fundraising for the space immediately.

An agreement dated the 20th of May 1994, signed by Agnes and Bob, highlights the ambition both had for the works. Bob agreed to show the works in a permanent exhibition space within the museum or, if possible, a separate building. The result—the Agnes Martin Meditation Gallery or Chapel—would firmly place the Harwood Museum on the national art map. It would also satisfy Agnes's competitive nature. Agnes had long been an admirer of the Rothko Chapel (which she visited with Suzanne Delehanty) and the Cy Twombly Gallery in the Menil Collection in Houston, Texas, impressed by the stature of these destinations and the uninterrupted potential for reflection that they offered guests.

Agnes's gallery would be a permanent home to impermanence; as resolute as her adobe homes, promising the serenity of the Zen garden she never managed to build, and mustering all the joy of her short-lived outdoor Galisteo swimming pool. Suzanne worked closely with Bob and Agnes on the gallery. Suzanne recalls, "they were happy days for Agnes."

At one point, while preparations were underway, Suzanne proposed

a film about Agnes to accompany the exhibition. In a letter mailed to Suzanne on February 22nd 1994, Agnes declined:

Dear Suzanne,

I have been trying to talk myself into making a Videotape but I have not succeeded. I have a horror of television. It is not my audience. I really only have something to say to young artists.

And I am so old and ugly and I hesitate in my speech. It is too late. I have given up lecturing because I cannot present the material properly.

I wish I could do it because you want it but I cannot.

Affectionately,
Agnes.[17]

Human vulnerability and vanity were not spared on Agnes. Though she eventually acquiesced to film in 1998, she was always dismissive about her looks, describing herself "fat like an old man,"[18] while noting that her face was too expressive to take a good photo.

An exhibition of an artist's work is an occasion to celebrate the artist as much as it is an opportunity to view the work. The Agnes Martin Gallery was no ordinary exhibition; it was an opportunity for Agnes to give something back to the town of Taos, and for Taos to celebrate their prodigal daughter. Over the years Agnes had amassed a dedicated following of fans and collectors, and many arrived in Taos to pay homage to their friend. Bea Mandelman sat with Agnes at the opening. Forty-four years earlier, when Agnes sat at Bea and Lou's dinner table with a demanding hunger in her stomach, it was almost impossible to imagine the kind of success that she would one day enjoy. Agnes and Bea looked unrecognizable from their younger selves, though the ease they had in each other's company was the same as always. Agnes also entertained many long-term patrons including Sydney Biddle and his wife Flora Miller Biddle, the granddaughter of Gertrude Vanderbilt Whitney, founder of the Whitney Museum. Jennie Dietrich and her husband, Daniel, were also one of Agnes's most loyal

long-term collectors. As an advisory board member (and donor) at the ICA in Philadelphia, Daniel made it possible for the ICA to host Agnes's 1973 exhibition organized by Suzanne Delehanty.

The seven paintings were donated to the Harwood on the grounds that they would never travel and remain as a permanent installation. The paintings traveled only once in 1996 to the Carnegie Museum of Art while they were awaiting their new home in Taos. When it was completed in 1997, the Agnes Martin Gallery was octagonal in shape with an overhead oculus pouring a halo of light into the room. The paintings were unnamed band paintings in the softest blue and cotton white. Four Donald Judd seats, unified in color, but each slightly different, were donated a short time later.

By all accounts the gallery was, and remains, a success. Afterwards, Agnes was a frequent visitor to her own gallery, sitting, feet squarely placed on the ground, staring straight ahead at her work. A few years after the opening, Bob, dropping by one Sunday afternoon on a whim, found Agnes sitting at the museum reception with a marker in her hand: she had come to name her work. The titles she offered were effusive compared to the reduced color and form of the work. *Loving Love, Love, Friendship, Perfect Day, Ordinary Happiness, Innocence, Playing.* These names bestowed a sense of joy on the chapel, transposing the space from one of meditation to celebration.

"I am awed by the simplicity, the beauty, the whatever," Bob said, when he was asked what he felt standing in front of Agnes's work.

There is a completeness, something about this visual experience that is very, very special...When I first saw those paintings in Pasadena I thought I had never seen anything like them, yet they weren't anything you could dismiss, or that I could dismiss, anyway. A lot of people look in that gallery and walk right on by. The paintings compelled me to drink in that image.[19]

Agnes seemed to repay her own approval of Bob one lunchtime, when

turning to him she said, "Well, let's check you out!" Agnes's eyes glazed over and she moved in and out of a little trance. Then, widening her eyes, she looked at Bob with surprise and said, "One hundred and six. Oh. I didn't think you'd be that high." Bob had not been found lacking on Agnes's barometer of spirituality.

SEVENTEEN
Studio Life

The Whitney exhibition and subsequent tour did much to popular-ize Agnes's work during the 1990s, as well as ignite further critical evaluation and scholarship on her career and output. Long before this, her work had been routinely included in a range of themed group exhibitions. The breadth of categories, schools, and themes under which her paintings were shown was testament to Agnes's popularity among curators. It also reflects the evolution of curatorial practice, the art market, and the rise of museums as uber-centers of entertainment and education. More than anything these exhibitions attest to Agnes's sure-footed standing in the history of American art, a distinction she had long dreamed of and worked toward.

When you take a magnifying glass to the complete list of group exhibi-tions Agnes was included in, certain themes emerge. Her work is divided into specific decades (60s, 70s etc.), time periods (postwar, cold-war), locations (America, New York, Coenties Slip), movements (Minimalism, Abstract Expressionism), and themes (grid art, art by women). It is no

wonder Agnes always claimed her work was anti-nature, anti-intellect, anti-gender, anti-isms. No one and no thing can have such a diverse lineage, can they? To admit belonging to one of these *isms* or categories would open the doors to confusion and responsibility, both distractions to studio life. Charting these exhibitions, however, is intriguing when we observe the shifting contexts and trends that emerge. In the 1970s "minimalism" and "purism" are commonly referenced themes. In the '80s and '90s, the appellation changes to "geometric." As women's art becomes increasingly visible and institutionalized, so the needle moves: *Paintings by American Women Artists* (Lynchburg, Virginia, 1972) changes to *Making their Mark: Women Artists Move into the Mainstream, 1970–85* (Cincinnati, Ohio, 1989) which becomes *Going the Distance: A Generational Survey of Women Artists* (Rosemont, Pennsylvania, 1997).

Agnes also found herself representing the New World in retrospectives that included *Critical Perspectives in American Art* (Venice, 1976), *American Masters* (London, 1989–90), and *Art at the End of the 20ᵗʰ Century: Selections from the Whitney Museum of American Art* (New York, 1996).

Her work also became emblematic of decades past; a historical anchor Agnes would shake her head at: *American Painting of the 1970s* (New York, 1978–80), *The Sixties Revisited* (New York, 1979), *The Fifties: Aspects of Painting in New York*, (Washington, D.C., 1980), *The Image of Abstract Painting in the 80s* (Massachusetts, 1990), *American Art in the Twentieth Century: Painting and Sculpture 1913–1993* (Berlin, London, 1993). Of this list, *The Fifties: Aspects of Painting in New York* is perhaps the most far-fetched. Agnes was dirt-poor throughout the 1950s and disavowed all her artwork before her move to New York in 1957. Even then, it was only with *The Tree* (1964) that she arrived at a style she was happy with, so it's unlikely she saw her work as emblematic of that decade.

Although Agnes said she never showed with other artists—she did. Group artist exhibitions included *Agnes Martin and Donald Judd* (Boston, 1989–90), *Agnes Martin/ Richard Tuttle* (Paris, 1992), *Retrospektiv I: Agnes Martin, Robert Mangold Werke 1962–1994* (Switzerland, 1994), *Diary of a Human Hand, Agnes Martin, Alice Trumbell Mason and Ann Ryan: Paintings*

and Collages from the 50's (New York, 1996), *Works on Paper: Richmond Burton, Brice Marden and Agnes Martin* (New Hampshire, 2000), and *Agnes Martin, Bridget Riley, Rosemarie Trockel* (London, 2003).

Each exhibition mentioned above took place in Agnes's lifetime. Since her death there has been an even greater range of themes and pairings, including *Hide/Seek: Difference and Desire in American Portraiture* (Washington, D.C., 2010) and *Illumination: The Paintings of Georgia O'Keeffe, Agnes Pelton, Agnes Martin, and Florence Pierce* (California, 2010). In 2015 the Tate Modern in London held a retrospective of the artist's work, which included many early works. This exhibition, simply titled *Agnes Martin*, travelled to the Kunstsammlung Nordrhein-Westfalen, Düsseldorf (2015–2016), the Los Angeles County Museum of Art (2016), and New York's Solomon R. Guggenheim Museum (2016–2017). The cumulative effect of these exhibitions in her lifetime and beyond secured Agnes a place in the history of world art, irrespective of a particular allocation in movement, geography, gender, or time period.

What did Agnes make of being called a master? A pioneer? An icon? How did she feel seeing her work placed alongside the work of her heroes in the grand halls and museums she had visited as a fledgling novice? The short answer is that she embraced her new status. And why not? For years, her existence had been defined by absence and privation rather than presence and reward. The recognition she garnered in her silver-haired years, she indulged. "I'm the greatest artist in the world," she said, in 1998, with surprise more than seriousness.[1] It seems that after a lifetime of resistance, Agnes welcomed pride into her world.

This pride, however, was a double-edged sword. In the mid-1990s Agnes's friendship with Lenore Tawney seemed to end because Agnes felt Lenore must be jealous of her; an instance of her pride clouding her judgment.

Suzanne Hudson, in her book *Night Sea*, observes that Agnes "expunged" Lenore from the accounts of her life in Coenties Slip.[2] At first this might not seem unusual. With the exception of Betty, Agnes rarely mentions her female friends from New York, instead choosing to talk about her male

counterparts, such as Ellsworth Kelly. However, when we remember how important Lenore was to Agnes during her time in New York, it does seem a glaring and willful act of omission to never refer to Lenore in any capacity over the years. Hudson suggests that Agnes harbored some resentment towards Lenore for the titles she gave her paintings in 1962, while Agnes was ill. At some point this small gripe escalated to an out and out argument in the early 1970s when Agnes told Lenore that she hated her work, calling her woven forms "fetishes."[3] This is a major reversal on Agnes's part. Agnes had once regarded Lenore's work as "treasures," and argued passionately for the acceptance of her art at the Interchurch Center. It must have been a blow to Lenore to hear her friend talk this way about her work, especially when they had spent many years closely working together, and particularly when Lenore had financially and emotionally supported Agnes through some of her darkest times. Despite this, Lenore continued to loan her personal collection of Agnes's work to museums, including to Agnes's 1992 Whitney retrospective. Indeed, Lenore visited Agnes in Taos in 1994, and wrote to her afterwards, sending her a photograph she had taken with Agnes during her trip, but the women's friendship never fully recovered.

Agnes's claim that she was the "greatest artist in the world" would win her no favors with her old friends, and seemed to legitimize her fantasy that other artists, including Lenore, were jealous of her. This was nothing new—she was paranoid about Betty showing interest in Taos artists Aline Porter and Oli Sihvonen in the late 1950s—but it is particularly sad when we reflect on how close the women had been in New York.

From 1993 onwards Agnes reduced her canvas size from 6 by 6 to 5 by 5 feet (72 x 72, and 60 x 60 inches, respectively). At eighty-one she was getting old and was no longer able to move the frames with ease. She still refused studio assistants, whom she had done without throughout her life (too distracting), except in special circumstances (such as injury).

Snagging a six foot canvas to the wall, rotating it to paint and hitching and unhitching it for viewings was laborious. The act of painting itself was hard work. The dry air in Taos made the thin application of watery Liqui-tex paint dry exceptionally fast. In order for Agnes to apply and sweep the mixture across the canvas without any drips and unwanted streaks it was necessary to paint quickly, all the time trying not to edge over the pencil lines: those borders of expertly ordained territory. In the documentary *Agnes Martin: My Back to the World* (2003), Agnes moves her hand quickly over the gessoed canvas (two layers of gesso to retain the 'tooth' of the canvas), the bristles on the paintbrush making a rough sawing sound. Agnes breathes laboriously in short shallow gasps, occasionally smacking her lips together; her mouth is dry: she needs a drink. The signs of this labor are often evident in her work. For instance, despite her best efforts, the direction of her brushstrokes are often obvious. Reproductions of individual paintings never capture what many love most about Agnes's work: the human touch that tries (and fails) through geometry to make itself disappear. Even in glowing work like *Untitled #10* (1975), or sparse work like *The Islands I–XII* (1979)—and more obviously in *Untitled #3* (1983) or *Untitled* (2004), her last painting—the work is anything other than "perfect." When you stand up close to the work it is often lumpy, splotchy, or grainy, with flicks of paint splashed accidentally beyond the border of quavering penciled lines. The human failure in the attempt to achieve a kind of "all over" visual balance exposes a mortal fallibility that is very heartening to witness. Photographs do not capture this. They also do not capture the size and scale of the artwork. Despite the retiring and reduced color palette, and the gentle application of paint, the size of many of the works, at six by six feet, can be overwhelming. While this scale is not as grand as some of the work of mural artists or the Abstract Expressionists, it is still confident and insistent in the demands it makes of the viewer, sufficiently engulfing them to the same effect as Barnett Newman's *Vir Heroicus Sublimis* (1950–1951) or Joan Mitchell's *Salut Tom* (1979). The measurements are not the same, but the impression of scale comes close.

From 1993, until her death, a large portion of Agnes's artwork is awash with light pinks and blues, her favorite color inspired by the Taos sky.[4] *Untitled #8* (1994) and *Untitled #2* (1995) are two examples.

In 1996 Agnes introduced a sad, sandy cream into her palette and embarked upon her next series of paintings entitled *With My Back to the World*. Agnes chose this title to reinforce the non-material or non-wordly content of the artwork: a vision of the mind, not the earthly realm.Agnes continued to use this tint, the color of sun-soaked newspaper, in her work as late as *Untitled #3* (2003). It's a tone that stretches back to some of her earliest paintings, including *Desert Rain* and *Wheat* in 1957.

Although Agnes generally painted in series, she only produced four *named* series. *The Islands I–XII*, a set of twelve glacial paintings was produced in 1979. This was followed by the Agnes Martin Gallery series at the Harwood Museum in 1993–1994: *Loving Love, Love, Friendship, Perfect Day, Ordinary Happiness, Innocence, Playing*.[5] *With My Back to the World*, a set of six paintings completed in 1997 came next. Finally, a series of commissioned paintings for Dia:Beacon in upstate New York was produced in 1999. These were *Love, Contentment, Innocent Living, Happiness, Innocent Happiness, Perfect Happiness, Innocent Love*, and *Where Babies Come From*. *On a Clear Day* (1973), and *Praise* (1976) are the two print series, the first an edition of sixty-four and the second of one thousand.

The colors in Agnes's work between 1998 and 2002 are warm and romantic. Pastel greens clash with sandy cream or pink, bringing a heightened sensuality to the work. Within what some consider a limited vocabulary, Agnes admits great nuance in her oeuvre. Some paintings such as *Untitled #1* (1995) and *Untitled #2* (1995) embrace the washy texture of the paint on the canvas, and the brushstrokes are loose and rippling. In other work, *Untitled #11* (1998) and Untitled #3 (2002), the brushwork is smoother, effacing possible traces of the artist's hand. Paintings seem to echo each other throughout time. *Untitled #4* (1997), *Happiness* (1999), and *Gratitude* (2001) each have a thin band running across the center of the canvas like a horizon line. In each painting the band is mirrored by, or twinned with, another band. Is this second band a reflection, a mirage, or a

support to the first? Or maybe, in a Gothic twist, the first line is the mirror to the second? The double? The split self? The bicameral mind? The musical fugue? Despite these bifurcating lines, these paintings are harmonious, not unbalanced. Similarities aside, each fulfills what Dore Ashton calls their own "distinct climate."[6]

It is one thing for paintings within the same decade to share similarities. This can be expected. It is quite another for paintings to resurface like memories from the past. In traditional academic and popular accounts of Agnes's artistic development, the story is the same: Realism. Biomorphism. Abstraction. Minimalism. Grid. This is Sunday-morning writing: sleepy-eyed and stale. But it is forgivable, if one is disposed toward forgiveness. Agnes was a prolific creator. But she was also a prolific destroyer, in particular of her early work. She worked hard to buy back her paintings pre-New York, and when friends refused to return her work, or allow Agnes to purchase it, she fumed at them and sometimes cut them from her life. As a result, very little was known about her early work until *Before the Grid*, an exhibition of her paintings between 1946 and 1961, held at the Harwood Museum in 2012.

Most literature on Agnes tends to focus on her grid paintings. In reality, the grid amounted to a tiny portion of her output. The grid remains important because it signified her artistic breakthrough and became, for a time, her signature artwork. But it was with the band paintings that Agnes was most satisfisfied throughout her life—toward which her inspiration returned over and over. In a 2014 interview Louise Sause, Agnes's longtime friend from Columbia Teachers College, recalls visiting Agnes in Taos in the 1950s. In the interview, Louise recollects with clarity a series of pink and blue watercolors in Agnes's home. Each painting consisted of delicate horizontal lines drawn across the page. If Louise's memory is correct, then historians need to re-evaluate the trajectory of Agnes's career. If Louise's memory is correct, and there is no reason to believe it is not, then Agnes was making band paintings before New York and "the grid." Her return to band paintings in *Mountain II* (1966) and *Adventure* (1967) up until her death in 2004 suggests Agnes achieved an artistic maturity before New

York, in Taos, in the mid-1950s, with these horizontal watercolors. Taking a step back to consider the longevity of her career, it seems that New York and the grid was an artistic sojourn or derailment; the imbalance in her overall output. Agnes had already found her bliss in Taos in the 1950s with these band watercolors; she just didn't know it.

Of course, Agnes would deny analyzing her work through any lens, temporal, historical, or biographical. As she had stated over and over again, the response is the only thing that exists. Agnes would brush aside linear narratives or any conclusions writers would hope to make of her work. But that is not to say that conclusions cannot be drawn, or that they are not meaningful.

Throughout the 1990s Agnes received some of the highest accolades an artist can achieve. The same year that she opened the Agnes Martin Gallery at the Harwood Museum, she received the Golden Lion award at the forty-seventh international Venice Biennale. It was the first year in the history of the exhibition that two Golden Lions would be awarded. Agnes's fellow recipient, the Venetian artist Emilio Vedova, painted large, gestural, intense, and abstract paintings radically different from Agnes's work. The exhibition's curator Germano Celant praised Agnes and Emilio for their "contribution to the history of contemporary art." A year later, in 1998, Agnes was awarded the National Medal of Arts by Bill Clinton "for her inspired—and inspiring—paintings." The accompanying certificate read.

Spare and luminous, her works reflect her vision of happiness and beauty. One of America's most prominent abstract artists, she is held in the highest regard by her fellow painters, and her work has attracted a broad and devoted following around the world.[7]

A photo taken on November 5th at the awards ceremony (later sent to Agnes in a Christmas card from the First Family) shows Agnes, with her

Buster Brown haircut, smiling bashfully between the first couple. With the large, heavy gold medal hanging from the royal blue ribbon around her neck, Agnes looks like she has finally received the Olympic medal for swimming that she had trained for as a young woman. This portrait of Agnes, Hillary, and Bill was one of the few portraits she had framed in her home in Taos.

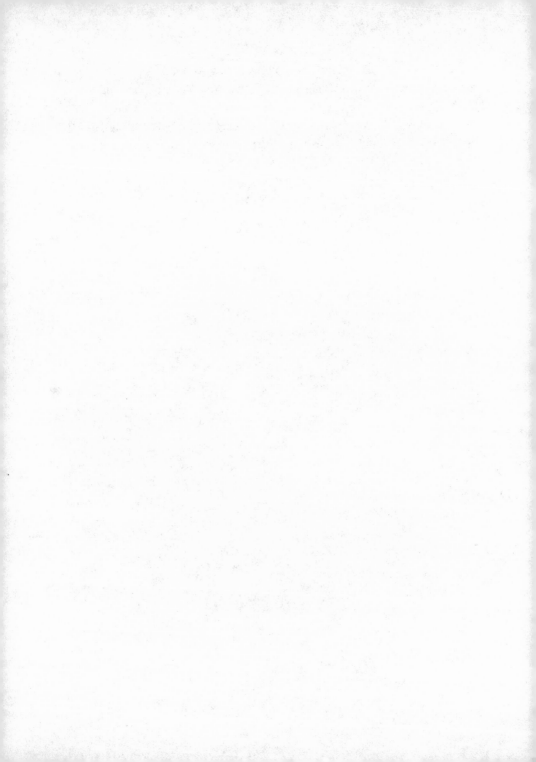

EIGHTEEN
The Storyteller Cinema

Another friend Agnes reconnected with when she moved to Taos in 1993 was the artist Marcia Oliver. Marcia first met Agnes through Kristina in the fall of 1968, the year Agnes went "missing." Marcia was in Taos, ostensibly on a Wurlitzer residency but also in a bid to escape reality—the media fixation on the Vietnam War and the assassination of Robert Kennedy was ongoing and morale was at an all-time low, creating widespread uncertainty and despair. Marcia needed a break from it all.

Abdicating the Golden State, Marcia drove west against the Santa Ana winds, up the Tehachapi Mountains, and through the Mojave Desert. Each mountain range brought Marcia closer to another time and another space, remarkable and unknowable—back to Taos.

In Taos, secluded in an adobe cottage, Marcia began to paint, creating, as Agnes had in her own Wurlitzer residency, a body of work that one day would be her ticket to New York, maybe even to the doorstep of Betty Parsons.

During her residency, Marcia became friends with Kristina. When Kristina found out that Marcia was a painter she said, "Oh, another Agnes." Marcia wasn't sure as to which Agnes Kristina was referring, but soon after, both Agnes and Kristina paid a visit to Marcia's Wurlitzer studio and she had the opportunity to find out.

At her studio, Marcia had been struggling with a canvas for a few days, not knowing in which direction she should take the work. Kristina and Agnes, with Marcia nervously standing back, looked at the unresolved piece. Agnes asked Marcia for a container of water. Marcia was puzzled, but fetched a small container of water filled halfway. Agnes bled a drop of paint into the container, swirled it around with a watercolor paintbrush, and handing both to Marcia said, "draw with the brush." Marcia did so and something in her mind clicked. "How did she know what needed to happen?" Marcia thought, looking from this robust mannish woman to the delicate wash of color on the canvas. With just the stroke of a brush the canvas suddenly seemed alive; it became—like Marcia—more sure of itself. "I remember how I was terribly impressed," Marcia recalls, "she seemed to have an insight on where I needed to go."¹ Agnes, the teacher, always. As she was leaving the studio that afternoon, Agnes turned to Marcia. Staring her straight in the eyes, Agnes asked "What do you want?" Marcia, unsure of herself and Agnes, inquired what Agnes meant, but Agnes just repeated her question, "What do you want?" Marcia replied that she wanted to succeed at painting, move to New York, and, maybe, one day, find companionship. Agnes narrowed her eyes, retrieving from her memory some rote advice: in order to achieve success one must live alone, only then could one express "universal feelings." This wasn't exactly what Marcia wanted to hear. "New York will be there next year," Agnes said, scanning the confused expression newly landed on Marcia's face.

When Agnes and Kristina left, Marcia had a flashback to New York and the Cedar Tavern in December 1958. "There was before me," Marcia said, "a grey white haze of cigarette smoke. Shoulder-to-shoulder, barely visible figures," gave out a muffled roar of conversation "meshed with the clatter from the bar." Marcia's attention was split between Bob, her date, and the

room. Marcia had only agreed to date Bob if he brought her to an artist haunt. And here she was. "I was twenty," Marcia says, "and eager to meet someone, i.e. another woman, who might be a painter, someone to help me develop into a real artist. There seemed to be only men there, maybe a hundred or more and not a single woman."

Bob and Marcia settled at a table. It was so packed and smoky that it took Marcia thirty minutes to observe two women, "an anomaly," seated at a nearby table. Marcia asked Bob if he knew who they were. "Oh. Yes. That's Betty Parsons and Agnes Martin. She does lines. Straight lines." Bob explained that she had just had a "one man" show reviewed favorably. She did paintings with pencil lines. On hearing this Marcia's stomach filled with disappointment. Marcia was a painter. She wanted to learn about painting. What could she possibly learn from a woman who put lines on a canvas with a pencil?

The Martin-Parsons table was busy with many people stopping to say hello and shaking Agnes's hand. After about an hour Marcia stood up. She had been building up the courage to go over to the two women and introduce herself. As Marcia stood away from her chair, she saw Betty Parsons lean toward Agnes and whisper in her ear. Agnes nodded and stood up, pulling her coat up with her. Agnes then turned and locked her eyes with Marcia's for a moment before disappearing through the crowd and out into the cold. She moved like an old man, thought Marcia, before the noise of the bar ushered her back to the present moment, and Bob, waiting.

Ten years later, throughout her Wurlitzer residency, Marcia finally got to know Agnes properly, visiting her in Cuba, camping outdoors under the Milky Way, listening to the howling coyotes in the valley and watching shooting stars arc across the night like arrows shot from a bow.

On one such camping trip, Agnes and Marcia lay side-by-side under a blanket, staring up at the cosmos, hearing the needles of the small *piñon* trees sift down on the earth-stuck rocks. Neither woman could sleep. At three in the morning Agnes suggested retreating into her camper. Agnes made tea and brought out some small drawings. Marcia looked at the pencil lines pulled across the pages, searching for words at the end of each

horizontal. None came.Agnes chuckled, "Clement Greenberg likes them."
At the time this trip took place Agnes had no intention of ever painting
again, but here she was, in the dead of night, returning to her work, even
more faint and imperceptible under lamplight.

The next day, on the way back to Taos, Agnes stopped at a river to take
a swim. The water was strong and wild and Marcia was amazed by her
friend's agility. Getting out, Agnes told Marcia she had trained for the
Olympics in Vancouver. Marcia didn't believe the claim in the slightest.

In 1969 Marcia's Wurlitzer residency ended. Despite Agnes's promise
that New York would always be there, Marcia decided that the time was
right to try and make it in the art capital of the world. Saying goodbye to
Agnes and Kristina, Marcia drove east once more. Passing the canyon
where Agnes pulled over to swim, Marcia felt a small pang of regret that
she was leaving Taos and her new friends.

By 1974, Marcia was faced with the same proposition that Agnes had
faced nearly twenty years previously. Betty Parsons was offering to show
Marcia's work. History was repeating for another Taos-Wurlitzer artist. As
before, Betty's offer was conditional. If Betty was to represent Marcia, the
artist needed to stay in New York. Marcia had inherited a little money and
was hoping to go to Europe but now she was torn. Show with Betty Par-
sons, arguably the world's most famous art dealer, or leave the U.S. and
travel the world? Marcia chose neither. Instead, she returned to New Mex-
ico, to land she had bought in 1971. Marcia had always craved "a place of
one's own" that "provides autonomy, boundaries as well as a retreat." And
so it was she came to build a home in Des Montes, close to Arroyo Seco at
the foot of the Taos Mountains. It was in Arroyo Seco where Marcia next
met Agnes, in 1974 at a Christmas gathering in Kristina's home.

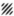

"Why aren't you working?" Agnes asked, when she had started meeting
Marcia regularly upon her return to Taos in 1993. Marcia replied that

her parents had been unwell and she had flown to Florida to take care of them. This was not a valid excuse for Agnes, who accused Marcia of doing anything she could to avoid painting. A week later Marcia found a message on her answering machine: "This is Agnes, and what I wanted to know, did you work four days in succession?" Agnes's tongue-lashing, unsurprisingly, had whipped Marcia into some activity in the interim, so she was able to answer Agnes's question in the affirmative.

Despite Agnes's own religious dedication to her studio, her life was not without its small luxuries. Throughout the 1990s, for instance, Agnes and Marcia frequently went to the movies together. Magazine accounts of Agnes at the time claim that by the time of her death in 2004 she had not read a newspaper in fifty years. The truth of this is worth challenging, though it does hint at Agnes's repudiation of conflict and exploitation; and news suppliers as they have become known, subject the former to the latter. If Agnes shunned reality as it was represented in the media, then she positively embraced the fantasy of the motion pictures, also dependent to some degree on conflict and exploitation. Agnes enjoyed the movies of Fellini and Kurosawa, in particular *Amarcord* (1969), *La Strada* (1954), and *Rashomon* (1950). Often she saw in these movies confirmation of her own precepts for living. For instance, of the thief in *Rashomon*, Agnes believed "Flies crawl on him. He is happiest."[2] Agnes had a romantic view of life where the work of each person fulfilled them, be they farmhand or art dealer. With that logic a flea-riddled thief could, in Agnes's world, be happiest. When in New York in the 1960s, Agnes went to see Westerns "for the scenery."[3] This suggests how important the New Mexico landscape had become for her, during her early time in Taos. Movies, therefore, were not merely instructive, they fulfilled a need in her visual experience.

The Storyteller 7 Cinema on Route 68 (or Paseo Del Pueblo Sur), the main road that leads into Taos, tended to show more mainstream movies than Fellini and Kurosawa. On Friday evenings, Marcia would finish working in her studio, shower, pick her clothes out carefully, and race into

town to collect Agnes for the 7pm screening. Agnes always sat patiently in her rocking chair waiting for Marcia at the Plaza de Retiro. The Storyteller was always busy on a Friday night. Teenagers, bursting with energy, zigzagged like fireflies searching for their friends, while older students, bathed in perfume and aftershave, prepared to make their own entertainment necking in the back row. It's hard to imagine silent, still, stolid Aggie surrounded by all that excessive commotion and extra large tubs of popcorn. There was always a line by the time Agnes and Marcia arrived. Every week Agnes complained, and not with discretion, that the cashier was slow making change. Thirty years of working out dimensions and ratios for her artwork meant Agnes had become super-quick at arithmetic. After the movie Marcia and Agnes would drive to Baskin-Robbins—all fluorescence and neon in the black desert night—for an ice-cream cone, or they would return to Agnes's home for a cup of tea to end the evening with a slow tempo.

Sometimes Marcia didn't finish in the studio in time to make the Storyteller, and they went for a drive instead to Marcia's house. Agnes's apartment, after all, had little distraction: a bad thing, when you wanted it. At least at Marcia's house there was a balcony from which to watch the sun set, wild deer grazing in the fields, and a radio or TV for background noise. On one such day, the movie was cancelled and Agnes and Marcia returned to Agnes's apartment. Marcia got bored and started doing her yoga stretches to kill time. An hour later, Marcia finished and sat on the ground looking up at Agnes. Agnes seemed pleased and said, "We found something to do." Later Marcia learned Agnes had hired a yoga instructor to come to her apartment each week to give her private instruction. At eighty-five, Agnes was never too old to learn a new skill.

Though Agnes frequently told reporters she had no friends, what she meant was that she was not beholden to anyone, and vice versa. Kristina agreed, and felt that very few people really knew Agnes. People were enthralled by, and attracted to her, but not many people had the strength to battle with her when her personality changed and her temper ignited. According to Kristina, Arne Glimcher could control Agnes, but not with-

out some effort and even then, not always. Kristina had learned early on, and the hard way, how Agnes could abandon friendships, flick a light switch on them, and leave friends in the dark. It seemed that the closer Agnes was to you, the more in danger you were of sudden and irrevocable actions.

Marcia experienced this first hand. On one occasion she and Agnes were sitting on the couch in Marcia's house. Marcia rested her arm on the back of the couch and Agnes jumped up from her place and sped across to the French window. The sun was setting and Agnes was a silhouette against the square panes of glass. Out of the blue, Agnes told Marcia that she never wanted to have shock treatment again. Affection. Attachment. Passion. Agnes couldn't allow herself these. At the age of eighty-five she was still traumatized by her past. Relationships, she told Marcia, brought her to the edge. She was afraid of the strength of her emotions and the voltage needed to bring her back from the threshold of insanity. And so Agnes bottled up her feelings, and even when she had friends, she told the world she had none. And when friends disappointed her, in small, innocent ways, she severed the relationship, unable to cope with or mend it.

Staring out the window at the sunset in Marcia's house, Agnes might have been reminded of the long line of women in her past—stretching all the way back to her childhood. Women Agnes had turned away, or married off, or done battle with. Agnes explained her predicament to interviewer Jenny Attiyeh, opening a rare window into her personal life. When asked if she loved anyone, in particular anyone in Taos, Agnes replied, "No. But I love their love for love,"

I love their goodness. But I do not love personally. There's a lot of people that want me to love them personally, but I don't. And believe it or not, but when I was 5 years old, I had a playmate. Perfect I thought she was. But I told her when I was five, I told her, 'You don't love me and I don't love you.' And I've never had that trouble about, you know, love interfering with a relationship.

When asked if she might be afraid of the mess and chaos of love, which can be a source of interest for some people, Agnes was adamant:

> I think that's insane, to want to be in a mess. I know people that do, but I never do. I even live like that—don't go down, don't go up, don't mess, go straight like that. I live very carefully.[4]

Marcia found her conversations and attachments with Agnes clearer now that she knew never to broach any emotional or volatile subject. Perhaps because of this both women became increasingly fond of each other's company. Despite Agnes's best efforts to stay above the line, "don't go down, don't go up...go straight," she grew to have expectations of Marcia.[5]

On another occasion, Marcia made the mistake of sending Agnes a postcard from Mexico, where she had accompanied a friend to attend a funeral. Agnes was livid. When she saw Marcia approach her apartment after the trip, she screamed at the top of her voice, "It's over. It's over." Marcia's heart dropped. She tried to calm Agnes, but Agnes was too worked up to listen. Eventually Marcia, afraid that Agnes might become unwell if she stayed, drove away in tears.

For the next two weeks Marcia sent letters and telephoned Agnes, hoping for reconciliation. Was it possible they could never be friends again? Never see each other again? Despite telling Marcia that affection, attachment, and passion were off-limits, Agnes had clearly nurtured a seed of each in her own mind, living out a romantic fantasy in her head: weekly dates at the cinema, shared ice cream, memories of camping under the stars. It dawned on Marcia that Agnes "had this fantasy relationship with me that was very romantic and precious and pure and innocent, but very intense: the attachment and the affection. And she felt betrayed when I went down there to Mexico." Here, Marcia was experiencing first-hand the difficulties of maintaining a friendship with Agnes once the symptoms of her schizophrenia surfaced. These anecdotes are the closest glimpse one has of understanding the dissolution of Agnes's relationships with

the other women in her life: Mildred, Daphne, Chryssa, and indeed, her mother, Margaret Martin.

On another occasion, Marcia held a door open for Agnes as they entered a restaurant. Even this small act of affection—a courting trope—was too much. Agnes immediately barked "get away from there." The door shut with a thud.

Agnes was not the only woman who struggled with her feelings of affection. Marcia was compelled to untangle the impact the relationship had on her during those years.

> I've found this true, and my experiences with Agnes bears this out, it really hardly matters whether you engage physically when these attachments and passions are present. Even if you never make love, you never go to bed together—if you keep seeing each other it gets more and more intense. You pay either way, whether it's unconsummated. It's just who we are. If you're in love with someone, whether you kiss them or touch them or not, you still pay. When it's over, you know, you miss them.

Even though Marcia knew that their mutual affection would never manifest in a verbal or physical gesture, she always hoped there would be some declaration from Agnes that she was valued. "Love, appreciation, commitment." No declaration came. One day Marcia went out on a limb anyway, planting the words solidly between her and Agnes: "Agnes, I love you."

Nothing.

Looking at Agnes's *Innocent Love* series from 1999, which includes *Perfect Happiness*, *Innocent Living*, and *Where Babies Come From*, Marcia saw a portrait of herself and her friendship with Agnes. The colors of the canvas matched the clothes she had so carefully chosen for their dates over the years. "Blue and yellow, or pink and blue: these pastel colors. Always I

thought to myself, Agnes knows I love her, and she loves me too, and that's why she painted that pastel series of paintings."

When Marcia finally tells this story, Agnes has been dead ten years. "I've still got the shirt, the salmon-colored one, and my pants are just over there." Marcia looks away. "They're just tatters now."

NINETEEN

An Unlikely Benefactor

A gnes's attitude toward money was not what one would consider straightforward. For the majority of her life, Agnes was poor. In Taos in the 1950s she lived in a dirt-floor hut, scavenging for food at day's end. In New York, she depended on Lenore Tawney's steady income in order to pay her bills and medical fees. She had very few possessions because of her tight purse strings, but also because materialism was not compatible with her view on life, in particular on the life an artist should lead. Worldly possessions were just one more distraction from creating work.

When Agnes finally did make money from her artwork, she had more than she ever thought possible. In fact, she had so much money she didn't know the *value* of it. For too long Agnes had lived an ascetic life: her needs never strayed beyond the immediate and her tastes were cultivated by necessary frugality. Money awakened no new desires in Agnes to change her routine or lifestyle beyond her little treats. Agnes was bemused by her own success, often telling interviewers (and their readers) that she was

a millionaire. This was wrong. She was a millionaire, many, many, many times over. As a result of her frequent boasts, strangers solicited Agnes for money, writing letters and visiting her home. On one occasion staff at the Plaza de Retiro removed a woman from Agnes's breakfast table because Agnes was visibly disturbed by her presence. When asked who the woman was, Agnes said she didn't know, but that the woman had asked her for money. These events created anxiety in Agnes. At times, during episodes of illness, she imagined figures coming through the walls at night, trying to steal from her. Fantasy and reality blurred.

Agnes's wealth also brought stability, particularly in Taos, where she could relax into a lifestyle of small treats outside of her home-studio time-table. At one point, after she had resumed painting in 1974, Agnes set up a foundation whose mission was to purchase Abstract Expressionist art-work for museums. Later, despite its success, Agnes closed the foundation down, dismayed by the rising prices of the artwork and a greedy commercial market.

In Taos, Agnes, with the help of Kristina, began to support a range of projects that had clear benefits for the people of the town. Agnes wasn't fully aware of the good that her wealth could do. "She had never thought of being generous," Kristina said, "She had been poor, poor, poor all her life. Generosity was not part of her thinking." This changed in 1997. One of Agnes's first charitable acts was the purchase of the Ponce de Leon Hot Springs, where she had once taught the daughters of the photographer Mildred Tolbert to swim. Agnes had visited the Hot Springs, a forty-four-acre site south of Taos, late in the 1940s, impressed by the communal spirit the site evoked as well as its spiritual significance for Pueblo ceremonies. By purchasing the land through the Taos Land Trust, she was protecting the springs from commercial development. In 2012, long after her death, the land was finally returned to the stewardship of the Taos Pueblo, a reparation she would have been happy with.

Agnes's financial giving was centered on improving facilities for Taoseños as well as safeguarding tracts of land for the benefit of the locals. One of the first projects that Kristina remembers working on was the cre-

ation of a community park for children living in low-cost housing. When Kristina was approached by a local and asked if Agnes might be interested in purchasing some trees and grass turf to improve a vacant lot for the local children, Kristina was doubtful but thought it wouldn't hurt to ask. To Kristina's surprise, Agnes agreed to donate and wrote out a check right there and then. "She liked doing things for children," Kristina recalls, "that was very important to her." After the trees and grass were in place, Kristina's friend came back again. Do you think Agnes would be interested in donating a swing set? Again, Kristina went to Agnes and again Agnes nodded her head and wrote out a check. Kristina's friend came back once more. Do you think Agnes would be interested in donating a gazebo? Kristina's palms itched. Again, Kristina went to Agnes, this time with some trepidation. Agnes sat, rocking forward and back in her chair. "Do you think you'd like to put a gazebo over there, Ag?" Kristina asked. Agnes stopped rocking, and sat up in the chair, tall as a tree. "I want *two* gazebos," she thundered, with a nod of the head. Kristina's palms stopped itching. A relief.

The park became the nexus for the small community. Young families walked their strollers around on the sidewalk, boys and girls took art classes in the gazebos, and Agnes looked on with pride.

A flurry of donations followed. Recipients included: a school in Arroyo Seco that used its funds to convert their desert playground into a lush sports field; the local Freemason's lodge who renovated the Kit Carson Home and Museum; and the Rocky Mountain Youth Corps who built a boardwalk through the wildlife sanctuary at Fred Baca Park, south of Taos. On numerous occasions Agnes donated to the Dream-Tree Project, an emergency youth shelter and crisis center set up to support young people emerging from a care home environment. Agnes also donated to the nonprofit Community Against Violence, a service supporting victims of domestic and sexual violence. Agnes, for all the years she spent alone, was clearly capable of empathizing with her neighbors:

They're different in Taos. They're friendly. The Anglos are friendly. The

Spanish are friendlier than them, and the Indians are friendlier still. So you have three sets of friendly people here."[1]

Despite her affection for her townspeople, Agnes was selective about what she supported. Sometimes Kristina would suggest something and the response was a definite, "No." "She was very decisive and sure of herself," Kristina recalls, adding with a hint of private frustration, "on *everything*." Kristina believed that Agnes's newfound philanthropy brought out the best in her. Agnes was happy to sign checks to Kristina because it meant she didn't have to get involved in the project at any point, and her donations remained anonymous. Agnes was painting full-time. If her charitable giving got in the way of her work, she would simply stop giving.

Two of the biggest projects Agnes supported financially were the renovation of the Taos Community Auditorium, under management of the Taos Artists Association (now the Taos Center for the Arts), and the building of the Taos Youth and Family Center Swimming Pool, a three-million-dollar project that Agnes was passionate about.

Agnes donated to the Taos Youth and Family Center with one stipulation, that it include a children's pool.[2] The shape of the "kiddies pool" is reminiscent of Arvo Aalto's famous vase and has two water features, each with a white stem and red cap. The feature with the convex red cap looks like a tall mushroom, the other, with the concave cap has the appearance of a poppy flower. When the pool is empty of swimmers and the water is still, the sunlight from the adjacent windows filters through in long horizontal bands—shadows and light—against the blue tiles of the pool's floor, just like an Agnes Martin painting.

The construction of the swimming pool nearly didn't happen. Agnes made the donation with the understanding that, within a year at least some building or foundation work would be underway. When this did not happen, her gallery requested that the money be returned. Kristina remembers returning from holiday and checking anxious voicemails from people involved in the project. Immediately she called on Agnes and asked her if the town could keep the money, assuring her that the plans for the pool

were well underway and construction would start soon. Agnes took a scrap of paper and wrote her signature under "the town can keep my money." The project was saved. "That tiny scrap of paper," says Kristina, "is why we have a pool today."

The Center also contained offices, a café, ping-pong tables, an outdoor skating park and a sandbox playground. When the skating park was finished it resembled a modernist concrete sculpture. Kristina remembers Agnes sitting outside staring at the park and the children skating and cycling, with the Taos Mountain Range undulating in the background like the bony plates on the back of a stegosaurus. "She got a kick out of that park," Kristina says. "She sat out there looking at the mountain and looking at that park. Glowing. I don't know that I've ever seen her glowing like *that*. Feeling good. Realizing, my God, I can do something with this money."

Maybe Agnes, in her donations, was trying to compensate for the absences in her childhood; an absence of affection, of facility, of support, of nurture? So often in interviews and in her writings, Agnes's stories of childhood and adulthood involve a battle of some sort: an obstacle to be overcome. Sometimes these stories take on medieval overtones, as when Agnes talks about slaying the dragon, a symbol for Agnes of pride in some writings and solitude in others.

> The solitary life is full of terrors...Worse than the terror of fear is the Dragon...The fire of his breath destroys and disintegrates everything... The solitary person is in great danger from the Dragon because without an outside enemy the Dragon turns on the self.[3]

In other instances Agnes's battles are mystical. In the documentary *My Back to the World* Agnes talks about her memory of being born, "I thought I was quite a small figure with a little sword, and I was very happy."[4] Happy maybe, but Agnes immediately went to war, cutting her "way through life, victory after victory," until she met her mother and, "half [her] victories fell to the ground." Agnes had experienced struggle in her life and had

been saved by Lenore and Kristina and other friends. Maybe donating to the DreamTree Project and Community Against Violence, and building the Taos Youth and Family Center was Agnes's way of repaying this love?

According to Kristina, Agnes had a feeling that she should have been married and had "a whole bunch of kids." Agnes loved children, but she was afraid of them:

> She always said she wanted six children. She liked little children. She was afraid of liking them. She didn't want to love them too much. But she was extremely observant of kids. She would analyze them and tell you exactly what career they were going to go into. She knew the answer to everything. This was the hard part about her. Her own childhood was pretty unhappy. She talked about her childhood endlessly.

Agnes never had children, but she had ties to many. She had nieces and nephews, cousins, the children of the Kane sisters, devoted students and friends, Arne Glimcher, and of course, Kristina and Daphne Cowper, two matches and two heartbreaks by Agnes's hand. Although she met Daphne again in 1995 for lunch in Taos, Agnes did not know Daphne's two children. Ian Wilson was the closest Agnes had come to having a child, living vicariously through Kristina. In *My Back to the World* Agnes speaks of being born over and over again. In her different lives she has had hundreds of children. One imagines that her children would be able to climb mountains, shoot BB guns, know the constellations, sew, swim free in rivers, and create boats out of apple barrels. Their feelings do not go up and do not go down. They do not suffer from sexual ambiguity or conflict, or struggle with inner voices. They do not forget their name and get lost and overlooked on the streets of New York. The children of Agnes Martin do not have one hundred rounds of electroshock treatment. They do not feel the need to rewrite their life to stay safe, they do not need to go up a mountain to be alone, to wrestle with their voices and their feelings. The children of Agnes Martin are not artists. They have no terrible will to create art. The children

of Agnes Martin know how to bake an adobe brick in the shade of a tree. They know how to build a house, and how to be content. Dream children.

In 2002, the community repaid its thanks on the occasion of Agnes's 90th birthday with a two-day celebration of her life. Artists and art-world heavyweights from Yale University, the Hirshhorn Museum and Sculpture Garden, and the Dia Art Foundation arrived in Taos to give themed talks and discuss Agnes's work at a symposium moderated by Arne Glimcher. The weekend included a screening of *Gabriel*, the opening of a new exhibition at the Harwood Museum, a music concert, and a grand dinner at Taos's Sagebrush Inn. At her birthday party Agnes was very much the center of attention, wearing a silver dress pinned at the neck with a silver brooch, a mother-of-pearl necklace, and a corsage of orchids. More than seventeen people were seated in a row at the head table, with a diminutive Agnes in the center, a spotlight directed above her place like an orb of heavenly light. The centerpiece dessert was a cake iced to resemble Agnes's painting *Affection* (2001). Half the cake's surface had ninety-six white candles—a few too many—if not one for every year of her life, then, one for each of her many lifetimes? The other half of the cake's surface had a solitary striped candle in blue, the perfect symbol for a woman who lived her life apart from the crowd, above the line.

TWENTY

The Peach Tree

In November 2012, the centenary of her birth, and eight years after Agnes passed away from congestive heart failure at the age of ninety-two, the exhibition *Agnes Martin: Before the Grid* opened at the Harwood Museum in Taos. It was the first attempt by a museum to present an account of Agnes's life and work before her move to New York in 1957. The curators, Jina Brenneman and Tiffany Bell, had the unenviable task of assembling from disparate private collections closely guarded artworks that Agnes herself had tried to locate and destroy. (One unguarded artwork was found in the janitor's closet of a local school). In the accompanying catalog, each contributor noted how resistant Agnes herself would be to the show. "She would have been furious," Jina says, "because she mythologized herself and she did it on purpose." For Jina, one reason for doing the exhibition was to demythologize Agnes, to make her human again after so many years of idolization that eclipsed the power of her art and accomplishments. "We're close enough to Agnes's life that we

can avoid and correct myth. I think demythologizing her is going to, in the long run, be much better for her in an art historical perspective. This makes her so much more vital."[1]

Jina was not the only one to challenge the iconography around Agnes that dedicated fans nurtured in their minds. Kristina recorded on film a talk she had written, which was screened in front of her friends and townspeople. Her aim was to "reveal some historical truths" about Agnes's life. At the age of eighty-three Kristina says, "I have had what she would have called 'an inspiration.'"[2] Her heart beating furiously, Kristina laid out her story of Agnes,

> In the beginning we were lovers back in the 1950s when there was much shame, guilt and secrecy. But more important our friendship held fast to the end of her life.
>
> Though Agnes talked, wrote and painted about the quiet mind, tranquility and happiness she seldom experienced these things in her own life. She was often tortured and tormented by her demons. It often seemed that her one hand literally wasn't aware of what the other was doing.
>
> I feel inspired to tell you this human side to Agnes because I believe that the real genius and heroism of Agnes was her passion for painting and determination that she kept on painting and believing in the serenity that she was never able to attain for herself. I also believe that the physical process of painting grids and lines quieted her mind and helped contain her madness.
>
> Agnes had an amazing forceful, entertaining and charismatic personality and showed tremendous interest in others wanting to know what their inner thoughts and opinions were. I think some people felt that she was looking straight into their souls. Unfortunately her paranoia often erupted along the line and many of these people became very confused and hurt. When she was good she was very good but when the demons took over it was devastating.
>
> The miracle is that she managed to contribute so much to this old

world while doing battle with her unruly mind. Therein lies the greatness.

Kristina's talk was bracing, honest, and in the literature about Agnes Martin, it was unusual: plain speech that required courage. It was born from great love and affection and acceptance, without any bid for reward.

Kristina says she was never really interested in Agnes's art, or Agnes the artist. When she thinks of Agnes's art, she doesn't think of grids or bands, she thinks back to the destroyed painting, *Father and Son*, which won a prize for Agnes at the Taos Art Fair in 1951. To Agnes the person, Kristina committed her friendship and her dedication throughout the years, despite the ups and downs. "There were times when I could have killed her," Kristina says, "hated the things she did. She did some very cruel things to people, including my own family." When asked why she stuck by Agnes, Kristina didn't hesitate to respond,

> There are several reasons that I stuck by her. I had tremendous gratitude for her. It's because of her that I got married. It's because of her that I have a son that I adore. And now I have a granddaughter who I totally adore. This would not have happened if she had not encouraged me. A lot of it was pure gratitude.

A short while after Agnes's death and cremation, Arne Glimcher, Bob Ellis and some friends scaled the walls of the Harwood Museum by moonlight to place Agnes's ashes beneath a tree in the garden. It was a brave and romantic act, well-intentioned and chivalrous. Afterwards, some neighbors knew where Agnes's ashes lay and would visit her to pass the time and watch the tree change color with the seasons. One detail, however, was amiss. Kristina recalls that Agnes always wanted to be buried beneath a peach tree, but the moonlight bandits placed Agnes beneath an apricot tree.

The leaves of a peach tree are long like spearheads and the blossom richer in color than the apricot bloom. Fables and mystique collect around the tree and its fruit. Peach wood wards off evil spirits in some legends. In others the fruit evokes desire and indulgence and is symbolic of spring and immortality.

Perhaps Agnes chose the peach tree remembering her grid painting *The Peach* from 1964. Or perhaps she was remembering the Tang Dynasty poet Li Bai:

> You ask why I live
> in the mountain forest,
> and I smile, and am silent,
> and even my soul remains quiet:
> it lives in the other world
> which no one owns.
> The peach trees blossom,
> The water continues to flow.
> I live in the other world,
> one that lies beyond the human.

Kristina managed to right this wrong following one stormy night a few years after Agnes's death. Arriving at the Harwood Museum garden to pay a visit to Agnes, Kristina saw the apricot tree split in half from the storm the night before. A while later, and without permission, Kristina purchased a peach tree and planted it firmly in the earth.

Agnes was long at rest by the time the peach tree revealed its first blossom, but for Kristina, it was a symbolic moment. All would come right in the end, as Agnes always said it would.

In the last two years of her life, in her ninth decade, Agnes produced unexpected work, full of definition and darkness, which moved away from the

series of themes she had focused on from the late 1970s onwards. *Untitled #21* (2002), *Untitled #1* (2003), *The Sea* (2003), *Homage to Life* (2003), and her last painting, *Untitled* (2004), take the viewer to a landscape very different from that of Agnes's other work of the past twenty years. What was Agnes's inspiration telling her? What was her mind's eye seeing? *Homage to Life* (2003) evokes the finality of its title. A black square (or is it a trapezoid), seen at an angle, is placed against a field of gray. The object could be a shallow dark pool, a concrete altar, or black mirror on life. This is not a painting about joy or happiness or love or innocence. It confounds. Its style and uncertainty connects it, most closely, with one of Agnes's earliest surviving paintings, *Untitled* (c.1957). *Untitled* was painted at a time of emotional, fiscal and artistic uncertainty for Agnes, when she was living in Taos with no money, failing to sell her artwork and dissatisfied with her output. Was Agnes expressing dissatisfaction in *Homage to Life*? Or reflecting on resilience?

When one looks through Agnes's entire output one discovers in her drawing *Mountain* (1960) the same shape repeated. *Homage to Life* might be a mountain scaled; the mountaineer's way of owning the moment. Likewise, *Untitled #1* (2003) finds its genesis in her drawing *Untitled* (c.1961), a single mountain peak, capped at the tip, which finds its own genesis in another work, *Untitled* (c.1949), one of Agnes's oldest surviving paintings, handed down from Mildred Kane. Is it only a specialist's hobby, an eager fan's, to try and join the dots and find some meaning in Agnes's work that pulls through the decades like a thread? Why, in her ninety-first and ninety-second year did Agnes return to symbols before the grid on which to close her life? Symbols she had previously tried to destroy? What kind of last-minute reparations went through her mind as she looked back to the Elk Lake Cabin, Mount Bachelor and The Three Sisters range, Faith, Hope and Charity, the first Oregon mountains she painted as a young woman? After forty-three years of drawing lines across a canvas to quell her mind, had Agnes finally achieved a state of peace, able to approach again old forms ingrained in her memory?

Agnes, of course, knew it was the end. Tony Abeyta, who helped her in

her studio in her very last years, recalls that Agnes felt the paintings she was finishing for her May 2004 Pace exhibition (entitled *Homage to Life*) represented "a spectrum of all the work she had done in her lifetime."[3] One would suppose that, as such, to properly represent her lifetime, it was impossible for Agnes just to paint joy and happiness and praise. It was, in fact, necessary for her to return to her work before the grid and *The Tree* (1964).

Another reason to account for the dark direction of her last works was that in truth Agnes never fully achieved a state of peace or solace from her illness. Even at the end of her life, her visions and voices took hold in ways that left her speechless or confused. Likewise, her mind was often somewhere else: locked in a distant past, walking down the street deep in the perishing heat of the high desert sun, or waiting on a bench outside the Harwood Museum for a friend—long dead—who would never come.

Marcia visited Agnes in the Plaza de Retiro in the fall of 2004, when Agnes's health was failing. When she arrived, she sat next to Agnes, as they had at done at the movies, and Marcia spoke a little. Agnes turned to her nurse, Priscilla, and to Marcia's surprise, requested a song. Agnes had become accustomed to friends singing to her. Arne Glimcher sang her Cole Porter and Marcia was not getting off lightly. Marcia chose "Four Strong Winds," a Canadian folk song by Ian Tyson from 1963,

> Four strong winds that blow lonely, seven seas that run high,
> All these things that don't change, come what may.
> But our good times are all gone,
> And I'm bound for moving on.
> I'll look for you if I'm ever back this way.

Marcia sang a few verses, the ones she could remember, and left Agnes to rest. Closing the door to Agnes's room behind her, Marcia stood in the hallway and cried.[4]

EPILOGUE

Serendipities

"Her life has been hard," Kristina says, "she won't admit it, but—she'll tell you there's never been an unhappy moment—that's one of the biggest myths of the world. One of the greatest myths that ever happened."[1]

Sunset Park began as three acres when Kristina purchased it with Agnes's donation at the end of the 1990s. In time, more acres were purchased and bequeathed, until finally it was handed over as a conservation easement to the Taos Land Trust in perpetuity. Nailed to the fence that runs along the winding path down to the park is a little wooden sign. On it, painted blue letters read, "No Camping," a decree the young and adventurous Iggidy Martin would have totally ignored.

Sitting in her home next to the park, reflecting on her training as an occupational therapist, Kristina pauses mid-sentence, "That's another story," she says, brushing the sentence aside with her hand, as if it were a buzzing fly. I have asked her about the first time she met Agnes. "Tell me that," I ask her. "Tell me how you ran into her."

As an occupational therapist, you take a lot of medical classes and a whole lot of art and craft classes, so I was taking a design class in this great big classroom at Columbia Teachers College. And I noticed there was someone using this room as a studio in the back, far in the back corner. On the last day of class I was going out the door and this woman came up to me and asked if I was related to my two brothers; that she had gone to college with them. She recognized me 'cause I looked like my brothers. She somehow figured out who I was. I don't know how. And we talked for ten minutes. I didn't remember her name or anything else, but when I next saw her she was at my mother's house. Oh, my God. Two years later.

Kristina paused, looking back in time to 1952, "Serendipities."
"Agnes noticed you," I said, "clearly."
"Well," Kristina looked out at the setting sun, suppressing a smile, "She obviously wasn't painting the whole time."

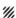

Agnes believed in reincarnation and believed she had been both men and women in past lives, but after her life on the Canadian plains, the North Pacific Ocean, the Hudson River, and desert mesas, after living through and beyond the twentieth century, rising from poverty to celebrity, and battling and overcoming personal turmoil, she was ready to rest.

"I'm not going to be born again," she informed the *Santa Fe New Mexican* in 1998, with characteristic assertiveness, as if she had a choice in the matter.[2]

I don't want it. I am so sure of an afterlife, I just want to go on and see what it's like. I've enjoyed my life this time very much. I have never had an unhappy moment. I don't feel anger, resentment, fear. I don't know why. I never go down. Above the line is happiness and rest. That's where I live— above the line.

Afterword

Before I knew anything about her or her painting, I saw Agnes Martin on video. At the time, in 2012, I was working for the publishing house Phaidon Press, putting together a sales conference presentation for a new book on the artist, and the editor wanted to show a clip of Agnes talking. Huddled in front of a laptop, the managing director and I watched this old lady speak slowly about beauty and innocence. When it ended, my boss turned to me and said, "we're not showing that." Later in the day, I couldn't shake the image of the artist, or the way she spoke, from my mind. I thought to myself, *that was the saddest woman in the world.*

Months passed before a finished copy of the book—*Agnes Martin: Paintings, Writings, Remembrances* by Arne Glimcher—arrived from the printer, and I thought it was one of the most beautiful books I had ever seen. It spared no attention to detail in design or production, with fold-out sections, multiple paper stocks, tipped-in facsimile notebooks, and a cover the most beautiful shade of blue—my favorite color, and, later I would learn, Agnes's favorite color too. When I finally got around to reading the

book, I found Arne Glimcher's portrait of this mysterious artist warm and charming. It was the artist's writings, however, that resonated with me more. I never heard someone talk about being an artist the way she did. I say "heard" and "talk," because most of her writings were written as lectures, and their syntax and my memory of her talking, made it feel like I was listening and not reading.

When she wrote "you must gather yourself together in your studio all of your sensibilities and when they are gathered you must not be disturbed" this connected to a desire already in me to do just that.[1]

As good as the book was, and it was very good, I didn't learn much about the artist herself. It was a portrait, but characteristically, an enigmatic one. I did not know at that early stage how important enigma was to the artist and her legacy.

I started digging around for details on Agnes's life, and to my surprise I found very little, just a good *New Yorker* profile and a few obituaries. It wasn't until I read Jill Johnston's profile of Agnes in *Gullibles Travels* that I thought I would like to try to write something on the artist myself. But how could I write about someone about whom very little is known?

At the time, Jill Johnston was an equally extraordinary discovery to me. Her writing—angry, hilarious, tender, irreverent—made me laugh out loud in public many times. Because I was a playwright (when I wasn't working for a publisher), I started writing dialogue and scenes featuring Agnes and Jill. This was quite easy to do, because both had very strong voices and an idiosyncratic way with words. As women, they seemed polar opposites; and opposites, every playwright will tell you, make for great drama.

In the summer of 2014 I wrote a small play about Jill and Agnes in New Mexico, and I had a public reading of the work in an out-of-the-way theater in South London. The experience, though a success, revealed to me that what I wanted to explore about Agnes wasn't suited to the elements of drama, after all. The details of her life that I loved could only be captured and questioned in prose.

Meanwhile, about six months prior to this, in December 2013, I got in touch with Jina Brenneman at the Harwood Museum of Art in Taos. In

2012 Jina had been co-curator of *Agnes Martin: Before the Grid*, an exhibition of the artist's early work, and I hoped that she might shed some light on Agnes's early life, about which there was so little to read at the time.

I blame Jina for everything that happened in my life ever since. Jina challenged and encouraged me. We e-mailed daily, and then, sometimes several times a day. While I was conducting my research on Agnes (and still holding down a full-time job), Jina, with the artist Kathleen Brennan, started to interview many of Agnes's oldest friends—the oldest, Louise Sause, was one hundred and two years old at the time. Jina and Kathleen didn't know it then, but these interviews would become the heart of their documentary *Agnes Martin Before the Grid* (2016), which focuses on Agnes's life before 1958.

In Jina I found a fellow geek and enthusiast, but also someone who was far beyond me in her ability to situate Agnes properly in an art-historical context, as well as understanding Agnes as a living, breathing person. At this point in my research I felt that the next step was to visit New Mexico and meet some of Jina's contacts. However, I wasn't satisfied to fly so far from London and only spend a week or so in just one state. So, in July 2014, I bought myself four separate flights: London to Los Angeles; Los Angeles to Santa Fe; Albuquerque to New York; and a return flight from New York to London. A few months later I handed in my notice at Phaidon, and on October 2nd I dragged a suitcase and a fold-up bike to Heathrow Airport, in a bid to follow my inspiration. I was going away for two months and I had no idea what I was getting myself into.

I would add that, on every level, I was hopelessly naïve. On September 28th I wrote in my journal, "My research is nearly done." On October 12th I wrote, "I want to get it finished as soon as possible so I can move on to the next project." I had travelled from London to Taos, nearly seven thousand feet above sea level, with no job to go back to, and although I thought my research was "nearly done," it was in fact only beginning, and although I thought I would soon "move on to the next project," I didn't even know what I was hoping to produce in my current one. I thought it might be a novella, or a piece of long-form travel writing, or art criticism. I wrote,

"The challenge is to take all of this—my reading and research—and shape it into something I am proud of: something real and true. Whatever that might be." By October 16th I had achieved some clarity, "It's most definitely a book, but from what and whose perspective?" My fold-up bicycle, the perfect metaphor for my journey, and the lifeline I depended on to connect my mesa *casita* to Taos, refused to stay operational. It left me stranded on dusty trails, and when it did function I had to walk it up steep hills: the altitude and heat made me feel I was wading through warm syrup. So too my research challenged me, and I often felt out of my depth. Like Agnes, I had assumed that the desert would be flat, but in my research and in my daily life I had highs and lows to toil through, and the experience was not always an easy one.

At some point in Taos, I decided I would try to write a short biography on the artist. No biography existed, and I had heard that a major retrospective of the artist's work was planned for the Tate Modern in 2015. Maybe with the aid of my publishing connections, discipline, and divine intervention, I could get a book together in time. I should add that at this juncture the only paintings by Agnes I had seen were a small handful at the Dia Art Foundation in New York. Did I even like her work? Did that matter?

My time in Taos was challenging and quietly life-changing. There were highs: a day-trip to Abiquiú with a friendly neighbor, and there were lows: eating Doritos and Reese's Pieces for dinner while watching *Annie Hall* on TV—I had run out of proper food, and it was too late and dangerous to cycle in to town.

The greatest high was in finally meeting Jina and Kathleen, whose enthusiasm for this project was exceeded only by their great generosity, humor, and encouragement. This book, *Agnes Martin: Pioneer, Painter, Icon* simply wouldn't exist without them. Kathleen, in particular, took me under her wing, and welcomed me into her home, and it was a kindness much needed and appreciated then, and now.

And then there was Kristina.

Kristina was reluctant to meet this "Scottish" interloper, and only agreed to meet me to discuss Agnes's philanthropic work. I brought along

a bottle of Bailey's Irish Cream (a gentle reminder that I am Irish not Scottish), and some Scottish shortbread, because Kristina's forebears (like Agnes's) in fact were. I smile when I think of Kristina. At the time, when we first met, she seemed to me regal and very strong, exactly what I would expect of a person who had spent a lot of her life living in a desert town. More than once did New Mexico remind me of Connemara in Galway and I understood how an inhospitable landscape can turn a soul strong and humble. At eighty-five Kristina was reluctant to drag up too much of the past and she was naturally suspicious of me. She had good reason. However, after a few hours together, and a glass or two of Bailey's, she realized my intentions and interests came from a pure place. Like everybody I met, she asked the same question, which can be paraphrased as follows: what the hell are you doing in New Mexico? And what do you want to write about Ag for? Everybody thought I was insane. At one point in our first meeting Kristina stopped mid-sentence on some personal reflection. "How did we get on to this?" She looked at me, sizing me up. "You're good," she said. This was an accusation as much as it was a compliment; she accused me of steering the conversation away from philanthropy, and she was right, I had. But, even if Kristina had her reservations about me, or Agnes, she answered every question, and I think she was secretly happy to do so. I imagine it was a way for her to relive some moments of the past, and however skillful Kristina lead me to believe I was, I suspect she was always the one in control.

The second time I visited, we spoke more freely, and drank a little more freely too. Kristina didn't talk or act like an "old person," and her recollections of which there were many, were exact, and animated. She brought Agnes to life for me, and her stories, expressions, and tone of voice, stayed with me throughout the writing of this book.

I remember sitting inside in her house when the sun was setting, and Kristina was telling me about the first time she'd ever laid eyes on Agnes. When she finished, I knew that that moment would be the final image in my book. I had the sense that she was telling me something very private, maybe even something she hadn't spoken about for years; something she

had almost forgotten. I never lost sight of both the generosity with which she shared her stories, and consequently the responsibility I felt to do them justice. It pleases me that this exchange was not one-sided: I shared with her new photos of the young Agnes, which she had never seen before, and told her stories she had never heard, which she enjoyed. I later learned I had also converted her to Bailey's Irish Cream, with which she toasted to this book before she passed away in November 2015. Although she only read a few chapters, I was told she enjoyed what she read, and it was important for me to have had that blessing.

I think often of Agnes Martin standing in her Coenties Slip loft on a Saturday night in New York City. There are candles burning and she is standing in the middle of the room on the untreated wooden floor. Around her, in a circle, sit young artsy men and women, cigarette ash on their fingers, and cheap sweet wine in paper cups at their folded or crossed legs. They are at least half her age, and hushed, and Agnes is talking about water, asking the people to imagine a body of water, or a wall of water, and what that might look like in their minds' eye, and how they might cross it. When Jill Johnston relays this episode in her *Village Voice* portrait she explains that at one point there was a "great overhead crash" that woke people from their trance-like state. Agnes, however, "didn't bat a lash...she went right on with this exercise," testing the visitors for answers "as though nothing had happened."[2]

I think that, for Agnes, water was the equivalent to the painted grid. It was the element she returned to and modulated in her speeches and writings to expose and interrogate states of mind and feelings. I get the sense that she felt very comfortable with that element. Not only was it important to her for leisure and reflection in Vancouver, Oregon, and New York, but it also manifests in interesting ways in New Mexico, even before she gifted the town of Taos a swimming pool.

There is no place where water is more important than in a desert; a

presence defined by absence. Joan Potter Loveless in her book *Three Weavers*, observes that water gives communities in New Mexico their names and their shape, for example Rio Hondo, Arroyo Seco, Rio Pueblo, Rio Fernando, Rio Grande del Rancho.[3] Even as a guest in the state for a month, I was aware of this. At night, as I listened to the coyotes, I heard babbling streams that I could not hear during the day, and at any moment one could turn a bend in the road and see a lush valley, and a chain of tall cottonwood trees along a river, which of course determined the path of the road you were on in the first place. Even in the driest elevation, the mind stretches back five hundred million years, if it can stretch that far, and you try to fathom that once this was the bottom of the sea, and that the forms and the colors around you are the remains of the dead: the floodplains, the algal reefs, the dust of fossils. On October 21st I wrote in my diary, "I took a lot of pictures of the desert landscape, but even with my 90mm lens it simply isn't enough to capture the wonderful waves of stone." The ocean was no longer there but somehow the waves remained. I did not know at the time that Agnes also saw the sea in the desert:

> One time, I was coming out of the mountains, and having painted the mountains, I came out on this plain, and I thought, Ah! What a relief! I thought this is for me! The expansiveness of it. I sort of surrendered. This plain...it was just like a straight line. It was a horizontal line. Then I found that the more I drew that line, the happier I got. First I thought it was like the sea...then I thought it was like singing! Well, I just went to town on this horizontal line...But I didn't like it without any verticals. And I thought to myself there aren't too many verticals I like. But I put a few in there. Finally, I was putting in as many verticals as horizontals.[4]

Agnes only occasionally had artwork in her home. These were usually paintings of flowers or, in one instance, retro advertisements of Coca-Cola pin-up girls. When Agnes's friend Ted Egri visited her in Galisteo he observed that the only painting she had on her wall was of a wave:

That's all she had on her wall. Water was very important to her. But I saw about six or seven rocking chairs at her place and I asked her, 'What about all these rocking chairs?' She said, 'Well, I love to move without getting anywhere.' And she thought about the ocean, the way the ocean waves come crashing in on the ocean and then recede. They crash in and recede. And this was very much like the rocking chairs were for her.[5]

Friends always noted that Agnes had rocking chairs in each of her homes, but until now, nobody knew why, or the extent to which Agnes meditated on water.

In her letters to Lenore Tawney, and in her writings, waves are a recurring motif. In 1965, on her world cruise she is "as though moving in [romance]—the wave upon wave," in 1963 her expression of gratitude "is going to be like the waves over and over again," in *The Untroubled Mind*, ego is "like a wave/ it makes itself up, it rushes forward getting nowhere really/ it crashes, withdraws and makes itself up again."[6]

Agnes used waves, water, and the ocean, to allude to inner feelings, and this carries through in her artwork such as *Gabriel* (1967), *The Wave* (1963), *Harbour I* (1959) and *Dream of Night Sailing* (1954) which all evoke water and "universal feelings." Although the grid is "just" a series of lines, I believe that the repetition of these lines is connected to the "wave upon wave" that Agnes fixates on in her writings and lectures. Some of the titles of these works—*Night Sea* (1963), *The Sea* (2003)—bear this out, but even if these paintings were also "untitled," I believe the association can still be felt.

I believe that Agnes understood feelings of the sublime intuitively. And while she could convert an aesthetic pleasure into a spiritual one—"There's nobody living who couldn't stand all afternoon in front of a waterfall. It's a simple experience you become lighter and lighter in weight"—she does not advocate meditation in place of living.

Of all the water-inspired quotes she has, my favorite is from her 1987 Skowhegan lecture:

It is better to go to the beach and think about painting than it is to be painting and thinking about going to the beach.[7]

I read into this a few witty observations I think the artist was making. Firstly, that there is no substitute for the real thing. While Agnes knew her paintings were beautiful and could inspire beauty and happiness, they were still part of the world of "culture" and culture, as Plato will tells, always pales compared to nature. Agnes believed it was better to be out there in the world surrounded by nature than stuck in a gallery or studio, and her own experiences bear this out. In one interview, she explains that her most "valuable memories" are "going into the mountains."[8] Secondly, that it is better to want to paint, to be inspired to paint, rather than forcing yourself to paint and wanting to be elsewhere. Although Agnes was a very devoted artist, she also made sure she had fun, took breaks from her work, and traveled, and this is what she was telling the students in Skowhegan: life is as much for living as it is for creating. I believe this is a lesson Agnes learned when, as Kristina put it, she "came back from the dead," in 1973. And it's something that all artists should remind themselves.

Early on in Taos, I wrote the following in my journal:

> This is the story of a woman who, against the odds, manages to find inner peace, but always struggles to maintain this. Agnes was conflicted by her need to belong and be present in a given situation, while also remaining outside it. Agnes was constantly working at finding a life that "worked" for her.

This was the first of what would become a kind of mission statement for the book, and something that I elaborated upon, and refined at different points in time. Very soon after my trip to New Mexico I realized that as well as being about Agnes, the book would be about the people in her life. This

gave me courage to tell the story of Agnes as told by her family and friends, allowing them to create with me a composite portrait. With Jina and Kathleen, I also had the great fortune to find the missing pieces to a jigsaw that many people had tried to finish, in particular those pieces of her earlier life.

These discoveries come at an important time in scholarship on the artist. In June 2015, a major retrospective on Agnes opened at the Tate Modern in London. Following London, the exhibition traveled to Kunstsammlung Nordrhein-Westfalen, Düsseldorf (November 2015—March 2016), Los Angeles County Museum of Art (April 2016—September 2016), and New York's Solomon R. Guggenheim Museum (October 2016—January 2017). The exhibit was enthusiastically received, and it introduced the work (including early work) of the artist to a new generation, in particular a social media-savvy generation, for whom Martin's pithy observations were perfect for sharing on those platforms. The exhibition was also accompanied by a slew of new publications, including *Agnes Martin* edited by Frances Morris and Tiffany Bell (Tate Publications), *Agnes Martin: Her Life and Art* by Nancy Princenthal (Thames and Hudson), *Agnes Martin and Me* by Donald Woodman (Lyon Artbooks), *Drawing the Line: The Early Work of Agnes Martin* by Christina Bryan Rosenberger (University of California Press), and *Agnes Martin: Night Sea* by Susan Hudson (Afterall Books)—books that offer an insight into the artist's world, and in particular her working practice. In addition, Artifex Press, an online publisher, have released a digital *catalogue raisoneé* on the artist, which features her entire catalog of paintings and works on paper, and the documentary *Agnes Martin Before the Grid*, which I was delighted to play a part in, remains the definitive documentary on Agnes's early life. I hope the wealth of information in these projects encourages readers in the future to develop their own ideas on the artist, and keep the story going.

When I set out to write this book I thought a lot about women artists, and throughout the book I have tried, where possible, to include women artists when I offer examples of particular artistic movements. When I set out to research Agnes in 2013, there were only two books on Agnes that were not exhibition catalogs. With *Agnes Martin: Pioneer, Painter, Icon*

there are now seven. Five of these have been published since 2015. This is extraordinary, particularly for books related to the arts: an expensive kind of book to bring to market. The only other female artist who seems to have equal attention lavished on her is Agnes's contemporary Louise Bourgeois. Georgia O'Keeffe remains, arguably, the most famous woman artist in the world (followed by, arguably, Frida Kahlo), but I hope in the years to come more attention is paid to women artists across all time periods and disciplines, because my research and instinct has taught me there are many incredible stories yet to be told, and wonderful art to be experienced, and if you've read this far, Lenore Tawney and Chryssa are a good place to start.

This brings me to the final word in the title of this book: icon. What makes an icon, how does someone become one, and who finally confirms the status? I have discussed in the book how legend and intrigue grew around Agnes after she abandoned New York, and I maintain that this departure firmly put her on the path to becoming the icon she is today. We have seen how people made pilgrimages to New Mexico to be with her and to learn from her, and we have seen how Agnes played her part in constructing the character we associate with her today. This book goes some way to freeing her from the shackles of that role. I hope it humanizes the icon she has become. Of course, being an icon isn't necessarily a bad thing; an icon can provide hope and protection, it can be a talisman, and it can appeal to our better nature.

Even though Agnes is no longer alive, market forces take over to ensure that her brand and value is protected and set to rise, further securing the icon status. We are at a point in time where Agnes's work is presented alongside masters such as Rembrandt and Picasso at exclusive art fairs, and where Google honors her with her own Google Doodle (on her one hundred and second birthday). In 2016 her painting *Orange Grove* (1964) was sold at Christie's for $10.7 million. Each of these small steps—the books, the exhibitions, the auction prices—make Agnes, and her artwork, more and more recognizable; this book plays a part in that. However, the word icon in the title of this book is as much a question as it is a statement. I hope it will challenge and encourage debate. Agnes was more than a pio-

neer, a painter, and an icon, and I would hate to see her become just one thing.

※

One of my favorite painters, Francis Bacon, in a televised interview with David Sylvester said,

> When you paint anything, you are also painting, not only the subject, but you are painting yourself as well as the object you are trying to record.

This seems to me, equally true of writing: it is impossible not to leave your mark on a work, however objective you try to be. Like Francis Bacon I left a little of myself in this book. As to what I left, I suppose that is—to borrow a word from Agnes—my "sensibility," and I hope that this is a good thing.

"I guess I've had what I came here for," I wrote in my journal towards the end of my time in Taos. The answer wasn't, as I might have anticipated, "a breakthrough," or "Agnes," or "the reason Agnes left New York." The answer was "contact." If this book is about anything it's about contact; the story of people reaching out to tell their stories and connect—with me, with you, and with Agnes too. Agnes isn't around anymore, but by talking about her and sharing their stories, her friends could relive their times with her.

I went to America is search of the "saddest woman in the world," but I found a whole lot more. Up to the very end New Mexico was teaching me that the journey I had taken was not the journey I was on, and that I could not control my story, or Agnes's story, any more than I could control a desert storm—each materialized according to their needs and nature, and the best I could hope for was to be their happy accomplice, and let the ending come naturally, if indeed at all.

Acknowledgments

This book would not exist without Jina Brenneman and Kathleen Brennan. Not only did they recognize the value of recording interviews with Louise Sause, Susan Sharpe, Kristina Wilson, John dePuy, Robert "Bob" Ellis, and Jim Wagner—interviews that alter what we know of Agnes Martin's life, particularly prior to 1957—but they instinctively understood the value of sharing these with a young researcher.

Thank you to the family of Agnes Martin—Christa Martin and Christopher Kinnon—for your encouragement and for answering my many questions on the family history. Thank you in particular to Christa Martin, and her children David McCulloch and Erin McCulloch, for sharing treasured family photographs and granting permission to use them in this book. Thank you also to Susan Sharpe for granting permission to use her family photographs and for sharing her memories of Agnes and the Kane family with me.

Thank you to Ian Wilson and Kristina Wilson for their support of this project, in particular to Kristina for welcoming me to her home and sharing her story with great humor and generosity of spirit.

Thank you to Robert "Bob" Parker and Deborah "Debbie" McLean for welcoming me to Blueberry Hill and offering me encouragement and support along the way—not to mention one of the best views of the Taos Mountains.

Marcia Olivier: thank you for the best pumpkin pie, opening your heart and mind to this project, and sharing your personal memories with such grace.

Thank you to Kathleen Nugent Mangan for facilitating my research, reviewing my manuscript, and welcoming me to the Lenore G. Tawney Foundation archives. Thank you for sharing your insights and memories of Lenore, but also for introducing me to the breadth of talent of this wonderful and important artist.

Thank you to Suzanne Delehanty, Dieter Schwarz (Kunstmuseum Winterthur), and Barbara Haskell (the Whitney Museum of American Art), for offering your memories of working with Agnes and your encouragement for the project.

Thank you to Dr. Jonathan D. Katz and William "Bill" Peterson for wonderful conversations on Agnes, and for warm welcomes in Albuquerque and New York. Likewise, thank you to Elyn Zimmerman and David Hayes for patiently answering my questions and sharing your memories with me.

Thank you to Lee Hall for your kindness and your hospitality in Massachusetts, and for your insight into this project, and sharing stories on Betty and the art world, as it was and is.

Each of the following people helped to connect me to resources, archives, and individuals, answering my many questions, and showing enthusiasm for the project, which meant a lot to me. Thank you to Jennifer E. Smith, Claire Nozieres, Suzanne Sangster, Orla Houston-Jibo, James Whittaker, Nat Foreman, Dr. David Anfam, Jerald Melberg (Jerald Melberg Gallery), Rebecca Huff Hunter (Institute of Contemporary Art, Philadelphia), Scott Daniels (Oregon Historical Society), Katerina Koskina (the J.F. Costopoulos Foundation), Cathy Wright, Andrew Connors, and Titus O'Brien (Albuquerque Museum), Stephen Lockwood (University of New Mexico Art Museum), Rebecca Potance (New Mexico Museum of Art),

Ashley Swinnerton (Museum of Modern Art, Film Study Center), Margaret Z. Atkins (Smithsonian Archives of American Art), Katerina Damvoglou (my personal Greek translator), Deborah "Debie" Vincent (the Harwood Museum of Art), Tomas Jaehn (Director of the University of New Mexico Libraries, Center for Southwest Research), Alexandra Benjamin (Mandelman-Ribak Foundation), and Suzanne Awen (University of New Mexico Foundation).

Thank you to Karen Schiff for your encouragement on this project, for directing me to articles, interviews, and audio recordings, and most of all for challenging my thinking on Agnes Martin, and for going "off the record" so we had the freedom to improvise on, and interrogate, our shared subject and fascination.

Thank you to Edward Pincus and Stephanie Waters for taking pity on a Taos blow-in and showing me some of the natural beauty of New Mexico, as well as the warmth of the people who live there.

Thank you to Becca Cousineau for showing me young L.A., taking me to Disneyland, and for your friendship and encouraging words as I struggled in the New Mexico desert. (And while I'm at it: thank you to the magical man in Disneyland who helped us when we got lost).

Thank you to James McWalter for being "James"—an adjective for those that have the pleasure of knowing him. Thanks Jimbo, for offering me a home in New York, and for the great conversation and adventures over the years.

Thank you to Seanan McDonnell for being the first brave person to read an early draft of the book, and for not ending our friendship then and there. You now have to read every draft of every book I write—but I promise to do the same. I look forward to the conversations, and corrections ahead.

Thank you to Tim Schaffner and Sean Murphy at Schaffner Press for bringing this book into the world, and helping to shape it for the better, and to Jordan Wannamacher for her beautiful design. And thank you to everybody who granted permission to reproduce images, endorsed the book, or gave advice along the way.

Thank you to Kate Johnson and everybody at Wolf Literary Services

LLC. Thank you for helping me to mold this project in its early stages and for offering me great advice and believing in the potential of this book to connect with others. That will always mean an awful lot to me.

Thank you to everybody who has ever offered a kind—and if not kind then well-intentioned—word over the years, including many of my friends at colleagues at Phaidon Press, and Head of Zeus books.

Thank you to all my friends over the years in Ireland, London, and the U.S. who warm my cockles when they need warming. If I have to go all the way back, thanks to Mary and Harry and the kids, and Phyllis, and Sheila, and Thomas.

And finally, and it goes without saying, thanks to Agnes Martin for never giving up—let that be a lesson to all of us.

Notes

PROLOGUE

1. *Santa Fe, New Mexican.* August 14, 1998.
2. Schwarz, Dieter, ed. *Agnes Martin: Writings/Schriften* (Germany: Cantz; Kunst museum Winterthur, 1992), 115.
3. Johnston, Jill. *Gullibles Travels* (New York: Links Books, 1974), 283.
4. "Stories to be read," is the literal translation of *legenda* in Latin.
5. Glimcher, Arne. *Agnes Martin: Paintings, Writings, Remembrances* (London and New York: Phaidon Press, 2012), 242.
6. Agnes tells Sally Eauclaire, "I myself am interested in artists' lives." Eauclaire, Sally. "All My Paintings are about Happiness and Innocence: An Interview with Agnes Martin," *Southwest Profile*, May/ June/ July, 1993, 14–17.

1. MILLET'S HORIZON

1. Princenthal, Nancy. *Agnes Martin: Her Life and Art* (London: Thames and Hudson, 2015), 18.

2. Oral history interview with Bob Ellis. Interview by Jina Brenneman and Kathleen Brennan. Taos, New Mexico, 2014.

3. Kinnon, Christopher. Interview by Henry Martin. London/Michigan, 2014.

4. In her book, Nancy Princenthal quotes Donald Woodman as saying Agnes's father died from syphilis (page 262). Her discussion of the Martin legal documents and move to Lumsden are found on pages, 22–23.

5. Attiyeh, Jennifer. "Agnes Martin: An Artist on her Own," *Horse Fly*, May 15, 2001, 16.

6. Simon, Joan. "Perfection is in the Mind, " *Art in America*. vol. 84, no. 5, May, 1996, 87.

7. Attiyeh, *Horse Fly*, 16.

8. Tiffany Bell in *Agnes Martin* (Tate, 2015, p. 21) notes that Agnes won Olympic tryouts in 1928. Meanwhile, Nancy Princenthal notes that Agnes came fourth in Olympic tryouts in 1932 (p. 27). Was it both? Or just the latter? Or did Agnes reinvent her failure as a success when she met people later in life? I retain the angle that Agnes won Olympic tryouts, because this is how Agnes presented herself.

9. Attiyeh, *Horse Fly*, 16.

10. It is very difficult to know for certain what exactly happened in Los Angeles. In an interview in 2000, when Agnes was eighty-eight she said that the University of Southern California offered her a scholarship "as an athlete" for four years, quickly adding, "I didn't go." Maybe "I didn't go" relates to the university and not the city itself? Interview with Agnes Martin, conducted by Douglas Dreishpoon in Taos, New Mexico, June 24, 2000, pp. 15–16. Mandelman-Ribak Foundation Oral History Project (hereafter MRFOHP), Beatrice Mandelman and Louis Ribak Papers, Center for Southwest Research and Special Collections, University of New Mexico.

11. Princenthal, *Agnes Martin*, 29.

2. THE KANE SISTERS

1. Sharpe, Susan. Interview with Jina Brenneman and Kathleen Brennan. Taos, New Mexico, 2014.

2. Princenthal, *Agnes Martin*, 29 (& footnote p. 263).

3. Sharpe, Susan. Interview with Jina Brenneman and Kathleen Brennan. Taos, New Mexico, 2014.

4. The earliest surviving artwork by Agnes also refutes any interest in urban scenes, including New York. Agnes's surviving early work includes portraits, still life, and landscapes. She was, however, a curious artist and a work such as the lithograph *Untitled* (c.1952) suggests that Agnes was also interested in modernist still life compositions, such as the singular work of Stuart Davis.

5. *The New York Armory Show* was, at the time, known as *The International Exhibition of Modern Art* (1913).

6. Ashton, Dore. *The New York School: A Cultural Reckoning* (California: University of California Press, 1972), 44.

7. Phaidon Editors. *Art in Time: A World History of Styles and Movements* (London: Phaidon Press, 2014), 126.

8. Oral history interview with Mildred Kane. Interview by Karen Beck Skold. Oregon Historical Society Research Library, Transcript 19, Audio Tape 24, 1976.

9. Ibid.

10. Collins, Tom. "Agnes Martin Reflects on Art & Life," *Taos Geronimo*, January 1999, 11.

11. Lance, Mary. *Agnes Martin: With My Back to the World*. Corrales, New Mexico: New Deal Films, 2003. DVD, 57 minutes.

12. Princenthal, *Agnes Martin*, 29 (& footnote p. 39).

13. For more detail on Columbia during the war, refer to Rosenberger, Christina Bryan. *Drawing the Line: The Early Work of Agnes Martin* (California: The University of California Press, 2016), 16–17.

14. Dore Ashton recalls that "In NYC Agnes talks to her paintings as if they are seeds asking them to grow." Ashton, Dore. "Art Drawn from Nature," *New York Times*, December 29, 1959, 23.

15. Princenthal, *Agnes Martin*, 46.

16. *Cherry Blossom Orchard* and *View from the Porch* are both in private collections. I argue that *Cherry Blossom Orchard* predates the latter, because its style and color is very unique among Agnes's early work, though it does share a heavy application of paint which is echoed in *Untitled* (1948), her still life of tulips. Meanwhile,

View from the Porch is more modernist, but still grounded. It makes sense that *View from the Porch* fits between *Cherry Blossom Orchard* and her early 'mountain' watercolors, *Untitled* (1946), *New Mexico Mountain landscape, Taos* (c.1947), and *Untitled, Landscape South of Santa Fe,* (1947). The trajectory of this work is that the artist's line and application of pigment become more and more fluid and fragmented. As such, one is watching the dissolution of recognizable forms, and the work becomes more abstract. This dissolution recalibrates itself in the early 1950s in the lithograph *Untitled* (1952), *Personages* (1952), and *Untitled* (1952). Of course, the change in style befits the move from oil, to watercolor, to lithograph.

17. Christina Bryan Rosenberger notes that Agnes's use of encaustic "suggests that she was comfortable working quickly and decisively, since encaustic cannot be scraped off or worked over as easily as oil point." Later in life this talent to be decisive would pay off when Agnes used watered-down Liquitex paint after the mid-1960s, that dried very quickly in the New Mexico heat. Rosenberger, *Drawing the Line*, 30.

3. ALL THE WAY TO ALBUQUERQUE

1. Sharpe, Susan. Interview with Jina Brenneman and Kathleen Brennan. Private interview. Taos, New Mexico, 2014.

2. Abatemarco, Michael. "The Art of the Transcendental Painters," *The Santa Fe New Mexican*, August 23, 2013.

3. Interview with Earl Stroh, conducted by Douglas Dreishpoon in Talpa, New Mexico, June 25, 2000, p. 12. MRFOHP, Beatrice Mandelman and Louis Ribak Papers, Center for Southwest Research and Special Collections, University of New Mexico.

4. Dorfman, John. "Mystic Vistas," *Arts and Antiques Magazine Online*. August, 2013.

5. Hambidge, Jay. *Dynamic Symmetry: The Greek Vase* (New Haven: Yale University Press, 1920), 44.

6. Ashton, Dore. *Agnes Martin: Paintings and Drawing 1957–1975* (London: Arts Council of Great Britain, 1976), 12.

7. Interview with Ted Egri, conducted by Douglas Dreishpoon in Taos, New

Mexico, June 24, 2000, p. 25. MRFOHP, Beatrice Mandelman and Louis Ribak Papers, Center for Southwest Research and Special Collections, University of New Mexico.

8. Lance, *Agnes Martin.*

9. "Harwood, Blue Door Exhibits Give Taosenos Double Feature in Art," *Taoseno and the Taos Review*, August 7, 1947, 6.

10. Oral history interview with Stanley Landsman. Archives of American Art, Smithsonian Institution. Jan 19–22, 1968. This and all quotes from Stanley Landsman from this interview.

4. DAPHNE COWPER VAUGHN

1. The dates are sketchy. In the chronology in *Agnes Martin: Before the Grid* the curators suggest Agnes worked at UNM until August 1948, and then entered the public school system. In other accounts Agnes said she quit because she needed more money. So she either quit before her house was finished in order to pay for the construction, or quit after the house was built to pay off her bills retroactively.

2. Information about Agnes's relationship with Daphne Cowper, and the construction of their Albuquerque home has come from a range of sources including the e-mail correspondence between the writer William Peterson and Daphne Cowper's daughter, which were kindly made available for my review. Further information was obtained from the Agnes Martin Archives at the Harwood Museum of Art, and the Albuquerque Museum of Art and History, where photocopies of Daphne Cowper's photographs are archived.

3. The Agnes Martin Archives, Harwood Museum of Art, Taos, New Mexico.

5. PERSONAGES

1. Simon, "Perfection is in the Mind," 82–9.

2. Quotes and incidental details taken from oral history interview with Louise Sause. Interview by Jina Brenneman and Kathleen Brennan. Michigan. 2014.

3. Various commentators have noted that John Dewey's *Art as Experience* (1934)

and *Experience as Education* (1938) were two important books that Agnes very well may have come into contact with. Dewey was a professor at Teachers College from 1904–1930 and his colleagues were Agnes's teachers and instructors. His philosophy on the importance of art within the community and his theory of education (extolling experiential learning and a child-centered approach) are very similar to ideas Agnes expressed throughout her life, as well as in her conversations with Louise.

4. Delehanty, Suzanne. *Agnes Martin* (Philadelphia, Institute of Contemporary Art, University of Pennsylvania, 1973), 24.

5. Oral history interview with Martin Ryan. Interview by Sean Ryan. Courtesy of Jina Brenneman and Kathleen Brennan. 2014.

6. Quotes and incidental details taken from oral history interview with Louise Sause. Interview by Jina Brenneman and Kathleen Brennan. Michigan. 2014.

7. Ibid.

8. The Agnes Martin Archives, Harwood Museum of Art, Taos, New Mexico.

9. Ashton, Dore. *The New York School,* 163.

10. Ibid., 145.

11. One of Reinhardt's "rules" for artists was that the idea should exist before the brush is taken up, which echoes Agnes's own saying that the idea exists in the mind, and her work as an artist, after conceiving of an image, is to increase its scale to fit on her canvas: Agnes never picked up a brush before knowing what she was going to paint.

12. Ashton, *The New York School,* 209.

13. Phaidon Editors. "Room 347: Abstract Expressionism," *The Art Museum* (London: Phaidon Press, 2011).

14. Dondero, George, Speech in U.S. House of Representatives, 16 August 1949, 81st Congress, 1st Session.

15. Ashton, *The New York School,* 132.

16. Meyer Schapiro, unlike the others, grew up in the U.S. He was born in Lithuania but moved to the U.S. at the age three in 1907.

6. TAOS, NEW MEXICO

1. The Agnes Martin Archives, Harwood Museum of Art, Taos, New Mexico. All quotes in this section from the Wurlitzer Letters at the Harwood Museum of Art.

2. Ibid.

3. Ibid.

4. Ibid.

5. Boll, Deborah. *Albuquerque'50s* (New Mexico: University of New Mexico Art Museum, 1989), 11.

6. Sims, Alida F. "The Provincetown of the Desert," *The New York Times*. December 25, 1921, 40.

7. Almost every account of the relationship between Agnes and the Ribaks (as they were known locally) stresses their support of the artist. However, Earl Stroh, a fellow artist, notes that Bea was "jealous as hell of Agnes Martin, viciously jealous." Now, this may just be Stroh's opinion, but if it contains a grain of truth it might at least suggest that Agnes was not the only competitive or ambitious artist in Taos at the time, which Mary McChesney suggests. Interview with Earl Stroh, conducted by Douglas Dreishpoon in Talpa, New Mexico, June 25, 2000, p. 38. MRFOHP, Beatrice Mandelman and Louis Ribak Papers, Center for Southwest Research and Special Collections, University of New Mexico.

8. Quotes and incidental details taken from oral history interview with Louise Sause. Interview by Jina Brenneman and Kathleen Brennan. Michigan. 2014.

7. KRISTINA BROWN WILSON

1. Recalled by Marcia Olivier who knew Lesley Brown, Agnes, and Kristina Wilson.

2. In an open online thread on April 10, 2011, Carolyn French Judson, a neighbor of the Browns in New Hampshire, wrote about Kristina as follows, "We always wondered how Kristina had fared out in Taos. She was tall, shy, a lovely blond girl who had original ideas about marriage and parenthood." http://beyond-brownpaper.plymouth.edu

3. Interview with Kristina Wilson, conducted by Douglas Dreishpoon in Taos,

New Mexico June 25, 2000, pp. 21–23. MRFOHP, Beatrice Mandelman and Louis Ribak Papers, Center for Southwest Research and Special Collections, University of New Mexico.

4. Ibid., pp. 23–24.

5. Oral history interview with Mary Fuller McChesney. Archives of American Art, Smithsonian Institution, Sept. 28, 1994.

6. Tolbert, Mildred. Unpublished Manuscript. Agnes Martin Archives. The Harwood Museum of Art, Taos, New Mexico, 17.

7. Ibid., 18.

8. Oral history interview with Mary Fuller McChesney. Archives of American Art, Smithsonian Institution, Sept. 28, 1994.

9. Oral history interview with John DePuy. Interview by Jina Brenneman and Kathleen Brennan. Taos, New Mexico. 2014.

10. This anecdote is recalled by the writer Kat Duff, who was a friend of Kristina Wilson. From e-mail correspondence between the author and Kat Duff, February 5, 2014.

11. Oral history interview with John DePuy. Interview by Jina Brenneman and Kathleen Brennan. Taos, New Mexico. 2014.

12. Oral history interview with Mary Fuller McChesney. Archives of American Art, Smithsonian Institution, Sept. 28, 1994.

13. Landauer, Susan. *The San Francisco School of Abstract Expressionism* (California: University of California Press, 1996), 95.

14. Landauer, *The San Francisco School of Abstract Expressionism*, 51.

15. At a lecture given on March 25, 1994, at the St. Francis Auditorium in Santa Fe, Agnes was asked who her favorite artist was, to which she replied, "I guess Rothko."

16. Christina Bryan Rosenberger notes that Suzanne Delehanty saw a biomorphic painting called *Father and Son* in New York in the early 1970s and notes another *Father and Son*—the father and son of this reference—"with black figures on a white ground" displayed at the New Mexico State Fair. This description brings to mind the figures in *Personages* (1952), owned by Louise Sause, as well as *The Expulsion of Adam and Eve from the Garden of Eden* (1953). Rosenberger, *Drawing the Line*, 191.

17. The critic Lizzie Borden also mentions the subject matter of this painting in her 1973 *Artforum* article.

18. Agnes Martin Archive, New Mexico Museum of Art Library and Archives, Santa Fe.

19. A traditional local saying was that gay men located to Taos, while lesbians located to Santa Fe.

20. Interview with Agnes Martin, conducted by Douglas Dreishpoon in Taos, New Mexico, June 24, 2000, p. 7. MRFOHP, Beatrice Mandelman and Louis Ribak Papers, Center for Southwest Research and Special Collections, University of New Mexico.

21. Collins, "Agnes Martin Reflects on Art & Life," 11.

22. Oral history interview with Mary Fuller McChesney. Archives of American Art, Smithsonian Institution, Sept. 28, 1994.

23. As an aside, Louise Sause recalls one of her last telephone conversations with Agnes: "Louise," Agnes said, "I always told you I was going to make it... I told you I was going to be rich someday." "Making it" was not just a subjective estimation by Kristina Wilson or Mary Fuller McChesney. It seems Agnes was not shy of hiding her ambition, and delighted in achieving some success. Oral history interview with Louise Sause. Interview by Jina Brenneman and Kathleen Brennan. Michigan. 2014.

24. Dore Ashton writing in Boll, *Albuquerque'50s*, 42.

25. De Kooning, Elaine. *Albuquerque*. Great Jones Gallery, New York, February Announcement, 1960.

26. For a proper exploration of this category, the artists, the venues, the atmosphere, I recommend that the reader refer to David Witt's excellent publications *Taos Moderns: Art of the New* (1992) and *Modernists in Taos from Dasburg to Martin* (2002).

27. Witt, David L. *Modernists in Taos* (New Mexico: Red Crane Books, 2002), 22.

28. Porter Archives, New Mexico Museum of Art Library and Archives, Santa Fe.

29. Oral history interview with Jim Wagner. Interview by Jina Brenneman and Kathleen Brennan. Taos, New Mexico, 2014.

30. Glimcher, *Agnes Martin*, 106.

8. BETTY PARSONS

1. Hall, Lee. *Betty Parsons, Artist, Dealer, Collector* (New York: Harry N. Abrams, 1991), 53.

2. Maxwell, Elsa. "Elsa Maxwell's Party Line," *The New York Post*. December, 20, 1946.

3. Oral history interview with Betty Parsons. Archives of American Art, Smithsonian Institution, June 11, 1981. Parsons is quoting from Cather's novel *The Song of the Lark* (1915).

4. Porter Archives, New Mexico Museum of Art Library and Archives, Santa Fe.

5. Ashton, *The New York School*, 229.

6. Breslin, James E. B. *Mark Rothko, A Biography*. (Chicago: University of Chicago Press, 1998), 297.

7. Oral history interview with Betty Parsons. Archives of American Art, Smithsonian Institution, June 11, 1981. A host of events and activities distanced the artists from each other: Barnett Newman sued Ad Reinhardt (unsuccessfully) for $100,000. Clyfford Still and Barnett Newman changed the dates of their works as part of a squabble over who did what first. Clyfford Still stoked flames between Mark Rothko and Barnett Newman, suggesting Rothko kept Newman "out" of the 1952 *Fifteen Americans* exhibition at the Museum of Modern Art. Still also labeled Reinhardt, Newman and Rothko "Bauhaus bullies," and despite Rothko's ongoing attempts to reconcile with Still, Still proceeded to pass judgment on Rothko's "evil...untrue life."

8. Oral history interview with Betty Parsons. Archives of American Art, Smithsonian Institution, June 11, 1981.

9. Hall, *Betty Parsons*, 101.

10. Oral history interview with Betty Parsons. Archives of American Art, Smithsonian Institution, June 11, 1981.

9. COENTIES SLIP, NEW YORK

1. Agnes had her own scow boat on Elk Lake in Portland, and in 1978 undertook to travel up the MacKenzie River in Canada, which at 1,738 kilometers is the second

longest river in North America—exceeded only by the Mississippi.

2. Sandler, Irving. "Agnes Martin Interview," *Art Monthly*, September 1993, 9.

3. From the notes of David Witt, The Agnes Martin Archives, Harwood Museum, Taos, New Mexico.

4. "After the parties in Taos, I thought the ones in New York were really dull... there were parties there and the people stood up in groups and talked—I thought, my goodness, it was so slow. I didn't want to go to them at all....I don't believe in keeping up with the scene, you know. If you come on with the scene, you go off with the scene." Interview with Agnes Martin, conducted by Douglas Dreishpoon in Taos, New Mexico, June 24, 2000, pp. 8–9. MRFOHP, Beatrice Mandelman and Louis Ribak Papers, Center for Southwest Research and Special Collections, University of New Mexico.

5. Eisler, Benita. "Life Lines," *New Yorker*, 25 January 1993, 70–83.

6. I say Uptown because most galleries associated with the Abstract Expressionist movement were located near 57th street, on the border between mid and upper Manhattan, but also to capture the group's own choice of name, in the early days, as the Uptown Group (though at the time many of the artists lived and worked in Greenwich Village). The clarity on an Uptown, Midtown, Downtown delineation becomes further complicated in 1949 when the Downtown Group forms The Club, the famous Abstract Expressionist hangout. For the purposes of ease and comprehension, the Coenties Slip artists did not see themselves as belonging to the world of Greenwich Village, or Midtown, or Uptown.

7. Hammel, Faye. "Bohemia on South Street," *The Look Out*. Seaman's Church Institute Magazine, New York, December 1957, 4–5.

8. Ibid.

9. Agnes socialized with gay men and women in New Mexico, but New York offered even more freedom, and a more robust counter culture she could tap into. Kristina recalls that Agnes loved hanging out with, what she called, the "hicks," and the "pansies." Her chosen labels suggest she didn't see herself as belonging to either group, despite her short time in the Canadian plains, or her sexual orientation.

10. Boxer, Sarah. "The Last Irascible," *New York Review of Books*, December 23, 2010.

11. Theodoros Stamos, Sonia Sekula, Forrest Bess, and Alfonso Ossorio were some of the gay artists Betty represented.

12. Hall, Lee. Interview by Henry Martin. South Hadley, Massachusetts, November, 2014.

13. Oral history interview with Marcia Oliver. Interview by Jina Brenneman and Kathleen Brennan. Taos, New Mexico. 2014.

14. Aylon, Helene. "Interview with Betty Parsons," *Women Art*, Fall 1977, 10–13, 20.

15. Betty Parsons Gallery records and personal papers, circa 1920–1991, bulk 1946–1983. Archives of American Art, Smithsonian Institution.

16. Ashton, Dore. "Art: Welded from Metal," *The New York Times*, 30 September, 1958.

17. Euaclaire, Sally. "All My Paintings are about Happiness and Innocence: An Interview with Agnes Martin," *Southwest Profile*, May/June/July, 1993, 17.

18. Aylon, "Interview with Betty Parsons," pp.10–13, 20.

19. Hall, *Betty Parsons*, 69.

20. Aylon, "Interview with Betty Parsons," pp.10–13, 20.

21. This and all letters by Aline Porter taken from the Porter Archives, New Mexico Museum of Art Library and Archives, Santa Fe.

22. Interview with Agnes Martin, conducted by Douglas Dreishpoon in Taos, New Mexico, June 24, 2000, p. 9. MRFOHP, Beatrice Mandelman and Louis Ribak Papers, Center for Southwest Research and Special Collections, University of New Mexico.

23. Fairfield Porter, Aline's brother-in-law was a well-respected artist and critic.

24. Lance, *Agnes Martin*. Even though *The Tree* is a "grid painting," there is an emphasis on the horizontal axis. For more democratic and "all over" grid renditions, one can look at *A Grey Stone* (1963), *Leaf* (1965), and *Orange Grove* (1965)

25. Rifkin, Ned. *Agnes Martin: The Nineties and Beyond* (Houston: Menil Collection, and Hatje Cantz, 2002), 11.

26. Mangan, Kathleen Nugent ed. *Lenore Tawney: A Retrospective* (New York: American Craft Museum, and Rizzoli International Publications, 1990), 41.

27. Rodgers, Timothy Robert. *In Pursuit of Perfection: The Art of Agnes Martin, Maria Martinez and Florence Pierce* (Albuquerque: Museum of New Mexico Press, 2005), 56.

28. Spretnak, Charlene. "The Spiritual Dynamic in Modern Art," *Art History Reconsidered, 1800 to the Present* (London: Palgrave Macmillan, 2014), 134.

29. Haskell, Barbara. *Agnes Martin* (New York: Whitney Museum of American Art, 1992), 109.

30. The idea of capturing externally a truth that is already known in the mind is very similar—in fact almost identical to—words used by Jasper Johns (her neighbor on Coenties Slip) in *Time* magazine in 1959. In this piece, Johns writes that the content of his paintings are "things the mind already knows."

31. Schwarz, *Agnes Martin*, 21.

32. Lenore G. Tawney Foundation, Archives, New York, 2014.

33. Stevens, Mark. "Thin Gray Line," *Vanity Fair*, March 1989, 56.

34. Delehanty, *Agnes Martin*, 31.

35. "Living above the Line," *The Santa Fe New Mexican*, Friday August 14, 1998, 37.

36. Oral history interview with Marcia Oliver. Interview by Jina Brenneman and Kathleen Brennan. Taos, New Mexico. 2014.

10. LENORE TAWNEY

1. Mangan, Kathleen Nugent, Sid Sachs, Warren Seelig and T'ai Smith. *Lenore Tawney: Wholly Unlooked For* (Maryland Institute College of Art, Baltimore, Maryland and University of the Arts, Philadelphia, Pennsylvania, 2013), 25.

2. The primary source for suggesting Agnes and Lenore were romantically involved is Jonathan D. Katz (via Ann Wilson) in Katz, Jonathan D. "Agnes Martin and the Sexuality of Abstraction," in *Agnes Martin*, ed. Lynne Cooke and Karen Kelly (New Haven: Yale University Press, 2012), 176.

3. Lenore G. Tawney Foundation, Archives, New York, 2014.

4. Martin, Agnes. *Lenore Tawney*. Additional text by James Coggin. (New York: Staten Island Museum, 1961).

5. Morris, Frances and Tiffany Bell. *Agnes Martin* (London: Tate Publishing, 2015), 79.

6. Mangan, Kathleen Nugent, *Lenore Tawney: Wholly Unlooked For*, 6.

7. Ibid.

8. Betty Parsons Gallery records and personal papers, circa 1920–1991, bulk 1946–

1983. Archives of American Art, Smithsonian Institution.

9. Dydo, Ulla E. *A Stein Reader* (Illinois: Northwestern University Press, 1993), 379.

10. Munro, Eleanor. *Originals: American Women Artists* (New York: Touchstone Publishing, 1989), 325–333.

11. Sandler, Irving. "Interview with Agnes Martin," in *Talking Art: Interviews with Artists since 1976*, ed. Patricia Bickers and Andrew Wilson (London: Ridinghouse, 2007), 422–429.

12. Kusama, Yayoi. Trans. Ralph McCarthy. *Infinity Net: The Autobiography of Yayoi Kusama* (London: Tate Publishing, 2013), 37.

13. Kusama, *Infinity Net*, 17.

14. Ibid., 17, 67.

15. Ibid., 87.

16. Ibid., 67.

17. Ibid., 47.

18. Schwarz, *Agnes Martin*, 70–71.

19. Woodman, Donald. *Agnes Martin and Me* (New York: Lyon Artbooks, 2015), 45.

20. Because Agnes's thank you letter was written to Lenore in October 1963, I am making an educated guess that Agnes was hospitalized in the first half of 1963. However, it's also possible that she was hospitalized in 1962, as there seem to be very few paintings produced this year. The fact stands that Agnes was hospitalized numerous times throughout her ten years in New York, so it's very possible she was hospitalized in 1962 and 1963, and of course, again in 1967. The fear of being re-admitted to a hospital in 1967 was one reason she was eager to leave New York before the end of that year.

21. Princenthal, *Agnes Martin*, 153.

22. Lenore G. Tawney Foundation, Archives, New York, 2014. Agnes wrote 'to' instead of "too." Suzanne Hudson in *Night Sea* (p. 68) suggests that Agnes might be thanking Lenore for purchasing and donating her painting *White Flower* (1960) to the Guggenheim Museum.

23. Christina Bryan Rosenberger also notes that Agnes used gold leaf on *Untitled* (c.1954), and *Greystone II* (1961). This is surprising considering her lack of funds at these times. Rosenberger, *Drawing the Line*, 80.

24. Morris, *Agnes Martin*, 61.

25. *The Wave* was not the first playful or literal artwork by Agnes. In 1960 she completed *Dominoes*, an artwork that united various elements surfacing in her work at the time: circles, squares, rectangles, and earth tones. Bookended by two large circles (which themselves call to mind *Untitled* (1958) and *Cow* (1960)), a domino set is arranged in a grid form, tiny black circles within their rectangles, within a rectangle canvas that includes larger circles, top and bottom. Not only is the idea of play directly referenced in *Dominoes*—the game also unites the concept of rules, grand design and chance.

26. Hudson, Suzanne. *Night Sea*. (London: Afterall Books, 2016) 38.

27. While I hold this to be true, Christina Bryan Rosenberger notes that in some works Agnes also used the back of her paintbrush to incise the paint on the canvas, suggesting that the removal of paint was "a compositional tool equivalent to the more standard additive practice of using layers of paint," (Rosenberger, 73). It is true that Agnes often "scored" her paintings in this way, and that subtraction is a feeling one gets from many of the works (as if the paintings are waiting to be filled), but the refined simplicity in her work is an effect achieved through the act of addition rather than subtraction: layers of gesso, layers of paint, pencil markings and so forth.

28. Meyer, James. *Minimalism, Art and Polemics of the Sixties* (New Haven: Yale University Press, 2001), 78.

29. Meyer, James, ed. *Minimalism*. (London: Phaidon Press, 2010) 24–25.

11. LEAVING NEW YORK

1. Collins, "Agnes Martin Reflects on Art & Life," 11, 13–15.

2. Kusama, *Infinity Net*, 84.

3. Collins, "Agnes Martin Reflects on Art & Life," 13.

4. Eisler, "Life Lines," 73.

5. Collins, "Agnes Martin Reflects on Art & Life," 13.

6. Letters accessed at the Lenore G. Tawney Foundation.

7. Princenthal, *Agnes Martin*, 152.

8. Interview with Mildred Tolbert, conducted by Douglas Dreishpoon in Taos, New Mexico, June 23, 2000, p. 13. MRFOHP, Beatrice Mandelman and Louis

Ribak Papers, Center for Southwest Research and Special Collections, University of New Mexico. In this interview, Tolbert recalls her portrait of Agnes: "It was taken in her [Martin's] studio with the Soho Reflex, and she traded me a painting for it. She has a kind of a vulnerable look there, doesn't she."

9. Hunter, Sam. *Chryssa* (New York: Thames and Hudson, 1973), 9.

10. Wilson, Ann. "Linear Webs: Agnes Martin," *Art and Artists I*, No. 7, October 1966, 47.

11. Hunter, *Chryssa*, 10.

12. Oral history interview with Chryssa. Archives of American Art, Smithsonian Institution, June. 26, 1967.

13. Wilson, Ann. Interview with Rachel Pastan, Institute of Contemporary Art, University of Pennsylvania, Online. July 14, 2014.

14. Hunter, *Chryssa*, 5.

15. Ibid.

16. Ibid., 21.

17. Oral history interview with Chryssa. Archives of American Art, Smithsonian Institution, June. 26, 1967.

18. Ibid.

19. Horsfield, Kate and Blumenthal, Lyn. VDB Interviews with Agnes Martin Transcript. Agnes Martin Archives. The Harwood Museum of Art. Taos. New Mexico.

20. Melville, Hermann. *Moby Dick* (Boston: The St. Bololph Society, 1922), 7–8.

21. Sandler, "Interview with Agnes Martin," 422–429.

22. Horsfield, Kate and Blumenthal, Lyn. VDB Interviews with Agnes Martin Transcript. Agnes Martin Archives. The Harwood Museum of Art. Taos. New Mexico.

23. Agnes took a bus from New York to Detroit, and drove the truck and camper back to Manhattan.

24. Reinhardt had studied at Teachers College in the 1930s and he had his first solo artist exhibition there in 1943.

25. Necol, Jane. *Art in America*, October, 1983, 132.

26. Oral history interview with Agnes Martin. Archives of American Art, Smithsonian Institution. May 15, 1989.

27. Princenthal, *Agnes Martin*, 163.

28. Aylon, "Interview with Betty Parsons," 20.

12. BECOMING SOMEONE ELSE

1. Lenore G. Tawney Foundation, Archives, New York, 2014.
2. Samuel J. Wagstaff papers, circa 1932–1985. Archives of American Art, Smithsonian Institution.
3. Christa Martin, Agnes's niece, is quoted from e-mail exchanges with the author.
4. Samuel J. Wagstaff papers, circa 1932–1985. Archives of American Art, Smithsonian Institution.
5. Glimcher, *Agnes Martin*, 243.
6. Ibid.
7. Oral history interview with Agnes Martin. Archives of American Art, Smithsonian Institution. May 15, 1989.
8. Hughes, Robert. *American Visions: The Epic History of Art in America* (London: The Harvill Press, 1997), 3.
9. Schwarz, *Agnes Martin*, 114.
10. Zimmerman, Elyn. E-mail interview by Henry Martin, 2015.
11. Oral history interview with Agnes Martin. Archives of American Art, Smithsonian Institution. May 15, 1989.
12. Loveless, Joan Potter. *Three Weavers* (Albuquerque: University of New Mexico Press, 1992), 27.
13. Ibid.
14. Ibid. 28.
15. Gruen, John. "Everything, everything is about feeling...feeling and recognition," *Art News*, September 1976, 91–94.
16. Horsfield, Kate and Blumenthal, Lyn. VDB Interviews with Agnes Martin Transcript. Agnes Martin Archives. The Harwood Museum of Art. Taos. New Mexico.

13. CUBA, ON A CLEAR DAY

1. Samuel J. Wagstaff papers, circa 1932–1985. Archives of American Art, Smithsonian Institution. The underlined words are done so by the artist.
2. Oral history interview with Pat Steir. Archives of American Art, Smithsonian Institution. March 1–2, 2008.

3. Agnes also made a painting called *Cow* in 1960, and Gertrude Stein wrote *As a Wife has a Cow, A Love Story* in a collection in 1926, which featured some of the last illustrations of the artist Juan Gris.

4. Brown, Kathan. "Pat Steir and Agnes Martin, No Pretensions," *Crown Point Press Newsletter*, April 2012, 2.

5. Glimcher, *Agnes Martin*, 61.

6. Samuel J. Wagstaff papers, circa 1932–1985. Archives of American Art, Smithsonian Institution.

7. This and all quotes from Suzanne Delehanty, unless otherwise indicated, are from Delehanty, Suzanne. E-mail interview by Henry Martin, 2015.

8. Institute of Contemporary Art Archive, Institute of Contemporary Art Archive, Rare Books and Manuscript Collection, Van Pelt- Dietrich Library, University of Pennsylvania, Philadelphia. As quoted in Princenthal, *Agnes Martin*, 188. I have inserted [/] for clarity.

9. Oral history interview with Pat Steir. Archives of American Art, Smithsonian Institution. March 1–2, 2008.

10. Oral history interview with Agnes Martin. Archives of American Art, Smithsonian Institution. May 15, 1989.

11. Delehanty, *Agnes Martin*, 19.

12. Ibid., 20–23.

13. Schwarz, *Agnes Martin*, 42–43.

14. Martin, Agnes. "Reflections," *Artforum*, April 1973, 38.

15. Borden, Lizzie. "Early Work," *Artforum*, April 1973, 44.

16. Ibid.

17. Samuel J. Wagstaff papers, circa 1932–1985. Archives of American Art, Smithsonian Institution.

18. Hillerman, Anne. "A Visit with Agnes Martin," *Santa Fe New Mexican*, 26 July 1973.

19. Interview with Agnes Martin, conducted by Douglas Dreishpoon in Taos, New Mexico, June 24, 2000, p. 10. Mandelman-Ribak Foundation Oral History Project (hereafter MRFOHP), Beatrice Mandelman and Louis Ribak Papers, Center for Southwest Research and Special Collections, University of New Mexico.

20. Johnston, *Gullibles Travels*, 267–268.

21. Johnston, Jill. "Agnes Martin: 1912–2004" *Art in America* 93, No. 3, March 2005, 41.

22. Johnston, *Gullibles Travels*, 271.

23. Ibid., 276.

24. Ibid., 282.

25. Woodman, *Agnes Martin and Me*, 39.

26. Auping, Michael. *30 Years: Interviews and Outtakes* (Fort Worth: Modern Art Museum of Fort Worth, 2007), 223.

27. Johnston, *Gullibles Travels*, 277. Mark Stevens in his piece for *Vanity Fair* is also one of the few writers to openly debunk the mythical mystical image of Agnes that had been for so long perpetuated in the popular and art presses.

28. Martin, Agnes. "Unskirting the Issue," *Art-Rite*, No. 5, Spring 1974, 6–7.

29. Johnston, *Gullibles Travels*, 283.

30. Ibid., 275.

31. Ibid., 272.

32. Oral history interview with Agnes Martin. Archives of American Art, Smithsonian Institution. May 15, 1989.

33. Stevens, Mark. "Thin Gray Line," *Vanity Fair*, March 1989, 50, 54, 56.

34. Though a photographer, Woodman designed and helped construct Agnes's Galisteo home.

35. Glimcher, *Agnes Martin*, notebook page 26.

36. Oral history interview with Agnes Martin. Archives of American Art, Smithsonian Institution. May 15, 1989.

37. Ibid.

38. Spranger, Denise M. "Center of Attention," *Tempo Magazine*, 21–27 March, 2002, 20–24.

39. Gruen, "Everything, everything is about feeling...feeling and recognition," 94.

40. Aylon, "Interview with Betty Parsons," 10–13, 20.

41. Stevens, "Thin Gray Line," 50, 54, 56.

42. Glimcher, *Agnes Martin*, 64.

43. Ibid., 120.

14. GABRIEL

1. Oral history interview with Agnes Martin. Archives of American Art, Smithsonian Institution. May 15, 1989.
2. Horsfield, Kate and Blumenthal, Lyn. VDB Interviews with Agnes Martin Transcript. Agnes Martin Archives. The Harwood Museum of Art. Taos. New Mexico.
3. Ibid.
4. Oral history interview with Agnes Martin. Archives of American Art, Smithsonian Institution. May 15, 1989.
5. Horsfield, Kate and Blumenthal, Lyn. VDB Interviews with Agnes Martin Transcript. Agnes Martin Archives. The Harwood Museum of Art. Taos. New Mexico.
6. Glimcher, *Agnes Martin*, 88.
7. Oral history interview with Agnes Martin. Archives of American Art, Smithsonian Institution. May 15, 1989.
8. Simon, "Perfection is in the Mind: An Interview with Agnes Martin," 82–89, 124.
9. Oral history interview with Agnes Martin. Archives of American Art, Smithsonian Institution. May 15, 1989.
10. Ibid.
11. Ibid.
12. Horsfield, Kate and Blumenthal, Lyn. VDB Interviews with Agnes Martin Transcript. Agnes Martin Archives. The Harwood Museum of Art. Taos. New Mexico.
13. Ibid.
14. Oral history interview with Agnes Martin. Archives of American Art, Smithsonian Institution. May 15, 1989.
15. Horsfield, Kate and Blumenthal, Lyn. VDB Interviews with Agnes Martin Transcript. Agnes Martin Archives. The Harwood Museum of Art. Taos. New Mexico.
16. As an aside, Jacquelynn Baas notes that "Many of her [Martin's] key themes—humility, obedience, praise—are demands of the Old Testament God and had their roots in Martin's bone-deep knowledge of scripture" in Morris, *Agnes Martin*, 225.
17. Adja Yunkers was teaching at UNM at the same time as Agnes in 1947.
18. Ashton, *Agnes Martin*, 11.

19. Ibid., 14.

20. Ibid., 13.

15. GALISTEO

1. Oral history interview with Agnes Martin. Archives of American Art, Smithsonian Institution. May 15, 1989.

2. Glimcher, *Agnes Martin*, 104.

3. Woodman, *Agnes Martin and Me*, 28.

4. Collins, "Agnes Martin Reflects on Art & Life," 14.

5. Woodman, *Agnes Martin and Me*, 29.

6. Collins, "Agnes Martin Reflects on Art & Life," 14.

7. Woodman, *Agnes Martin and Me*, 30.

8. Collins, "Agnes Martin Reflects on Art & Life," 14.

9. Oral history interview with Agnes Martin. Archives of American Art, Smithsonian Institution. May 15, 1989.

10. Johnston, *Gullibles Travels*, 276.

11. Rifkin, *Agnes Martin*, 25.

12. Ibid.

13. Glimcher, *Agnes Martin*, 89.

14. Oral history interview with Agnes Martin. Archives of American Art, Smithsonian Institution. May 15, 1989.

15. Princenthal, *Agnes Martin*, 210.

16. Ibid., 209.

17. Horsfield, Kate and Blumenthal, Lyn. VDB Interviews with Agnes Martin Transcript. Agnes Martin Archives. The Harwood Museum of Art. Taos. New Mexico: 19.

18. Eauclaire, Sally. "All My Paintings are about Happiness and Innocence: An Interview with Agnes Martin," 17.

19. Ibid.

20. Interview with Ted Egri, conducted by Douglas Dreishpoon in Taos, New Mexico June 24, 2000, p. 27. MRFOHP, Beatrice Mandelman and Louis Ribak Papers,

Center for Southwest Research and Special Collections, University of New Mexico.

21. Stevens, "Thin Gray Line," 54.

22. Simon, "Perfection is in the Mind: An Interview with Agnes Martin," 124.

23. Oral history interview with Agnes Martin. Archives of American Art, Smithsonian Institution. May 15, 1989.

24. Glimcher, *Agnes Martin*, 116.

25. Ibid., 117.

26. Morris, *Agnes Martin*, 29.

27. Glimcher, *Agnes Martin*, 120.

28. Donald Woodman explained that the pool was vandalized with paint, which was one reason Agnes decided to have it filled in. See *Woodman*, 126.

29. Agnes Martin, *Spotlight Magazine*, December, 1997, 20.

30. Rifkin, *Agnes Martin*, 39.

31. Glimcher, *Agnes Martin*, 246.

32. Princenthal, *Agnes Martin*, 155.

33. Necol, *Art in America*, 132.

34. Information on this episode taken from the affidavit for criminal complaint and arrest warrant issued to Herta Spitzweiser and coverage of the case in local media.

16. I CAME HOME

1. Donald Woodman's first-hand account of living with Agnes in Galisteo is revelatory. In his book Woodman recounts the ups and downs of his relationship with Agnes, at a particularly vulnerable time in the artist's life (and indeed, Woodman's). The book gives some further insight into these Galisteo years.

2. Haskell, Barbara. Interview by Henry Martin. London. 18 May 2015.

3. Eisler, "Life Lines," 78.

4. When Artforum asked Pat Steir to question Agnes on her sexuality in an interview, Pat refused, recalling, "that was a toxic subject for Agnes." Oral history interview with Pat Steir. Archives of American Art, Smithsonian Institution. March 1–2, 2008.

5. Himes, John Ward. *I Saw My Father Cry* (Canada: Trafford Publishing. Canada, 2006), 161.

6. In an interview in 2000 Agnes describes fighting off "the hysterical society" (the Taos Historical Society) who objected to Agnes installing skylights in her studio building. Even though the building was three hundred years old, Agnes won. Interview with Agnes Martin, conducted by Douglas Dreishpoon in Taos, New Mexico, June 24, 2000, p. 13. MRFOHP, Beatrice Mandelman and Louis Ribak Papers, Center for Southwest Research and Special Collections, University of New Mexico.

7. Kusel, Denise. "Rock of Agnes," *Pasatempo*, 8–14 October, 1999, 60.

8. Schwarz, Dieter. Interview by Henry Martin. Taos, New Mexico, November, 2014.

9. Schwarz, *Agnes Martin,* 16. The reference for the Coates review is, Coates, Robert M. "The Art Galleries: Variations on Themes" (Betty Parsons review). *New Yorker*, 14 October 1961: 202–04, 07.

10. Princenthal, *Agnes Martin*, 157–158.

11. Woodman, *Agnes Martin and Me*, 135.

12. Princenthal, *Agnes Martin*, 158.

13. Ibid., 188.

14. Schwarz, *Agnes Martin,*115.

15. All direct quotes from Bob Ellis from oral history interview with Bob Ellis. Interview by Jina Brenneman and Kathleen Brennan. Taos, New Mexico, 2014.

16. Collins, "Agnes Martin Reflects on Art & Life," 11. Agnes had weekday lunches with various people in Taos. Bob was just one lunch date among many.

17. Delehanty, Suzanne. E-mail interview by Henry Martin, April, 2015.

18. Attiyeh, Jennifer. "Agnes Martin: An Artist on her Own," *Horse Fly*, Taos, April, 15 2001, 17.

19. Andrews, Mike. Interview with Bob Ellis. Transcript. The Harwood Museum of Art. Taos, New Mexico. 2014.

17. STUDIO LIFE

1. "Living above the Line," *The Santa Fe New Mexican*, Friday August 14, 1998, 37.

2. Hudson, *Night Sea*, 69–70.

3. Ibid. This quote is taken from Lizzie Borden writing to Suzanne Delehanty. The original source isInstitute of Contemporary Art Archive, Rare Books and Manuscript Collection, Van Pelt- Dietrich Library, University of Pennsylvania, no number, Lizzie Borden Correspondence.

4. Attiyeh, Jennifer. "Agnes Martin: An Artist on her Own," *Horse Fly*, Taos, April, 15 2001, 16.

5. Although the paintings are dated to 1993—1994, the Agnes Martin Gallery did not open until 1997.

6. Ashton, *Agnes Martin*, 12.

7. Venice Biennale, Press Release, The Agnes Martin Archive, The Harwood Museum of Art, Taos, New Mexico, 2014.

18. THE STORYTELLER CINEMA

1. Marcia Oliver details and quotes taken from e-mails with the author, the artist's notes (supplied to this author), an interview between the artist and author, and an oral history interview between the artist and Jina Brenneman and Kathleen Brennan.

2. Rifkin, *Agnes Martin*, 24.

3. Rosenberger, *Drawing the Line*, 120.

4. Attiyeh, Jennifer. "Agnes Martin: An Artist on her Own," *Horse Fly*, Taos, April, 15 2001, 16.

5. Ibid.

19. AN UNLIKELY BENEFACTOR

1. Agnes Martin, *Spotlight Magazine*, December, 1997, 20.

2. To be more specific, Agnes was an anonymous donor and Kristina represented this "anonymous donor" and the funds, which were allocated to the town of Taos. It is not immediately clear to me, or easy to find out, if Agnes funded both the center and the swimming pool, or the swimming pool only. The way Kristina presents it, she suggested that Agnes's money was spent on both. The swimming

pool was completed in 2005, after Agnes had died in 2004.

3. Schwarz, *Agnes Martin*, 71–72.

4. Lance, *Agnes Martin*.

20. THE PEACH TREE

1. Jina Brenneman in conversation with Susan Montoya Bryan from the Associated Press. Published as "Discovering Agnes Martin's Artistic Roots," *The Huffington Post*, Online, 21 February 2012.

2. The transcript of this talk was accessed at the Agnes Martin Archive. The Harwood Museum. Taos, New Mexico, 2014.

3. Morris, *Agnes Martin*, 176.

4. Oliver, Marcia. Interview by Henry Martin. Arroyo Seco, New Mexico, October, 2014.

EPILOGUE: SERENDIPITIES

1. Interview with Kristina Wilson, conducted by Douglas Dreishpoon in Taos, New Mexico, June 25, 2000, p. 13. MRFOHP, Beatrice Mandelman and Louis Ribak Papers, Center for Southwest Research and Special Collections, University of New Mexico.

2. "Living above the Line," *The Santa Fe New Mexican*, Friday August 14, 1998, 37.

AFTERWORD

1. Glimcher, *Agnes Martin*, notebook page 26.

2. Johnston, *Gullibles Travels*, 274.

3. Loveless, *Three Weavers*, 8.

4. Gruen, "Everything, everything is about feeling...feeling and recognition," 94

5. Interview with Ted Egri, conducted by Douglas Dreishpoon in Taos, New Mexico, June 24, 2000, p. 26. MRFOHP, Beatrice Mandelman and Louis Ribak Papers, Center for Southwest Research and Special Collections, University of New Mexico.

6. Letters accessed at the Lenore G. Tawney Foundation, dated, respectively, July 26th 1965, October 25th 1963, and from *The Untroubled Mind* in Delehanty, *Agnes Martin*, 20–23.

7. Martin, Agnes, Skowhegan Lecture, 1987.

8. Interview with Agnes Martin, conducted by Douglas Dreishpoon in Taos, New Mexico, June 24, 2000, p.18. MRFOHP, Beatrice Mandelman and Louis Ribak Papers, Center for Southwest Research and Special Collections, University of New Mexico.

Select Bibliography
(Books, Articles, Video, and Film)

Abatemarco, Michael. "The Art of the Transcendental Painters," *Santa Fe New Mexican*, August 23, 2013.

Ashton, Dore. *Agnes Martin: Paintings and Drawing 1957–1975*. London: Arts Council of Great Britain, 1976. Exhibition Catalog.

Ashton, Dore. *The New York School: A Cultural Reckoning*. Berkeley: University of California Press, 1972.

Ashton, Dore. "Premiere Exhibition for Agnes Martin." *New York Times*, 6 December 1958: 26.

Ashton, Dore. "Art: Drawn from Nature: Agnes Martin's Paintings at Section Eleven Gallery Reflect Love of Prairies." *New York Times*, 29 December 1959: 23.

Ashton, Dore. "Art: Welded from Metal." *New York Times*, 30 September, 1958.

Attiyeh, Jennifer. "Agnes Martin: An Artist on her Own." *Horse Fly*, Taos, 15 February 2001: 16–17.

Attiyeh, Jennifer. "Agnes Martin: An Artist on her Own." *Horse Fly*, Taos, 15 March, 2001: 14–15.

Attiyeh, Jennifer. "Agnes Martin: An Artist on her Own." *Horse Fly*, Taos, 15 April 2001: 16–17.

Attiyeh, Jennifer. "Agnes Martin: An Artist on her Own." *Horse Fly*, Taos, 15 May 2001: 16–17.

Aylon, Helene, "Interview with Betty Parsons," *Women Art*, Fall 1977: 10–13, 20.

Baas, Jacquelynn. *Smile of the Buddha: Eastern Philosophy and Western Art from Monet to Today*. Berkeley: University of California Press, 2005.

Barron, Stephanie. "Giving Art History the Slip." *Art in America* 62, no. 2, March 1974: 80–84.

Boll, Deborah. *Albuquerque '50s*. Albuquerque: The University of New Mexico Art Museum, 1989. Exhibition catalog.

Brennan, Kathleen, director, and Jina Brenneman, co-producer. *Agnes Martin Before The Grid*. Taos: New Mexico: Kathleen Brennan Studio, 2016. 56 minutes.

Brenneman, Jina and Tiffany Bell, editors. *Agnes Martin: Before the Grid*. Taos: Harwood Museum of Art, University of New Mexico, 2012. Exhibition catalog.

Breslin, James E. B. *Mark Rothko, A Biography*. Chicago: University of Chicago Press, 1998.

Brown, Kathan. "Pat Steir and Agnes Martin, No Pretensions". *Crown Point Press Newsletter*, April 2012: 1-6.

Borden, Lizzie. "Early Work." *Artforum II*, no. 8, April 1973: 39–44.

Boxer, Sarah. "The Last Irascible." *New York Review of Books*, December 23, 2010.

Coates, Robert M. "The Art Galleries: Variations on Themes." *New Yorker*, 14 October 1961: 202–04, 07.

Collins, Tom. "Agnes Martin Reflects on Art & Life." *Taos Geronimo*, January 1999: 11, 13–15.

Cooke, Lynne, Karen Kelley, and Barbara Schröder, editors. *Agnes Martin*. New York and New Haven: Dia Art Foundation; Yale University Press, 2011.

de Kooning, Elaine. *Albuquerque*. Great Jones Gallery, New York, February Announcement, 1960.

Delehanty, Suzanne. *Agnes Martin*. Philadelphia: Institute of Contemporary Art, University of Pennsylvania, 1973. Exhibition catalog.

Dorfman, John. "Mystic Vistas." *Arts and Antiques Magazine Online*. August, 2013.

Eauclaire, Sally. "All My Paintings are about Happiness and Innocence: An Interview with Agnes Martin." *Southwest Profile 16*, no.2, May–July 1993: 14–17.

Eisler, Benita. "Profile: Life Lines." *New Yorker*, 25 January 1993: 70–83.

Gibson, Ann. "Lesbian Identity and the Politics of Representation in Betty Parsons' Gallery." *Gay and Lesbian Studies in Art History*, edited by Whitney Davis. New York: Harrington Park Press, 1994.

Glimcher, Arne. *Agnes Martin: Paintings, Writings, Remembrances.* London and New York: Phaidon Press, 2012.

Glimcher, Mildred. *Indiana, Kelly, Martin, Rosenquist, Youngerman at Coenties Slip.* New York: Pace Gallery, 1993. Exhibition catalog.

Gottlieb, Adolph, "The Artist and Society," *College Art Journal.* New York, 1955.

Gruen, John. "Everything, everything is about feeling ... feeling and recognition." *ARTnews 75*, no. 7, September 1976: 91–94.

Hall, Lee. *Betty Parsons, Artist, Dealer, Collector.* New York: Harry N. Abrams, 1991.

Hambidge, Jay. *Dynamic Symmetry: The Greek Vase.* Yale University Press, 1920.

Hammel, Faye, "Bohemia on South Street," *The Lookout.* Seaman's Church Institute, New York, December 1957: 4–5.

Haskell, Barbara. *Agnes Martin.* New York: Whitney Museum of American Art, 1992. Exhibition catalog.

Hayes, David. "Lines in the Desert." *Saturday Night*, December 1997: 79–80, 82–84.

Hillerman, Anne. "A Visit with Agnes Martin." *Santa Fe New Mexican*, 26 July 1974.

Himes, John Ward. *I Saw My Father Cry.* Canada: Trafford Publishing, 2006.

Horsfield, Kate and Blumenthal, Lyn. *Agnes Martin.* Chicago: School of the Art Institute of Chicago Video Data Bank, 1976, VHS.

Hudson, Suzanne. *Night Sea.* London: Afterall Books, 2016.

Hughes, Robert. *American Visions: The Epic History of Art in America.* London: Harvill Press, 1997.

Hunter, Sam. *Chryssa.* New York: Thames and Hudson, 1973.

Johnston, Jill. "Agnes Martin: 1912–2004." *Art in America 93*, no. 3 (March 2005): 41–43.

Johnston, Jill. *Gullibles Travels.* New York: Links Books, 1974.

Katz, Jonathan. "Agnes Martin and the Sexuality of Abstraction." in *Agnes Martin*, edited by Lynne Cooke. New York and New Haven: Dia Art Foundation; Yale University Press, 2011.

Kramer, Hilton. "An Art That's Almost Prayer." *New York Times*, May 1976.

Kusama, Yayoi. Trans. Ralph McCarthy. *Infinity Net: The Autobiography of Yayoi*

Kusama. London: Tate Publishing, 2013.

Lance, Mary, dir. *Agnes Martin: With My Back to the World.* Corrales, New Mexico: New Deal Films, 2003. DVD, 57 minutes.

Landauer, Susan. *The San Francisco School of Abstract Expressionism.* Berkeley: University of California Press, 1996. Exhibition catalog.

Linville, Kasha. "Agnes Martin; An Appreciation." *Artforum,* June 1971: 72–73.

Lippard, Lucy R. *Grids, grids, grids, grids, grids, grids, grids, grids.* Philadelphia: Institute of Contemporary Art, University of Pennsylvania, 1972. Exhibition catalog.

Loveless, Joan Potter. *Three Weavers.* Albuquerque: University of New Mexico Press, 1992.

Mangan, Kathleen Nugent, editor. *Lenore Tawney: A Retrospective.* New York: American Craft Museum and Rizzoli International Publications, 1990. Exhibition catalog.

Mangan, Kathleen Nugent, Sid Sachs, Warren Seelig and T'ai Smith. *Lenore Tawney: Wholly Unlooked For,* Maryland Institute College of Art, Baltimore, Maryland and University of the Arts, Philadelphia, Pennsylvania, 2013. Exhibition catalog.

Martin, Agnes. Additional text by James Coggin. *Lenore Tawney.* New York: Staten Island Museum, 1961. Exhibition catalog.

Martin, Agnes. *Gabriel.* 16 mm film. 79 minutes, 1976.

Meyer, James. *Minimalism, Art and Polemics of the Sixties.* New Haven and London: Yale University Press, 2001.

Meyer, James, ed. *Minimalism.* London: Phaidon Press, 2010.

Munro, Elenor. *Originals: American Women Artists.* New York: Touchstone Publishing, 1989.

Stevens, Mark. "Thin Gray Line," *Vanity Fair,* March 1989.

Martin, Agnes, "Untroubled Mind," *Flash Art,* June 1973: 6–8.

Martin, Agnes, "Reflections," *Artforum,* April 1973: 38.

Maxwell, Elsa. "Elsa Maxwell's Party Line." *New York Post.* December, 20, 1946.

Meyer, James, ed. *Minimalism.* London: Phaidon Press, 2010.

Morris, Francis and Tiffany Bell, editors. *Agnes Martin.* London: Tate Publishing, 2015. Exhibition catalog.

Necol, Jane. *Art in America,* October 1983: 132.

Newmann, Dana. *New Mexico Artists at Work.* Santa Fe: Museum of New Mexico

Press, 2005.

Phaidon Editors. *Art in Time: A World History of Styles and Movements*. London: Phaidon Press, 2014.

Phaidon Editors. *The Art Museum*. London: Phaidon Press, 2011.

Peterson, William. "Agnes Martin: The Island." *Artspace*, Summer 1979: 36–41.

Princenthal, Nancy. *Agnes Martin: Her Life and Art*. London: Thames and Hudson, 2015.

Prokopoff, Stephen S. *A Romantic Minimalism*. Philadelphia: Institute of Contemporary Art, University Pennsylvania, 1967. Exhibition catalog.

Rifkin, Ned. *Agnes Martin: The Nineties and Beyond*. Houston: Menil Collection, and Hatje Cantz, 2002. Exhibition catalog.

Rodgers, Timothy Robert. *In Pursuit of Perfection: The Art of Agnes Martin, Maria Martinez and Florence Pierce*. Albuquerque: Museum of New Mexico Press, 2005. Exhibition catalog.

Rosenberger, Christina Bryan. *Drawing the Line: The Early Work of Agnes Martin*. Oakland: The University of California Press, 2016.

Sandler, Irving. "Interview with Agnes Martin." *Talking Art: Interviews with Artists since 1976*. Patricia Bickers and Andrew Wilson, editors. London: Ridinghouse, 2007: 422–429.

Sandler, Irving. "Agnes Martin Interview." *Art Monthly*, September 1993: 3–11.

Schwarz, Dieter, ed. *Agnes Martin: Writings/Schriften*. Ostfildern-Ruit, Germany: Cantz; Kunstmuseum Winterthur, 1992.

Schiff, Karen L. "Slow Reveal," review of *Agnes Martin: Paintings, Writings, Remembrances* by Arne Glimcher. *Art in America*, 101, no. 6 (June/July 2013): 49–52.

Simon, Joan. "Perfection is in the Mind: An Interview with Agnes Martin." *Art in America 84*, no. 5, May 1996: 82–89, 124.

Spranger, Denise M. "Center of Attention." *Tempo Magazine*. 21–27 March, 2002: 20–24.

Spretnak, Charlene. "The Spiritual Dynamic in Modern Art." *Art History Reconsidered, 1800 to the Present*. London: Palgrave Macmillan, 2014.

Wilson, Ann. "Linear Webs." *Art and Artists I*, no. 7, October 1966: 46–49.

Witt, David L. "The Taos Moderns: Agnes Martin." *Taos Magazine*, July 1990.

Witt, David L. *Modernists in Taos*. Santa Fe: Red Crane Books, 2002.

Woodman, Donald. *Agnes Martin and Me*. New York: Lyon Artbooks, 2015.

INTERVIEWS:

Chryssa. Oral history interview, Archives of American Art, Smithsonian Institution, June 26, 1967.

Delehanty, Suzanne. E-mail interview with Henry Martin, April 2015.

de Puy, John. Interview by Jina Brenneman and Kathleen Brennan. Taos, New Mexico, 2014.

Egri, Ted. Interview conducted by Douglas Dreishpoon in Taos, New Mexico June 24, 2000, Mandelman-Ribak Foundation Oral History Project, Beatrice Mandelman and Louis Ribak Papers, Center for Southwest Research and Special Collections, University of New Mexico.

Ellis, Robert "Bob". Interview conducted by Mike Andrews. Transcript accessed at the Harwood Museum of Art, University of New Mexico, Taos, New Mexico, 2014.

Ellis, Robert "Bob". Interview by Jina Brenneman and Kathleen Brennan. Taos, New Mexico, 2014.

Hall, Lee. Interview conducted by Henry Martin, South Hadley, Massachusetts, November, 2014.

Haskell, Barbara. Phone Interview with Henry Martin, 18 May, 2015.

Kane, Mildred. Interview by Karen Beck Skold. Oregon Historical Society Research Library, Transcript 19, Audio Tape 24, 1976, Oregon.

Kinnon, Christopher. E-mail interview with Henry Martin, 2014, 2015, 2016.

Landsman, Stanley. Oral history interview, Archives of American Art, Smithsonian Institution. January 19–22, 1968.

Mangan, Kathleen Nugent. Interview conducted by Henry Martin, New York, November, 2014.

Mangan, Kathleen Nugent. E-mail interview with Henry Martin, 2015, 2016, 2017.

Martin, Agnes. Oral history interview, Archives of American Art, Smithsonian Institution. May 15, 1989.

Martin, Agnes. Interview conducted by Douglas Dreishpoon in Taos, New Mexico June 24, 2000, Mandelman-Ribak Foundation Oral History Project, Beatrice Mandelman and Louis Ribak Papers, Center for Southwest Research and Spe-

cial Collections, University of New Mexico.

Martin, Christa. E-mail interview with Henry Martin, 2015, 2016, 2017.

McChesney, Mary Fuller. Oral history interview, Archives of American Art, Smithsonian Institution, September 28, 1994.

Oliver, Marcia. Interview conducted by Henry Martin, Arroyo Seco, New Mexico, October, 2014.

Oliver, Marcia. Interview by Jina Brenneman and Kathleen Brennan. Taos, New Mexico, 2014.

Parker, Robert "Bob". Interview conducted by Henry Martin, Taos, New Mexico, November, 2014.

Parsons, Betty, Oral history interview, Archives of American Art, Smithsonian Institution, June 11, 1981.

Ryan, Martin. Interview by Sean Ryan, courtesy of Jina Brenneman and Kathleen Brennan, 2014.

Sause, Louise. Interview by Jina Brenneman and Kathleen Brennan. Michigan, 2014.

Schwarz, Dieter. E-mail interview with Henry Martin, November, 2014.

Steir, Pat. Oral history interview, Archives of American Art, Smithsonian Institution. March 1–2, 2008.

Stroh, Earl. Interview conducted by Douglas Dreishpoon in Talpa, New Mexico June 25, 2000, Mandelman-Ribak Foundation Oral History Project, Beatrice Mandelman and Louis Ribak Papers, Center for Southwest Research and Special Collections, University of New Mexico.

Tawney, Lenore. Oral history interview, Archives of American Art, Smithsonian Institution, June 23, 1971.

Tolbert, Mildred, Interview conducted by Douglas Dreishpoon in Taos, New Mexico June 23, 2000, Mandelman-Ribak Foundation Oral History Project, Beatrice Mandelman and Louis Ribak Papers, Center for Southwest Research and Special Collections, University of New Mexico.

Wilson, Ann. Interview conducted by Rachel Pastan, Institute of Contemporary Art, University of Pennsylvania. Accessed online, July 14, 2014.

Wilson, Kristina. Interview conducted by Henry Martin, Taos, New Mexico, November, 2014.

Wilson, Kristina. Interview conducted by Douglas Dreishpoon in Taos, New Mex-

ico June 25, 2000, Mandelman-Ribak Foundation Oral History Project, Beatrice Mandelman and Louis Ribak Papers, Center for Southwest Research and Special Collections, University of New Mexico.

Zimmerman, Elyn. E-mail interview with by Henry Martin, London/ California, 2015.

ARCHIVES:

Agnes Martin Archive, Harwood Museum of Art, University of New Mexico, Taos, New Mexico.

Agnes Martin Collection, New Mexico Museum of Art Library and Archives, Santa Fe, New Mexico.

Archives of the Albuquerque Museum of Art and History, Albuquerque, New Mexico.

Beatrice Mandelman and Louis Ribak Papers, Center for Southwest Research and Special Collections, University of New Mexico, Albuquerque, New Mexico.

Betty Parsons Gallery Records and Personal Papers, circa 1920–1991, bulk 1946–1983, Archives of American Art, Smithsonian Institution, Washington D.C.

Celeste Bartos International Film Study Center, Museum of Modern Art, New York.

Lenore G. Tawney Foundation Archives, New York.

Porter Archives, New Mexico Museum of Art Library and Archives, Santa Fe, New Mexico.

Samuel J. Wagstaff Papers, circa 1932–1985, Archives of American Art, Smithsonian Institution, Washington D.C.

Index

Avalon (Albuquerque, NM), 60–61, 315n2

Baas, Jacquelynn, 330n16

Bach, Johann Sebastian, 158, 235–236

Bacon, Francis, 310

Bailey's Irish Cream, 303–304

band paintings of AM, 268–270

Bed (Rauschenberg), 123, 125

Beethoven, Ludwig van, 236

Bell, Tiffany, 239, 291

Bellevue Psychiatric Hospital, 158–160

Besant, Annie, 69

Betty Parsons Gallery (NYC), 110–111; Christmas show at, 112–113; loses artists, 115–116; AM's contract with, 128–129; sells AM's paintings, 130; Chryssa and, 171; M. Oliver and, 276

Bible, 141, 330n16

biography, AM on, 21–22, 189, 229, 270

Bisttram, Emil, 53–54, 69

Black Mountain College (Black Mountain, NC), 56–57

Black, White and Gray (exhibition), 163

Blumenschein, Ernest L., 50–51

Borden, Lizzie, 203, 208–209

Bourgeois, Louise, 125, 309

Brennan, Kathleen, 301–302, 308

Brenneman, Jina, 291, 300–302, 308

Brett, Dorothy, 52–53

Brown, Bruce, 85–86

Brown, Eric, 86

Brown, Kathan, 198

Brown, Kristina. *See* Wilson, Kristina

Brown

Brown, Lesley MacDougall, 84, 85–86

Brown, Malcolm, 86

Brown, Paul, 85

Budd, David, 129

Buddhism, 59–60, 137–139, 142

Butler, Alban, 141

Bynner, Wittner, 139

Cage, John, 139

Callery, Mary, 125

Canada, 187–188. *See also individual towns and cities*

Captivity (film) (AM), 232–234

Carr, Arthur, 160, 253

cars, 88–89

catalogs of AM's work, 201–202, 204, 228, 247–248, 251–253

Cather, Willa, 113

Cedar Tavern, 128

Celant, Germano, 270

celebration of AM's life, 289

Central Park (NYC), 55

charity. *See* philanthropy, of AM

Charlton, Maryette, 147

Chianti Foundation (Marfa, TX), 199

Chicago Institute of Design, 147

childhood of AM, 31–35

children, AM's attitude on, 21, 63, 193, 224, 285–289

Chryssa. *See* Vardea-Mavromichali, Chryssa

citizenship, U.S., 63, 190

Clarke, Bob. *See* Indiana, Robert

perfection and imperfection in AM's work, 139–146, 228, 267

philanthropy of AM, 284–288, 334–335n2

Phillips, Bert Geer, 50–51

photography, 61, 74; women and, 43; and AM, 168–169, 226, 259; documentary, 237–238

Plato, 307

Plaza de Retiro (Taos, NM), 17–18, 250, 284

plein air, AM and, 61

Pollock, Jackson, 74, 111, 116, 126

Ponce de Leon Hot Springs, 284

Poons, Thalia, 155, 211

Porter, Aline, 82; and Ruins Gallery, 98; on abstraction, 114; relationship with AM and B. Parsons, 132–135; on NYC, 155

Porter, Eliot, 133–134

Portland, OR, 39, 44, 47

portraiture, 61–62. *See also* photography

poverty, chosen, 87–88

Precisionism, 41

pride of AM, 265

Princenthal, Nancy, 33, 46, 235

Prokopoff, Stephen, 199–200

psychiatrist, AM sees, 160, 168–169, 177. *See also* mental breakdowns; paranoia; schizophrenia

Public Works of Art Project, 42

Pullens, Barbara, 61

Qi (princess), 232

Ranchos de Taos, NM, 98–99

Rauschenberg, Robert, 125, 127, 172

Red Cross (Taos, NM), 88–89

Reflections (Martin), 207–208

Regionalism, 42–43

Reinhardt, Ad, 68–69, 74, 91, 139, 316n11, 320n7, 326n23; and AM, 175

religion and spirituality, 83, 137–138, 141–143, 156, 241, 261. *See also* Bible; Buddhism

response to art, AM on, 22, 222–223, 239, 270

Responsive Eye, The (exhibition), 136

retrospectives of AM's work, 195, 199–202, 239–240, 247–249, 266, 308

reviews of AM, 54–55, 129, 203

Revolt Against the City (Wood), 43

Reynal, Jeanne, 130

Ribak, Louis, 83, 89, 317n7; and Ruins Gallery, 98

River (Tawney), 154

Robert Elkon Gallery, 135–136

Rocker series (Kelly), 124

Rogoway, Alfred, 81, 90

Rogoway, John, 90

Romantic Minimalism, A (exhibition), 174, 199

Rosenberger, Christina Ryan, 314n17, 318n16, 325n27

Rosenquist, James, 125

Rothko, Mark, 74–75, 116, 126, 320n7; AM on death of, 193

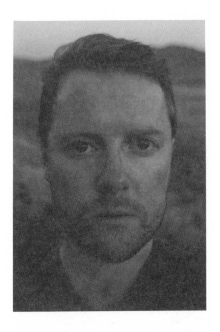

HENRY MARTIN is an award-winning Irish writer. His plays have featured at Project Arts Centre, Roundhouse, Underbelly, Arcola, Theatre503, and Belltable; his fiction and poetry is published in Ireland, Mexico, USA and UK; and he has written on art and books for Soho House and Phaidon Press, where he worked in editorial and rights. He has a BA in English and Philosophy from the National University of Ireland, Galway, an MA in Playwriting from Royal Holloway, University of London, and he is pursuing an MA(Res) in art history at the University of Buckingham and the National Gallery, London, with a Tavolozza Foundation Scholarship. His limited edition book *Yappo* (2017) received a Tipperary Artists Award, and funding from the University for the Creative Arts, London. Henry is an Emily Harvey Foundation resident, and was researcher on, and narrator of, the award-winning documentary *Agnes Martin Before The Grid* (2016). www.henry-martin.co.uk